Complete
Watercolour

For Beginners and Beyond:
Art Materials, Techniques and Picture Making

Complete Watercolour

David Webb

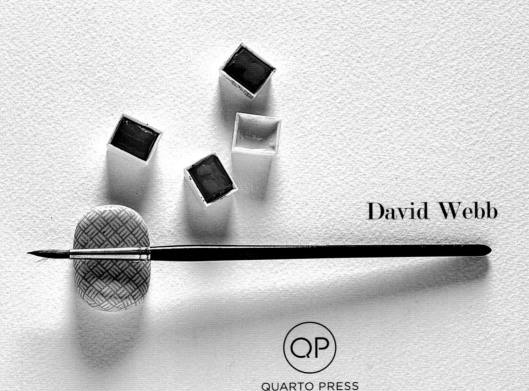

QP
QUARTO PRESS

A QUARTO BOOK

Published in 2016 by
Quarto Press
6 Blundell Street
London N7 9BH
www.quartoknows.com

ISBN 978-0-85762-147-4

QUAR WCCG

Conceived, edited and designed by
Quarto Press
6 Blundell Street
London N7 9BH

Senior Editor: Sarah Hoggett
Designers: Sue Wells and Rebecca Malone
Photographers: Phil Wilkins and Kim Sayer
Picture Researcher: Sarah Bell
Assistant Editor: Georgia Cherry
Proofreader: Claire Waite Brown
Art Director: Caroline Guest
Creative Director: Moira Clinch
Publisher: Paul Carslake

Colour separation by PICA Digital Pte Ltd, Singapore
Printed by Hung Hing Off-set Printing Co. Ltd, China

Contents

8 Meet David Webb

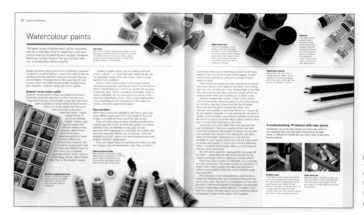

Colour photos
All tools and
materials are
shown in clear,
colour photographs.

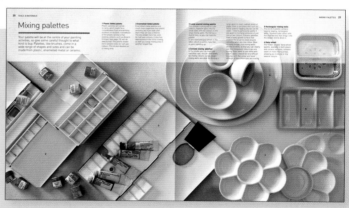

Chapter 1
Tools & Materials **10**

12 Watercolour paints
14 Pigment properties
16 Brushes
19 Holding brushes
20 Mixing palettes
22 Paper types & weights
24 Stretching paper
26 Other equipment
28 Getting comfortable
29 The watercolour artist's travel kit

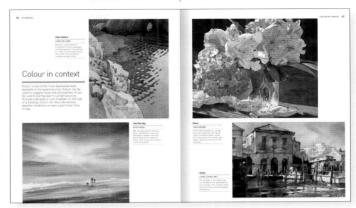

Inspirational finished paintings
Specially selected watercolours by professional artists show the techniques in context.

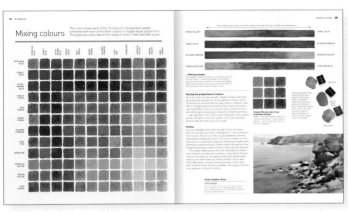

Charts
Specially commissioned charts offer quick ways to access information.

Step-by-steps
Clear step-by-step photographs are accompanied by concise instructions on how to achieve each technique.

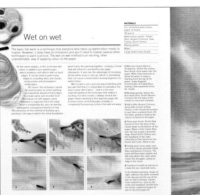

Actual size
The most important wash techniques are shown at actual size so you can see the inspirational texture of the paint on the paper.

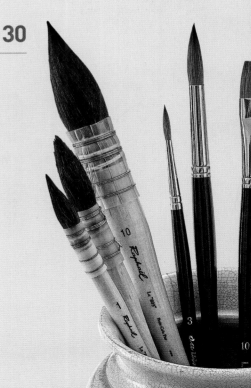

Chapter 2
Techniques

30

32 The colour wheel: the artist's friend	**66** Drybrush
34 Choosing your colours	**68** Resists
36 Mixing colours	**72** Preserving areas of white
38 Tonal values	**74** Layer masking
	76 Lifting out
Special feature	**78** Achieving whites in context
40 Water in watercolour	**80** Spattering
42 Three ways of mixing colour	**82** Salt
	84 Backruns
46 Colour in context	**86** Texture in context
48 Tone in context	**88** Line & wash
50 Flat wash	**92** Line & wash in context
52 Gradated wash	**94** Thick gouache
54 Variegated wash	**96** Thin gouache
56 Tinted background wash	**98** Gouache in context
60 Wet on wet	**100** Ways of working
62 Wet on dry	
64 Wash techniques in context	

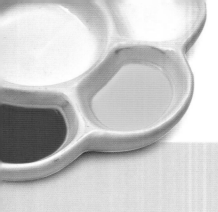

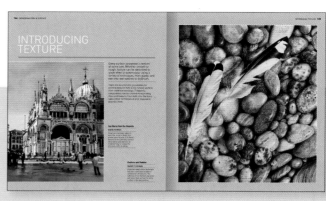

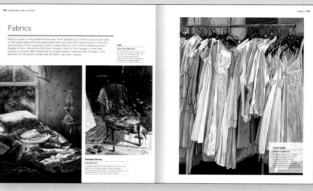

Subjects to inspire

Paintings from around the world demonstrate the versatility of the medium.

Chapter 3
Making Pictures 102

104 Viewpoint & format
106 Selective seeing
110 Placing elements in the picture space
112 Selecting a focal point
114 Creating a path through the picture
116 Perspective
120 Colour and tone as compositional devices
124 Creating atmosphere and mood

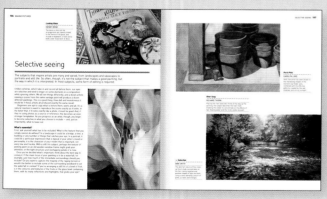

Gallery paintings

See how professional artists compose their images.

Chapter 4
Expressing Form & Surface 128

130 **Introducing landscapes**
134 Skies & clouds
136 Moorland sky
138 Trees & foliage
142 Autumn woodland
146 Study in green
150 Sunlight & shade
152 Waterscapes
154 Sparkling seascape
158 Rippling reflections
162 Snowscapes

164 **Introducing texture**
168 Still life of shells
172 Decay & worn textures
174 Worn textures
178 Fabrics

180 Glass & shiny objects
182 Architectural details
184 Architectural textures
188 Animals & birds
190 Flowers
192 California poppy

196 **Introducing figures & portraits**
198 Posing for portraits
200 Portrait
204 Figures in locations
206 Street café scene

Trade secrets

Ten professional artists, working in a variety of styles, reveal their very personal approaches to painting in watercolour.

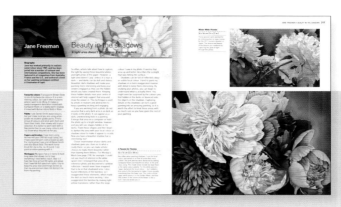

Techniques

The artist explains techniques that he or she returns to time and time again, and offers tips for readers to use in their own work.

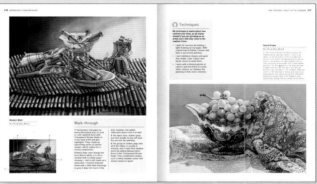

Step-by-step demonstrations

Specially commissioned demonstrations on popular subjects to paint are included for readers to try at their leisure.

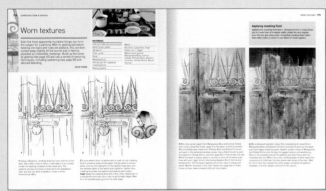

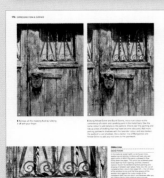

Walk through

Each artist selects one of his or her favourite paintings and talks through the process(es) used in creating it.

Chapter 5
Approaches to Watercolour 210

212 Mike Barr *Keeping it simple*
216 Jane Freeman *Beauty in the shadows*
220 Laurie Goldstein-Warren
 Creating watercolours that sparkle
224 John Lovett *Transparency versus opacity*
228 Leo Davey *Water ways*
232 Graham Marchant *Painting fabric in watercolour*
236 Brenda Swanson *Stained paper collage*
240 Thomas W. Schaller
 Creating atmosphere in watercolour
244 Théo Sauer *Beauty in decay*
248 Frank Webb *A tale of two aesthetics —
 realism and the abstract*

252 Index
256 Credits

INSPIRATION

I enjoy the challenge of painting a range of subjects in watercolour. I love the rocky coastal scenery where I live, but I am also inspired by the lively nature of animal subjects.

Meet David Webb

As a child I was always scribbling away, drawing animals, planes or dinosaurs. My father was an architectural draughtsman and also had an interest in drawing and painting, which I think must have sparked something in me. I first picked up some 'grown-up' watercolour paints in the late 1970s, and felt an immediate natural affinity for the medium.

When I left school at 18 I was fortunate enough to get a part-time job at an art agency, where I got to meet some of the top illustrators of the day, and learned how to apply my painting and drawing skills to the workplace. After a couple of years, I began what was to become 20 years of illustrating natural history publications. Although I worked with watercolour, I was using it with a very detailed technique, necessary for the demands of illustration. However, I never stopped painting in watercolour for pleasure in my spare time.

Around the millennium, I changed direction from illustration to a more painterly style. I'd always appreciated the techniques of artists like Edward Wesson, Trevor Chamberlain and James Fletcher-Watson, so I decided it was time to switch from illustration to a looser approach. It wasn't easy at first, after having worked on fine details for so long. However, I kept at it and, after some time, began to produce something of worth. At the same time, I took a course in teaching adults, which was a bit of a leap for someone who had basically been working alone in a room for two decades!

Now, 16 years later, my work is very different from my illustration days. I paint animals, land- and seascapes and still lifes, using large brushes and (mostly) a traditional watercolour technique. I teach watercolour workshops and painting courses throughout the year, and demonstrate to art societies. Seeing the problems that my students encounter has also led me to write on the subject in magazines and books. I still love this wonderful, fluid medium that I first began with in my teens.

Working on this book has introduced me to a lot of exciting new artists, working in a wide variety of styles. Regardless of your choice of subject, and whether you are an absolute beginner or, perhaps, a more experienced artist seeking new techniques and inspiration, I hope that, leafing through it, the images and the invaluable technical information will inspire you to pick up your own watercolour paints and have a go.

DAVID WEBB

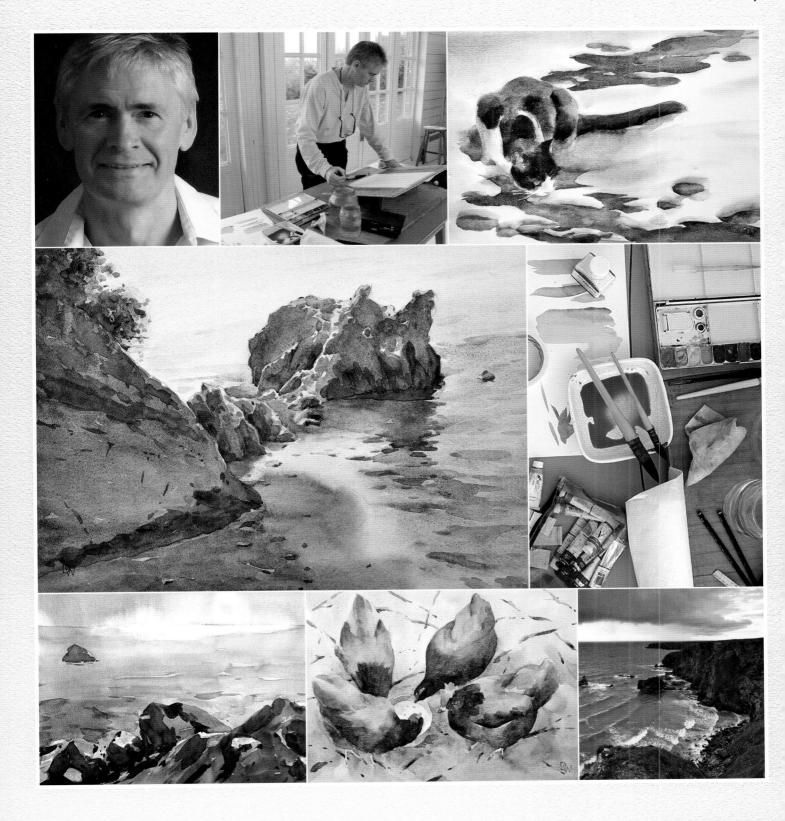

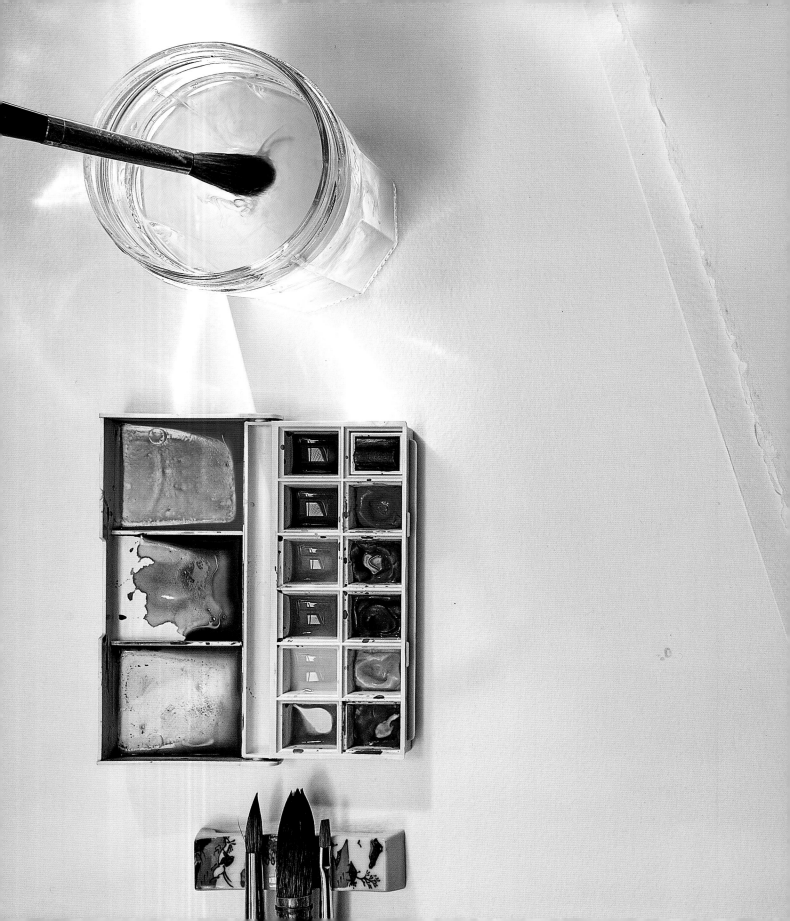

Chapter

1

Tools & Materials

Watercolour paints

The wide range of watercolour paints available can be a little daunting for beginners, and your choice may be dictated by your budget. However, there are certain factors that you should take into consideration before buying.

Pan sizes
Solid cakes of colour pigment are known as 'pans'. Half pans are half the size of full pans. To release the pigment from the dried pan colour, apply a damp brush to the paint and lift off colour to be diluted in water in a mixing well.

Always buy watercolour paints from established, reputable companies, of which there are many. If you want to take up painting seriously, avoid the cheap sets of paints that you see on display in discount stores. Once you take this into account, there are really only two grades of watercolour paint available: students' quality and artists' quality.

Students' versus artists' quality
Students' quality paints contain less pigment and more of the less expensive ingredients in their manufacture. They tend to be less concentrated, so you will need more paint to produce a result similar to that of artists' colours. It can be argued that they are a false economy, as the more expensive artists' colours will go further. If you're on a limited budget, however, and want to experiment with the medium, they may be a good choice. Some of the more expensive pigments found in artists' colours are synthetically created for use in students' quality paints and are often described as 'hues' in their name. So, a relatively expensive artists' colour, such as Cobalt Blue, may be called 'Cobalt Blue Hue' in the students' variety.

Students' quality colours can be readily mixed with artists' colours — so, if you start with student grade, you can gradually replace them with artists' colours as you become more confident.

Artists' colours have a higher ratio of good-quality, finely ground pigments and they are also more permanent, which is worth bearing in mind if you decide that you want to sell your work. There is usually a much wider range of colours available, too. As some pigments contain more expensive ingredients, artists' colours are usually graded 1 to 5, depending on the manufacturer. The higher the number, the more expensive the paint.

Pans and tubes
Watercolour paints are available in two forms: pans and tubes. Within a particular brand, the quality of the paint in pans is no different from that of the tube variety.

Pans are solid cakes of colour, usually encased within a plastic box that can be inserted into a plastic or enamel paintbox. Pans are available as sets; you can also purchase them separately to create your own palette. Half pans are, naturally, half the size of a full pan. Pans are available as artists' colours and some manufacturers also produce students' quality pans.

Pans are a good choice for painting out of doors, as they are compact and contained within a box. They are also a

Different sizes of tubes
Both students' and artists' quality watercolours are available in different sizes of tube. It may prove more economical to buy bigger sizes of those colours you use the most.

Students' quality pans in box
A set of 12 half-pan students' quality colours, in a lidded paint box. A set such as this is a good option for a beginner.

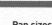

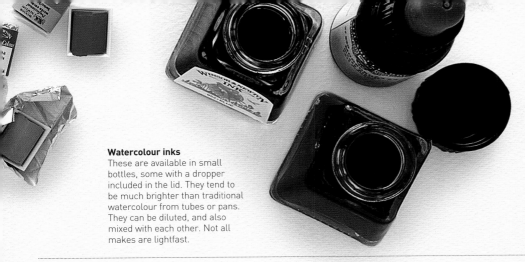

Watercolour inks
These are available in small bottles, some with a dropper included in the lid. They tend to be much brighter than traditional watercolour from tubes or pans. They can be diluted, and also mixed with each other. Not all makes are lightfast.

Gouache
Like watercolour, gouache paints are water based. Unlike watercolour, however, they are opaque and cannot be used to build up layers, or washes, of transparent colour. They can be used in conjunction with watercolours.

good choice when you're travelling, as they can be easily packed. If you carry them in your hand luggage, though, enamel boxes will attract attention as you go through airport security.

Pans need to be moistened with a wet brush to release the colour, which is then added to the water in the mixing well set in the lid of the box. Their disadvantage is that they take more work to get colour onto your brush, which can slow you down when you're working on a larger scale.

Another disadvantage of pans is that certain darker colours look similar when the paints are dry. Ultramarine, for instance, may look pretty much like Burnt Umber before you wet the pan to release the colour. This shouldn't be a problem if you know where your colours lie on your palette. However, it is not unknown for the pans to scatter across the floor if you drop the paintbox. It can then be a bit of a chore to ascertain which colour is which when you're trying to put them back in the slots.

Tube paints are much softer than their pan and half-pan counterparts. Pigment is squeezed from the tube, much like toothpaste. Remember to replace the cap after use to prevent the contents from drying out. Like pans, tubes can be bought individually or in sets and are available in sizes ranging from 5 ml to 21 ml. If you intend on using a lot of paint, or tend to use a lot of a particular colour, it is worth buying larger tubes as, in the long run, they are more economical.

You will need a separate mixing palette (see page 20) for tubes — preferably one with small sections for the colours and larger wells for diluting or mixing colours.

Paint from tubes is faster to work with, as it is already of a soft consistency. This makes it ideal for painting on a larger scale. I work mainly with tubes, but also have a small enamel palette of half-pan colours that fits easily into my pocket.

The tube paint in my mixing palette is protected by a hinged lid. Students often ask me whether the paints dry out in such a box. The truth is, it all depends on how often you paint. I find that the paints in my palette stay workable if I paint several days a week. However, if I haven't used them for a while, the tube colour can be revived by adding a few drops of water to the colour, from a pipette.

Watercolour pencils
Watercolour pencils contain soluble pigment. Water can be applied to an existing drawing, which has been shaded with the pencils, to release the colour.

Troubleshooting: Problems with tube paints

Sometimes, too much paint comes out of the tube, which is very wasteful when you only need a tiny amount. At other times, it's difficult to remove the cap. Here's how to overcome these problems.

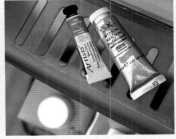

Stubborn caps
If you haven't used a particular tube for some time, any paint left in and around the cap from your last painting session dries like glue and makes the cap difficult to remove. To overcome this, run the cap under hot water for a few minutes. Even then, you may still need to use a pair of pliers to ease the cap off.

Paint oozes out
When you open a new tube of paint, you often find that the colour almost bursts from the tube uncontrollably. Storing your tubes in a fridge helps to overcome this problem.

Pigment properties

The many and varied watercolour pigments possess different properties. In a range of artists' colours, these unique characteristics are usually stated on the tube or pan. The main properties usually indicated are transparency, opacity, lightfastness or permanence and staining.

A full description of a colour can usually be found on the information sheets provided by each manufacturer. It is worth obtaining these, as colours from one brand may possess different qualities from the same colour produced by a different maker. This information may also be found on the label.

Transparency

If you paint in the pure watercolour tradition (by this, I mean that the white of the paper is used to its fullest extent to shine through the washes), it follows that the paints used should be as transparent as possible. Also, if your painting technique involves layering wash over wash, you will get a cleaner result if you rely on purely transparent colours.

Opacity

All watercolour pigments are transparent to a certain extent. It also follows that the more water you add to dilute a pigment, the more transparent it will become. Certain colours, however, are described as opaque, and these colours are more likely to produce dirty or muddy results than mixes derived from purely transparent pigments.

Permanence or lightfastness

Most watercolour pigments made today are permanent. However, there are a few whose lightfastness, or permanence, is not as reliable. These are known as 'fugitive' colours and will fade with exposure to strong light. In the U.S. lightfastness is signified by the letters ASTM, which stands for American Society for Testing and Materials. The standard for this system rates colours from I to V, with I being the highest degree of lightfastness and V the lowest. In the UK the grades are AA, A, B and C, with AA being the most permanent under normal daylight conditions.

Transparent or opaque?
In the two diagrams below, there are three vertical strips of colour: Alizarin Crimson, Aureolin Yellow and Cobalt Blue. These vertical strips are then overlaid with horizontal washes of different colours — dilutions of transparent pigments in the left-hand diagram, and opaque colours on the right-hand diagram. You can clearly see that the transparent bands on the left allow the under washes to show through, while in the opaque bands on the right much less of the previous wash is visible.

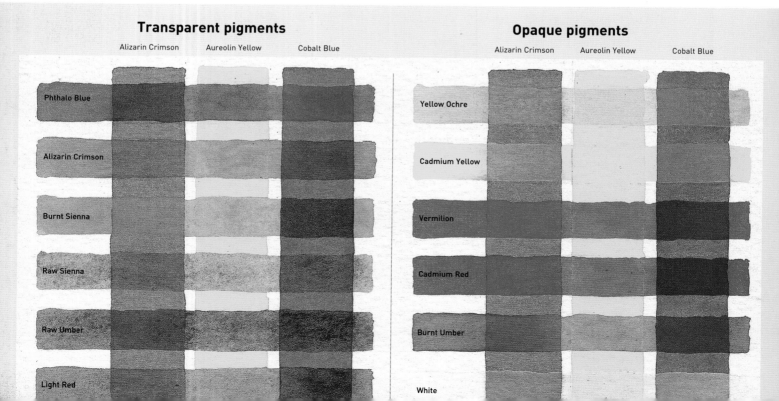

Transparent pigments

| | Alizarin Crimson | Aureolin Yellow | Cobalt Blue |

Phthalo Blue

Alizarin Crimson

Burnt Sienna

Raw Sienna

Raw Umber

Light Red

Opaque pigments

| | Alizarin Crimson | Aureolin Yellow | Cobalt Blue |

Yellow Ochre

Cadmium Yellow

Vermilion

Cadmium Red

Burnt Umber

White

Staining

Certain pigments in the transparent range are known as staining colours, which means that they are absorbed by the paper and are resistant to lifting-out techniques. Sometimes it's possible to lift them out partly, especially if they are still wet, but it is likely that they will still leave behind a trace of colour. Staining colours include Phthalo Blue and Alizarin Crimson. If you are not sure, check the label or maker's colour chart.

Staining colour

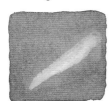

Alizarin Crimson is a staining colour; when paint is lifted off with a damp brush, traces of it remain on the paper.

Non-staining colour

Cobalt Blue is a non-staining colour; it can be removed with a damp brush while still wet, leaving the white of the paper unstained.

What's in a name?

The Colour Index (CI) name is the international standard code for each pigment. It tells you whether a colour has been made from a single pigment or mixed from more than one. It is generally considered better if a colour is made from a single pigment; however, modern manufacturing processes now allow for mixed-pigment colours that retain brightness.

Sometimes, different manufacturers may use the same name for a colour, even though they have produced it from different pigments. Conversely, colours made from the same pigment may be given different names by separate manufacturers. The CI name shows exactly which pigments have been used, so you can compare different brands.

You may also see something called the CI number, which identifies each pigment using a five-digit number. Of the two systems, the CI name is more user-friendly and more prevalent.

A single pigment – pigment red 83

A colour made from two pigments — pigment brown 7 and pigment yellow 42

PBr7·PY42
Lightfastness
★★★
Transparency: A

Pigment name abbreviation

PY = pigment yellow	PV = pigment violet	PBr = pigment brown
PO = pigment orange	PB = pigment blue	PBl = pigment black
PR = pigment red	PG = pigment green	PW = pigment white

Granulation

Certain colours such Raw Umber and Cobalt Violet, and blues such as Ultramarine, Cobalt and Cerulean, tend to precipitate when they are diluted, and the paint granules have a sandy, or granular, appearance when applied to the paper. The extent of granulation can vary widely between individual brands. The effects of granulation are also more pronounced on rougher papers, as the paint granules sit within the little indentations and pits on the paper surface. Students often ask me if they have done something wrong when a colour granulates. Granulation is not a fault of the painter, however — it is simply a quality of certain colours.

Granulation should not be regarded as a problem — in fact, its effects can enhance a painting. I often choose a colour for its granulation properties if I am painting old buildings or stonework.

The effect can become more obvious if you mix a granulating pigment with another colour. I use a mix of Ultramarine Blue and Burnt Sienna, which does not granulate, to achieve a textured grey or brown.

Brushes

If you wander into any art shop or take a look through an art materials catalogue, you will find a bewildering array of brushes. However, you only need a few varieties of shape and size.

Brush shapes

There appears to be an infinite variety of shapes and sizes but, in reality, many of the stranger shapes are not really necessary. Speaking personally, I usually use just two or three brushes. I use mop brushes for most of my painting. The size of brush is determined by the paper size I am working on. I also use a nylon flat for lifting out, and a rigger for details.

Brush sizes

Round brushes are usually graded from the smallest sizes such as 000 up to perhaps 24, although the actual sizes may vary from one manufacturer to another. The smallest round brushes are extremely fine, containing only a few fibres. They may be useful for miniaturists or floral painters but would be completely useless for producing a large, loose wash. Mop brushes, too, are often rated differently between manufacturers. I have one mop brush, described as a 16, that appears to be measured across the ferrule in millimetres, and another that looks exactly the same but is classed by the manufacturer as an 8. Flat brushes tend to be described by the actual width measurement across the fibres, either in inches or millimetres.

Choosing which size brush is best for painting depends on a number of factors. Do you tend to paint in a broad, loose style? If so, you should probably be looking at larger sizes. It is also important to consider the size of the paper you wish to work on, as the larger the painting area, the bigger the brush you will need. As a general rule of thumb,

use the largest brush that you feel comfortable with for a given paper size. With this you should be able to paint a large wash, perhaps a sky, and the larger shapes within your composition. You may also need a smaller brush for details such as tree branches.

Small brushes, by their very nature, tend to lean towards a tighter, more illustrative style. If this is the direction in which you wish to take your painting, then it makes perfect sense to opt for finer, smaller brushes.

Mop brush
The mop brush may be either round or wide and flat, but both shapes have a large head. It is chiefly used for broad areas of colour such as background washes, as it can hold a lot of paint and can cover large areas quite quickly. You can also create finer strokes using the point.

Round brush
The round brush has a broad body that tapers to a point. It can produce both wide brushstrokes for large areas of colour and thin strokes using the tip of the brush.

Storing brushes
Brushes are expensive and should be stored carefully. A brush case (left) keeps them safe, and is ideal for transporting them if you're working on location. Alternatively, store them upright in a jar (right).

What to look for when buying a watercolour brush

The first thing is to ensure that it has a decent point — unless, of course, it's a flat.

Avoid any brushes that bend over at the tip, as this is usually a sign that they've been stored upside down. Also, look out for any stray fibres that stick out and refuse to join the main body of the brush.

It can be difficult to assess the quality of a brush when it is dry. Quite often, art shops supply a small container of water to allow you to check the shape and quality. Once the brush has been wetted, try flicking it. Does the brush return to its original shape? It should, if it is made from sable or is synthetic. Squirrel hair brushes will not do this, but that is a distinct quality of this type, and not a fault.

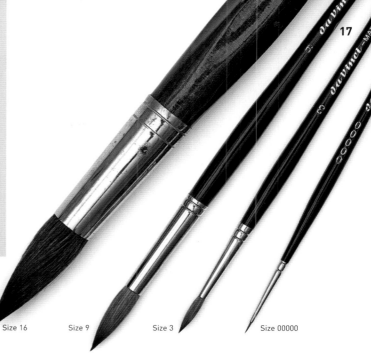

Size 16 Size 9 Size 3 Size 00000

Flat brush

The flat brush consists of a flattened ferrule (the metal tube holding the filaments in place) and fibres that are squared off instead of coming to a point.
You can make broad, flat strokes by using the whole body of the brush and a thinner line by using it edge on.

Rigger brush

This narrow brush consists of extra-long filaments. It is ideal for creating thin lines such as railings, power lines or, as the name implies, the rigging lines on ships and boats.

Filbert brush

The filbert brush has a flattened ferrule, much like a flat. Unlike the flat, however, the fibres are rounded, which gives the brush some of the properties of both a flat and a round. It can be used to make broad strokes, but has enough of a point to create a variety of shapes.

Brush sizes

Watercolour brushes are available in a range of sizes, which are signified by a number on the handle. The smaller the number, the smaller the brush size. Beware when buying online, though, as variations do occur between manufacturers.

Brush pens

A fairly recent innovation, brush pens feature a reservoir, like a fountain pen, that can be filled with water or diluted watercolour paint. They have a fibre tip, as opposed to filaments, and can be useful for sketching outdoors as there is no need to carry a water bottle.

Untitled

LYNNE CHAPMAN

In this sketch, the lines were first drawn in watercolour pencil, then the brush pen containing water was brushed over the lines to soften them and create shading.

Other brush shapes

There are also numerous peculiar-shaped brushes on the market, such as fan, angled, stippler and even foliage. In my view these brushes aren't really necessary, as you can achieve every effect you might need with the brushes shown here.

Brush fibres

Watercolour brushes are traditionally made with natural hair, such as sable, squirrel or goat. There are also many synthetic brushes on the market. Each type has distinctive characteristics such as level of springiness and water-holding capabilities. Your choice will depend on what style of painting you practise and also your budget.

Kolinsky sable (1)

Confusingly, Kolinsky sable comes not from the endangered sable marten but from the Siberian weasel, which is found in Russia and northern China; the fibres used in watercolour brushes are obtained from the tail. The animals do not fare well in captivity, and so the fibres are taken from animals trapped in the wild, making them the most expensive brushes available. Some brushes are marked 'red sable'. These are not made from Siberian weasel hair and are less expensive.

Brushes made from Kolinsky sable have long been recognised as the best brushes for watercolour. They possess good water-holding capabilities and their springy nature ensures that they always return to a point.

Synthetic (2)

Synthetic, man-made brushes have all the spring of a sable, but cost a fraction of the price. Like their sable counterparts, synthetic brushes are available as rounds, flats or riggers. It is true to say, though, that they may have less water-holding capacity than sables.

There are also brushes containing a blend of sable hair and synthetic fibres, which are a moderately priced compromise between sable and synthetic.

Squirrel hair (3)

Unlike sable and synthetic brushes, squirrel hair brushes are very soft and possess no spring. They are disliked by painters who like a degree of firmness in their brushes. On the plus side, they hold more water than any other brush, which can be a key factor if you like to paint in a loose and free technique. A loaded squirrel hair brush will cover a lot of paper in one go.

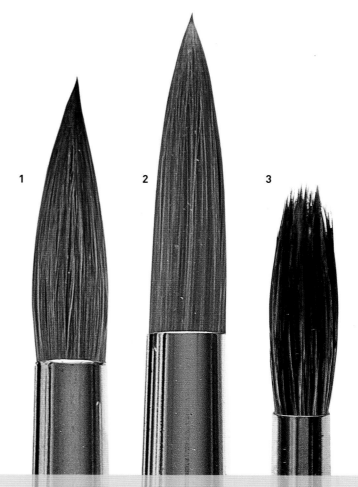

1 2 3

Caring for your brushes

Unlike oils or acrylics, watercolour paints are relatively kind to brushes. However, a little care will make them last a lot longer.

Whenever you finish a painting session, rinse the brush thoroughly to remove all traces of paint. Particles that are left to dry out in the brush can prevent the brush from returning to a point. Usually water is all you need. However, if you have forgotten to wash out the brush from the previous day, you may need to use a little mild soap with some warm water. Gently work the soap into a lather with the brush on the palm of your hand. Once it is free of paint, rinse the brush thoroughly in clean water until all traces of the soap are removed.

Gently reshape the brush with your fingers to restore it to its original shape.

Once they have dried, store your brushes upright in a jar, or in a brush case (see page 16).

Holding brushes

Varying the way you hold the brush allows you to create a range of different marks, even with the same brush. Experiment with some of the holds shown here to discover what marks you can create and how much control over the brush each one gives you.

Squirrel mop

Hold the brush like this to make horizontal strokes, perhaps for a large flat wash.

Grip the brush like this for a vertical stroke.

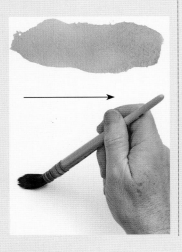

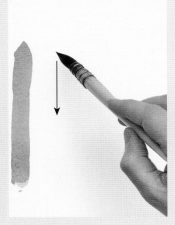

Round

This is the best hold for a wash or filling in an area with colour.

Hold it like this for creating vertical marks.

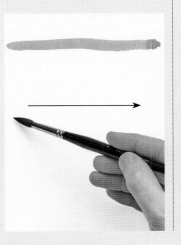

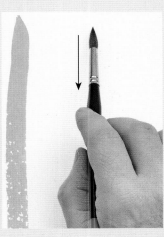

Flat

For creating broad strokes, make the most of the flat shape area of the brush.

For thin lines, hold the brush perpendicular to the paper.

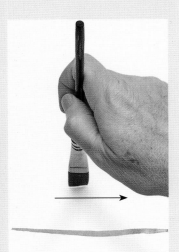

Rigger

Hold the brush like this for horizontal marks. It is often easier to create straighter lines with a fast action. A slow, painstaking brushstroke usually results in a wobbly line.

For vertical lines, it can be more comfortable to hold the brush like this.

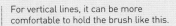

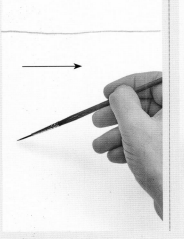

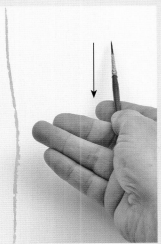

Mixing palettes

Your palette will be at the centre of your painting activities, so give some careful thought to what kind to buy. Palettes, like brushes, come in a wide range of shapes and sizes and can be made from plastic, enamelled metal or ceramic.

1 Plastic lidded palette
Plastic palettes are lighter to carry, which might be a consideration if you are working outdoors on location. A drawback of the plastic variety is that staining colours, such as Alizarin Crimson (see page 15), will do exactly that! The palette shown here contains slots for half-pan colours. The lid also doubles as a mixing area.

2 Enamelled lidded palette
Enamelled metal palettes are much more expensive than plastic versions, but if you look after them they can last a lifetime. The one shown here has slots for half-pan colours; it also has depressions in the lid for mixing, as well as a large mixing area in another hinged flap.

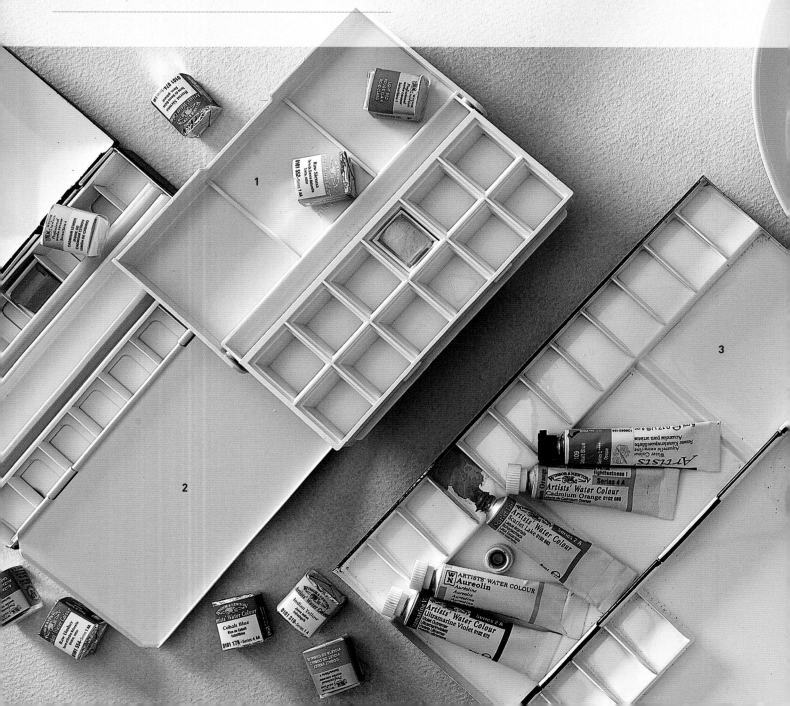

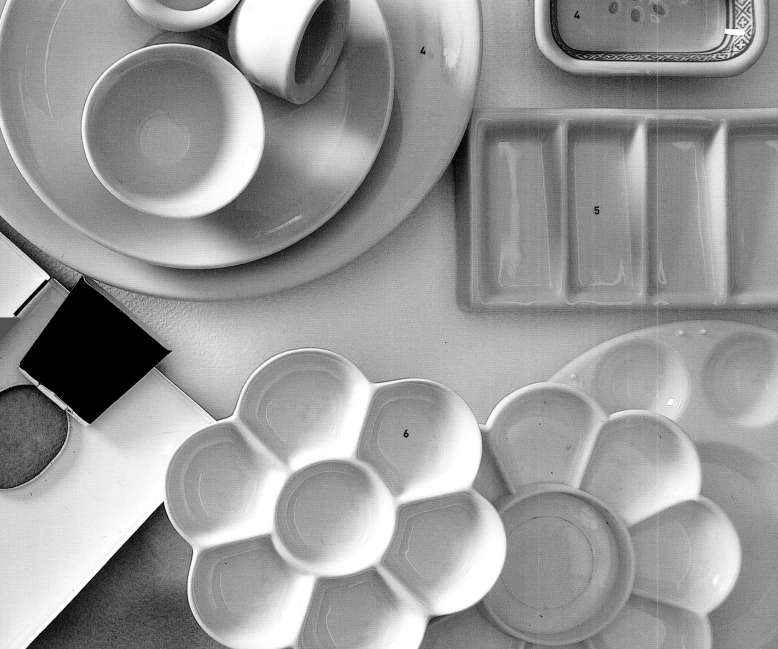

3 Large enamel mixing palette

This palette is designed for tube colours. Squeeze paint into the small slots and mix colours in the large mixing wells. The lid has a thumb hole, so you can hold the palette in one hand and your brush in the other, which is useful if you like to paint standing up.

4 Ceramic mixing 'palettes'

In the studio, you can even use everyday cups, saucers and bowls for mixing colours. Large, single mixing wells are ideal for diluting a large wash to cover a whole sheet of paper. Even a sectioned dish such as those used for dipping sauces can be used — they're particularly useful if you want to mix large amounts of just one or two colours. Ceramic palettes have a lovely glazed surface that enables the brush to move around smoothly when you mix colour. Bear in mind, though, that mixing wells should be white, so that you can clearly see the transparent colours you are mixing. If you were to use items with a dark glaze, it would be very difficult to judge both the colour and tonal strength of the colours you are mixing.

5 Rectangular mixing wells

This kind of palette contains several sloping, rectangular wells. Squeeze tube colour onto the shallow end, then drag it into the deeper end to dilute it.

6 Daisy wheel

The flower-shaped 'daisy wheel' palette, available in both plastic and ceramic versions, contains seven or more mixing areas, allowing you to dilute or mix several colours.

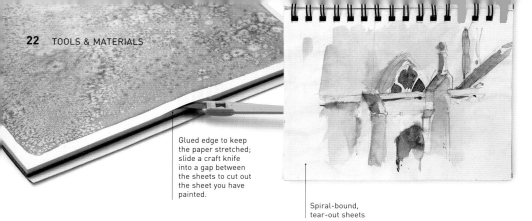

Glued edge to keep the paper stretched; slide a craft knife into a gap between the sheets to cut out the sheet you have painted.

Spiral-bound, tear-out sheets

Watercolour pads
Pads are an alternative to buying watercolour paper in loose sheets. They are available spiral bound or with glued edges that you tear out. Like sheets, pads may contain pages of hot-pressed, cold-pressed or rough paper. Pads are also available with pages of different-coloured papers. If you want to try working with coloured papers, this is a good way to start.

Bound in different formats, sketchbooks can be either upright or horizontal, and used across the whole two pages for panoramic views.

Manzac den Bas 28/5/13

Paper types & weights

There are various types and qualities of watercolour papers. The paper on which you paint will have a marked effect on your finished painting.

At the most expensive end of the scale are the handmade papers. These are made to high archival standards from 100% cotton fibres. Typically, the edges of the individual sheets are deckle edged, rather than clean cut. Quite often, they will also have a maker's watermark — a useful device, as it shows you which side you should paint on. Less expensive are the mould-made, wood-pulp papers often known as 'wood free', which are made from chemical wood pulp.

Paper surfaces
There are three distinct surfaces of watercolour paper: hot-pressed (HP), cold-pressed or NOT, and rough. Each one 'takes' the paint in a different way.

Buying paper
You can buy paper as sheets, either individually or in a pack, or in pads or blocks, which can be useful if you're travelling or painting outdoors. Spiral-bound pads are

convenient to use outdoors, as the pages fold back easily onto the back of the pad.

Blocks are like pads, but the pages are gummed around all four edges. They are also good for outdoor work, as the gummed pages prevent loose sheets from flapping in a breeze. When your painting is finished, you simply insert a knife into a small, non-gummed, section of the pad, and run it around all the edges to free it from the block.

Paper weights
Watercolour papers are available in different weights. The heavier the sheet of paper, the thicker it is. Thicker papers will accept more water before they show signs of buckling.

There are two standards for weighing paper and some confusion can arise between the two.

First, there is the imperial standard of measurement, in which paper weight is measured in pounds. The weight refers to the weight of a ream of paper of a given size (say, approx. 76 x 56 cm, or approx. 30 x 22 inches), a ream being 500 sheets. So, 500 sheets of a thin paper may weigh 90 lb, whereas thicker papers may weigh 140 lb or more.

Paper weight is also calculated by the weight of a single sheet of paper measuring one square metre — so the unit of measurement in this system is grams per square metre, or gsm. A 300 gsm sheet of watercolour paper is roughly equivalent to 140 lb.

Troubleshooting: Protecting your paper

Watercolour paper should be stored carefully, preferably in a dry atmosphere. If it is kept in damp conditions for a length of time, the sizing breaks down and the paper seems to act like blotting paper when you try to paint on it. I always buy my paper in full imperial (56 x 76 cm/22 x 30 inches) sheets, which arrive in polythene sleeves. I then cut the paper to whatever size I want, but keep the sheets on shelves, still in their plastic sleeves. If you use pads of paper, I recommend that you store these in the same way. Keep them sealed in a plastic bag to protect them from the elements, grease and dust.

1 Hot-pressed paper
During manufacture, this type of paper is pressed between hot metal rollers, which gives it both its smooth surface and its name. Hot-pressed paper is very smooth and is best suited to highly detailed work, such as botanical studies, or pen and wash, where a rougher paper might cause a pen nib to snag. It is less suitable for broad, flat washes as the paint tends to slide over the smooth surface.

2 Cold-pressed paper
This is probably the most commonly used paper, as it has some 'tooth' to its surface but is not overly rough. In the UK it is known as 'NOT', which means that it is not hot pressed. Instead, it is cold pressed and the papers are laid on sheets of felt; the pattern on the felt gives a paper its distinctive surface appearance. Cold-pressed paper accepts a wash well, but is also smooth enough to define details.

3 Cold-pressed paper
This is another example of cold-pressed paper — look at it closely and you will see that the tooth is subtly different than in the previous version. Try out different brands to find one that suits your individual needs and style of painting,

4 Rough paper
Rough paper is made in the same way as cold-pressed paper, but rougher mats are used to create the distinctive textured surface. Rough paper is the best choice for drybrush techniques, as it produces a hit-and-miss effect when a loaded dry brush is dragged across it.

5 Tinted paper
Tinted papers are usually in warm or cool pastel shades. You'll need to use opaque white paint for highlights and any white areas that you would normally leave untouched. A tinted paper will also influence any transparent colours placed on top. For example, if you are using a warm, yellow tinted paper, a blue wash will appear to have a greenish bias.

1 2 3 4 5

Commonly used weights of paper

Metric	Imperial
190 gsm	90 lb
300 gsm	140 lb
425 gsm	200 lb
535 gsm	250 lb
640 gsm	300 lb
850 gsm	400 lb

Stretching paper

Thin papers (140 gsm/90 lb or lighter) will not stand up to the application of a large wash without 'cockling' or buckling. Even heavier papers will warp a little if you apply a lot of water. The solution is to stretch the paper before use.

'Cockled' paper

This photo perfectly illustrates the effects of using a really wet wash on a lightweight sheet of paper. The wash has caused the paper to ripple and, as it dries, it has created uneven marks and streaks. The rippled surface, caused by the inability of the thin paper to stand up to a soaking, makes it impossible to paint a flat wash.

This is a relatively simple process, as long as you are prepared. You may find that it takes a few attempts to get it right but, once you have mastered it, you will have a painting surface that is drum tight and will not buckle.

The first thing you need is a board that will withstand the surprisingly strong pressure involved as the paper dries and stretches. I use 9 mm (⅜ in.) external grade plywood. Usually, I paint in two sizes of paper — half imperial (56 x 38 cm/22 x 15 in.) and quarter imperial (38 x 28 cm/15 x 11 in.) — so I have boards cut for each of these sizes.

You will also need gummed paper tape, approximately 5 cm (2 in.) wide. (Masking tape is not suitable.) Half of the tape is attached to the paper and half to the board, so your boards need to be at least 2.5 cm (1 in.) bigger all around than your paper.

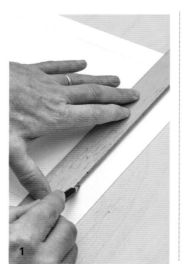

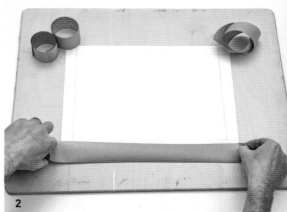

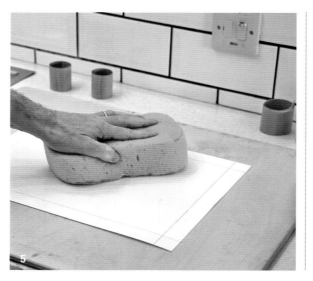

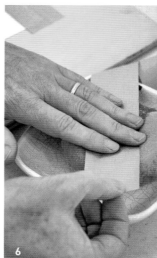

MATERIALS

Sheet of watercolour paper

Board

Gummed paper tape

2 clean sponges

China plate

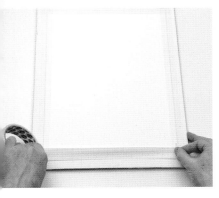

Attaching heavy paper to a board
Even heavy papers that have not been stretched — perhaps 425–640 gsm (200–250 lb) — still need to be attached to a board somehow. Masking tape around each side will help to keep the paper flat.

Troubleshooting: Preventing resin marks

It is a good idea to give your boards a couple of coats of ordinary white household acrylic primer, as sometimes the resin present in the wood can leech into the paper when it is wet, leaving a brown stain on the back of your painting. Although this cannot be seen from the painting side of the paper, it is possible that, over time, it could work its way through and damage the work.

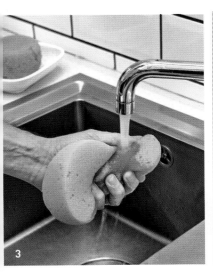

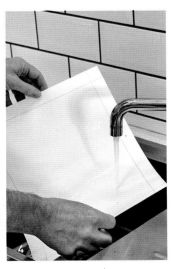

1 Begin by drawing a line approximately 2.5 cm (1 inch) from the edge of the paper, on all sides.

2 Cut four strips of gummed paper tape — two lengths for the long edges and two for the short edges.

3 Rinse the sponges under a cold tap. Squeeze the water out of one and leave the other one quite damp. Put the damp sponge on the plate.

4 Now soak your sheet of watercolour paper in a trough or bath of cold water or under the tap for a few minutes. Pick up the sheet by one corner and allow most of the water to drain off.

5 Place the sheet in the middle of your board, leaving enough space around the edges to affix your gummed tape. Dab the excess water off the paper with the drier of the two sponges. Do not drag it roughly across the surface which may damage it.

6 Now pick up one of the longer pieces of tape and dab it on the damp sponge on the plate.

7 Place the tape half on and half off the paper. Repeat this process with the remaining three pieces of tape, working around the edge of the paper in a circular motion. Press down the edges of the tape with a damp sponge.

8 Allow the paper to dry and stretch overnight, by which time it will be completely flat and ready to paint on.

Once your painting is finished, remove it from the board by cutting around the edge with a sharp blade against a straight edge or metal ruler. I tend to cut about 5 mm (¼ in.) out from the painting, which leaves a thin border of tape around the edge. This ensures that I lose none of the image when the painting is mounted and framed.

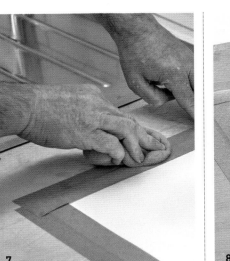

Other equipment

As well as paints, paper and brushes, there are a number of extra items that are useful when painting in watercolour.

1 Pencils
For sketching on drawing paper, you can use any grade that suits you. If you are drawing directly onto watercolour paper, use the softer grades such as a 2B or 3B. The H grades tend to gouge the soft paper; they are also usually quite light in tone, which makes any lines more difficult to see.

2 Water jars
A couple of glass jars are ideal — the larger the better. It pays to have one for washing your brushes and another for adding water to your mixing palette and mixing your colours.

3 Masking fluid
Masking fluid is available in blue, yellow and white, and also as a fine-nibbed pen.

4 Soap
Use this for cleaning masking fluid from your brush.

5 Masking tape
Masking tape is useful for attaching paper to a board, if you are not going to stretch the paper.

6 Pens
Waterproof fibre-tip pens are available in a range of nib widths for line and wash.

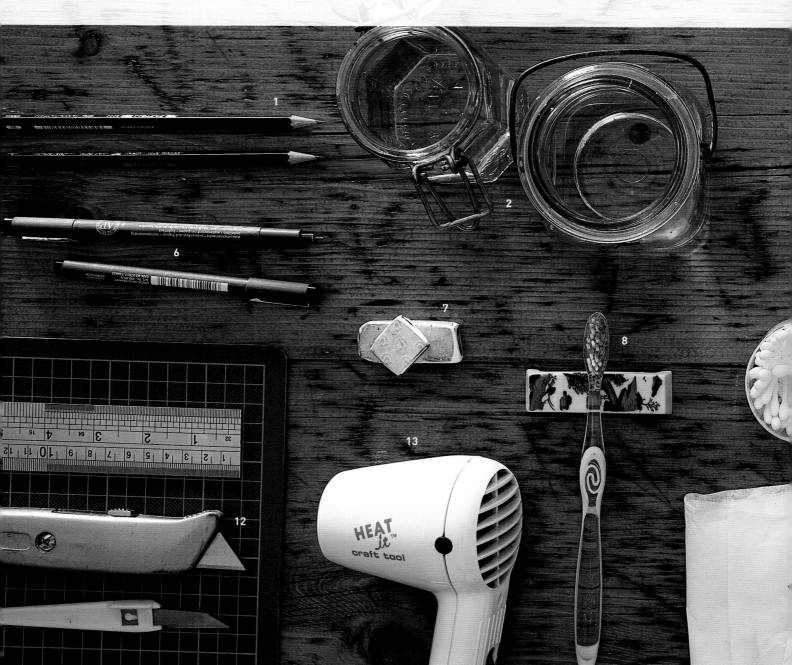

7 Erasers
I prefer plastic erasers to soft, putty erasers, which I find make dirty marks on the paper surface. Plastic erasers can be cut to shape with a craft knife.

8 Toothbrush
An old toothbrush is useful for spattering (see page 80).

9 Cotton buds
Use cotton buds for soaking up small runs of paint and lifting out (see page 76).

10 Sponges
Natural sponges are useful for both lifting out (see page 76) and for applying paint. Use clean, man-made sponges when stretching paper.

11 Gummed paper tape
For stretching paper you need gummed paper tape — a wide brown paper tape that needs to be wetted before you can use it (see page 24).

12 Craft knife, straight edge and self-healing rubber cutting mat
If you buy full-size sheets of watercolour paper you will need a sharp craft knife, preferably with a retractable blade, to cut them to size, plus a straight edge (preferably a metal one) to hold the knife against and a self-healing cutting mat to protect your work surface. You can also use the tip of the craft knife to lift out highlights (see page 77).

13 Hair-dryer
A hair-dryer can be used to speed up the drying time. Beware of using it when the wash is still very wet, or the paint will be blown across the surface.

14 Paper towel
No watercolour studio is complete without a plentiful supply of paper towels. Apart from clearing up the occasional spillages, it is also useful for removing excess water from your brush and dabbing off unwanted droplets from the paper surface.

15 Scrap paper
A plentiful supply of scrap paper for testing colour mixes is a must. You can use the reverse side of failed paintings.

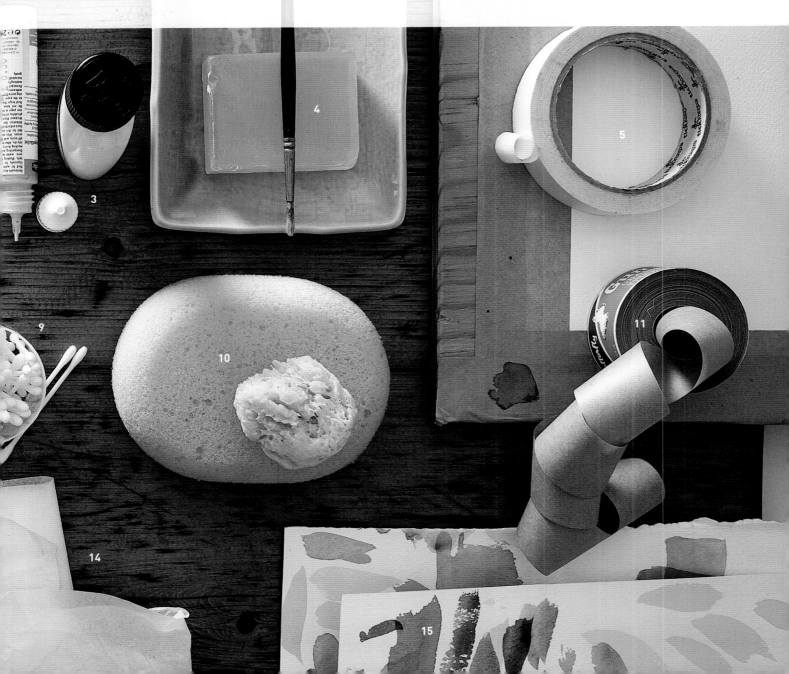

Getting comfortable

Your studio space should be a welcoming, comfortable area in which to work. Create the best atmosphere and you will be more inspired, and more likely to create your best work.

Not everyone has access to a large, airy studio; most people have to make do with a quiet corner somewhere or, if they're really fortunate, a spare room. The beauty of watercolour is that it doesn't take up too much space and, unlike oil painting, does not need special ventilation. If space is limited, you can still work on a small pad with a pocket set of half pans. However, the more inviting you make your space, the more likely you are to feel like painting.

Lighting

Good light is preferable when it comes to choosing your painting space. If your workspace has limited light, then look into the possibility of an artificial lighting set-up. Some artists balk at the prospect of using anything but natural light and, speaking as a professional artist, you can't beat working outdoors for good light. However, on a rainy day in November, good natural light can be in short supply!

I have an anglepoise lamp with a clamp for attaching it to the table or my easel. It is fitted with a daylight bulb and gives a good, even, natural-like light.

Artificial light sources have at least two benefits. First, you are no longer ruled by the rising and setting of the sun, as you can work all through the night if your inspiration is really firing. Second, you can place the light wherever you like. If you are right handed, have the light source on the left so that the shadow cast from your painting hand does not fall across your work. If you are left handed,

of course, then position the light on the right.

Standing or sitting?

If you prefer to stand when you are working, you can either opt for a standing easel (shown on the right) or use a table-top easel set up on a table or desk (shown below). If you stand, it helps to have some space to move back from occasionally, so that you can check your work from a distance.

If you prefer to sit, there are many folding table-top easels on the market. Failing that, you can prop your painting board up on a small pile of books.

If you do sit when you're working, make sure that you are sitting at a comfortable angle in relation to your painting board. If you are too high and have to stoop, you may well end up with backache.

Positioning your equipment

If you are right handed, place your paints, water and brushes to the right of your board. The opposite will be true if you are left handed.

Water supply

Access to running water is desirable, but not essential. Once your water jars are topped up, they should last a while before you need to refresh them.

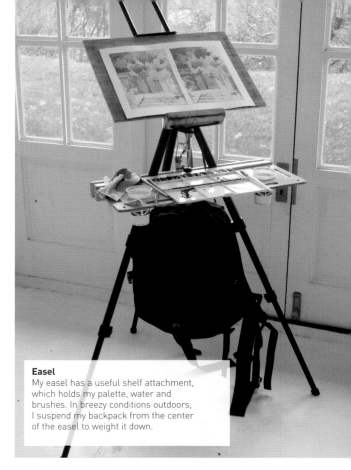

Easel
My easel has a useful shelf attachment, which holds my palette, water and brushes. In breezy conditions outdoors, I suspend my backpack from the center of the easel to weight it down.

Be organized
Set your easel at a height that allows you to work without stooping. Have your paints and brushes next to your painting hand, so that you can reach them without having to stretch across your painting and risk smudging your work. It pays to have one water jar for washing your brushes and another for mixing colours.

The watercolour artist's travel kit

One of the beauties of watercolour is just how few paints and brushes you need, which makes it ideally suited for travelling and painting outdoors. The thing to remember when putting together your kit is to keep it as lightweight as possible. After all, who's going to be carrying it? I find that carrying a backpack is the most convenient way of transporting everything: the weight is evenly distributed and it leaves both my hands free.

1 Pads
For travelling, the most convenient painting surface is a pad or a block of paper. I find that spiral-bound pads are best, as the pages are easier to turn over than gummed pads. A pad of 300 gsm (140 lb) watercolour paper is sturdy enough to take a wash without buckling too much. To prevent the pages of your pad from flapping around in a breeze, hold them down with a bulldog clip or by stretching a large elastic band across the edge of the page.

2 Paints
In the studio I prefer to use tube paints, but when I'm out walking, I like the convenience and lightness of a small half-pan box of paints. This contains near enough the same colours as my studio tubes. Made from enamelled tin, with two small mixing wells in the lid, it measures only 8.25 x 6 cm (3¼ x 2½ in.). Of course, a plastic palette would be even lighter. I occasionally take a small plate to give myself a bit of extra mixing space.

3 Brushes
Just one or two brushes are all you need. I have an extendable brush tube, essential to protect brush tips. I take one brush that is big enough to paint the larger areas, along with a smaller one for details. To reduce size even further, I have cut the end off the long handle so that it is now only about 15 cm (6 in.) long and can fit into the side pocket of a backpack or even the inside pocket of my jacket.

4 Water
Unfortunately, the heaviest item you need to carry is water, which you can't really do without. I carry a plastic 1 l (2 pint) bottle. It's a good idea to ration your supply. Only pour out a little at a time, into a plastic cup or collapsible water pot (lighter than a glass jar). This way, you can refresh your cup as it becomes dirty, which is difficult to do if you pour all the water out in one go. It also means that, if you knock it over, all is not lost.

5 Extras
A few useful extra items could include pencils, an eraser and pens for line and wash (see page 88). There are a great variety of fibre-tipped drawing pens available, which are ideal for use on location.

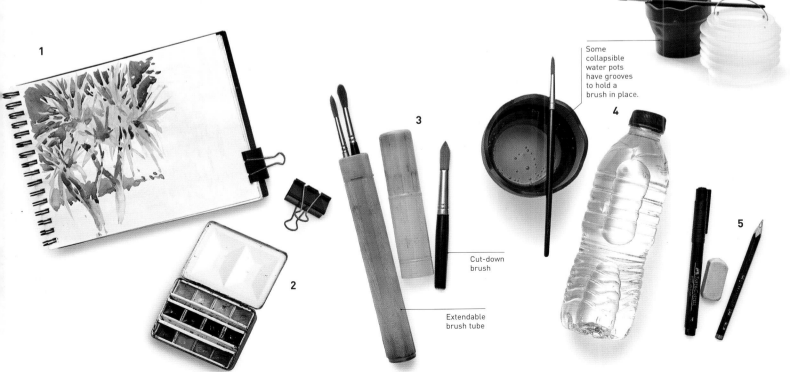

Some collapsible water pots have grooves to hold a brush in place.

Cut-down brush

Extendable brush tube

Chapter

Techniques

2

The colour wheel: the artist's friend

Any discussion on the subject of colour will eventually lead to the mention of the colour wheel. This tends to put off many beginners, as they often see it as a technical exercise that can take the fun and spontaneity out of painting. However, a basic understanding of the wheel and colour relationships is easy to learn and can lead to stronger, more creative paintings.

The first colours that you need to identify and understand are the 'primary' colours, which are those that cannot be created by mixing other colours together — yellow, red and blue, in other words. By mixing pairs of just the three primaries, you can create a huge number of 'secondary' colour combinations. For example, by steadily adding small amounts of Cobalt Blue to a solution of Aureolin Yellow, you can produce an amazingly full range of greens, from pale yellow greens through to deep blue greens.

'Tertiary' colours are those that occur between the primaries and secondaries. For example, between orange and yellow you will find yellow-orange, and between yellow and green you'll find yellow-green.

Neutral colours are created by adding a colour to its complementary. For example, the complement of blue is orange; by adding a little orange to blue, you can create a pleasant, grey ed-down, neutral blue. Browns an be created by adding red

to green. The results of these mixes are usually more harmonious than ready-made, manufactured mixes.

New colours are always appearing on the market. Whenever I discover a new colour that I think may be sympathetic to the others in my palette, I combine it with my existing colours and, if it behaves well, I may add it or even substitute it for one of the others. Make swatches of the different combinations that you can create, and keep them for future reference.

Colour temperature
Primary colours can be warm or cool. For example, Alizarin Crimson is a very cool red, leaning towards the blue part of the colour wheel, while Vermilion is a much warmer red that leans towards the yellow part of the wheel. A cool red, such as Alizarin Crimson, can be warmed with the addition of a little yellow.

It's important understand colour temperature, especially if you're painting

landscapes. Warmer colours advance, while cool colours recede. Warmer colours, such as yellows, browns and reds, are usually present in the foreground but get steadily cooler the further back you go. Greens, especially, tend to become more blue as you get nearer the horizon. This visual phenomenon is known as aerial, or atmospheric, perspective (see page 119). An understanding of colour temperature will make your landscapes look much more convincing.

Colour wheel
The colour wheel has been used for centuries as a way of demonstrating the relationships between colours. The best way to understand it is to make one for yourself. Once you have a basic understanding of colour relationships, you can apply it to your own paintings. Colours that sit close together on the colour wheel, such as blues shading through to greens, create a harmonious or analogous colour

The wheel in action
Here are some paintings that are shown in more detail later in the book to demonstrate how artists have exploited colour relationships to make their paintings successful. Generally, every painting will demonstrate one or more aspects of the colour wheel.

A cool range of greens: even the yellow-green is a cool yellow, with touches of blue for the sky.

A range of yellow to mid-tone greens, which also includes some mixed neutrals and tertiary browns.

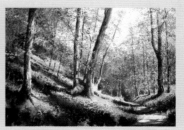

A warm and harmonious combination of greens and yellows creates this tranquil autumn scene.

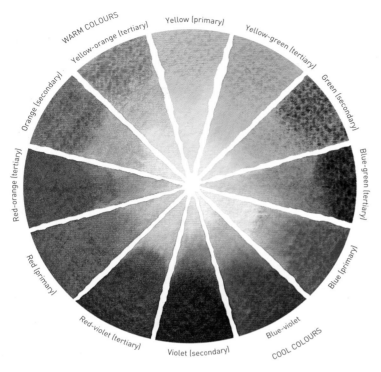

WARM COLOURS
Yellow (primary)
Yellow-orange (tertiary)
Yellow-green (tertiary)
Orange (secondary)
Green (secondary)
Red-orange (tertiary)
Blue-green (tertiary)
Red (primary)
Blue (primary)
Red-violet (tertiary)
Blue-violet
Violet (secondary)
COOL COLOURS

Colour wheel created from the primary colours in my palette
This colour wheel was created using Aureolin Yellow, Cobalt Blue and Alizarin Crimson. Of course, different sets of primaries will create different mixes. A warm colour wheel can be created by using colours such as Cadmium Yellow, Ultramarine and Vermilion, while a cooler arrangement can be achieved with, say, Lemon Yellow, Cerulean Blue and Alizarin Crimson.

Create your own colour wheel

1 Start by drawing a circle, then divide that circle into 12 segments. If you want all the segments to be the same size, that works out at 30 degrees for each angle.

2 Yellow is at the top of the wheel, with blue positioned four segments along, going clockwise, and red four segments later.

3 In the spaces that are left, sit the tertiary colours. There are six of these: yellow-green, blue-green, blue-violet, red-violet, red-orange and yellow-orange.

4 Each primary colour has what is known as a complementary colour, created by mixing together the other two primaries, which sits opposite it on the colour wheel — so violet sits opposite yellow, orange opposite blue and green opposite red.

scheme. Because they are closely related, they work well together. More dynamic colour schemes can be created by adding a small amount of a complementary. For example, in a countryside scene dominated by greens, a small amount of red flowers will pop out from the background. For more information on colour and tone as compositional devices, see pages 120–123.

Two examples of analogous or harmonious colour schemes

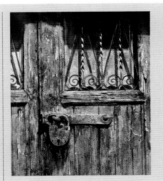

Complementary pairs of colours

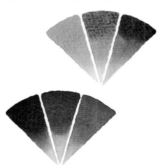

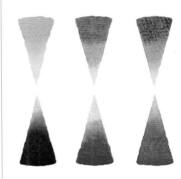

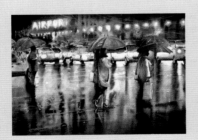
This night scene uses cool, recessive blues and violets, which are analogous colours. They harmonize to create this cold, rainy street scene.

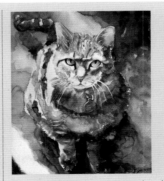
Making the most of the complementary colour clash, the red paintwork and orange rusty metal pop out from the blue-green door and violet shadows.

The contrast between warm and cool colours in this painting helps to push the cat forwards, creating a three-dimensional effect.

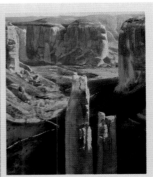
Cool, recessive shadows push the background cliffs into the distance, while the foreground pinnacle is warmed by reflected light, which brings it forward.

Choosing your colours

The best way of learning how colours behave is to start with a limited palette. Getting to know a handful of colours and the mixes they are capable of will provide you with a good, solid grounding in your understanding of colour — and with a palette of just six to eight colours, you will have an almost unlimited number of colour-mix possibilities available to you.

When deciding which colours to buy, it's a good idea to start with a warm and a cool version of each of the primaries — red, yellow and blue. Add to this a brown and you'll be well placed to tackle pretty much any subject, in a variety of lighting conditions. After you have spent time familiarising yourself with your chosen palette's possibilities, you can then gradually add new colours.

It's also a good idea to choose transparent colours (see page 14) wherever possible, as they tend to make much cleaner combinations. Transparent colours are especially recommended if glazing (see page 45) is a major part of your working method.

What colours should you choose?
There are countless art books on the shelves. Pick up any one of them and you will find lists of recommended colours — and they will all be different! This is because every artist has his or her own favourites.

In my own watercolour palette I have 12 colours, but these are not set in stone. My colour palette has evolved over the years, as should yours. On the page opposite are the 12 colours that I currently use and my reasons for choosing them. I've indicated which of the primaries are cool and which are warm. Out of these 12, there is a core of five colours (shown separately below) that I use constantly. I add the remaining seven colours to my mixes when I need them, depending on my subject and the lighting conditions.

If you're not sure which colours to buy, you could use my palette as a starting point — but do be prepared to adapt it later to suit your subject matter and the lighting conditions in which you work.

Cobalt Blue

Burnt Sienna

Alizarin Crimson

Aureolin Yellow

Raw Sienna

Using a limited palette

In addition to being a good way of learning how to mix colours, using a limited palette has another advantage: working with a small number of pigments means that all your combinations will be harmonious, as they are made up from a limited choice of primaries.

These are the five colours that comprise my own limited palette. Of these, Cobalt Blue is semi-transparent and the rest are transparent. This means that they are all great mixers and are also ideal for glazing.

My palette

Cerulean Blue (cool) Cerulean Blue has a greener bias than that of Cobalt Blue or Ultramarine Blue. It also granulates (see page 15) and has slightly chalky characteristics. It is useful for skies — particularly in winter, as its relative coolness indicates colder conditions.

Cobalt Blue (warm) This is a beautiful, clean blue that I use for skies, mixing greens and seascapes. I probably go through more Cobalt Blue than any other colour. It granulates, but not as much as Ultramarine Blue.

Ultramarine Blue (warm) Of all the blues, granulation (see page 15) is probably most noticeable with Ultramarine Blue. This can make it a good choice when mixing grey s to be used in architectural subjects, as the grainier results are useful to indicate texture in stone walls.

Cobalt Violet I tend not to have many secondary colours in my palette, as I prefer to mix my own. However, Cobalt Violet is wonderfully soft and is useful for creating shadows, particularly in areas of strong green foliage. It is a warm colour and does granulate.

Raw Umber This warm, earthy brown will create a soft green when mixed with a blue such as Cobalt or Cerulean. It also granulates.

Burnt Sienna (warm) This is a lovely, transparent warm brown. Almost an orange, it is a very good choice for mixing with Cobalt Blue to create a grey .

Alizarin Crimson (cool) A clean, transparent, cool red, Alizarin Crimson can be warmed by the addition of a little Aureolin Yellow. It is a staining colour (see page 15), which is something to bear in mind if you intend to do any lifting out (see page 76).

Vermilion (warm) A very warm, fiery red containing yellow, Vermilion is similar to Cadmium Red but less opaque. It can be used for areas of local colour; when mixed with blues, it results in some neutral grey s that can be used for shadows.

Light Red (warm) Its name suggests otherwise, but Light Red is quite a dull, earthy colour. More of a red-brown, it is an opaque colour. However, when mixed with blues it creates some useful grey s, which can be used in shadow areas.

Aureolin Yellow (cool) I use Aureolin Yellow for many of my green mixes and favour it over Lemon Yellow, which is opaque. It is a cool, brilliant yellow.

Indian Yellow (warm) This very warm yellow almost verges on orange. It is transparent and capable of some beautiful mixes when used with other colours.

Raw Sienna (warm) This is a warm, mustard yellow, which I think is essential for any artist who paints landscapes. I use it instead of Yellow Ochre, as Raw Sienna is transparent. It makes a pleasant, sage green when mixed with Cobalt Blue.

Mixing colours

This chart shows each of the 12 colours in my standard palette combined with each of the other colours in roughly equal proportions. This gives you some idea of the range of colour mixes available to you.

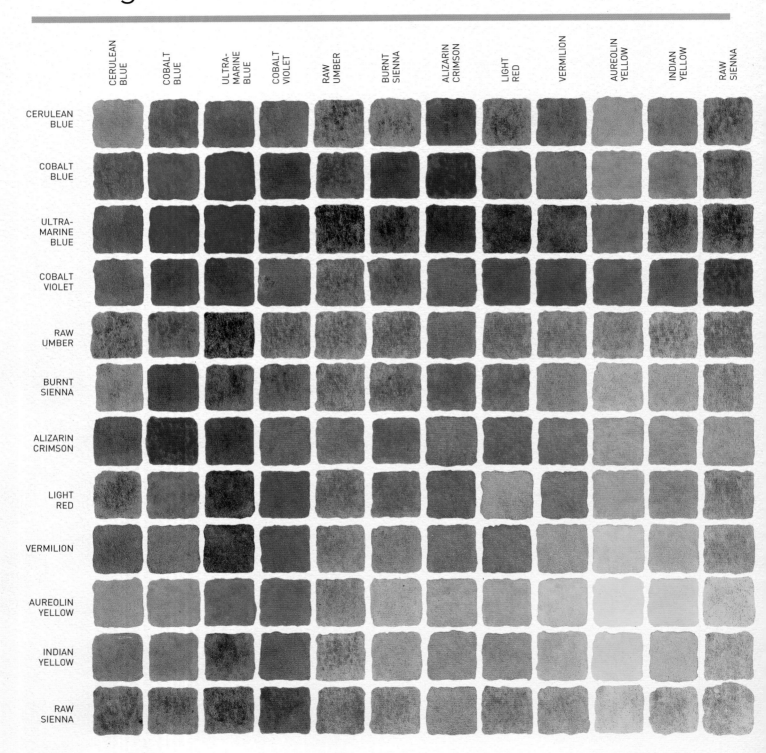

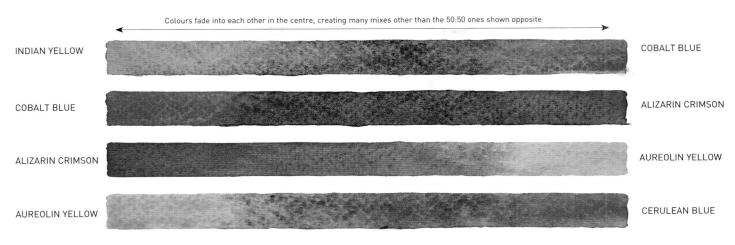

Colours fade into each other in the centre, creating many mixes other than the 50:50 ones shown opposite

INDIAN YELLOW		COBALT BLUE
COBALT BLUE		ALIZARIN CRIMSON
ALIZARIN CRIMSON		AUREOLIN YELLOW
AUREOLIN YELLOW		CERULEAN BLUE

▲ **Differing strengths**
This diagram shows the effects of mixing four pairs of primary colours in differing strengths. The original colours can be seen at either end of each strip. Where they meet around the centre, you can see the effect of mixing various concentrations of each colour.

Varying the proportions of colours

You can create an even greater range of mixes and tones by varying the proportions of the pigments in your mixes. To familiarise yourself with the way colours combine, start with a strongly pigmented wash of one of your primaries — say Cobalt Blue, if you're using the same colours as me — and add progressively larger amounts of another primary — say Light Red. Then try the same thing with a blue and a yellow, and with a red and a yellow. You'll soon become familiar with the mixes you can create.

Greens

You will probably notice that my own choice of colours does not include any ready-mixed greens. I much prefer to mix my own. Greens can often cause problems, even for professional landscape artists. If a scene contains a lot of greenery, it is important to keep it changing throughout the painting to avoid monotony. Greens tend to be warm in the foreground and get cooler as they recede into the distance.

The ready-mixed greens that are invariably included in sets of paints can often be unnatural, especially if they are used just as they are. An experienced artist would know how to calm them down by mixing another colour with them. My palette contains mostly primary colours and, with my three blues and three yellows, the range of greens I can produce is almost limitless.

Greens: Mix your own or use proprietary brands?
Above: These varied greens were all mixed using colours in my standard palette — see the top right corner of the chart opposite.

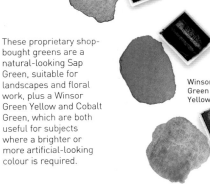

These proprietary shop-bought greens are a natural-looking Sap Green, suitable for landscapes and floral work, plus a Winsor Green Yellow and Cobalt Green, which are both useful for subjects where a brighter or more artificial-looking colour is required.

Sap Green

Winsor Green Yellow

Cobalt Green

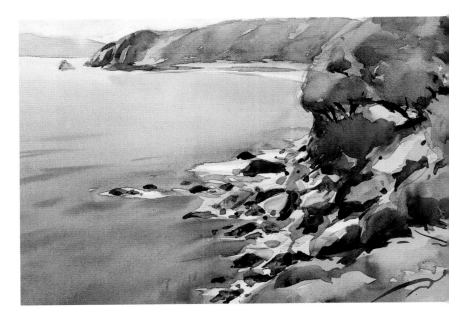

Rocky Coastline, Devon

DAVID WEBB

All the greens in this seascape were mixed from varying amounts of Cobalt Blue, Aureolin Yellow and Raw Sienna.

Tonal values

Tonal values are the areas of dark, light and anything in between in a painting. No matter what medium you choose to work in, getting the correct tonal values is the most important aspect of creating paintings with impact — even more important than colour.

Many beginners fall down when it comes to tonal values, producing work that hovers somewhere in the mid-tones, with no real darks or lights. Contrasts of light and shade are what enable us to identify solid, three-dimensional subjects and to separate them from their backgrounds. Shadows also help to create the illusion of depth and to fix an object in place; without a cast shadow, an object appears to float in space.

In watercolour painting, the whiteness of the paper itself is the very lightest tone available. Using transparent washes you can create all the subsequent darker tones, from the lightest lights to the darkest darks. To achieve darker tones, mix a higher concentration of pigment in the wash; for lighter tones, use less pigment and more water.

Get into the habit of seeing your subjects in terms of their tonal values. When you look at a scene, ask yourself what the lightest, middle and darkest tones are. Look for areas where there are contrasts, such as sunlit figures against a shaded area. Forget colour: think of your subject in grey tones (like a black-and-white photo), as this can help to simplify matters.

Tonal values are often an intrinsic part of designing your painting (see also pages 48–49),

so look for the patterns of light and dark and the way they are distributed throughout a scene. Look for shapes that join together. Areas of similar tone can be joined into larger shapes where they meet. This makes for a much more interesting design than carefully drawing an edge around each component. Making a shape stand out by putting an outline around it is not the solution. Your shape needs to be either darker or lighter in tone to make it contrast with the background.

Of course, not every scene contains extremes of tonal value. Although bright days will contain areas of very light tones in the sunlight and very dark tones in the shadow areas, an overcast day will contain mostly mid-tone values, with more soft-edged shapes. Misty scenes, too, have a narrower range of tones with soft shapes. But being able to describe something in separate tonal values of light, medium and dark is crucial to your development as a painter. With practice, you will be able to create three-dimensional forms that leap off the page.

Aureolin Yellow

Cerulean Blue

Indian Yellow

Raw Sienna

Vermilion Alizarin Crimson

Cobalt Blue Light Red

Cobalt Violet Raw Umber

Burnt Sienna

Ultramarine Blue

Creating a tonal scale
Different colours have different tonal values before you even think about diluting them. By their very nature, all the yellows will be of a lighter hue than, say, Ultramarine Blue. Get to know the colours in your palette and become familiar with the range of tones they are capable of producing. This exmple, left, shows the 12 colours in my chosen palette set against a grey tonal scale.

1 To determine which colours are lighter or darker in value, create a tonal scale using just black. Draw a line of 10 squares, each roughly 1½ inches (4 cm), on a piece of watercolour paper.

2 Now create a series of different tones, starting with almost undiluted black pigment for the bottom square. Fill in the remaining squares with steadily paler dilutions. The last square, at the top, should be blank watercolour paper.

3 Make strong dilutions of each of the colours in your palette and try to place them where you think they appear on the grey tonal scale. It is not an easy task. Obviously the strength of your wash has a bearing on the intensity of the resulting tone.

Light source

Sphere

Flat wash of one tone —
flat circle shape

Second wash applied to shaded
underside — shape now looks rounded

Cast shadow anchors the sphere in place

Using tone to make objects look three-dimensional
If you paint a single-colour object in just one tone, it will
simply look like a flat shape. To make it look three-
dimensional, you need to assess the way light hits it.
Remember that light usually comes from only one
direction and that the side of the object that's hit by the
light will be brighter than the opposite side, which is in
shadow — so you need to make any shaded areas darker
in tone than the very lightest areas.

Cube

Flat wash of one tone —
basic square shape

Mid tone (one extra wash) on one wall and
dark tone (two extra washes) on a third wall —
the shape looks like a three-dimensional cube

Wash on part of the inside wall —
the cube looks like a hollow box

Cast shadow anchors the box in place

Troubleshooting: Paintings that lack 'punch'

If you find that your paintings are
not as 'punchy' as you think they
should be, do a small tonal sketch
before you attempt a full-size
colour painting, to establish the
areas of light and dark in your
subject.

Top left: Colour photo of interior,
with daylight streaming through
the window and onto the floor
below.

Top right: Photo with the colour
removed, to reduce the scene to a
series of grey s, to make it easier to
judge the tonal values.

Bottom left: Monotone study of the
scene, painted only in black
pigment in varying dilutions.

Bottom right: The tones used in the
final colour painting were largely
based on the values of the small
tonal study.

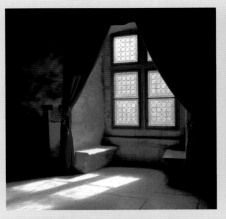
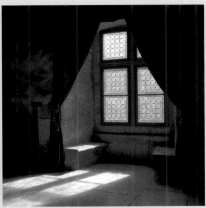
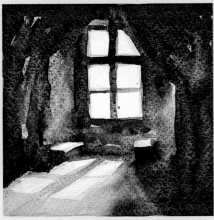
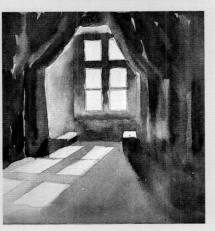

Special feature

WATER IN WATERCOLOUR

Not surprisingly, water is as important as paint in watercolour painting. There are two factors that you need to bear in mind: the ratio of pigment to water, which determines the strength of your colour mixes, and how wet the paper is, which determines whether or not the colour spreads.

1 Ratio of pigment to water

Too much water, and your washes will appear insipid. Too little, and the wash will not flow, leaving streaks and hard edges. Make a brush mark on scrap paper. If it is too weak, add a little more pigment; if it is too strong, add a little more water. Test each time until you get the strength you want.

Water first, then pigment
When you mix up a wash, first put some water into one of the mixing wells with either a brush or a pipette. Then begin to add pigment, making sure that it dissolves completely.

Test the strength of the colour
Always keep a scrap of paper next to your palette to test your wash strength before you commit it to your painting!

The pigment in this brush mark is too strong. The luminosity of the paper is almost lost, and if you were creating a glaze the underlying colour would not be clear.

The strength of pigment in this brush mark is about right, with clear colour and the white of the paper shining through.

The strength of colour in this brush mark is a little too weak, and a painting made from washes of this dilution would appear insipid and lack impact.

Troubleshooting: Gauging colour strength and consistency

Always add pigment to your water, and not the other way around. If you squeeze out some tube colour into a mixing well and then add water to it, it is very difficult to estimate how weak or strong the final result will be. It is also likely that you will waste paint this way.

I often see little sausage-shaped lumps of pigment surrounded by a pool of water, which makes it difficult to achieve a consistent strength of colour. This also leads to undissolved particles of pigment unexpectedly appearing to streak across the paper when you apply a brush load of paint, which is definitely not desirable.

2 How wet should the paper be?

If you wet your paper before applying a wash, give it a minute or two before you apply the paint. If you wet the paper with water first to create a soft, wet-into-wet foundation wash, you may need a higher concentration of pigment as, if the paper is wet when you apply a wash, the water on the surface will further dilute it.

If the paper is too wet, the paint will spread considerably. There may, of course, be occasions when you want this effect — perhaps for a sky.

If you wait a few minutes first, your paint will have a soft outline without spreading too much. The paper will have a slight sheen; it is useful to get to know this stage in the drying process, as it is probably the most effective time for putting washes down on the paper.

A brushstroke on dry paper produces charateristic sharp edges. The more defined outline draws the eye and is a useful method of creating more solid shapes and forms, perhaps near the painting's centre of interest.

Special feature

THREE WAYS OF MIXING COLOUR

In watercolour, colours are diluted in water and washed over white paper. There are three methods of mixing colours, each one producing a distinct effect, which can be used for different parts of your painting.

Mixing in the palette

Mixing on the paper

Glazing

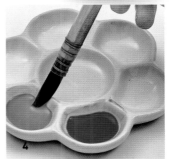

1 Mixing in the palette

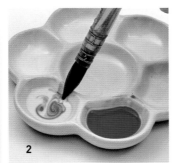

Mixing in the palette is probably the most straightforward method of mixing colour: just add one colour to another to produce a third. You can test the colour as you go until you achieve the result you want. When you are mixing colours this way, it is usually best to limit yourself to just two, to avoid your wash turning muddy. It is also wise to start with the colour that is likely to dominate. For example, if you want to mix a light green from a blue and a yellow, have a dilution of yellow prepared and then gradually add the blue in small increments. You will need only a small amount of blue to make a light green, so doing it this way round avoids wasting paint. Conversely, if you want to make a darker green, begin with a solution of blue and then add small amounts of yellow.

1 Mix separate dilutions of the paints you are going to use. Dip the brush into the first mixing well.

2 Pick up a little pigment and add it to the well containing the second pigment. Thoroughly mix to make a third colour.

3 Pick up some more of the first colour.

4 Add it to the mix to make a deeper colour.

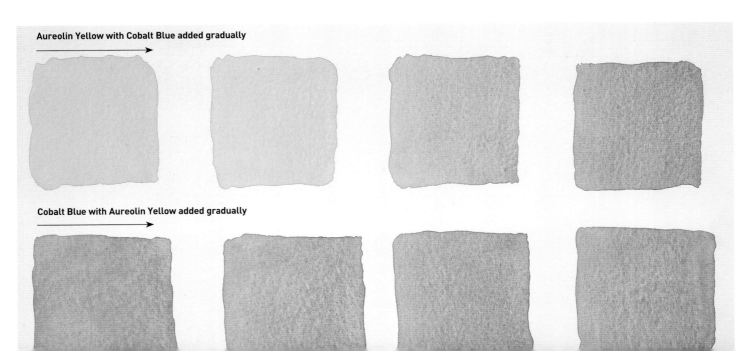

Aureolin Yellow with Cobalt Blue added gradually

Cobalt Blue with Aureolin Yellow added gradually

2 Mixing on the paper

Another way of mixing colours is on the paper itself, wet on wet (see page 60). This is a very expressive way of mixing colours together, as you can change colours on the page. It is very useful for areas of subtle colour change, such as masses of foliage. If you look at a stand of trees, for example, you will notice that the greens are very variable, changing from almost yellow to a dark, shady green and then back again. Mixing colours in the palette will produce a flat, overall colour, but by mixing yellow and blue on the paper you can create a variety of greens, ranging from dark to light, as your brush travels across the paper.

This method is also very useful for painting skies, where blues merge into grey s and then back again. In fact, mixing colours on the paper is the ideal method for any area where a gradual change from one colour to another is required.

1 Using a mop or a round brush, brush clean water over the paper.

2 While the paper is still wet, pick up some paint with the brush and drop it into the wet area of the paper; it creates a soft-edged area of colour.

3 Now, add a second colour to the still-wet first wash, creating a soft, third colour where the two pigments meet.

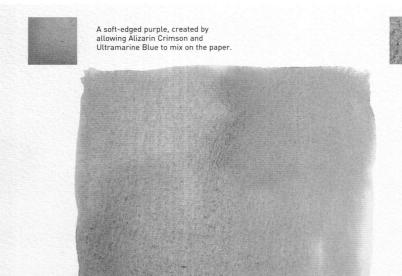

A soft-edged purple, created by allowing Alizarin Crimson and Ultramarine Blue to mix on the paper.

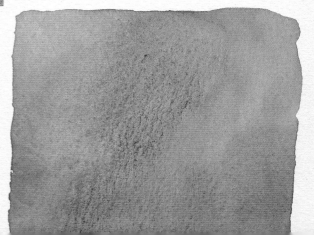

Ultramarine Blue is a granulating colour (see page 15); granulation is particularly noticeable where the two colours overlap.

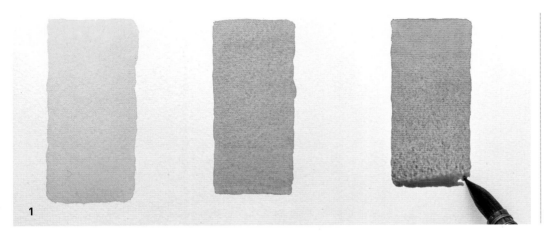
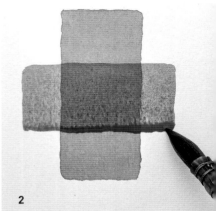

3 Glazing

The third method of creating new colours is glazing, which means laying a wash of one colour over another one that has been allowed to dry completely. It is a way of changing colour through building up washes. For example, if you lay a wash of yellow onto white paper and then wait for it to dry, a second wash of blue will create a green where the two colours overlap. Similarly, if you lay a wash of red over a yellow wash, orange will be produced in the overlap. This technique relies for its success on the brilliance of the white paper and the transparency (see page 14) of the colours used.

1 Using a mop or a round brush, paint a wide, vertical brushstroke of each colour (from left to right, Aureolin Yellow, Cobalt Blue and Alizarin Crimson) and allow to dry.

2 Brush a horizontal stroke of a different colour over each vertical stroke. Here we just show the blue over the red. Clean the brush between each stroke, and allow to dry. The results are shown below. Note how a secondary colour (see page 32) is created where the two colours overlap.

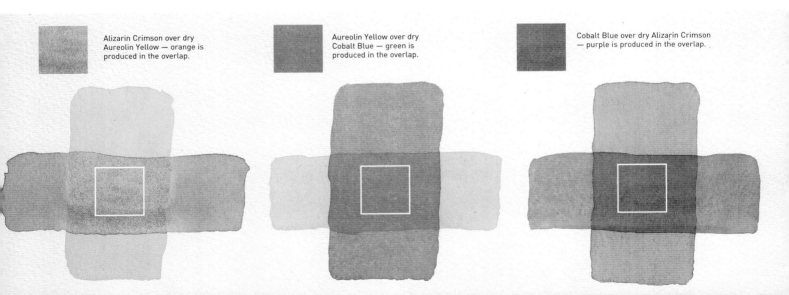

Alizarin Crimson over dry Aureolin Yellow — orange is produced in the overlap.

Aureolin Yellow over dry Cobalt Blue — green is produced in the overlap.

Cobalt Blue over dry Alizarin Crimson — purple is produced in the overlap.

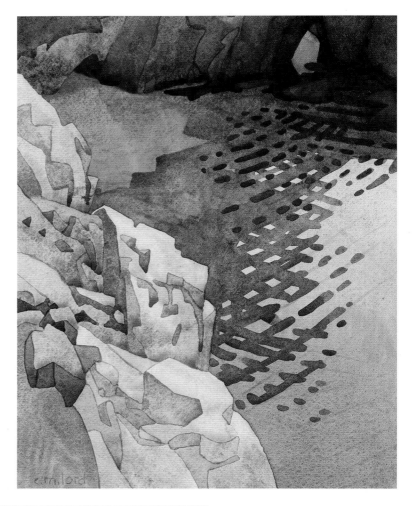

China Pattern

CAROLYN LORD

Beautiful, clean glazes of transparent colours have been carefully applied in this painting to create a rocky coastal scene. The subtle reds and greens complement each other.

Colour in context

Colour is one of the most expressive tools available to the watercolourist. Colour can be used to suggest mood and atmosphere. It can be used to portray warm sunlight pouring through a window or cool shadows on the side of a building. Colour can describe various weather conditions or even a particular time of day.

Two Plus Dog

KEITH NASH

Wet-into-wet washes of blues, grey s and yellows create soft, amorphous shapes in the sky, which dominate this painting. Some of the colours are echoed in the sandy beach.

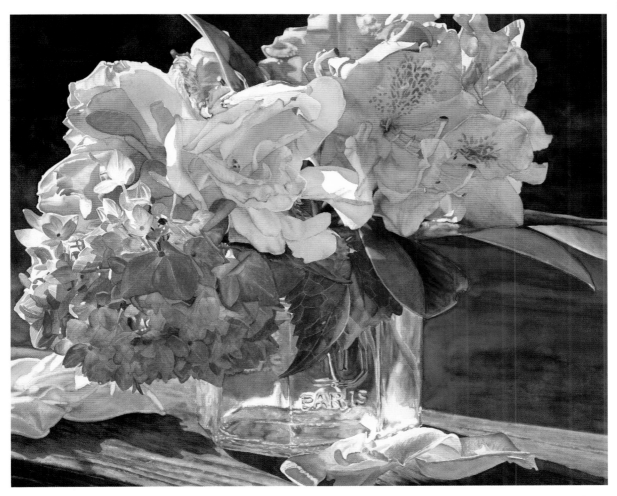

Douce

CARA BROWN

In this high-key painting, sunlight and colour glow from this floral study. The backlit flowers show the translucency of the petals and leaves, revealing a variety of reds and blues.

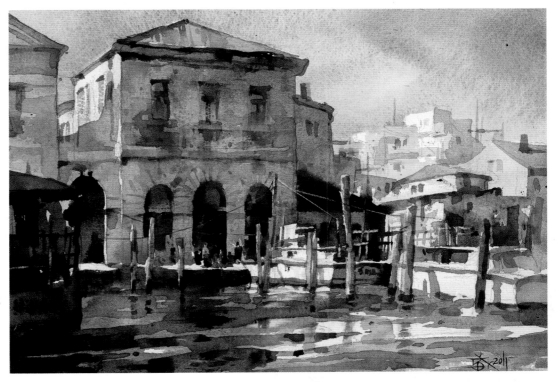

Venice

CHIEN CHUNG WEI

The sunlight in this scene picks out the warm reds and browns in the buildings. The cool blue of the sky and the blue-purple shadows add balance.

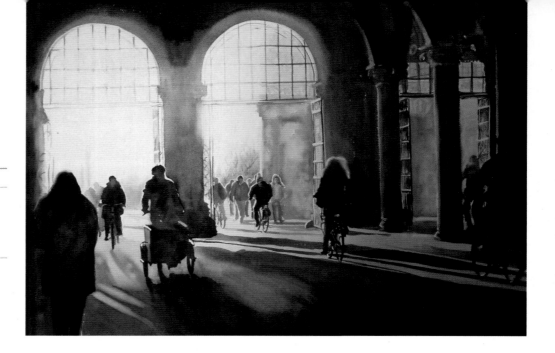

Bicycle Passage

HANNIE RIEUWERTS

This contre-jour study is predominantly dark in tone. The low sun creates strong, interesting shapes in the arches and long cast shadows of the figures on bicycles.

Tone in context

From the lightest lights to the darkest darks, contrasting values are so important in producing good paintings. Tonal values have been used here to create both strong and dynamic, and moody and subtle works.

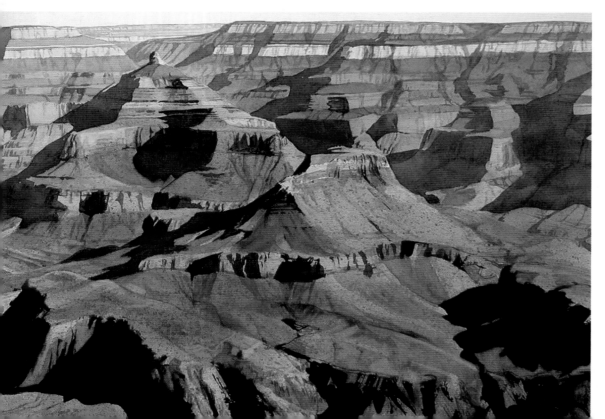

View at Yavapai Point

ROBERT HIGHSMITH

The sunlight makes the rocks glow in the fore and middle ground, causing shadows to rake across the surface. The more distant ridges are cooler and paler because of the effects of aerial perspective (see page 119).

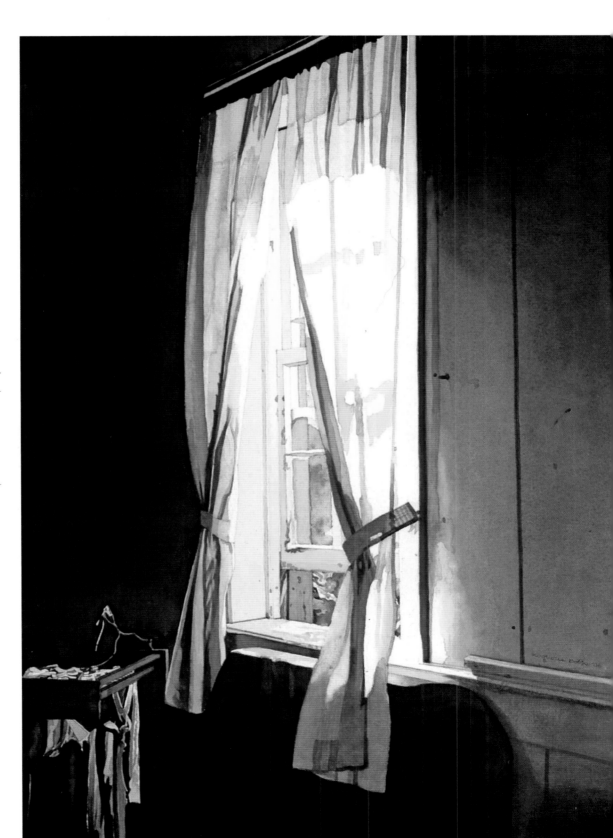

Black Creek Window

LINDA KOOLURIS DOBBS

Bright sunlight can be suggested by placing very light areas next to deep, dark-toned areas, as in this view of an open window. The painting is balanced by the smaller sunlit section on the left. There is a feeling of great depth in this scene.

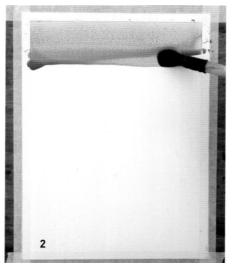

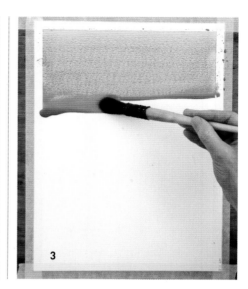

Flat wash

The flat wash is probably the most basic technique that you should learn to master when you are starting out in watercolour painting. A good wash should be clear, even and constant from top to bottom.

Angle of board
Angle your board at about 20 degrees so that the wash can flow gently down the paper.

The size of brush you use to create your wash will be dictated by the size of the area you wish to cover: a flat wash may cover a large area of the paper or just a small section. A large round brush is a good choice for flat washes, as it has a good shape and a decent size body for holding water. A general rule of thumb is to use the largest brush that you feel comfortable with.

A flat wash can be painted on either a dry paper surface or a damp one; if you are a beginner, you may find that the wash flows more easily on a damp surface.

It is very important to have enough wash diluted in your mixing well to complete the task from start to finish. If you run out of paint halfway down the paper, you will find that it's impossible to mix up exactly the same colour and tone. Even if you could manage to do this, by the time you arrive at the correct strength, the section you previously painted would have dried too much to enable you to complete a smooth wash. You would find that a line had appeared between the two halves.

Of course, in a painting you may find that there are objects or features that you do not want to cover with the wash. This means painting down to and around the object. This can be tricky so, as with all techniques, practise on scrap paper first.

MATERIALS

Pre-stretched watercolour paper on board

Your chosen colour of paint

Mixing palette

Water

Large watercolour brush

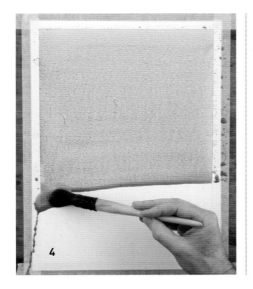

1 Dilute a wash of your chosen colour, making sure you mix enough to cover the entire sheet. **Inset:** Dip the brush into the mixing well. Make a horizontal brushstroke across the paper. If the board is at the correct angle, a bead of colour will form at the base of the stroke.

2 Working quickly, reload the brush with colour if you need to and make a second brushstroke directly underneath the first, with the brush just touching the base of the first brushstroke; this allows the bead to flow down into the second mark.

3 and **4** Repeat this process until the wash reaches the bottom of the paper (or the area you wish to cover).

5 Blot off excess water from the brush on a piece of paper towel, until the brush is just damp. Touch the brush tip to the remaining bead of colour: the bead is absorbed up the brush by capillary action. If you leave the bead on the paper, it will form a backrun or cauliflower (see page 84), as it dries.

Troubleshooting: Stripy washes and uneven marks

Sometimes you may find that your finished wash has a stripy appearance, which I call the 'Venetian blind effect'. This is caused by not having enough water in the wash. You must maintain the bead at the base of each brushstroke. Don't get lazy and think that there is enough paint on the brush to get to the end: if it seems that the bead is disappearing, reload the brush and continue. You should be able to physically see the wash flowing down the paper. If you can't, the brush is too dry.

You can use a hair-dryer to speed up the drying time (above left). However, you must give the surface sheen time to disappear, otherwise the hair dryer may blow the water across the paper, resulting in uneven patches and drying marks (above right).

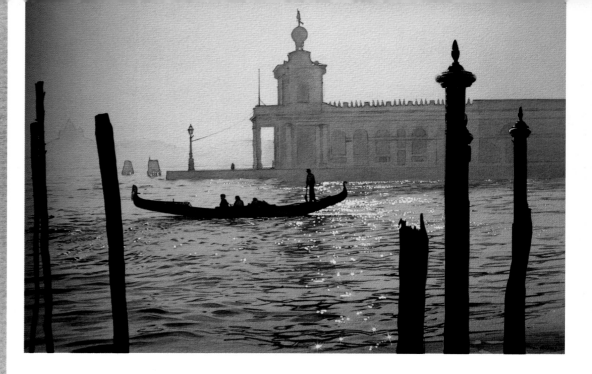

Gradated wash

Having mastered the basic flat wash (see page 50), you will soon realise that there are limitations to its use. The gradated wash allows you to change the strength of the tonal values while you are applying the wash, so that it gradually becomes lighter as you work your way down the paper.

The way to achieve this effect is to begin your wash at its fullest strength, or darkest tone, and then to gradually dilute it as you are painting. As you add more water to your wash, it becomes less concentrated and paler in tone, allowing more of the light to be transmitted from the paper surface. This can have many applications in picture making. When you are painting skies, for instance, it may appear that they are darker overhead, gradually getting lighter as you get closer to the horizon.

As with the flat wash, it is vital to have your board at an angle to enable the wash to flow down the paper. The gradated wash can be applied to dry or damp paper; practise both methods to see which suits you best.

The results of the gradated wash can be unpredictable, and I find that it is almost impossible to replicate the same effect twice. It is a useful technique to master, though, as there are many instances in landscape and seascape painting where a gradual change of tone is required.

Statue of Fortune at Dawn, Grand Canal, Venice

DENIS RYAN

In this painting a gradated background wash has been applied first. The sky area is actually light at the top, getting steadily darker in tone towards the foreground. This effect can be achieved either by adding stronger tones as you work down the paper, or by working light down to dark and then turning the paper around once the wash has dried.

MATERIALS

Pre-stretched watercolour paper on board

Your chosen colour of paint

Mixing palette

Water

Large watercolour brush

Gradated wash at actual size

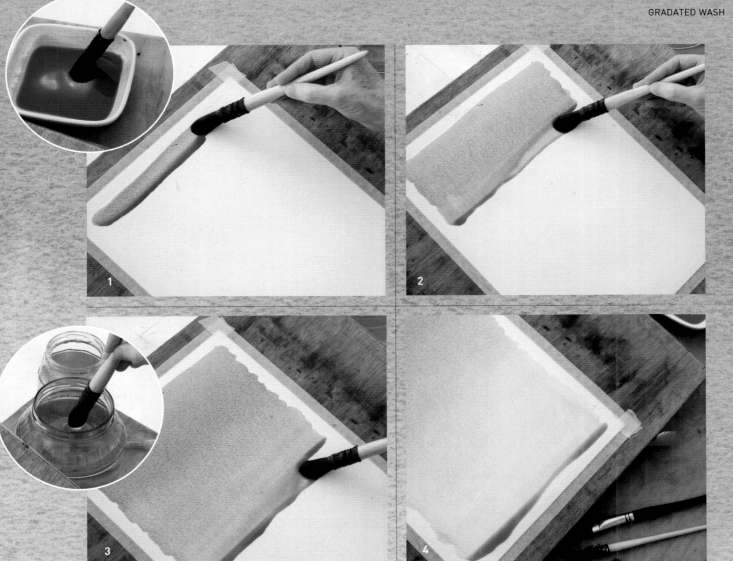

1 Make a strong dilution of your chosen colour in the mixing well, making sure you mix enough to cover the entire sheet. **Inset:** Dip the brush into the mixing well. With the board at the correct angle (20 degrees), make a horizontal brushstroke across the paper. A bead of colour should be apparent at the base.

2 Reload the brush with colour and make a second brushstroke directly under the first, allowing the bead of colour to flow down. Repeat this action once or twice more.

3 Inset: Instead of loading more paint on the brush, dip it into the water jar and quickly lift it out, then apply the next brushstroke. The brush should still contain some colour, but it will be diluted — so the next brushstroke will be weaker in colour. You have to do this quite quickly, as you still want the wash to flow down the page.

4 Repeat this process until the paper is covered. If it has been done correctly, the wash should become steadily paler towards the bottom of the paper. As in the flat wash, remove the bead of colour with a damp brush.

Troubleshooting: Uneven gradations

Sometimes you may find that your wash doesn't lighten as gradually as you might like, resulting in a dark top half and a light bottom half, lacking any subtle, gradual transition in between. This can be caused by diluting your paint a little too much in one go. Remember, it is a 'gradated' wash — so try to use a little restraint when it comes to diluting the colour.

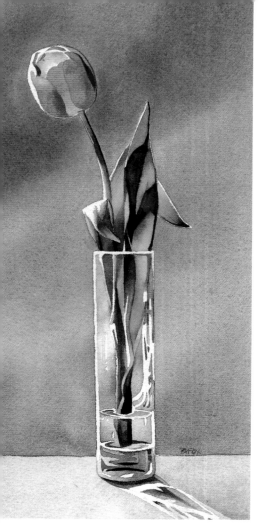

Spring

BARBARA FOX

A soft, variegated wash has been used here to create a simple background of dark blue gradually changing through to a blue-green and then green, allowing the viewer to focus on the tulip.

Variegated wash

In the variegated wash method, more than one colour is employed to create a seamless, soft-edged blending of colours down the paper. The technique can be used to great effect in skies and may also be used in a foundation wash at the beginning of a landscape, perhaps starting at the horizon with a cool colour and then gradually changing to warmer colours as you approach the middle- and foregrounds.

For best results use a large brush, as wide strokes of colour will create a better effect than those made with a small brush. A variegated wash can be painted on dry or damp paper; however, the different colours will flow more readily into one another on a damp surface.

Be prepared for the unpredictable: with this method, as with the gradated wash (see page 52), you can seldom obtain the same result twice. Sometimes, the finished result may suggest to you a particular mood or subject, which you can then work on with subsequent washes once the variegated wash has dried.

It is well worth experimenting with a technique like this before using it in a painting. We all have paintings that we're not quite happy with. It's worth keeping them as, if you turn them over, you can always practise techniques such as this on the back of them.

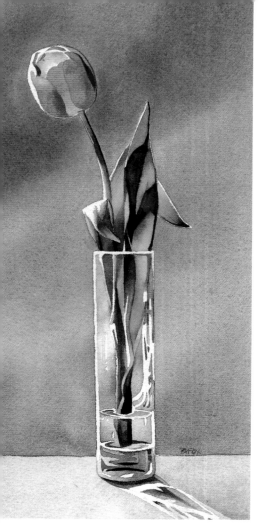

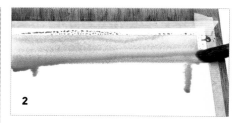

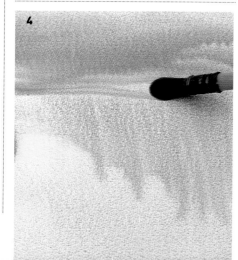

1 Make sure your board is at a 20-degree angle, as it is very important that the wash is allowed to flow down the paper. Dip your brush in clean water and, working from top to bottom, dampen the paper.

2 Load your brush with colour and make the first horizontal brushstroke. Reload the brush with paint, if necessary, and repeat this action a few times.

3 When you want to change colour, quickly rinse the brush in the water jar, remove any excess water and then dip it into the next colour. Now begin painting brushstrokes of the new colour directly underneath the previous one.

4 The previous colour continues to flow down the paper, mixing with the new colour to create a soft blend of the two.

MATERIALS

Pre-stretched watercolour paper on board

Watercolour paints in your chosen colours

Mixing palette

Water

Mop brush

Variegated wash at actual size

Troubleshooting: Common variegated wash problems

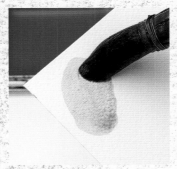

Not mixing enough colour
Be sure to mix enough of your chosen colours beforehand as, once you've started the wash, you have to work quickly and there will be no time to mix up extra colours when you're halfway down the paper.

Unintentional patchy marks
Always make sure that you have a good amount of water/paint on the brush, as the paint will flow much more smoothly and you will avoid making streaks and lines. If you find that your brush is overloaded, remove any excess by dragging the brush along the rim of your water jar.

Unexpected colour strength
It is difficult to judge the strength of colour in the mixing well, so test your colours first on a piece of scrap paper.

Rundown
When you reach the end of the wash, you will find that a run has collected at the base. Remove this with a damp brush or piece of paper towel to prevent a cauliflower (see page 84) from forming. You may have to soak up the rundown more than once, as gravity will keep the wash flowing down the paper until it has dried.

Tinted background wash

A tinted background wash provides a pre-coloured surface that will influence any transparent washes laid on top. It's a great way of creating atmosphere and mood in your paintings.

Of course, you can buy tinted watercolour paper (see page 23), but by creating your own you can tailor it to the exact colour and tone that you want, perhaps with a particular mood in mind. Sometimes, simply making a wash with a spontaneous choice of colour, or colours, will actually suggest ideas for a subject that you may not have thought of before.

Warm colour washes using yellows, oranges or browns tend to create a romantic, peaceful atmosphere, which permeates the entire painting. Cooler background washes using blues and purples will lead to a completely different result and feeling. The background wash does not necessarily have to be of one, flat colour: it could be a variegated wash (see page 54). Early evening, sunset and daybreak scenes are all subjects that lend themselves to having a tinted background wash as a foundation.

A background wash also reduces the contrast in a painting, as there will be no white areas (unless you lift them out or add body colour). I often begin my paintings with a variegated background wash and then, before it dries, lift out highlights with a damp brush (see page 76). I begin by having my board propped at an angle, to allow the washes to flow downwards. I then paint a loose, wet wash of a particular colour over the surface. I may then repeat the process while the previous wash is still wet. It's possible to repeat this action several times, as long as the wash remains wet, until you achieve the desired effect.

MATERIALS

Pre-stretched watercolour paper on board

3B pencil

Watercolour paints: Raw Sienna, Cobalt Blue, Aureolin Yellow, Burnt Sienna, Alizarin Crimson

Mixing palette

Water

Large round or mop brush

Pencil outline
For this demonstration I want to show you how two different background colours can influence the same scene. Begin by drawing two outlines of the same scene, side by side. Avoid the details, and concentrate on just the larger shapes. Make separate dilutions of all your colours (you will be using the same colours for both paintings).

Warm tinted background

1 With your board tilted at 20 degrees, put a flat wash of Raw Sienna over the entire drawing to create a warm background tone, and allow it to dry.

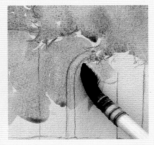

2 Starting at the top left, brush in Cobalt Blue. Then add a touch of Raw Sienna, wet into wet, to create a soft sage green. Moving across the paper, add a little Aureolin Yellow to create a lighter, sunnier green. Then add a little Cobalt Blue into the sky area.

3 Rinse your brush and pick up some Burnt Sienna. Allow it to touch the bottom edge of colours you've just put down, and wash this over the area of the wall. Add a little Cobalt and Alizarin Crimson in the shadow areas.

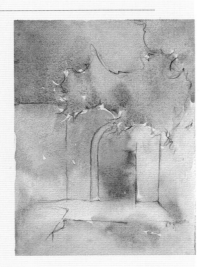

4 Carry on to the bottom of the paper, all the while changing and mixing colours to roughly represent the colours in the reference photo. You should have no hard edges at the end of this stage, just a soft, formless, light-toned wash. Allow this to dry completely.

Cool tinted background

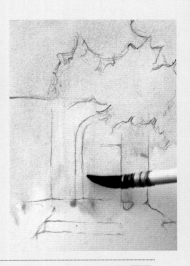

1 With your board tilted at 20 degrees, put a flat wash of Cobalt Blue over the entire drawing, to create a cool background tone, and allow it to dry.

2 Starting at the top left, mix combinations of Cobalt Blue and Aureolin Yellow for the shadowy tree. You can introduce a little Raw Sienna in places, but the Aureolin Yellow creates a cooler green, which is the goal in this painting.

3 Carry on down the painting, using mostly Alizarin Crimson for the wall, with a little Cobalt Blue in places. This combination is also cooler than that used for the wall in the first painting.

4 Continue mixing colours on the paper, working down to the bottom of the paper. You should end up with another soft, light-toned wash. Allow this to dry completely.

(continued overleaf)

Warm tinted background (continued)

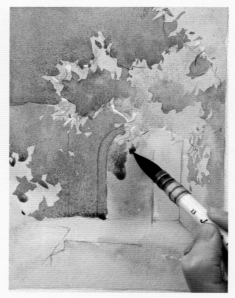

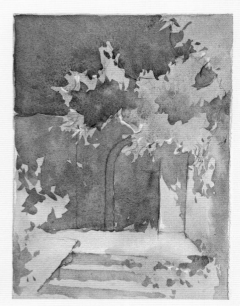

5 Begin to create more solid forms and shapes. Start in the top left, where there is a lot of shadow. Again, mix the colours on the paper using Alizarin Crimson, Cobalt Blue and, here and there, some Burnt Sienna. In lighter areas, paint negative shapes around these, such as in the overhanging trees. Paint a similar wash over the wall, leaving chinks of light in places.

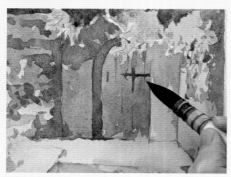

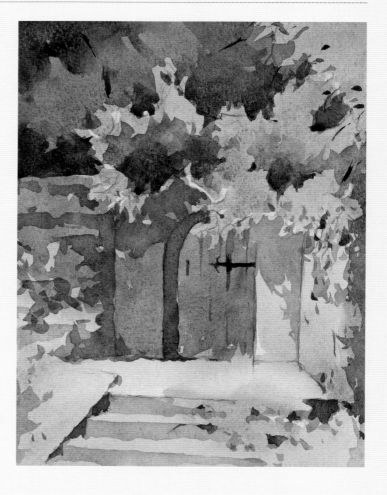

6 Finally, paint in the darkest tones using stronger mixes of Cobalt and Alizarin and Cobalt and Burnt Sienna. Paint the details in the wall, gate and steps. The finished painting emanates a feeling of warmth, from the original Raw Sienna wash.

Cool tinted background (continued)

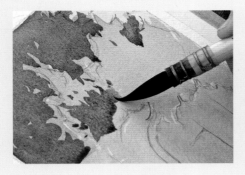

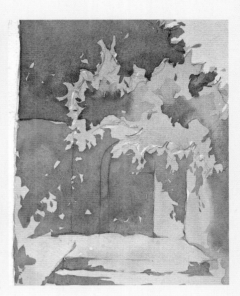

5 Create more solid forms, starting with the shadowy foliage at the top left of the painting, using a stronger combination of Cobalt with a touch of Alizarin. Create negative shapes, i.e. the space surrounding an object, around the paler, sunlit tree forms. Add shadows over the wall, remembering to leave small gaps to represent light filtering through the leaves. Place a few shadows on the vertical planes of the steps.

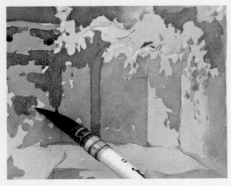

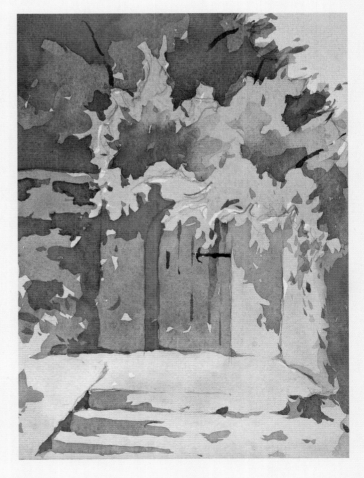

6 Now paint your darks, beginning with some deeper shadows in the tree at the top left and using a strong mix of Cobalt with a touch of Burnt Sienna and maybe a little more Alizarin, allowing the colours to mix on the paper. Finally, add some small, dark details such as the hinge on the gate, texture in the wall and a few branches emerging from the leaf masses. The final mood of the painting is a welcoming, cool shade.

Wet on wet

The basic flat wash is a technique that everyone who takes up watercolour needs to master. However, it does have its limitations and you'll need to master several other techniques to paint a picture. The wet-on-wet method is an exciting, often unpredictable, way of applying colour to the paper.

MATERIALS

Pre-stretched watercolour paper on board

3B pencil

Watercolour paints: Cobalt Blue, Alizarin Crimson, Raw Sienna, Burnt Sienna

Mixing palette

Water

Large watercolour brush

As the name implies, in this technique wet colour is added to pre-wetted paper, which produces soft effects with no hard edges. It can be used to paint many subjects, including skies and clouds, misty scenes and atmospheric landscapes.

Of course, the technique cannot be used to paint an entire painting as it would be devoid of hard edges. To create some sort of order from the masses of soft shapes, some definition is required. Once the initial wash is completely dry, you can overlay subsequent, transparent washes on top. The attraction of this method of building up a painting is the way in which the initial foundation wash fuses the painting together, creating a mood that will influence any washes you apply afterwards. It also has the advantage of removing all the white areas in one go, which is something that can cause consternation among beginners to watercolour.

Wet on wet is not a precise way of working and you will find that it is impossible to reproduce the exact same effect twice — but it is the very unpredictability of the technique that makes it exciting. For best results, I always stretch the paper before working in this way (see page 24). A sheet of pre-stretched paper provides a completely flat painting surface that will not warp.

1 With your board tilted at 20 degrees, sketch the outline, then brush clean water over the paper. Wait a few moments to allow the water to soak in. Starting from the top of the paper, make diagonal brushstrokes of Cobalt Blue, leaving a few unpainted areas for clouds.

2 Working quickly, before the first wash dries, brush Alizarin Crimson into the base of the clouds to represent shadows.

3 Add a little Alizarin Crimson, along with a touch of Raw Sienna, to the clouds themselves to give them a pinkish flush. All the while, gravity is helping the colours to blend on the paper.

4 Rinse your brush. Brush Raw Sienna in from the base of the clouds down to the bottom of the paper. Wash a little Cobalt Blue over the sea to give a greenish tinge. Brush Burnt Sienna over the headland on the right, returning to Raw Sienna for the beach and rocks. Allow to dry.

5 Gently wash clean water over one of the clouds and add Cobalt Blue and Alizarin Crimson. The paint will flow down slightly, but will stop where the clean water meets the dry paper, giving an edge to the cloud.

6 Continue to build up washes to create the sea, land and rocks.

In the finished painting, shown at right, softness has been achieved in the sky area by the use of the wet-on-wet technique. Harder, more solid forms, such as the rocks and headland, benefit from the harder-edged technique of wet on dry (see page 62).

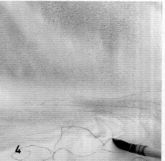

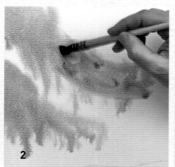

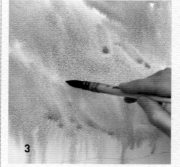

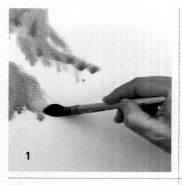

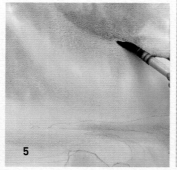

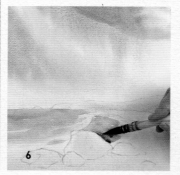

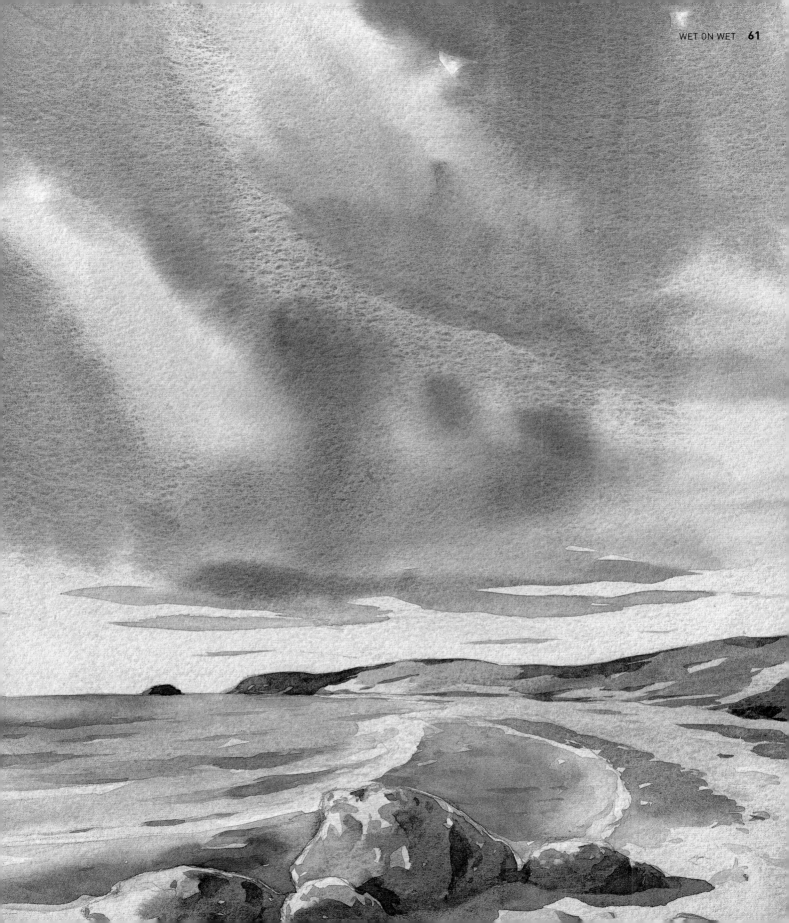

Wet on dry

In watercolour, there are several methods of applying paint, the most straightforward being wet on dry, which means — not surprisingly — that you apply wet paint to dry paper. This method can be used on virgin paper or over the top of a previous wash that has been allowed to dry completely.

Wet on dry produces a wash with clean, sharp edges, which is useful for describing the appearance of a straight-edged, three-dimensional object such as a box. It can also be used where texture is required. In the demonstration on the right, the leaves on the left-hand side of the tree have been suggested by small, wet-on-dry dabs of colour using the tip of the brush. The same technique can be used when depicting splashes of water, or stones and pebbles in a foreground area. In fact, small, calligraphic wet-on-dry marks of varying shapes can be used in any situation where the illusion of a textured surface is required.

However, it is best to use a combination of several brush techniques in a painting to avoid monotony. If you were to use a wet-on-dry approach for the whole painting, you would end up with a lot of hard edges and the viewer's eye might find it difficult to know where to settle. The painting would also lack atmosphere. A balance of hard and soft edges creates a more natural look.

MATERIALS

Pre-stretched watercolour paper on board

2B pencil

Watercolour paints: Cobalt Blue, Raw Sienna, Light Red

Mixing palette

Water

Large watercolour brush

1 Begin with a 2B pencil outline, showing just the basic areas and shapes. Try to avoid drawing too much detail, as most of the work is done with the brush. Make separate dilutions of Cobalt Blue, Raw Sienna and Light Red.

I always use a soft pencil, from the 'B' range, on watercolour paper, as harder 'H' pencils tend to make indentations on the paper.

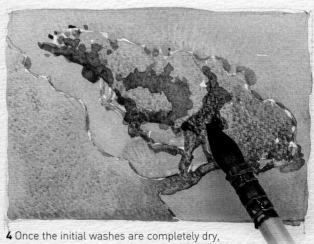

4 Once the initial washes are completely dry, overlay a second wet-on-dry wash of Cobalt Blue with Light Red into the foliage areas to suggest the shadows.

Troubleshooting: Avoiding backruns

Backruns (see page 84) can be caused by failing to remove a drip from the base of a wash. The area above the drip dries quite quickly, whereas the drip acts like a small reservoir. To avoid this, let the tip of a damp brush touch the bead, then the fibres of the brush will soak up the water by capillary action. I have a nylon flat that I use for this.

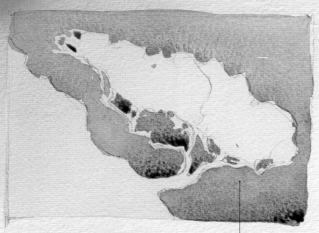

2 Load a mop brush with Cobalt Blue and paint the area of the sky on the dry paper, working from top left down to bottom right. To create interest, add a little Light Red about halfway down the wash. Leave to dry.

The technique allows you to paint around areas you wish to reserve, without fear of the paint bleeding over the edges.

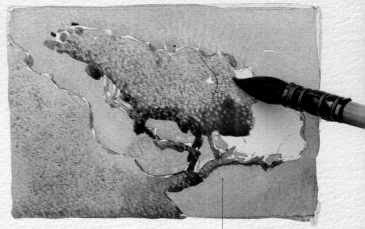

3 Paint the hillside with Raw Sienna. Start painting the top of the foliage with Raw Sienna, then add Cobalt Blue into the wet paint on the paper to make a green and work this down the paper. Allow to dry.

Make sure the previous wash is dry before you start painting the foliage, otherwise the colours will merge wet into wet.

5 You can clearly see the characteristic hard edges produced by this technique. Again, allow the washes to dry completely before doing any further work.

6 Finally, using the Cobalt Blue and Light Red mix, add a little more shadow on the branches and tree trunk, and also on the ground beneath the tree. The wet-on-dry technique reates a hard edge between adjoining washes.

Wash techniques in context

The paintings in this gallery display a variety of wash techniques including wet on wet, wet on dry and also multiple layers. Some show a loose treatment, while others demonstrate a tighter, more illustrative, style.

Lakeside

RANDY EMMONS

The swirling cloud shapes have been created by the wet-on-wet technique. The white of the paper represents the cloud area, while blues and reds have been used for the darker areas.

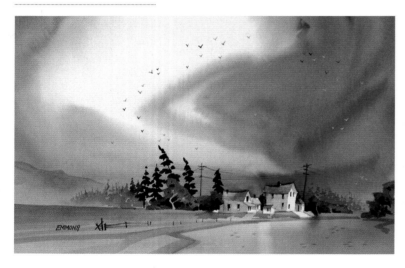

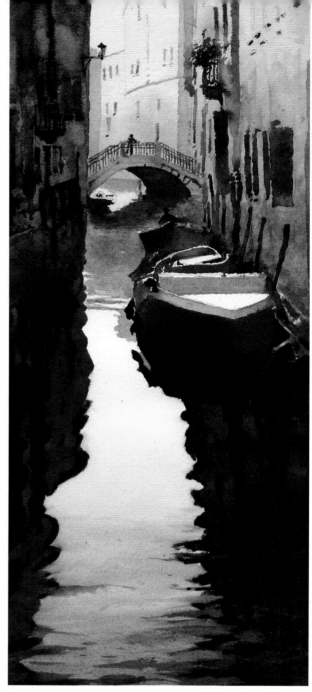

Venice

MICHAEL REARDON

A gradated wash was used as the foundation of this Venice scene, alternating warm and cool colours to reflect the sky. Wet-on-dry washes were then applied once the initial wash was dry.

Blossom

ANN SMITH

Wet-on-wet mixes of reds, yellows and purples have been used extensively for the background wash, while some clever negative painting has created the flower shapes.

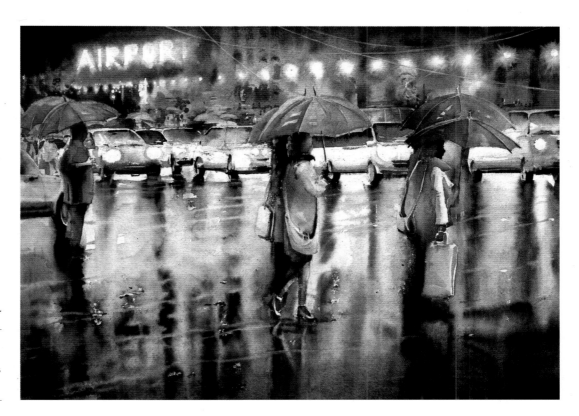

White Steps to the Airport

FERNAND THIENPONDT

The atmosphere of a rainy night has been achieved here with a wet-on-wet wash on the road surface, allowing soft dark shapes to run down to represent reflections of the car wheels.

Sweet and Sour

LIANE BEDARD

This painting began with an outline of carefully drawn shapes. These were then filled with mostly flat washes, achieving an effective, illustrative result.

The North Sea

FERNAND THIENPONDT

In this study of waves rolling over the beach, drybrush is clearly visible on the foamy areas of the waves.

MATERIALS

Pre-stretched rough surface watercolour paper on board

3B pencil

Watercolour paints: Raw Sienna, Ultramarine Blue, Burnt Sienna, Aureolin Yellow, Alizarin Crimson

Mixing palette

Water

Mop or round brush

Paper towel

Drybrush

The drybrush technique is a useful tool for depicting rough surfaces such as tree bark, rocks, sparkling water and foreground areas where you want to introduce detail into an otherwise featureless space.

This method of applying paint to paper takes a bit of practice and requires just the right amount of paint and water on the brush, along with a light, deft movement across the paper surface. If you do it right, you'll get a broken strip of colour where flecks of untouched paper will be visible. Too much water on the brush will result in little or no bare areas of paper. Too little and the opposite will be true: the brush will skip across the surface leaving hardly a mark.

Except for hot-pressed paper, which is smooth, watercolour paper has a textured surface. As the brush is dragged across the surface, paint will be released onto the proud ridges of the paper, leaving the depressions free of any pigment — so the rougher the paper, the more pronounced the effect will be.

Although it is a useful tool, drybrush should be used with restraint as the effect can be overpowering if it is overused.

One point to remember is that drybrush is usually used in the final stages of a painting as, obviously, if you lay a wash over the top of a drybrushed area, the effect will be softened or lost completely. I find that it's best to try a few practice runs just before you intend to use it on your painting. When you know that you have just the right amount of paint on the brush, that's the time to use it.

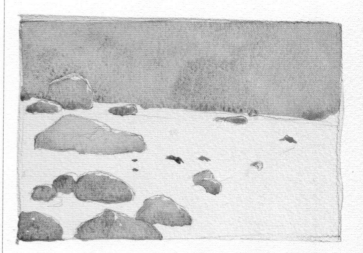

1 Draw an outline of the rocks and the line dividing the river's edge and the shaded background. Dilute your colours in separate mixing wells. Wash Raw Sienna across the background, dropping in Ultramarine Blue, Burnt Sienna and Aureolin Yellow from time to time to create a varied background wash. Paint the foreground rocks using the same technique and colours.

2 Bring the sky wash down as far as the river's edge (far left) and then use the same mixing technique to carefully paint the rocks (left). Allow the wash to dry.

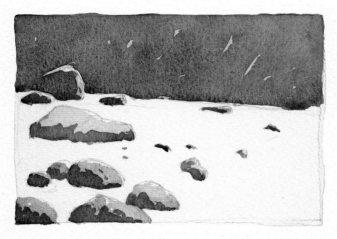

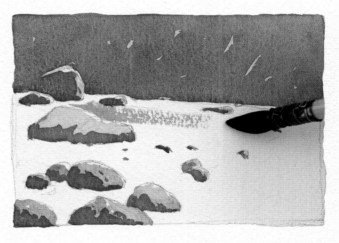

3 To create the shadows on the background, mix Ultramarine Blue, Alizarin Crimson and Burnt Sienna on the paper, leaving gaps here and there to suggest highlights. Use the same mix for the shadows on the rocks in the river.

4 Load your brush with a blue-grey mixed from Ultramarine Blue and Burnt Sienna, then touch the brush onto paper towel to remove most of the water. Drag the brush across the river area, following the direction of the water flow, to create a drybrush 'sparkle' effect.

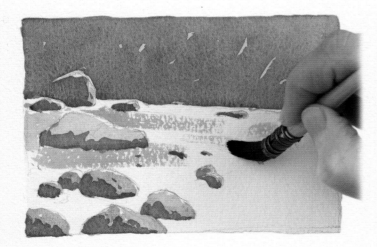

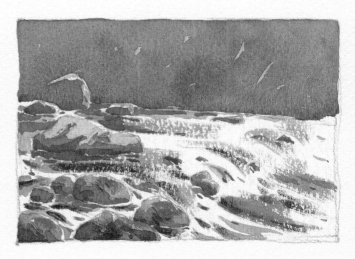

5 Continue with the drybrush technique, leaving a few patches of paper untouched to suggest white water areas.

6 Add a little Alizarin Crimson to the drybrush mix and use the technique again to provide darker streaks on the water surface. Add a few darker shadows to the foreground rocks.

Load and test The drybrush technique works best when the brush contains pigment, but not much water. Load your brush from the mixing well, then lightly press it onto a piece of paper towel to remove the excess water. Test the paint strength on a scrap of paper.

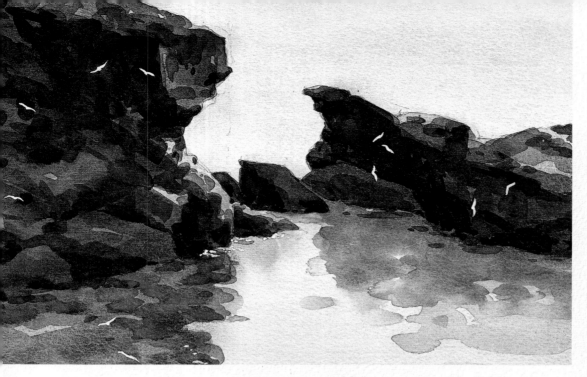

Durle Stone

DAVID WEBB

I wanted to include a few gulls in this painting, to add a sense of scale. To paint around them would have been almost impossible, especially as I started with an all-over foundation wash. So, I picked out their shapes with masking fluid, using a fine brush.

MATERIALS

Pre-stretched watercolour paper on board

3B pencil

Old brush for applying masking fluid

Masking fluid

Watercolour paints: Ultramarine Blue, Light Red, Raw Sienna

Mixing palette

Water

Mop or round brush

Rigger brush

Resists

Resists are used when an area needs to be left unpainted. They act as a barrier to the wash, keeping the area free of paint. In watercolour, the two main resists used are masking fluid and wax.

Masking fluid

Masking fluid is a liquid latex solution, which dries on contact with air. It is available in several colours, including blue and yellow, and can be applied to watercolour paper with a brush or a dip pen. If you use a brush, keep one specifically for use with masking fluid as, once dry, it is virtually impossible to remove it from the bristles.

To use masking fluid, paint or draw in the parts you want to remain white, allow the fluid to dry completely, then apply a wash over the whole area. When the wash is dry, just rub the masking fluid off with your fingertips; the paint on the masked areas will come away at the same time, revealing the pristine white of the paper. If the exposed area is too bright, you can paint over it with a very pale wash of the appropriate colour.

There may be occasions when you are painting a large wash across the paper and, right in the middle of it, there is a small area that has to be kept as white paper — for example, a small, sunlit flower in front of a wall in shadow or dots of sunlight sparkling on water. It is possible to paint these sorts of subjects without resorting to masks or wax, but it is difficult to go around every small object without going over the lines here and there, or painting some bits that do not quite go up to the edges when you are painting a large, loose wash.

Without the use of masking fluid, your painting may have a looser, more spontaneous feel. Yes, you may go over some areas that you would have preferred to remain untouched — but does that really matter? If a looser style is what you are aiming for, then it is probably better to get by without masking fluid. If you're aiming for a tighter, more detailed feel to your painting, however, then you may prefer to mask out every individual small detail to retain your original idea. It is all a matter of personal taste.

If you want to create a hard-edged division in your painting — for example, where a wall meets the sky — you can use masking tape instead of fluid.

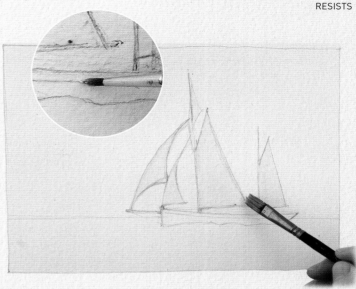

1 Draw the horizon line, which is about one-third up from the bottom of the sheet. Now carefully draw the outline of the boat.

2 Using an old brush, paint masking fluid over the area of the sails. **Inset:** Paint a thin line along the length of the hull. Allow the masking fluid to dry, which should only take a few minutes.

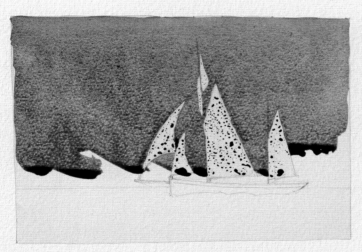

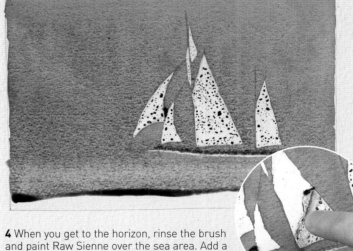

3 Load your brush with Ultramarine Blue and, starting at the top of the paper, create a wash running down the sky. From time to time; dip into the Light Red and mix this with the Ultramarine. Paint right across the sails, as they have been masked.

4 When you get to the horizon, rinse the brush and paint Raw Sienne over the sea area. Add a little Ultramarine Blue to make it greener. **Inset:** Once dry, rub off the masking fluid with your finger. You can see that the sails and thin line have been reserved: this would have been difficult to do without using masking fluid.

(continued overleaf)

Protect your brush
Any brushes that you use for the application of masking fluid should be thoroughly washed with soap before the masking fluid has a chance to dry.

Keep a brush just for masking

So I don't accidentally pick up one of my best, more expensive brushes, I have an old brush with a piece of insulation tape around the handle that I use solely for applying masking fluid.

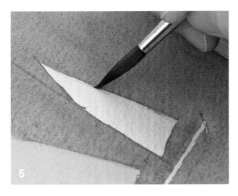

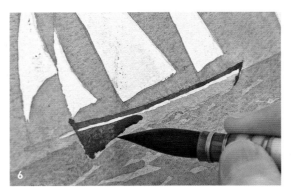

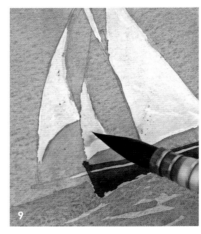

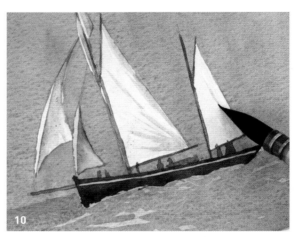

5 If the edges of the masked sails are too sharp, you can soften them by dragging a damp brush along the edge.

6 Put a second wash of Raw Sienna, with a little Ultramarine Blue, over the sea, leaving a few 'wave-shaped' gaps. On the boat hull, use a strong mix of Ultramarine and Light Red to make a dark blue-grey . Carefully paint the hull, either side of the thin white line.

7 With a pale wash of Light Red, carefully paint the red line on the hull of the boat.

8 Left as they are, the sails are a little too stark. Use a pale wash of Raw Sienna to give a warm tint to the sails, apart from the small triangular staysail.

9 Paint the staysail using a pale wash of Light Red.

10 Paint creases in the white sails with a stronger Raw Sienna mix. Add a little Ultramarine Blue to the Light Red for the shadow area on the staysail.

11 With a stronger mix of Ultramarine Blue and Raw Sienna, add darker shadows to the wave shapes. Finally, using a rigger brush, paint the fine rigging lines and any other small details.

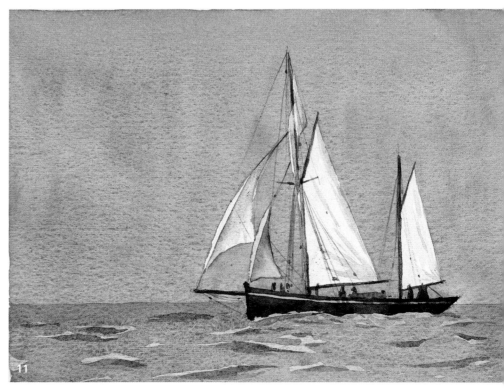

Troubleshooting: Common masking problems

Masking fluid allows you to reserve small details that would be either very difficult or impossible to achieve otherwise. However, there are a few potential problems that can occur if you are not careful.

Smudging paint

If the paint around the masked area is still wet when you remove the masking fluid, you can easily smudge paint across the very area you were trying to reserve. Always make sure theat the surrounding area is completely dry before you begin rubbing off the masking fluid.

Smudged paint

Damaging the paper when removing the masking fluid

Remove the masking fluid as soon as possible after you have painted over the masked area. It dries hard and, if you leave it for too long, it will take the surface of the paper with it when you try to remove it.

Paper tear

Lifting off paint smudges

If you do smudge the paint, gently moisten the smudged area with a damp brush (a flat is good for this) to loosen the paint and carefully lift it off.

Wax

Wax can also be used to reserve areas, as it repels water. You can use an ordinary household candle, shaping it with a knife, or wax crayons. If you use a wax resist on rough paper, the result is textured and broken, and resembles the drybrush technique (see page 66). Once wax has been applied, however, you cannot remove it.

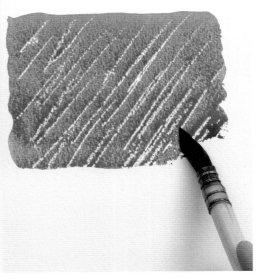

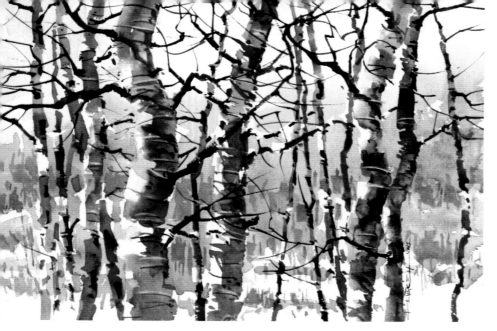

Aspen Tangle

CARL PURCELL

In this painting of birch trunks, the artist
has left areas of untouched paper to
represent the distinctive silvery, paper-
like bark. The same method has also
been used for the background grass.

MATERIALS

Pre-stretched watercolour paper on board

3B pencil

Watercolour paints: Aureolin Yellow, Cobalt Blue,
Raw Sienna, Burnt Sienna

Mixing palette

Water

Mop or round brush

Preserving areas of white

It is often more effective to paint around an object, describing its shape as you go, than to mask
out large areas of a painting. This is known as 'negative painting.' It can produce a fresher, livelier
effect than applying masking fluid (see page 68), which is better suited to relatively small areas.

We read a lot about being 'spontaneous' with watercolour, and it's
true that the medium can be used for fast, expressive techniques.
However, it is also a medium that requires a little more planning
than, say, acrylics or oils. In watercolour, you don't get many
second chances and you can't cover up major mistakes; once
you've made a bold statement, you often have to live with it.

For paintings where a lot of white or light-coloured areas occur,
you need to do some forward thinking. I usually start my paintings
with a pencil outline. Make sure that your drawing is careful and
accurate; any areas that are left as white will be quite obvious, so
make sure they are in the right place. Try not to put in too many
details, as you don't want your painting to become a coloured
drawing as opposed to a painting. Just aim to pencil in the big
shapes and ensure that your proportions and perspective are right,
then do the rest with the brush.

After painting around any reserved areas, you will probably
want to paint a pale wash over some of them. Large patches of
pure white, exposing the paper surface, can look like holes in the
painting. In any subject, even in a painting depicting large white
flowers, there will be some darker shadowy tones over much of
the area. You can apply these after the surrounding wash has
completely dried.

You may find that the edges of the darker wash leave a very
hard edge where it meets the white. In a painting it is desirable to
have a balance of hard and soft edges. Decide for yourself which
edges need to be, perhaps, a little softer. You can then blur these
with a damp brush.

Negative versus positive shapes

Another reason for negative painting is that, with fiddly, detailed
subjects like flower petals or light-toned boat masts against a dark
background, or perhaps a white picket fence against some dark
bushes, it's easy to get too caught up in the detail and you can find
yourself getting the shapes or proportions wrong. It's sometimes
easier to get shapes right by looking at the empty space around
them — the 'negative shapes' — than to try to draw individual
elements such as branches or flower stems.

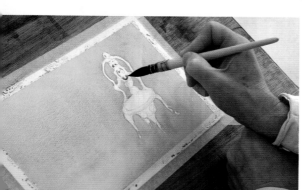

Making a 'mahl hand'
To avoid your brush hand smudging your painting,
rest your free hand on the board, outside the image
area, then rest your brush hand on it. (Oil painters
use a tool called a mahl stick to do this.)

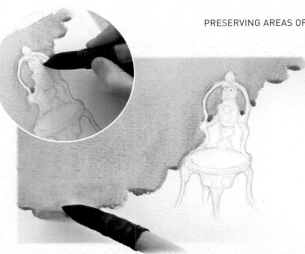

1 Using a 3B pencil, carefully draw the outline of the garden chair. The feet of the chair disappear into the grass. Dilute all your colours separately in the mixing palette.

2 Paint the background in Aureolin Yellow, picking up some Cobalt Blue and mixing it on the paper with the Aureolin as you go. Paint the negative shape around the chair. **Inset:** Carefully paint between the gaps in the back of the chair.

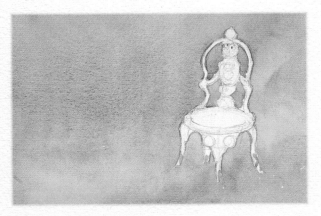

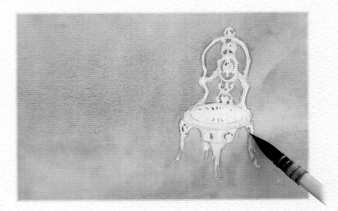

3 When you are about two-thirds of the way down the paper, add some Raw Sienna to warm up the foreground area. Allow this first wash to dry.

4 With a mix of Aureolin Yellow and Cobalt Blue, add some of the green background areas that can be seen through the gaps in the chair.

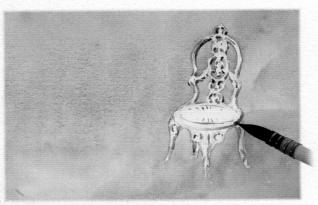

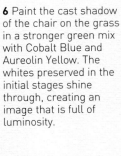

6 Paint the cast shadow of the chair on the grass in a stronger green mix with Cobalt Blue and Aureolin Yellow. The whites preserved in the initial stages shine through, creating an image that is full of luminosity.

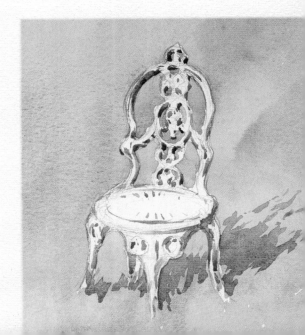

5 Mix Cobalt Blue with Burnt Sienna to make a blue-grey and paint the shadows on the chair back. Further down, the grass reflects warmer colours back into the shadows, so here, use a little Raw Sienna.

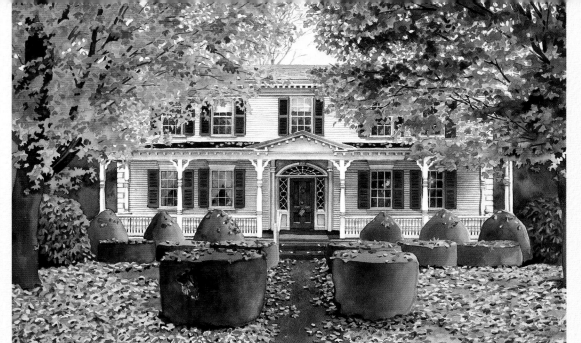

New England Carpet

MOIRA CLINCH

The layer-masking technique has been used to create a dense canopy of leaves for both the trees and the carpet of fallen leaves. Variegated yellow and orange washes were the basis for both trees, then the different ranges of orange, reds and greens were built up.

Layer masking

As well being used to preserve areas of white paper (see page 68), masking fluid can also be used to preserve areas of your colour washes. Building up a series of masked layers is a useful technique for adding detail without losing the character of the larger background washes.

Subjects that use the technique successfully include pebbly beaches, any dense foliage and patterns on fabric. It is generally easier if the subject's colours are harmonious or analogous (see page 32). However, you can use the technique with very different coloured details by painting these colour details first, masking over them and then building up background layers.

Start by planning what to mask. At each tonal stage, mask the positive areas and paint the negative areas. Work in the traditional way, from light to dark, painting either variegated or fading washes in a series of gradually darkening colours.

At each wash stage, let the paint dry, then mask out chosen areas, applying masking fluid with a small brush. Repeat the process, masking the shapes over different areas (some can overlap previous masked shapes, as this gives a more natural effect). The masks will gradually build up, reserving the different colours each time. The number of layers you apply is down to personal preference; you can use the technique over a whole area, to imply dense detail, or you can leave areas showing normal, loose washes.

Towards the end of the process your painting will be a bit of a mess! The last painted layer will generally be the shadow areas. Wait for this to dry, then remove all the mask layers, gently rubbing them away with your finger. Another method is to make a ball of old, dried-out masking fluid and use this to remove the old layers. The painting may need some adjustment. Make shadows deeper, tweak any shapes that don't work, such as flower heads that have masked slightly larger than you like, and paint any further details in the normal way of wet on dry (see page 62).

If, when you have removed the masks, you don't think there is enough detail, you can remask all the positive shapes as one area, then start the masking and painting process again.

MATERIALS

Pre-stretched watercolour paper on board

3B pencil

Old brush for applying masking fluid

Masking fluid

Watercolour paints: Aureolin Yellow, Sap Green, Light Red, Cobalt Blue, Alizarin Crimson, Ultramarine Blue

Mixing palette

Water

Round brush

Rigger brush

Masking tools

Masking fluid will damage your brush, so use an old brush, or you could use a wooden calligraphy pen, as this cleans easily.

1 Lightly draw the basic shapes. Wet the paper with clean water, then wash Aureolin Yellow over the whole area, leaving a vignetted area for where the white flowers will be. Use an old brush to paint masking fluid shapes to reserve the yellow and white flower heads. Leave to dry.

2 Lightly draw simple leaf shapes. Mask out the shapes. Leave to dry. Wet the whole are with clean water, allow to dry slightly, then with the round brush drop Sap Green over the grassy areas and Light Red onto the carpet of fallen leaves. Leave to dry.

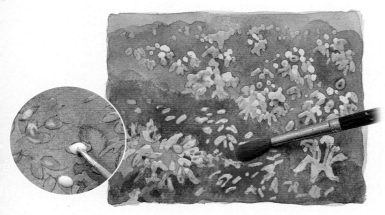

3 Mask out more leaf shapes and allow to dry (**inset**). Working wet in wet, drop a darker green mix of Sap Green and Cobalt Blue onto the plants, and a stronger mix of Alizarin Crimson and Light Red onto the ground. Let the paint dry.

4 Mask out more leaf shapes. **Inset:** Paint a darker green shadow wash under the plants by dropping in a variegated mix of Sap Green and Ultramarine Blue. On the ground, paint another stronger wash of Alizarin Crimson and Light Red.

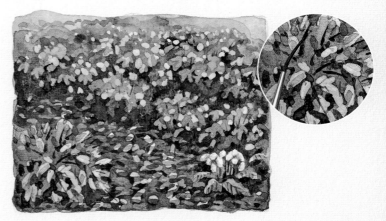

5 Finish this process of successive layers of masking and painting. Generally, four layers will give enough tonal variation. Leave to dry. Using a ball of dried-up masking fluid, carefully rub off the masks.

6 Adjust the final details. Add darker shadows using normal wet-on-dry technique, add form to some of the leaves and flower heads. **Inset:** Use a rigger brush to paint stems and twigs for the final details.

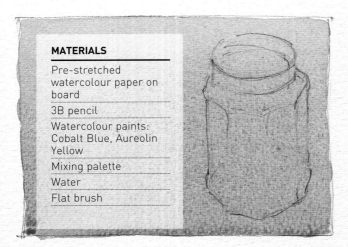

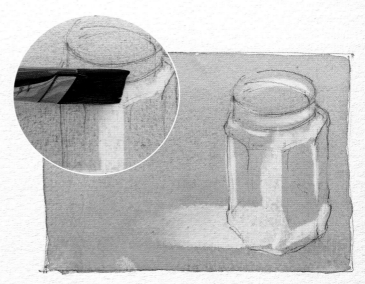

1 Begin by drawing the jar with a 3B pencil, taking care to get the ellipses right. Apply a flat wash of Cobalt Blue across the whole sheet.

2 Use a damp brush to lift off paint from the faceted edges of the jar, which catch the light, and also to the left of the jar, where light shines through the glass onto the surface on which it's standing. **Inset:** Use the edge of the brush to lift off fine lines of paint.

MATERIALS

Pre-stretched watercolour paper on board

3B pencil

Watercolour paints: Cobalt Blue, Aureolin Yellow

Mixing palette

Water

Flat brush

Lifting out

In watercolour the very lightest areas — such as highlights on glass, water or chrome — are best left as the white of the paper itself. It is not always practical to paint around these areas, or to use resists like masking fluid (see pages 68 and 74) to reserve them — but there is another method known as 'lifting out', which literally means lifting the paint from the paper surface.

Lifting out is best done while the wash is still wet, by slowly dragging a just-damp brush across the area from which you want to remove the paint. (The brush has to be damp, otherwise it will not absorb any paint.) Alternatively, you can use a clean, damp sponge or piece of paper towel, especially if you want to lift out, for example, soft-edged cloud shapes from a sky. For controlled shapes, though, the brush is best.

Some colours are known as 'staining' colours (see page 15); these are synthetic. Unlike pigments, which are colours suspended in liquid, synthetics are dyes and are completely dissolved. They soak into the paper quite readily, as opposed to forming a layer on the surface. Staining colours are more difficult to lift out. Most good-quality makes of paint state the individual properties on the side of the tube.

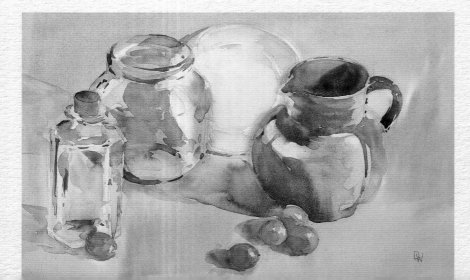

Still Life with Reflective Objects

DAVID WEBB

Many of the highlights in this painting were achieved using the lifting-out technique, particularly the large, curved highlight on the blue jug, which was taken out with a nylon flat brush.

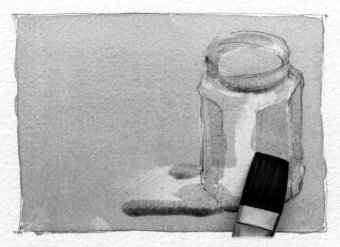

3 Allow the first wash to dry, then paint the faceted sides of the jar using a thin mix of Cobalt Blue and Aureolin Yellow. While it is still wet, remove some areas of green, leaving the highlighted edges white.

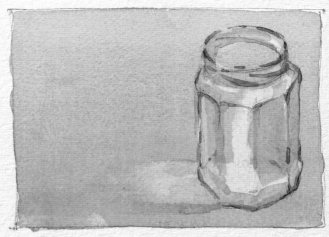

4 Once the second wash has dried, use a stronger mix of the green to paint some final darks on the edges and rim of the jar. The final result gives the illusion of a glass jar with sparkling highlights.

5 For very small areas, a knife can be used to scrape paint back to the paper surface. This requires practice, though, as it is all too easy to ruin a perfectly good painting in this way. Make sure that you use a very sharp blade.

Lifting out with a flat brush

A nylon flat is a very useful brush for lifting out. Once damp, its fibres readily soak up paint and water from the paper surface. The shape of the brush is important, too. If I want to remove a wide area of colour then I use the whole width of the brush. If I want to lift out a narrow strip of paint, I can use just the edge; by moving it sideways, I can take out a thin line of colour.

You can modify too-bright lifted-out areas by adding a glaze.

Main highlight

Modified highlight with glaze

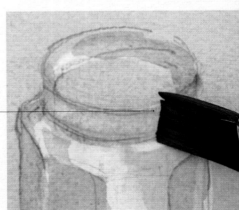

Achieving whites in context

In all of these paintings, the whiteness of the paper plays an important role in establishing tones through transparent washes, and in creating bright highlights, misty effects, backlit features and important compositional shapes.

Blowing Snow

DEB WATSON

The soft, white areas in this snow scene have been achieved by lifting out. The snow lying on the ground was built up in washes, leaving the highlights as untouched paper.

Cactus on a Hot Tin Roof

RIC DENTINGER

The needles of this cactus plant glow brightly against the shady background, as do the thin gossamer threads. Such details are much easier to achieve with masking fluid.

Whiskey Island

DOUGLAS HUNT

This lake scene consists of a range of muted tones. Only a very thin sliver of white appears where the mountain meets the water, yet the comparative brightness of this area draws the eye.

Yacht Tales

CARL PURCELL

The artist began by drawing the shapes in this boatyard scene. Contrasting shapes of light and dark have been used to great effect, with many areas being left as white paper.

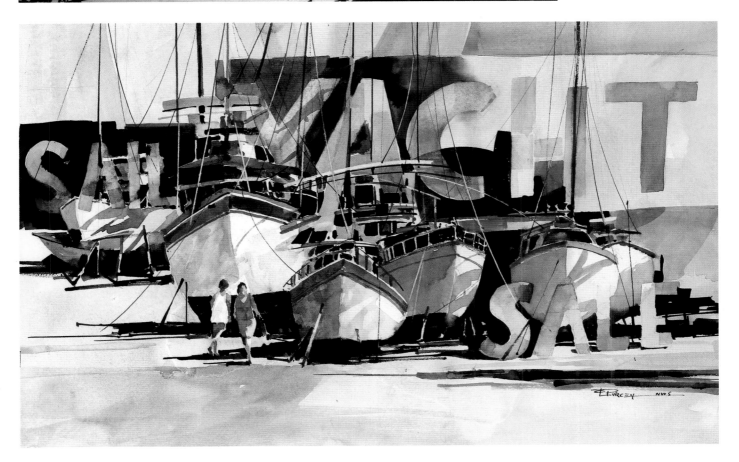

Salzburg Trees in Hellbrunn

BERNHARD VOGEL

The spatter technique can be unpredictable, so it should be used with care. The artist has used just enough in this woodland scene to add texture and interest to certain areas.

Spattering

Areas of flat colour, particularly in the foreground of a painting, can look very bland. You can enliven them by adding textural effects such as spattering.

Spattering involves flicking pigment from the bristles of a brush onto the paper surface. It can be a very unpredictable method of applying paint and, as its use is often confined to the final stages of a painting, it can be all too easy to ruin a perfectly acceptable piece right at the very end. It is well worth practising the technique many times before applying it to a work in progress. The effectiveness will depend on how thick the paint is; too thick and it will stick to the bristles. The distance between the brush and the paper surface also has a bearing on the end result. It is, however, a technique that needs to be used with restraint.

It is a good idea to have a selection of brushes that you use just for spattering, as the size of the droplets may differ with each brush used.

As the method is quite random, you will need to mask off any areas that do not require the spattered effect with paper masks, cut or torn to shape.

Spattering can be used on foreground areas such as sandy beaches to indicate small stones. It can also be used to simulate foliage areas, as the droplets will be of differing shapes and sizes.

You can also use the spattering effect with masking fluid, instead of paint. If you're painting a beach, for example, you could spatter the foreground with masking fluid and, once dry, apply a sandy-coloured wash over the top. When you remove the masking fluid you will see small, white speckled areas, suggestive of small white pebbles against a darker background. You could then spatter watercolour paint over the same area, creating the effect of darker speckles against the lighter area of the beach. The technique can also be used to represent light sparkling on water. Paint over the random masking fluid droplets with a blue or green wash and then, once the wash is dry, remove the masking fluid to leave behind the unpainted, sparkling highlights.

Protecting your work

To protect areas where you do not require spattering, mask them off with tape, card or paper.

MATERIALS

Pre-stretched watercolour paper on board

3B pencil

Watercolour paints: Alizarin Crimson, Cobalt Blue, Aureolin Yellow, Burnt Sienna

Mixing palette

Water

Mop or round brush

Rigger brush (optional)

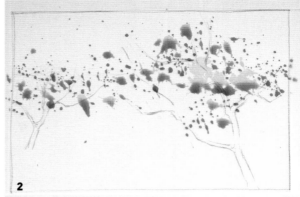

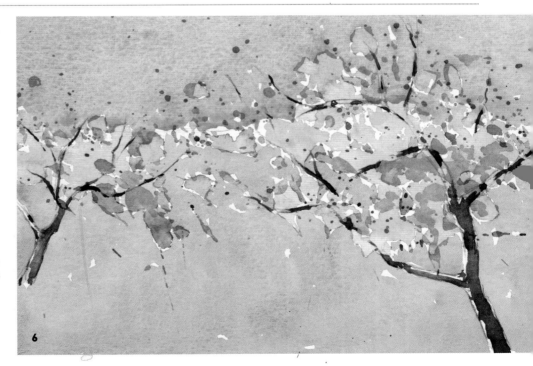

1 Lightly draw your subject. Load your brush with Alizarin Crimson and hold the brush over the area of the trees. Tap the brush on a finger of your free hand, holding it 5 cm (2 in.) or so above the paper surface.

2 Carry on with this technique across the area that will represent blossom, holding the brush closer or further away and tapping harder from time to time. Let dry.

3 Add a little Cobalt Blue to the Alizarin Crimson and create some darker, purple spatters on top of the previous layer. Let dry.

4 Using Cobalt Blue, paint a wash from the top of the paper to the tree tops to represent the sky, leaving a few white gaps around the blossom area to add a little sparkle.

5 Mix a fresh green from Aureolin Yellow and Cobalt Blue. Paint the grassy area around the blossom and down to the bottom of the paper. Allow the painting to dry.

6 Add Cobalt Blue to Burnt Sienna to make a dark brown. Use this mix to paint the tree trunks and branches. You could use a rigger for the finer twigs.

Salt

Adding salt crystals to a wet wash produces a very distinctive texture that can be used on subjects such as old stone walls, ancient buildings, lichen-encrusted rocks and areas of foliage.

This technique simply involves sprinkling salt crystals onto a wet wash and waiting for the salt to absorb the paint, which can take some time. Once the wash has dried, just brush away the salt to reveal the effect. The salt soaks up the paint directly underneath each crystal and in the surrounding area, producing a mark that resembles a snowflake.

Table-salt marks have a small, tight appearance, owing to the grain size. For a more textured effect, rock salt is better, as the crystals are larger and will produce a more granular look. Like many of these watercolour effects, trial and error will show you how to get the best results. Any kind of water can be used to create the effect, though some artists believe that boiled tap water results in a more dramatic crystallization effect.

Tourists on Miyajima Beach

LAUREL COVINGTON VOGL

The salt technique has been used to great effect here, to add texture to the beach area while the paint was still wet. The figures were painted on top of this once it had dried.

1 Draw an outline of the basic rock shapes, with some indication of the water flow over them. Make separate dilutions of your colours. Mix various amounts of Aureolin Yellow, Ultramarine Blue and Burnt Sienna on the paper to create the background colour of the rocks. While this is still wet, sprinkle on some rock-salt grains.

2 In this picture you can see that the grains readily absorb the paint. When you've finished, allow this to dry.

3 Using your finger, gently rub the salt granules away from the paper surface to reveal the distinctive textured marks that are unique to this technique.

4 Mix a blue-grey from Ultramarine Blue and Burnt Sienna, and use this to indicate the water flow. When dry, strengthen the tone with Alizarin Crimson and paint the darker shadows on the water and rocks. The salt technique produces a distinctive textured look, which can represent lichens and weathering on the rocks.

MATERIALS

Pre-stretched watercolour paper on board

3B pencil

Watercolour paints: Aureolin Yellow, Ultramarine Blue, Burnt Sienna, Alizarin Crimson

Mixing palette

Boiled tap water

Mop or round brush with fine point

Rock salt

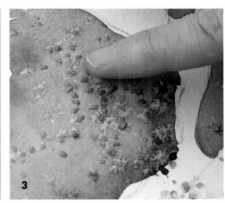

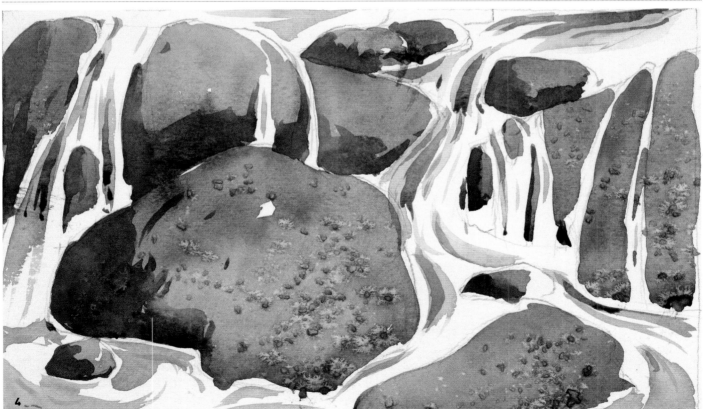

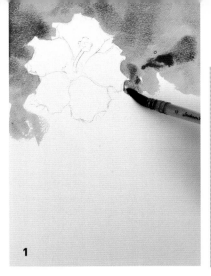
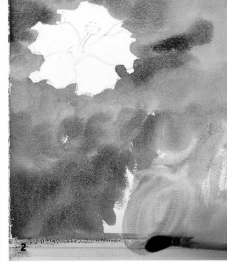

MATERIALS

Pre-stretched watercolour
paper on board

3B pencil

Watercolour paints: Aureolin
Yellow, Cobalt Blue, Alizarin
Crimson

Mixing palette

Water

Mop or round brush with fine
point

Plastic pipette

Backruns

Backruns or blooms, also known as
cauliflowers owing to their distinctive mark,
are often caused by accident. They tend to
appear where you least want them and are
usually difficult to remove. However, they can
also be used creatively.

Backruns occur when a brush loaded with wet colour is
applied to a wash that is almost dry. The water pushes
back the paint that is nearly dry, creating an uneven fringe.
The area where the brush was placed spreads outwards
like a ripple, with the interior shape being lighter than the
surrounding area.

The technique can be employed to create cloud shapes,
texture in areas of foliage or a foundation wash over which
other shapes can be painted once the first wash has dried.

Besides using a brush loaded with watercolour paint,
you can create similar effects by simply dropping clean
water onto a dampened wash. On hitting the paper surface,
the drops will expand outwards. By dripping the water in
tight clusters, the patterns will spread outwardsu and into
each other, creating exciting effects.

1 Carefully draw the outline
of the flower. Dip the brush
in Aureolin Yellow and, with
the board at an angle, paint
down from the top of the
paper up to the edge of the
flower. While the painting is
still wet, reload the brush
with Cobalt Blue and drop it
into the Aureolin, allowing
the colours to merge wet
into wet.

2 Continue to the bottom of
the paper, leaving the flower
shape untouched. In the
bottom left, add Alizarin
Crimson to darken the wash.

3 Drop water onto the just-
damp paper from a pipette
or the tip of your brush: the
water droplets push aside
the wash to reveal
characteristic backruns.

4 Wet the flower area and
add some Alizarin Crimson.
Manipulate the paint around
the flower shape, varying the
strength so that you have
pale and strong areas of
colour. Let dry.

5 Add further washes, wet on
dry, to create more definite
shapes. Paint the leaves. Use
stronger mixes of Alizarin
Crimson with a little Cobalt
Blue to create the veins in
the flower and the darker
centre. The backruns add
interest and texture without
detracting from the main
subject.

Backruns

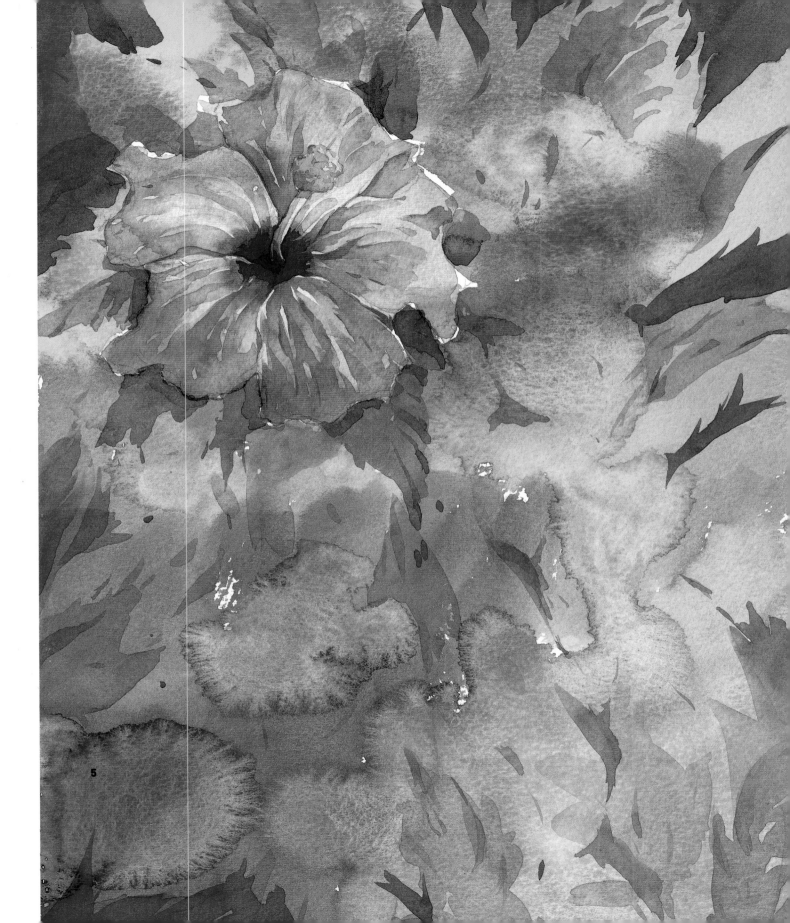

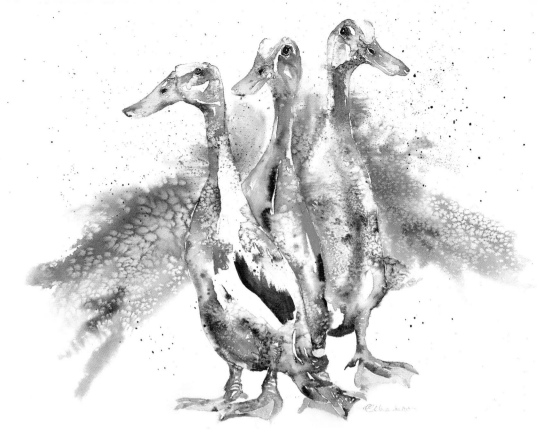

The Three Degrees

LIZ CHADERTON

There are passages of wet into wet on the ducks themselves and in the background, where salt technique has also been used extensively. Spattering has also been used to add further texture.

Texture in context

A variety of techniques have been employed by these artists to represent texture in these paintings. Spatter, salt, masking fluid and gouache (see page 94) can all be used to create both subtle and striking textural effects.

Saxy Leroy

JOS ANTENS

In this lively painting of the musician, spattering has been used to enhance an atmosphere of liveliness and energy. The artist was careful to first mask out the area of the face. Backruns enliven the background.

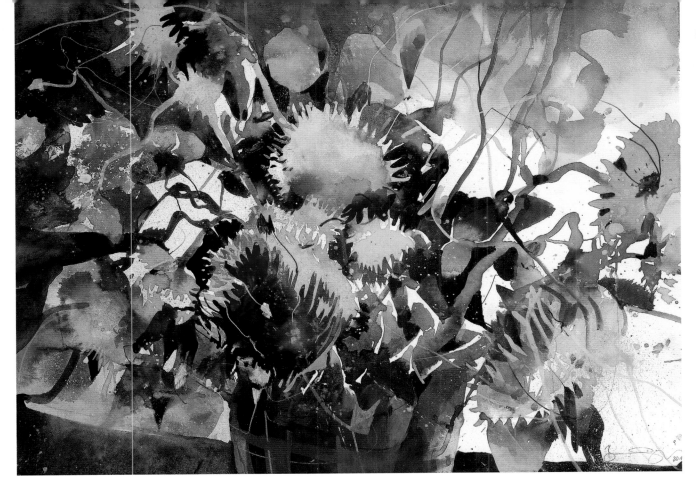

Sunflowers in Blue Jar

BERNHARD VOGEL

This loosely painted floral still life includes areas of spattering. Used with restraint, the technique can be employed to add texture and bring a little liveliness to otherwise quiet areas of a painting.

Sparkling Water in the Moorland Channel

PAUL TALBOT-GREAVES

Texture has been added to the grass areas by spattering with opaque white paint. Spattered highlights have also been added to represent sparkle on the surface of the stream.

Line & wash

Line and wash allows you to combine the precise detail of pen-and-ink work with the fluidity and spontaneity of watercolour washes.

Using line and wash techniques is a great way of suggesting the subject with just a few well-chosen lines. You can also use these methods for more delicate, finer work such as flowers and natural history subjects.

Line and wash is particularly suited to sketchbooks and journal making. As it requires just a handful of watercolours and brushes, a pad and a pen, you can easily carry everything you need with you. For pen work a smooth surface is preferable, so hot-pressed and NOT surfaces are best, as the pen glides over the surface much more easily than on rough papers.

Traditionally, artists used dip pens and Indian ink for this type of work, but there are many more types of pen available now, including fibre-tipped pens with various sized nibs, which are ideal for an artist on the move.

There are two methods of approaching line and wash: you can apply paint to the paper first, then draw with the pen once the paint has dried; alternatively, you can start with a pen drawing and then apply watercolour over the top. There isn't really a right or wrong way, but each method has a bearing on the final result.

One thing to watch out for is that the pen or ink you are using is actually waterproof. On modern fibre-tipped pens this is usually stated on the barrel. However, it is worth testing your pen on a scrap of paper and then brushing over it with a wash. If the ink isn't waterproof, it's better to find out before you apply a wash to your precious drawing.

1

2

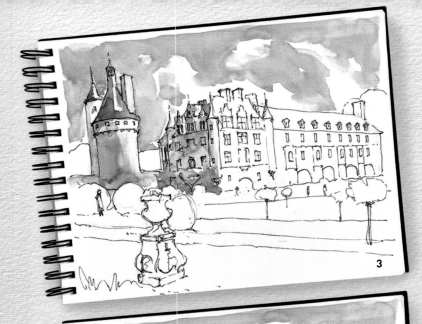

Line work with wash over

Drawing the outline first tends to lead to a tighter, more controlled finished result, which may be suited to more illustrative styles. The danger is that the drawing may become too tight, in which case painting becomes merely a 'painting-by-numbers' exercise.

1 Make a pencil sketch of your subject. (This is only an underdrawing and need not be very detailed.) If you are confident in your drawing skills, you could draw directly with the pen.

2 Create an outline in pen, using your drawing as a guide. Don't feel that you have to follow each line rigidly — it's important to maintain a looseness in your line work, for a lively feel. The amount of detail you put in the pen work is down to personal taste, but less pen work usually works best when a wash is also being used.

3 Once the ink has dried, add colour washes to the drawing. A loose approach works best; don't feel that you have to stay within the boundaries of the lines, as if in a colouring book.

4 Apply your washes, working from the top of the page downwards. Take note of the direction of the light and add shadows where necessary.

5 Finally, add any remaining details with a small brush. Be careful not to overwork the painting, though — the final result should have a loose, sketchy feel.

MATERIALS

Spiral-bound watercolour sketchpad

Waterproof sketching pen

2B pencil

Watercolour paints: Ultramarine Blue, Light Red, Burnt Sienna, Raw Sienna, Aureolin Yellow

Mixing palette

Water

Large mop brush

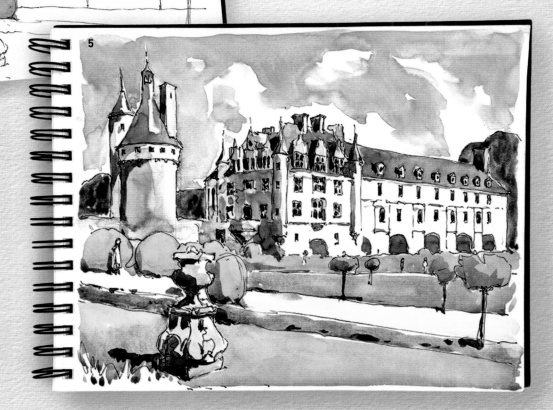

Wash followed by line work

A popular line-and-wash method is to paint a loose watercolour wash and then freely apply the pen work, which produces a lively, loose result.

MATERIALS

Spiral-bound watercolour sketchpad

2B pencil

Watercolour paints: Ultramarine Blue, Burnt Sienna, Raw Sienna, Aureolin Yellow, Alizarin Crimson, Vermilion

Mixing palette

Water

Large mop brush

Waterproof sketching pen

1 Apply a loose wet-into-wet wash before doing any pen work (see page 60). Use lots of water in your washes and, most important of all, avoid any attempt at detail. The softer the outline, the better. Mix colours on the paper (see page 44), starting with the background, then loosely paint the forms of the birds. Don't worry about colours merging. You should end up with soft edges at this stage.

2 Once the initial wash has dried, begin to paint the darker forms within the birds' shapes, creating harder edges where there are contrasts of tonal values. For example, the dark green tail of the furthest bird contrasts with the lighter head of the foreground bird. Once dry, add a few shadows, such as the undersides of the birds and their cast shadow on the ground.

3 With your pen, sharpen up your underpainting with some lines and shading, but be careful to avoid overworking. The pen work should complement the free approach used in the underpainting. Restrict any shading with the pen to the darker parts of the painting. Avoid putting a line completely around the edge of objects.

1

2

Non-waterproof ink

Although you usually want the pen lines to remain crisp in a line-and-wash painting, you can get some interesting results by using a non-waterproof ink, brushing over the lines with clean water and allowing the lines to blur and spread. In areas where there is more ink, the concentration will be stronger and the tone will be darker. Lighter tones can be suggested by using more water to dilute the ink on the paper.

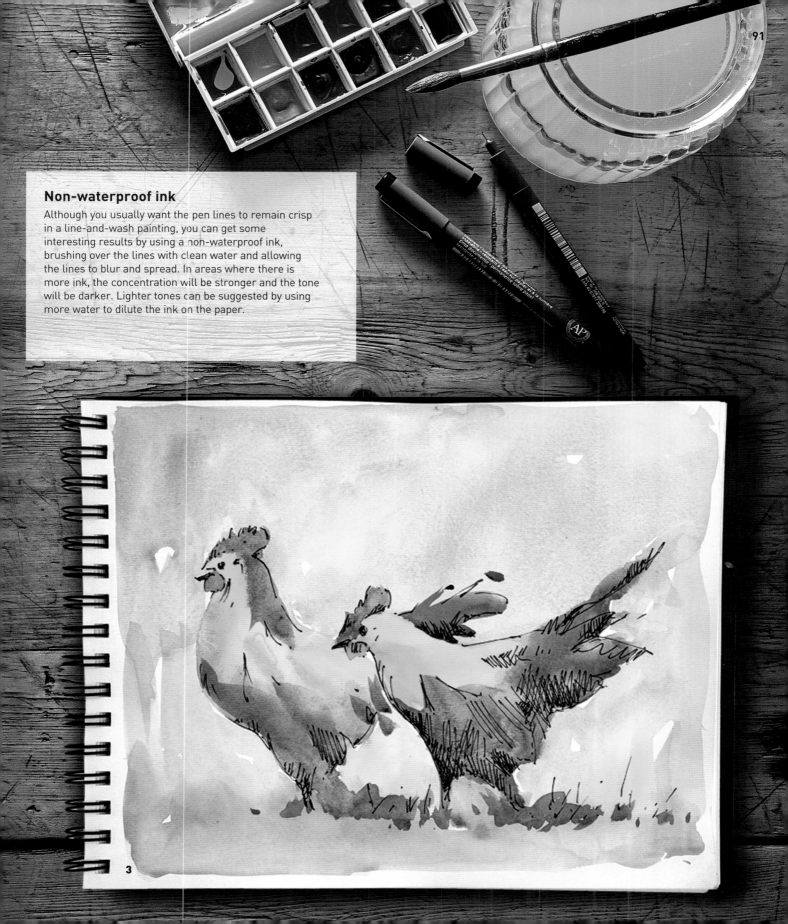

Behind You

JULIA CASSELS

With perhaps just a few moments to make a sketch before the subject moved away, the artist has managed to capture the character of the monkey in a loose wash held together by a few lines in ink.

▶ *Lucca, Italy No.3*

TONY BELOBRAJDIC

This unusual aerial view of the town was achieved with just a few washes of colour. The pen work adds just enough detail to hold the drawing together.

Line & wash in context

Line and wash has been used to create loose, lively studies in this gallery of paintings. Like handwriting, practitioners of line and wash tend to develop a very individual and unique style.

119

Belair

LAPIN

These line-and-wash sketchbook studies of a classic car show enough detail to satisfy any enthusiast, yet still project a lot of character for a non-living subject.

Market, Pune City, India

SACHIN NAIK

The artist has applied pen work to this fluid watercolour study of buildings, in various washes of reds and browns, with a light touch. Small areas of white paper add sparkle to the painting.

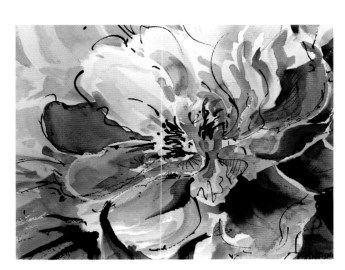

Up Close with Peony

DHANASHRI BAPAT

This loose, splashy, close-up floral study shows a lightness of touch with the watercolour medium. The shape of the flower is reinforced with just a few ink lines of varying thickness.

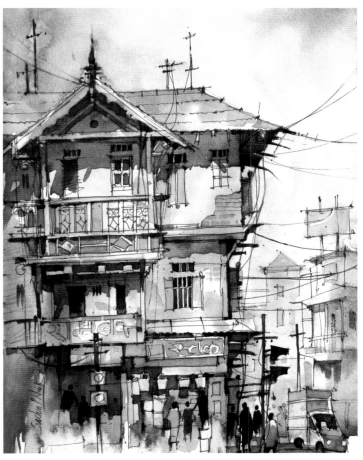

Thick gouache

Gouache is useful for placing light on dark and can either be white or coloured. It can be painted on directly or mixed to a creamy consistency and spattered on top of a painting.

Gouache is much the same as watercolour, except that it contains a greater amount of pigment and this makes the paint opaque. Using gouache as part of a painting technique allows you to apply light on top of dark. I often use it for missed highlights or awkward shapes that are difficult to paint around in a traditional watercolour manner. It's great for creating texture effects, too. To keep the paint opaque, mix it with only a tiny amount of water — just enough to make the paint workable. For small highlights in a painting, it can be used neat from the tube.

MATERIALS

Pre-stretched watercolour paper on board

4B pencil

Mixing palette

Water

Brushes: Large and small mop, no. 8 round

Watercolour paints: Cobalt Blue, Burnt Sienna, Alizarin Crimson, Neutral Tint, Cobalt Turquoise, Hooker's Green, Lemon Yellow, Quinacridone Magenta

Gouache paints: Permanent White

Paper towel

Apply the lightest green first.

Add the dark shapes while the previous wash is still wet.

1 Draw out the windows and rough shape of the tree. Dampen the paper with a large mop brush. Working light to dark, apply a weak wash of Cobalt Blue and Burnt Sienna in some areas of the building. Paint the roof with Cobalt Blue, Alizarin Crimson and Neutral Tint, and the windows in Cobalt Turquoise. Paint the tree with a small mop brush, using Hooker's Green and Lemon Yellow for the brighter parts. Add Burnt Sienna for variety and Neutral Tint mixed with Hooker's Green for the shaded tree areas.

Consistency
Add just a tiny amount of water to the paint to make a thick gouache that is the consistency of yogurt.

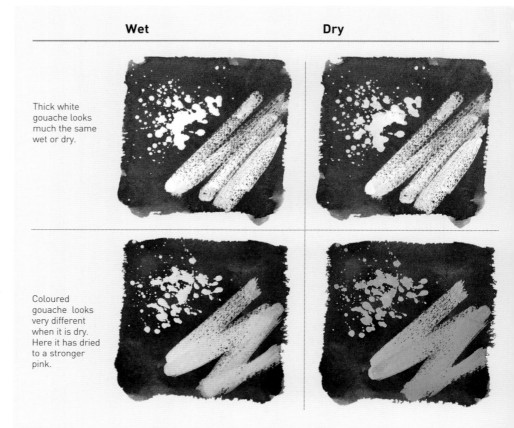

Wet	Dry

Thick white gouache looks much the same wet or dry.

Coloured gouache looks very different when it is dry. Here it has dried to a stronger pink.

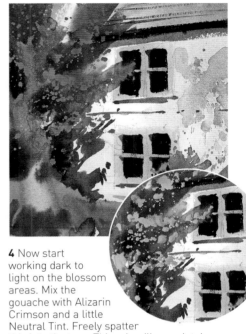

2 Paint the shadows on the wall, under the windows and eaves of the roof using Cobalt Blue, Alizarin Crimson and Neutral Tint. Make a darker mix with extra neutral tint and paint the dark interiors of the windows. **Inset:** Spatter the walls with slightly stronger Cobalt Blue and Burnt Sienna watercolour.

3 Mix Permanent White gouache with Cobalt Turquoise to a thick, yogurt-like consistency and paint the bars of the windows. Using thick paint to create drag brushmarks in the window bars often looks better than carefully painted shapes.

4 Now start working dark to light on the blossom areas. Mix the gouache with Alizarin Crimson and a little Neutral Tint. Freely spatter this into the tree. This mix will completely block out the green tree behind (the essential difference to working just with watercolour paints). **Inset:** The colour may change sightly as it dries. Here it has dried to stronger pink hue.

While you are spattering colour, occasionally spatter a little water, too. This will soften and blend some of the shapes.

Fully load the brush and give short, sharp taps to release paint spatter.

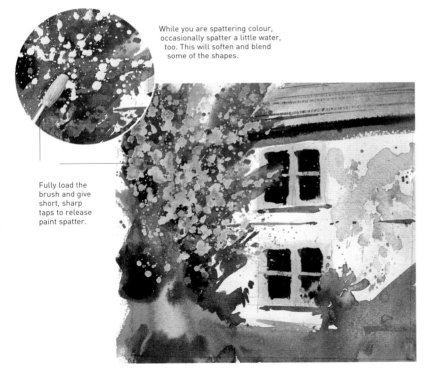

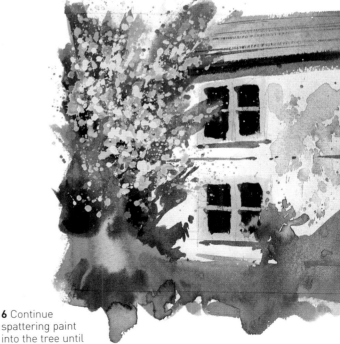

5 Mix Permanent White gouache with Quinacridone Magenta watercolour to a yogurt-like consistency and spatter this over the tree using a no. 8 round brush. Allow to dry.

6 Continue spattering paint into the tree until you are happy with the effect. You may wish to protect the surrounding painting with some paper towels.

Thinned gouache

Gouache can be used thin as well as thick (see page 94). When it is thinned with water, you achieve a semi-opaque colour that works well for textures or subtle highlights.

Gouache retains a certain level of opacity that alters with the amount of dilution. One of the difficulties of using it thinned is that it looks like solid opaque colour when applied, but almost disappears when dry. Practise using thinned gouache and familiarize yourself with how the colour alters when the paint dries.

MATERIALS

Pre-stretched watercolour paper on board
4B pencil
Mixing palette
Water
Brushes: Large and small mop, no. 4 round
Watercolour paints: Yellow Ochre, Winsor Violet, Cerulean Blue, Burnt Sienna, Cadmium Orange, Neutral Tint
Gouache: Permanent White
Paper towel

Consistency
Mix gouache with water to the consistency of milk.

Changes in opacity

Thinned gouache looks different depending on whether it is wet or dry.

Wet

When gouache is diluted with water, it still looks opaque while wet.

Dry

As the gouache dries, it changes to a thin film of colour and the background may show through.

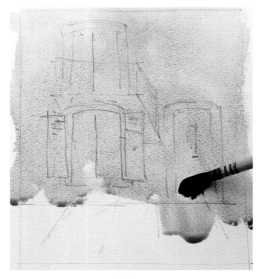

1 Using a large mop brush, freely apply a light wash of Yellow Ochre, Winsor Violet and Cerulean Blue, allowing the colours to mix on the paper. In the door and left-hand window, add Burnt Sienna and Cadmium Orange.

Try to keep the wetness of the colours even. If it helps, you can pre-wet the paper. Use a spray bottle to target the area, as you can more easily dampen the painting without disturbing the colours you have already laid down.

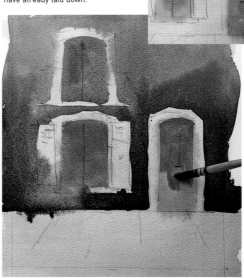

2 Dampen the top window shape and the bottom left of the lower window. Paint the wall in Burnt Sienna and Winsor Violet, gradually adding Neutral Tint and making it slightly stronger lower down. Paint the doors and windows in Cadmium Orange and Burnt Sienna. Using the smaller mop brush for better control, add the shadows within using a thicker mixture of Burnt Sienna, Winsor Violet and Neutral Tint.

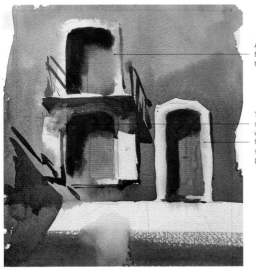

Allow the shapes to fuse slightly. You can tighten them up later.

The windows are to be slightly soft edged whereas the door is hard edged, giving it slightly more prominence.

3 Dampen the top window and then reshape the window and door shadows with Burnt Sienna, Winsor Violet and Neutral Tint. Mix Burnt Sienna, Cerulean Blue and Neutral Tint and apply the shadows cast from the balcony and across the foreground.

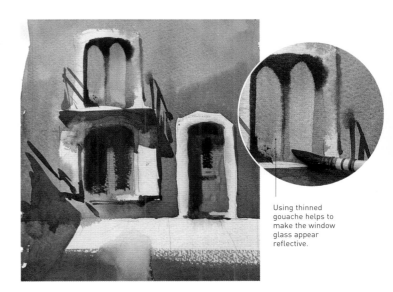

Using thinned gouache helps to make the window glass appear reflective.

4 Moisten the top and bottom windows. Mix Cerulean Blue with Permanent White gouache and add the glass of the top window using a small mop brush. Then use Neutral Tint and Yellow Ochre for the bottom window and Neutral Tint for the door glass.

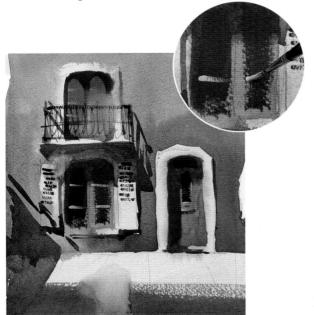

5 Paint the balcony, shutter slats and the pavement marks with a no. 4 round brush. **Inset:** Make a thick mix of Burnt Sienna with Permanent White gouache and paint the window bars and highlights on the door.

6 Finally, dilute Permanent White gouache and spatter it over parts of the wall to create a texture effect. You may want to protect the painting with paper towels.

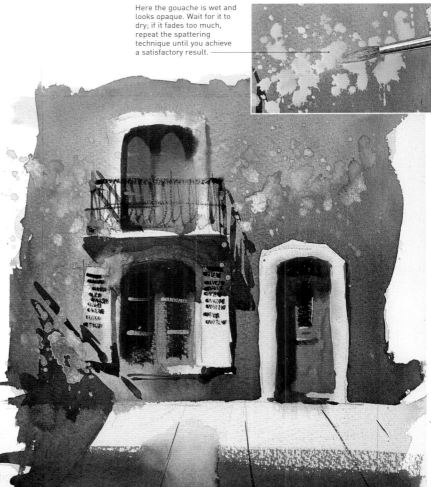

Here the gouache is wet and looks opaque. Wait for it to dry; if it fades too much, repeat the spattering technique until you achieve a satisfactory result.

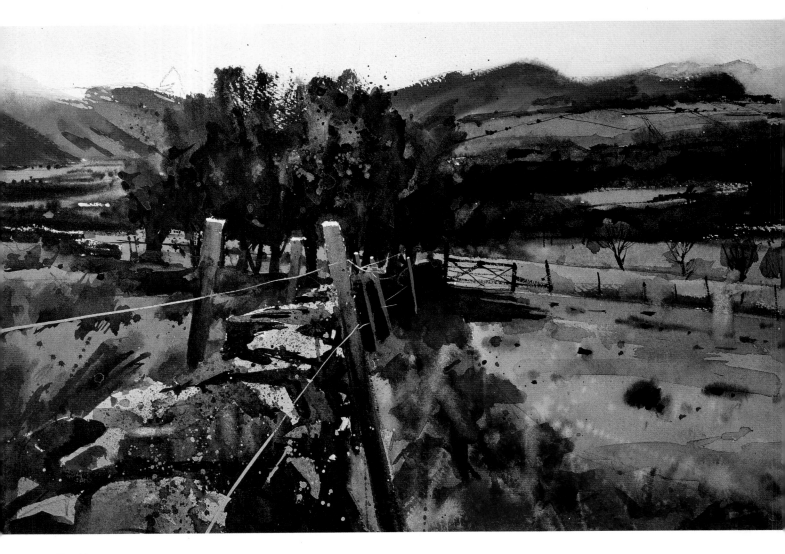

Tree Lines

PAUL TALBOT-GREAVES

Opaque gouache has been used here to add fine details during the last steps of this painting. Texture has been added to the rocks by spattering. Gouache has also been used to add the fine lines of the wire fence.

Gouache
in context

Gouache can be used as a medium in its own right, but can also be used in conjunction with watercolour, as the examples on these two pages show.

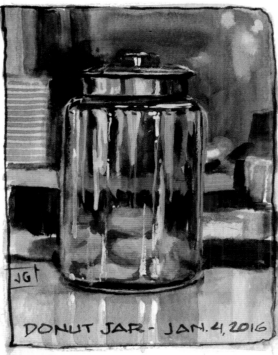

Donut Jar

JAMES GURNEY

In this watercolour painting of a glass jar containing doughuts, gouache has been used to depict the highlights in the reflective surface of the jar, which greatly helps in achieving the illusion of a shiny, transparent, curved object.

Osnabrück, Rainy Day

BERNHARD VOGEL

In this moody street scene, the atmosphere has been enhanced by the addition of swift gouache brushstrokes to represent streaks of rain.

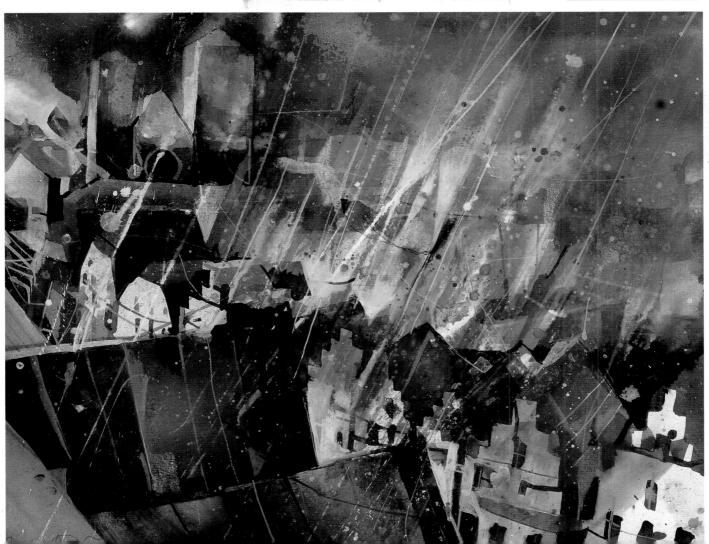

Ways of working

There are two main methods of approach in watercolour: the multiple-wash method, where you build up the painting in a series of layers or washes; and the direct method, in which each part of the painting is pitched at the finished tone.

MATERIALS

Pre-stretched watercolour paper on board

3B pencil

Masking fluid

Old brush for applying masking fluid

Watercolour paints: Burnt Sienna, Raw Sienna, Cobalt Blue, Alizarin Crimson, Aureolin Yellow

Mixing palette

Water

Mop or round brush with fine point

Multiple-wash method
1 Begin with a soft pencil outline of the main shapes, then mask any areas that need to be reserved. Wet the surface of the paper and, working wet into wet, mix Burnt Sienna, Raw Sienna, Cobalt Blue and Alizarin Crimson on the paper, to depict the approximate shapes of your subject. Allow to dry. Remove any masking fluid.

2 On dry paper, begin building up the mid-tone washes. Mix the original colours on the paper, plus Aureolin Yellow for the foliage, creating a few hard edges — particularly where there are changes of contrast. At this stage try to avoid detail; instead, concentrate mainly on painting large areas.

Direct method
1 Begin with a soft pencil outline of the main shapes, then paint the wall using combinations of Burnt Sienna, Raw Sienna and Alizarin Crimson. These colours should be mixed on the dry paper. Paint only up to the edges of features such as the alcove, shutters and foliage.

2 Paint the interiors of the alcove and window, using combinations of Cobalt Blue, Burnt Sienna and Alizarin Crimson. Leave a thin gap between washes to prevent the colours from running into each other. Try to achieve the correct final tone.

The multiple-wash method

Using this method, you work from light to dark by putting down your lightest washes first, reserving any highlights by either painting around them or using some kind of resist (see page 68). The first, and lightest, wash is very loose and soft. It does not matter if colours bleed into each other, as this is merely a foundation wash for the lightest tones.

Once this has dried, the next step is the middle tones; here I aim to paint large shapes. Some edges will be sharp and some will be allowed to join together, establishing the main forms and masses. Each time you apply a wash, think about what needs to be covered and which parts need to be avoided.

Finally, put in the darkest areas, including any small details. This final wash means that, in some areas, the painting will be three layers deep, yet it should still show clean, transparent colours.

The direct method

The direct method of painting differs from the multiple-wash method in several ways. Multiple layers of washes are not used. Instead, colour is applied directly to dry paper at the correct, final tonal value. The image is built up by painting very definite, interlocking, almost jigsaw-like shapes to create a whole finished image.

You do not need to paint the lightest tonal values first: you can just as easily begin with the darks, since each shape will be laid down only once.

The direct method is faster, as you don't have to wait for washes to dry before applying the next. This makes it well suited to painting in damp conditions, when the multiple-wash method would not be practical.

3 Now begin to paint your darkest tones, particularly the shadows, using stronger dilutions. Continue to mix colours on the paper where you can. However, if you need a specific colour, mix the correct colours in your palette.

4 Add any remaining darks and small details, but take care not to overwork. The finished result should be fresh and full of atmosphere, with tones ranging from the very lightest lights to deep, but transparent, darks.

3 Mix Aureolin Yellow and Cobalt Blue on the paper, to create the varied green of the foliage. Again leaving a thin gap between the washes, paint the shutters using Raw Sienna plus Cobalt Blue. Leave thin areas of untouched paper for the highlights.

4 Use wet-into-wet blends of Burnt Sienna, Cobalt Blue and Alizarin Crimson for the deep cast shadows on the wall. Use a darker mix for the shapes on the window itself.

Chapter

3

Making Pictures

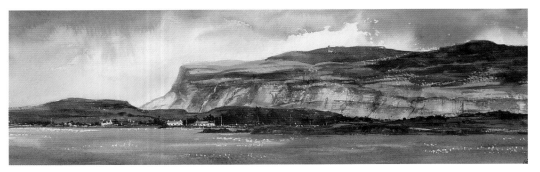

Viewpoint & format

So you've chosen a subject for your painting. Before you pick up a brush, however, there are two important decisions that you need to make: where you're going to position yourself in relation to your subject (your viewpoint) and what shape your painting is going to be (the format).

Viewpoint

Whenever I find a subject I want to paint, I always pause for a moment and ask myself whether changing my position by moving just slightly to the left or right or, if the situation allows, up or down, might improve things. By doing this, other features may suddenly come into view. Relationships between features may change for the better or, perhaps a new vista may open up when you are able to see around a rock or a building.

Subjects containing buildings, bridges or other structures can often be improved by moving slightly. Face-on views of buildings, where only one side is visible, do not always make the most interesting subjects: a three-quarters view where another wall, or part of a wall, can also be seen, makes a much more pleasing composition, even if it does mean extra care at the drawing stage!

This also applies in still-life painting. Sometimes it takes just a slight movement of the head to completely change the way in which objects are lined up. Moving to a position that allows you to include some background features, such as a window or mirror, can transform the composition.

And you don't always have to view your subject from your natural eye level. In a city environment, you could emphasise the height of skyscrapers and create a really dramatic image by adopting a view looking upwards; the same idea could apply to paintings containing tall trees. Or in a still-life set-up, you could try viewing your subject from directly overhead. This kind of view is a break from the norm, and can present quite dramatic compositional ideas, especially when used in conjunction with creative lighting. For example, tall pots or jars can be viewed from above, casting long shadows to indicate their height. So before you begin painting, always take the time to explore your subject from different angles.

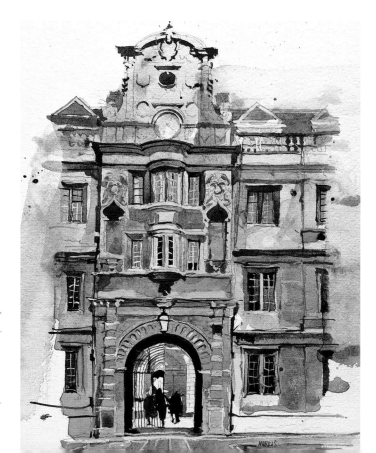

Trinity Hall Courtyard

DAVID MORRIS

This view is quite tightly focused on the tall façade of the elegant building, and is well suited to the portrait format where the main centre of interest is a strong vertical. Putting this slightly off centre has enlivened the face-on view.

Looking Up at Autumn Leaves

DAVID LOBENBERG

The low viewpoint chosen for this painting gives us a sense of the height of the trees, as we follow the trunks leading us up to the leaf canopy and sky above.

Format

The next decision you have to make before putting brush to paper is the format, or shape, of your painting. You have three main choices: landscape, which means that your longest edge will be the horizontal one; portrait, where your longest edge will be the vertical; or square. There is also the so-called 'letterbox' format — a long, thin format that can be either horizontal or vertical.

With some subjects, the correct orientation may be obvious. For example, long beaches with lots of sky are usually best suited to the landscape format, but when you want to portray height in a scene, such as a woodland setting with tall trees or a cityscape with skyscrapers, the portrait shape is usually best. The square format can be useful when you have a combination of tall, vertical features and long, horizontal ones, and is often chosen to suggest a mood of calmness. Round subjects such as close-ups of flower heads or still-life objects, can work well in a square format.

The letterbox format is particularly useful for panoramic scenes. Some still-life or figure-painting subjects may also be suited to this, especially if you have an arrangement of subjects in a line. One classic example is Da Vinci's *The Last Supper*. Turn the letterbox format on its side, so that the shortest sides are now at the bottom and top, and you have a format for creating very dramatic views of subjects with vertical features.

Playing with Shadows and Light

HANNIE RIEUWERTS

This unusual viewpoint is most effective as we look down to the floor, two-thirds of the painting being dominated by the cast shadows of legs and feet.

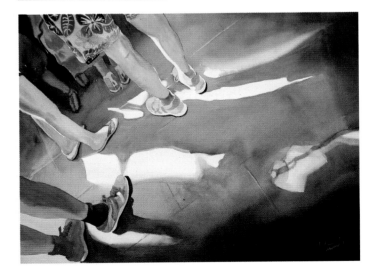

Troubleshooting: Which format works best?

If you can't decide on the best format, draw a landscape, portrait and square shape in your sketchbook, then do a very simple pen sketch of the main features of your subject in each of the boxes. Having all three options in front of you makes it much easier to make a decision.

Looking Glass

DENNY BOND

The items in this still-life arrangement are cleverly linked to the theme of the book, and include a stopwatch, a hare and a book-cover illustration of Alice.

Selective seeing

The subjects that inspire artists are many and varied, from landscapes and seascapes to portraits and still life. So often, though, it's not the subject that makes a good painting, but the way in which it is interpreted. In most subjects, some form of editing is required.

Unlike cameras, which take in and record all before them, our eyes are selective and tend to linger on some elements in a composition while ignoring others. We all see things differently, and a dozen artists viewing a scene from the same vantage point will produce a dozen different paintings. This is a good thing. How dull and monotonous it would be if those artists all produced exactly the same result.

Beginners are apt to copy what is before them, warts and all. It's a natural reaction to want to reproduce the scene exactly as it looks, in the belief that, if it looks exactly like a photo, it must be good. And, if they're using photos as a source of reference, this becomes an even stronger temptation. As you progress as an artist, though, you begin to become selective in what you choose to include — and, just as importantly, what to leave out.

What's essential?

First, ask yourself what has to be included. What is the feature that you simply cannot do without? In a landscape it could be a bridge, a tree, a building or any number of things that catches your eye. In a portrait, it could be a particular expression that is typical of your sitter's mood or personality; it is the character of your model that is important, not every line and freckle. With a still-life subject, perhaps the texture of peeling paint on an old wooden window frame might grab your attention, or the tight structure and overlapping petals of a rose.

Once you've decided what's important, think about the best way to convey it. If the main focus of your painting is to be a waterfall, for example, just how much of the immediate surroundings should you include? Do you want to capture the majesty of the raging torrent or would it be better to include some of the surrounding woodland to set the waterfall in context? If you're arranging a still life of a bowl of fruit, is it the colourss and textures of the fruits or the glass bowl containing them, with its many reflections and highlights, that grabs your eye?

Porch Pots

CAROLYN LORD

Here, the artist has been drawn to the interesting shapes of the stacked clay flower pots, combined with the effective patterns created by the cast shadows and strong sunlight.

River Song

RICHARD THORN

Placing the river bank two-thirds of the way up the painting, the subject becomes the river itself, enabling the viewer to concentrate on the effects of fast-flowing water and the rocks visible beneath.

◄ *Seduction*

ANN SMITH

The abstract nature of this close-up floral study concentrates on the fascinating negative and positive shapes of light and dark, using subtle, blending colours of pinks, purples and oranges.

What could you leave out?

What complements your subject and what detracts from it? Quite often, there are elements that you can remove without affecting the overall scene or lessening the reason you wanted to paint it in the first place. Sometimes there is an inconveniently sited lamppost, rubbish bin or brightly coloured truck, which can easily be left out. Perhaps you have put together a still-life arrangement that has too many elements, creating a confused, jumbled scene that makes it hard for the viewer to work out what it is supposed to be the focal point. Sometimes less can be more, particularly in still-life subjects. Take some time to think about what's important — and don't be afraid to move items or discard them completely.

What could you add in?

You may even add things to your painting that were not visible in your initial view. The addition of a few figures can greatly improve a town or village scene, even if they were not originally present. Clear blue, cloudless skies, although pleasant to behold, do not make for interesting paintings, so don't be afraid to introduce one or two well-placed clouds to add a little drama and interest. Birds and animals can also be introduced to otherwise featureless foregrounds — for example, you could add a few soaring gulls to break up a vast expanse of sea.

With a little thought, then, it is not difficult to find something within a scene that you can direct the viewer's gaze to, whether you are painting a landscape, portrait or still life. By carefully emphasising the main points and pushing others into the background, you can make your message clear.

Spoolin' Around

BETTY ROGERS

In this unusual view, the artist is looking from directly above, carefully cropping right up to the edges of the tin and scissors, allowing the viewer to concentrate on the subject.

Riva degli Schiavoni, Venice

DUSAN DJUKARIC

By adopting a viewpoint that looks into the light, the artist has concentrated on the darker shapes, seen mostly in silhouette, created by the reflections on the wet surface.

Make thumbnail sketches

Keep a sketchbook and pen with you at all times. Even a very small one, which fits into a pocket, is useful. When you are out walking and find an inspiring subject, make small thumbnail sketches and written notes. Whatever it is that initially caught your eye, jot down some ideas and ways in which you can make your first impressions clear for use in a possible future painting. You can do the same for still-life subjects, too. Make several small drawings with ideas for bringing out what attracted you to the subject in the first place.

Holkham Beach

KEITH NASH

In this painting, we are drawn to the burst of sunlight through the clouds. The bright area is made all the more attractive by surrounding it with sombre colours.

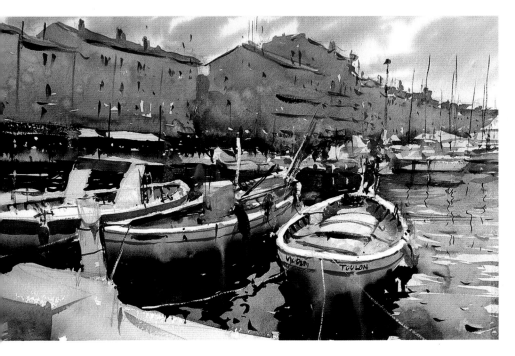

St Tropez

TIM WILMOT

In a busy scene like this, the artist has concentrated on the important shapes of the foreground boats, simplifying the background and resisting the urge to paint too much detail.

Placing elements in the picture space

After deciding what format will best suit your painting and editing what you see, the next thing to think about is where to place the different elements within the picture boundaries.

Some paintings have greater impact than others. This may have nothing to do with the subject matter or the artist's colour palette — there is just something in the way the picture is composed, or arranged, that makes it stand out. There are a few simple compositional tools that will help you create strong compositions.

Rule of thirds

An easy compositional device is the 'rule of thirds'. Imagine that your picture area is divided into thirds, both horizontally and vertically, with two vertical lines creating three equal columns on your page and two horizontal lines creating three equal rows. You can use these imaginary lines to help compose your painting.

Your horizon could be placed on one of the horizontal lines. If the sky is the most important part of your picture, place the horizon on the lower third, giving you two-thirds sky and one-third foreground. If the foreground is more interesting, simply move the horizon to the top third so that you have two-thirds foreground and one-third sky.

This imaginary grid can also be used to place your focal point. You will notice that, where the lines cross on your page, you have four intersecting points. Any one of these points makes a good choice to place your main point of interest.

Where Cliffs and Clouds Meet

ROLAND LEE

Here, the mountain is placed on the right-hand vertical third, and the peak itself is situated where this line intersects with the line of the upper horizontal third.

Asymmetrical balance

If you were to place a large feature such as a tree just off centre in your painting, it would not, on its own, create a very satisfying composition. Adding a smaller feature somewhere in the picture can have a balancing effect. For example, you may have a large tree just to the left of the centre line and a smaller tree further to the right. In a still life, a large vase could be placed to one side of the centre line, with a smaller one to the right, further on. In a seascape, you might have a large boat or ship close to the centre line, balanced by a more distant ship farther to the other side.

The effect has been compared with children sitting on a see-saw: two children sitting on one side, quite close to the pivot, can be balanced by one child sitting at the far end on the opposite side. This is sometimes described as 'steelyard balance'.

Lago di Garda, Pai

BERNHARD VOGEL

The shaft of sunlight leads us from the foreground to the focal point, the tower, which is placed at the intersection of two thirds, one being the line of distant hills.

Breaking the rules

The 'rules' of composition are very useful guidelines for arranging the subjects in your painting, but they are not written in stone. You can create dramatic compositions by breaking them.

In portraiture, following the 'rule of thirds', the subject is often placed on one of the vertical thirds looking back into the remaining two thirds. Placing the model on the very edge of the frame, looking outwards, goes against the normal guidelines but it can create a strong sense of dramatic tension.

Placing your focal point in the centre of the painting is generally not recommended as it does not create the most interesting of designs. However, it can create a feeling of calm, so there may be times when it would be the preferred option.

Sometimes you have to try a few different arrangements until you arrive at the one you think works best.

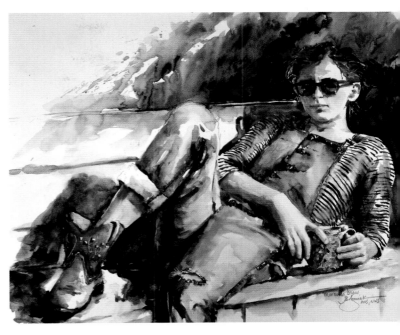

Troubleshooting: Avoid 'bullseyes'

If you place your main point of interest right in the centre of the picture, as if it is a bullseye on a target, or position the horizon right across the middle of the picture, it tends to cut the picture in half. For a more dynamic composition, try positioning your subjects off centre.

Morning Brew

BEV JOZWIAK

If you follow the line of the bent right knee and relaxed left leg, you are led to the focal point at top right of the painting in this three-quarters view of a seated figure.

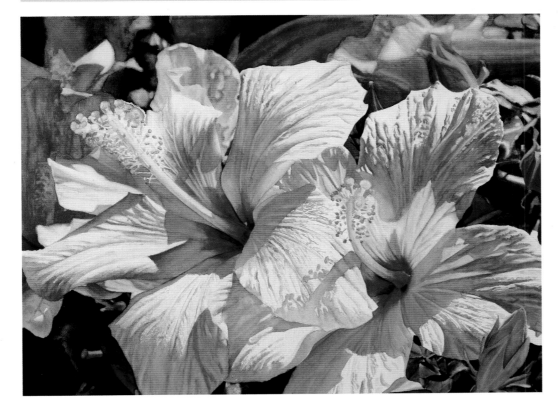

Dazzling

CARA BROWN

This floral study is an example of asymmetrical balance. The larger of the two flowers is placed just left of the vertical centre line, while the slightly smaller flower sits just to the right.

Selecting a focal point

Every painting needs a focal point — a point that enables the viewer's eye to settle where you intend them to look. Without this, a painting is just a collection of nicely painted objects, with no apparent reason or focus.

Ask yourself what it is that you want people to focus on. If you don't know, how can you expect the viewer to? In any subject, there is always something that stands out. Once you've decided what your particular focal point is, you can use the rule of thirds (see page 110) to place it on one of the intersecting points.

There are also techniques you can use to make a feature more (or less) obvious. If you have more than one prominent building in a scene you can, of course, leave out the less important ones or make the main feature more prominent by spotlighting it with a burst of sunshine. You can also make the supporting buildings less important by softening their edges or making their tonal values less strong than those of the main focal point.

Rural scenes can be a little bland without the introduction of a focal point to break them up. Green can be overpowering, but adding a man-made object such as an old gate or a rusting tractor can transform the scene into something worth painting. The same goes for estuary scenes: vast expanses of mud, sand and sky need something for the eye to settle on. Such scenes are usually dominated by horizontal features, and so a few boat masts, posts or figures breaking up the lines are always a welcome addition.

In animal paintings, a single animal set within a landscape will usually stand out as an obvious focal point. However, if you have a group of animals or birds, you can draw attention to one in particular by changing its attitude. For example, if you have a flock of geese in a marsh or estuary setting, most of them will be either resting or feeding, but there is often one individual keeping a lookout

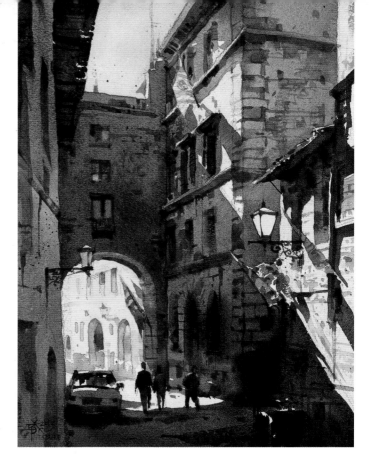

Dazzling Sunlight in Italy

CHIEN CHUNG WEI

The brightly lit arch is neatly framed by the surrounding buildings, making it the obvious focal point. The spot-lit area and converging lines also help to lead the eye.

Stone, Wire and Wood

PAUL TALBOT-GREAVES

The focal point here is the buildings on the horizon line. The line of posts and wire fence leading in from the bottom right help to point the way to them.

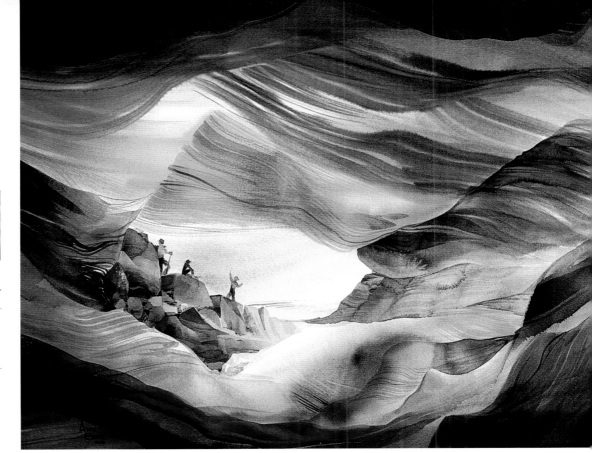

Slot Canyon

ANN SMITH

The eye is drawn to the brightly lit area, at centre left, and forms a natural focal point where the figures are located. The surrounding shadowy areas also make a natural frame.

for danger. This one could be your focal point, simply because its head is raised higher than the rest.

A still-life scene without a focal point is just a collection of objects, but there are ways of indicating which features are more important. If you have an arrangement of objects of one colour, the introduction of an item of a different colour will instantly draw the eye. A different-textured object, too, would attract more attention. With floral arrangements, you can make a focal point more prominent by changing the colour of one or two blooms, or draw attention to a particular area by introducing some markedly larger, or smaller, blooms. Everything is within your control, so take your time: move things around, add or remove items and try placing your main subject in different positions until you find an arrangement that works.

All these techniques can be used to identify what it is that you, the artist, are trying to communicate. One of the best compliments you can receive is, 'I can see why you painted that'.

Cuckoo Nest

JOS ANTENS

Follow the line of the foster-parent bird to direct you to the young cuckoo's gaping bill. The patch of light also helps to draw the eye to the focal point.

Creating a path through the picture

Troubleshooting: Move things around
Remember that it's perfectly acceptable to move features slightly to improve the composition of your painting.

You may have chosen your focal point and positioned it in a good place in your painting, but is that enough? Are there any other ways you could improve the composition and lead the viewer's eye to where you want it to eventually settle?

A good lead-in to a painting can be something as simple as a winding path, which takes you up to your focal point of a windmill, cottage or castle. The path through a painting doesn't have to be a literal path or track, however. By placing elements carefully, starting from the bottom or one side, you can imply a pathway and use the elements positioned alongside it as stepping stones to reach the main point of interest.

The first object or feature that draws the viewer's eye should be powerful enough to get attention, but not so powerful that the eye decides to linger there and doesn't go anywhere else. Once the eye reaches that first stepping stone, there should be something close by in the composition that allows the eye to leave it and go to the next one, and so on.

One common device that is used to lead the viewer through a painting is the S-path — a pathway weaving through the painting like a snake, leading, eventually, to the focal point. Again, this can be an actual footpath in a scene or a series of markers placed along the route that the S forms. A U-shaped pathway can be used when tall trees line a path, or when the painting is of a street scene with buildings either side of a road.

Compositions in which a focal point is positioned at each corner of a triangle also help to lead the eye around the painting.

In a street scene, we are often led into the painting by the effects of linear perspective (see page 116): the lines converge to give the impression of the buildings receding into the distance. Our eyes will naturally follow the lines up or down the street to see what's at the end. This is a powerful device for leading the viewer into the picture. However, it's important that we are not led straight out of it, too.

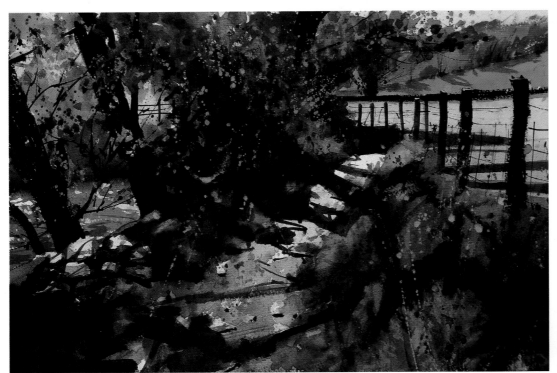

Down by the Dee

PAUL TALBOT-GREAVES

The footpath forms a natural pathway through the painting, leading us to the bright, sunlit field beyond. The angle of the river on the left also helps to lead us there.

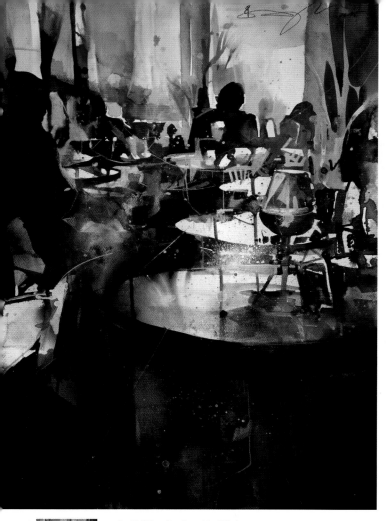

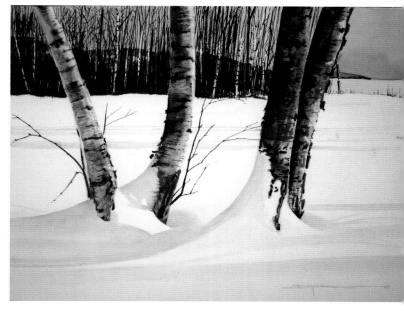

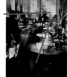

Café, Wernbacher, Backlight

BERNHARD VOGEL

There are several elements here that help to lead the eye into the picture, the most obvious being the bright, reflective table tops, which direct the viewer's gaze to the window. We can also follow the line of figures to this area.

Winter Shadows

DOUGLAS HUNT

The foreground shadows lead the eye between the two foreground tree trunks, directing us to the belt of trees beyond, which in turn takes us to the dark hill in the distance.

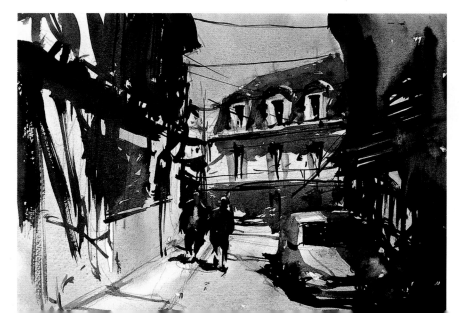

Montpon-Ménésterol, France

TIM WILMOT

Streets and roads create natural pathways in a painting. Here, they lead the eye to the two figures. The eye then follows the road as it carries on through and around the bend.

Perspective

We use perspective to create the illusion of a three-dimensional scene or object on a flat, two-dimensional sheet of paper. Unless you have an understanding of perspective, your paintings will lack a convincing sense of distance. There are two forms of perspective — linear and aerial.

Linear perspective

The most important thing to remember about linear perspective is that objects appear to diminish in size the further away they are. Details, too, become less obvious with distance. For example, if you have a tree or bush in the foreground, individual leaves and branches will be clearly visible; the further away they are, the less distinct these features will become. Those trees close to, or on, the horizon will be reduced to simple shapes.

The other important aspect of linear perspective is that parallel lines going away from you appear to meet at a (hypothetical) point on the horizon known as the 'vanishing point'. Imagine you are standing in a tree-lined avenue that stretches ahead to infinity, with all the trees roughly the same height. You will notice that the gaps between the trees on each side of the avenue appear to narrow as the avenue approaches the horizon until the trees eventually appear to converge on a single point.

This is an example of what is known as 'one-point perspective', because there is a single point at which the parallel lines appear to meet.

A view that includes a building where two sides are visible is called 'two-point perspective'. If you were to extend the horizontal lines of, say, the roof line, gutters, window ledges and where the building sits on the ground, you will see that the lines from each side of the building meet up at two separate vanishing points on the eye level line, at left and right.

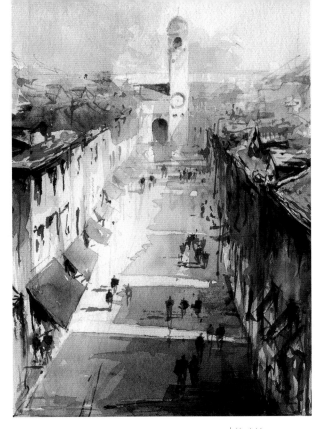

Dubrovnik Blues

TONY BELOBRAJDIC

This elevated scene is a good example of one-point perspective. The eye level or horizon line is placed quite high up in the painting and the vanishing point is almost dead centre, halfway up the tower.

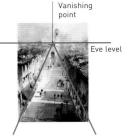

Painting People

HANNIE RIEUWERTS

In this letterbox-format painting, the eye level or horizon line is approximately at the head height of the figures. Only the positions of the feet change as they converge towards the off-centre one-point perspective vanishing point.

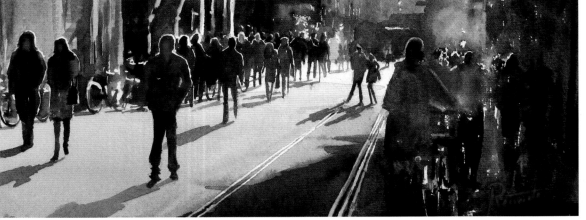

Measuring angles and proportions

A useful technique for measuring the angles of roofs, windows, doors and other features is to hold your pencil out in front of you, aligning it to the angle in question. Then ask yourself where the pencil would be pointing if it were the hour hand of a clock. You can then transfer this angle to your paper.

Estimating proportions can also be problematic. The simplest way of getting it right is to find a feature within the scene that you can use as a standard. For example, in a building, if you locate a relatively small feature such as a window, you can then estimate how many times this will fit into the height of the door, the space between the ground level and the gutters, and also the distance from ground level to the roof line. The same technique can also be used for estimating the widths of features. This technique is also employed by portrait artists where they measure a figure in 'head heights'.

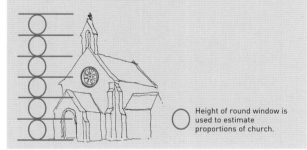

Height of round window is used to estimate proportions of church.

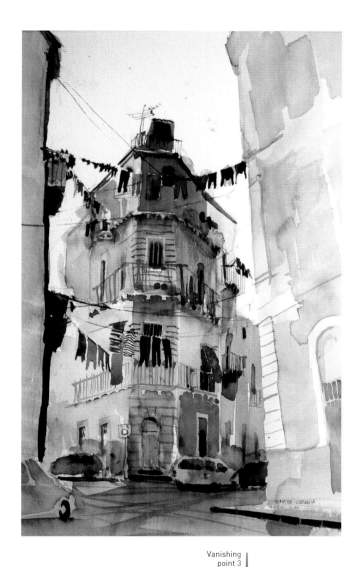

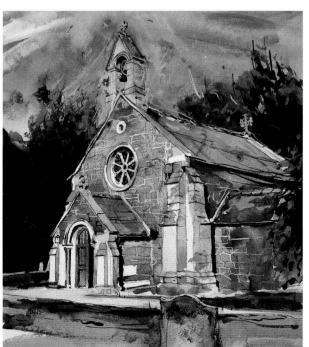

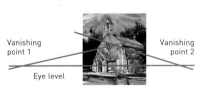

Vanishing point 1

Vanishing point 2

Eye level

Stewton – St Andrew's

DAVID MORRIS

In this two-point perspective painting, the eye level is located quite low in the picture. The left and right vanishing points are located somewhere far outside of the picture frame. Knowing how to plot these will help you create a realistic three-dimensional building.

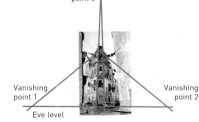

Vanishing point 3

Vanishing point 1

Vanishing point 2

Eye level

Festooned Apartments

OMAR JARAMILLO

As well as the two vanishing points on the eye level, in this painting, the artist also has to contend with the building's converging verticals, which meet at a third vanishing point situated some way above the building.

Perspective in practice

In both one- and two-point perspective, vanishing points are always situated on the eye level, so the first thing you need to do is locate this line.

Hold out a pencil, horizontally, directly in front of your eyes. It doesn't matter whether you are at the foot of a hill, at the top, or on a beach — your eye level will always be directly in front of you.

Although your eye level will always be directly in front of you, the angle of the converging lines will be different depending on your vantage point.

Vanishing point under arch

— Eye level

— Lines above eye level converge down towards the vanishing point

— Lines below eye level converge up towards the vanishing point

There are occasions where multiple perspective points are needed. For example, if you are painting a view of buildings from a high vantage point, there will be three vanishing points. Two of these will be on your eye level, as in one- and two-point perspective. However, as you are looking down on the scene, the vertical sides of tall buildings will also appear to converge as they reach street level. Similarly, if you are standing at ground level and looking upwards, tall buildings will appear to converge as they reach towards the sky.

Multiple vanishing points also occur in situations where you may be viewing a winding street scene. As each building curves around, new vanishing points will occur further away each time, along the eye level.

After reading this, you might think that you have to be a mathematical genius to understand the principles of linear perspective. This is not the case and I, for one, certainly do not fall into this category! In reality, careful observation is key and there is no need to cover your entire sheet of watercolour paper in a tracery of perspective guidelines.

Toscana

MICHAEL REARDON

The artist has created a strong sense of depth and distance in this painting through his clever use of aerial, or atmospheric, perspective, making the furthest clifftop and buildings much paler in tone than those in the foreground.

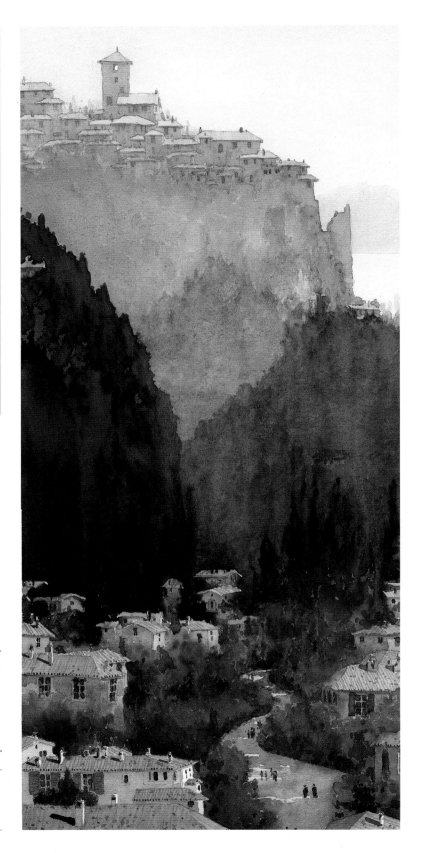

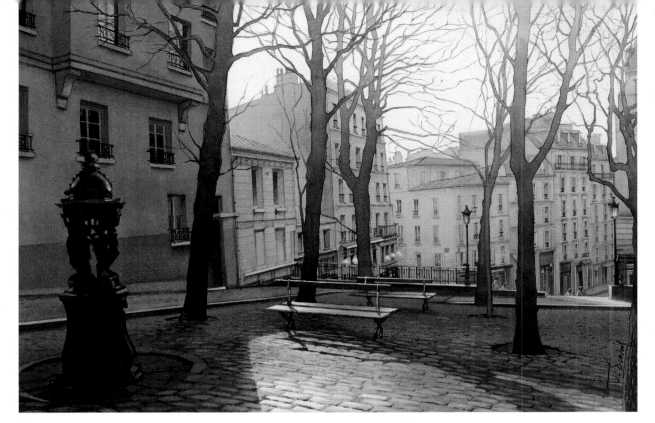

Twilight on Montmartre

THIERRY DUVAL

Soft evening light filters through the trees and illuminates some of the distant buildings, while the foreground is mostly kept in shadow, suggesting atmosphere and depth.

You just need to be aware of the phenomenon and the approximate position of vanishing points — but don't be a slave to them.

Aerial (or atmospheric) perspective

Atmospheric effects also have a strong influence on the way we perceive distance in the landscape. Unlike linear perspective, in which objects appear smaller with distance, in aerial perspective atmospheric qualities affect the appearance of colour and tone as we travel from the foreground to the horizon.

Our atmosphere is not completely transparent. It contains dust, pollen, water droplets and pollutants, particularly in urban areas. These act as a filter that, over great distances, blocks out some of the light and colour reaching our eyes. This is why, when you see a range of hills receding into the distance, they appear to become both paler in tone, and steadily more bluish, as they get nearer the horizon.

In urban scenes, too, such as a view filled with terracotta-tiled roofs, the terracotta colour will be brighter and more intense in the foreground. As your eye travels further into the distance you will notice that the roofs become less intense in colour. Similarly, in a coastal scene a foreground of red-coloured cliffs may be quite warm and bright, while a more distant headland, featuring similar rocks, will be cooler and less intense.

The amount of detail that we can discern also lessens with distance. Imagine standing in a forest in winter on a misty day. You will notice how the trees become more faint the further away they are. As well as becoming lighter in

tone, edges also become less sharp and details less clearly defined.

We can see then that, used together, these two aspects of aerial perspective are powerful tools for giving your paintings a strong sense of distance and scale. Remember, in most situations, make your colours paler towards the horizon and lessen the amount of detail. Reserve strong textural effects for the fore- and middle grounds.

Perspective as a compositional tool

As well as giving your paintings a sense of scale, perspective can also be a useful aid for composition. Linear lines of perspective, on buildings, roofs and roads, can create natural pathways that lead the eye into a painting. The eye will automatically follow a road to see what lies at the end. Similarly, meandering rivers and streams can be used as a device to lead the viewer into a painting. It's not just lines and colours that can be used to direct the eye. Groups, or herds, of animals can be placed to lead the eye, as can objects such as boats or cars.

By combining linear perspective with careful use of aerial perspective, you can create dynamic designs in your paintings, as well as a sense of scale and distance.

All Day, Chinatown

DENIS RYAN

The warm reds, browns and yellows of the neon sign dominate this painting, but are counterbalanced by the smaller area of cool, complementary green. The predominately dark tones contrast with the bright light.

Colour & tone as compositional devices

Both colour and tone can be used as compositional tools. Your choice of colour palette and where you place colours can greatly improve the composition of your paintings, as can the careful use of tonal values. Colour and tone can also be used to create a pathway through a painting.

The way we arrange the colours in our paintings, and give greater emphasis to some than others, is an important aspect of composition. There are a variety of schemes and strategies for using colour in art, some of which are shown here. However, you shouldn't feel that these have to be followed precisely or that the proportions of one colour to another need to be calculated exactly.

If you do, you may risk your painting becoming nothing more than a technical exercise.

Complementary colours

Complementary colour schemes use colours that are opposite each other on the colour wheel — red/green; blue/orange; yellow/purple. If you place two complementaries near or next to each other in a painting, the colours seem very intense and can make your painting more dynamic. Even just a hint of a complementary can lift a painting and bring it alive.

Many countryside scenes, for example, are dominated by one or more forms of green, which can be a little overpowering. By adding a little red, which is the complementary of green (for example, a few red flowers, or red-tiled roofs), some balance is achieved.

The same applies to any of the other colours on the wheel. For example, a seascape that is dominated by blues can be balanced by a beach or rocks in complementary oranges or siennas.

Analogous colours

A less vibrant but, nonetheless, pleasing scheme is to use analogous colours — colours that occur alongside each other on the colour wheel. Invariably, the dominant colour will be either a primary or secondary, supported by two tertiaries. For example, you may have a dominant green, with yellow-green and blue-green tertiaries in lesser amounts. This kind of colour scheme creates a very calming effect, as all the colours used are closely related.

It is also important to remember that you do not necessarily have to imitate exactly the colours you see. As artists we are free

The theory of colour

The colour wheel (see page 32) sets out the relationships between colours and can help you establish why your painting is (or isn't!) working.

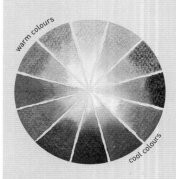

warm colours

cool colours

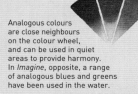

Examples of complementary colours used in the paintings opposite. It's not absolutely essential that the colours be the exact opposites on the colour wheel for the results to be effective.

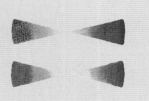

Analogous colours are close neighbours on the colour wheel, and can be used in quiet areas to provide harmony. In *Imagine*, opposite, a range of analogous blues and greens have been used in the water.

Sugar Orange

LIANE BEDARD

This still life is mostly comprised of soft, cool greens and blues in the stripes on the table and the patterns on the plate. The single complementary orange brings warmth to the painting.

Look for the dominant colour

Whatever subject you are painting, whether it is a landscape, still life or even a portrait, take a moment to think what the dominant colour is. Once you know this, introduce smaller amounts of its complementary into the composition where appropriate.

Imagine

CARA BROWN

The lightest tones in this study of a water lily are the highlights on the petals, which draw the eye to the flower. The complementary pink also works well with the dominant blues and greens.

to manipulate and change colours as we see fit, which means that there can be many interpretations of a single subject.

Tone

Tonal values are as much a compositional device as colour and, if a painting has a dominant colour, strong paintings usually contain a dominant tonal value.

If you find that your paintings have an insipid, washed-out look to them, spend a few minutes thinking about the distribution of your tonal values.

If you think of your painting in terms of light, medium and dark, a painting can be dominated by any one of these three tonal values. For example, if a painting is dominated by medium tones, the greatest area of the painting will be about two-thirds in the middle tonal values, with the remaining third taken up mostly by dark tones with a small amount of light tonal values. (Of course, in reality there are more than just three tones in a scene, but concentrating on the main three to design your painting makes life simpler.) You can use tonal contrast to highlight parts of your painting and draw attention to them. A small area of light tone set against a medium or dark tone will instantly draw the eye.

By making several small preparatory sketches, you can work out different arrangements of the same scene until you arrive at one that works for you. With a medium like watercolour, it is far better to take a few minutes to do this beforehand than work it out on your actual painting. We want our paintings to have some spontaneity to them — but having an idea of the final result in your mind allows you to put down bold strokes with confidence.

By using only the three tonal values of light, medium and dark, you can arrive at six combinations for the distribution of tonal values within your paintings. The simplest way to illustrate this is in the form of a chart (see page 38).

Good Book

ANDY EVANSEN

This analogous painting glows with warmth, even in the shadows. The lone figure is spot-lit by a patch of sunlight and the warm colours are balanced by some cooler purples on the shirt and in the foreground.

A View from the Highline

DORRIE RIFKIN

Although the overall tone in this street scene is a cool grey-blue, it is spiked with complementary colours — warm yellows, reds and orange — that help to add life to the painting.

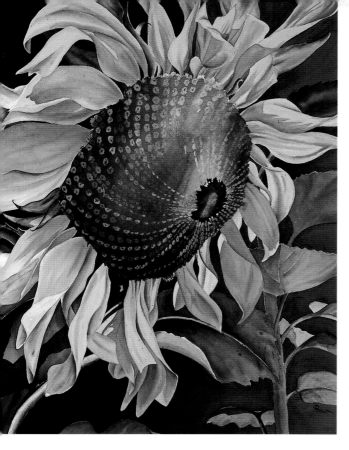

Crowning Glory

CAROLINE LINSCOTT

The fiery oranges and yellows of this sunflower are balanced by the cooler blue and green shadows in the background. The darker background tones also help to push the flower forwards in the picture space.

Late Afternoon Still Life

LINDA KOOLURIS DOBBS

This painting is almost split 50/50 into light and dark tones. The negative shapes of the light-toned flowers are neatly described by the darker, blue shadow shapes.

Dawn's Early Light

ANGUS MCEWAN

A shaft of sunlight brings warmth to this otherwise shady scene. Warm, reflected light infiltrates all but the very darkest recesses of the painting.

Creating atmosphere & mood

As an artist, you can give a scene whatever mood you want. It's up to you whether to portray a landscape as warm or cool, or a subject in silhouette or brightly lit. To understand how to create mood in your paintings, you need to be aware of the effects of different colours and tonal values and when to use hard and soft edges.

Colour and mood

Colour temperature can have an effect on the way we feel about certain scenes or compositions. Broadly speaking, colours from the warmer parts of the colour wheel, such as yellows, oranges and reds, are more likely to make us feel positive and upbeat. In contrast, colours from the cooler part of the spectrum, such as blues, greens and violets, are more likely to impart feelings of sadness or isolation (we even talk about 'feeling blue'), and can even create a slightly uneasy or sinister mood.

This is a generalization, however, as not all blues are cool and not all reds are warm — it's all relative! For example, Ultramarine Blue is a warm blue, as is Cobalt Blue, but Cerulean is cooler than both of these. There are both cool and warm reds, too: Alizarin Crimson is very cool, especially if it is seen beside Vermilion, which is a fiery orange-red.

Often it is the overall colour scheme that creates a particular mood, and not just individual colours. A Mediterranean or Californian sea scene would need to have other features and colours to convince us that it is warm. By adding a sandy beach, using warm yellows, the picture is well on the way to making us feel as if we're looking at a scene from a warm climate.

A still-life arrangement featuring oranges will automatically suggest warmth, but you may need to balance the orange with some cooler complementary colour such as blue. However, as long as the orange is dominant, it will still have a feeling of warmth. On the other hand, a still life comprising a collection of blue objects will still be cool, even with the addition of one orange. It is the dominant colour that dictates the overall mood of the painting.

A toned background could also suggest a particular mood. By pre-washing the paper with a cool or warm base colour, you will establish a mood before the subsequent washes are applied. This is a useful technique for setting the mood of the painting from the very start (see page 56).

Hard and soft edges

The wet-on-wet approach (see page 60) lends itself to creating atmospheric effects. Applying a loose wet-on-wet wash over the entire paper surface, mixing colours as you go, provides the best foundation for a sensitive, atmospheric feel to your paintings. Much of the work in creating a soft look to your painting is done with this initial overall wash. Mist and fog, in particular, are ideally suited to this treatment, as the soft forms of the landscape can be described within the wash before it dries. Misty scenes, by their nature, invoke feelings of mystery. Forms can be suggested without putting in too much detail, to conjure up a mood that might make us think of some potential danger, or create a slightly threatening feel.

Edges, too, play an important part in suggesting mood. Soft, blurry edges suggest tranquillity and harder edges create drama. Most paintings, though, need a certain amount of hard edges, particularly around the focal point.

Marseille Holidays

SERGEY KURBATOV

A lovely feeling of warmth is suggested in this painting, with reflected sunlight bouncing between the walls. This is balanced by the smaller patch of cool blue-grey, just behind the two figures.

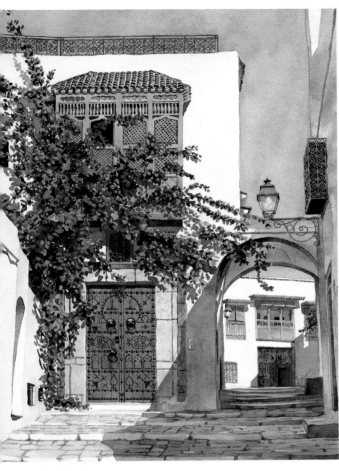

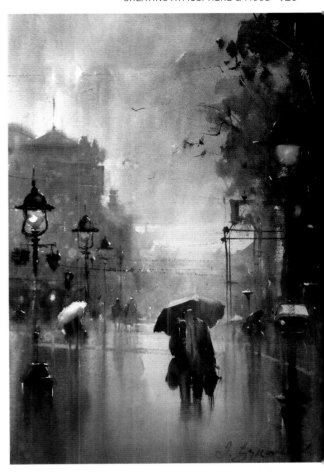

One Day in Belgrade

DUSAN DJUKARIC

A foundation wet-into-wet wash has set the mood for this street scene filled with light. The technique also helps greatly in suggesting rain and the wet surfaces.

Tunisian Doorway

MOIRA CLINCH

The artist has suggested an overall feeling of bright sunshine by using the white of the paper to portray sunlit walls and cool blue-grey, sharp-edged shadows to great effect.

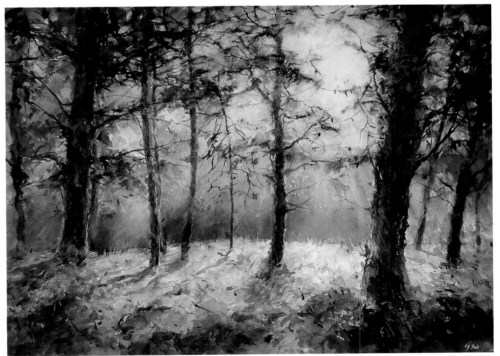

Sunlight Through the Trees

LIZ YULE

The effects of filtered, dappled sunlight coming through the trees create a very atmospheric feel to this watercolour. The cooler blues and greens in the background also help to suggest distance.

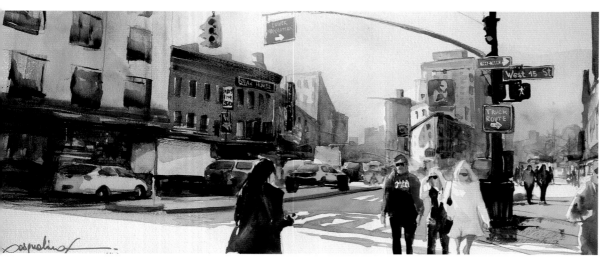

Sunday in New York

PASQUALINO FRACASSO

The atmosphere of a sunny New York Street is captured perfectly in this painting. The low sun coming from the left also creates wonderfully long, cool, blue cast shadows.

Tonal values

Tonal values are also useful for portraying a particular mood. Very high-key paintings — that is, those that contain mostly light tones — can suggest other-worldly, almost dream-like situations. A wide range of tonal values, from light to dark, tends to relay bright, happy scenes. An air of mystery can often be suggested by a limited range of mid-tones, especially when used in conjunction with misty, cool effects. However, a limited range of dark tones is more likely to create a more sinister mood.

Lighting

The way in which a subject is lit can influence the mood of a painting more than any other factor. Bright, sunlit scenes suggest an upbeat mood and contain more contrast than misty subjects, and so in this instance a more direct method of applying the paint may be advantageous. Without the soft edges of an overall wash, a cleaner, hard-edged approach may be the better alternative. The direct approach (see page 100), working from dark to light, provides a crisper end result, which could be a better option for suggesting bright light conditions where contrast is more evident, strong shadows being a corollary of the bright conditions. Sunny scenes almost always suggest warmth and a happy mood.

In backlit or contre-jour subjects, your focal point may be in silhouette and so, with the details being washed out and most of the elements of the composition reduced to simple shapes, an air of mystery can be easily achieved. This kind of lighting can also create quite a romantic feel for portraits.

Backlighting can often produce almost monotone effects. Solid objects such as buildings may be quite flat but, if a sunlit tree is placed in a position where the building is behind it, the foliage can glow quite brightly against it, creating a mood of drama and tension in the painting.

Wiseman's Woods

NAOMI TYDEMAN

The low sun coming through the trees creates a mysterious atmosphere here, where its rays penetrate the leaves to illuminate just a few patches of woodland flowers on the forest floor.

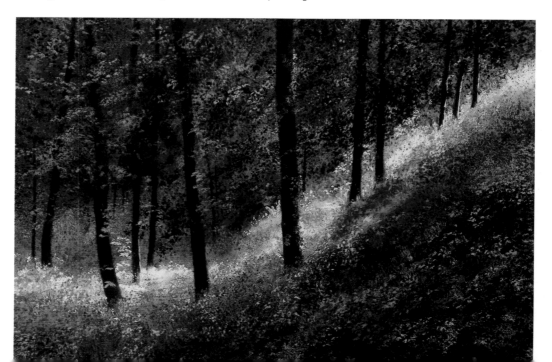

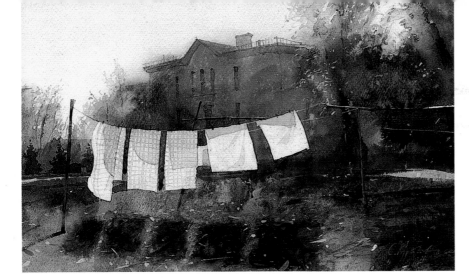

Drying Day

SERGEY KURBATOV

A wet-into-wet foundation wash of warm yellows and browns sets the scene for this atmospheric contre-jour study. The shadowy silhouette of the building creates negative shapes around the items on the washing line.

The quality of light also changes around the globe, and different places and countries can be suggested by certain colours. Northern and southern countries tend to be dominated by cool colours, while countries close to the Equator usually contain more warmth in the light. The mood of a particular part of the world can be suggested by the colours you chose. In fact, many landscape artists who live and paint in cooler climes use different colours in their palette when they visit warmer, sunnier locations.

Shadows, too, can be used to influence the mood of a painting, and even suggest a bit of mystery. Cast shadows can be placed in the foreground, from something unseen outside the picture frame.

They can also help describe features that may be just out of sight, such as trees, a church or cathedral or chimneys. A more sinister atmosphere could perhaps be suggested by the cast shadow of a figure just out of the picture frame.

Walking in Sunshine

CHIEN CHUNG WEI

A bright, sunny atmosphere is created by the sun raking across the façade of the building, creating cast shadows. Warm yellows are balanced by the cool greys.

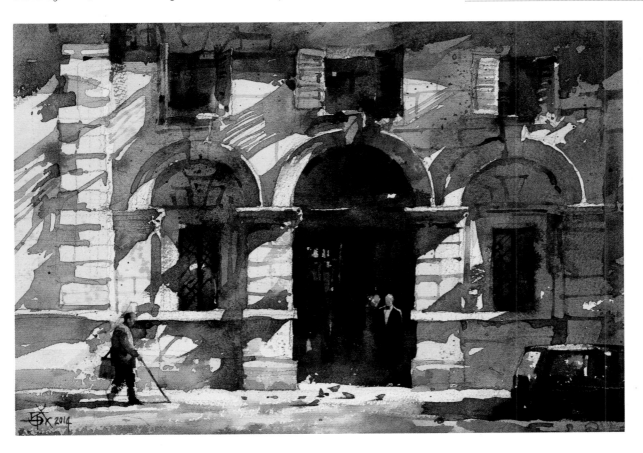

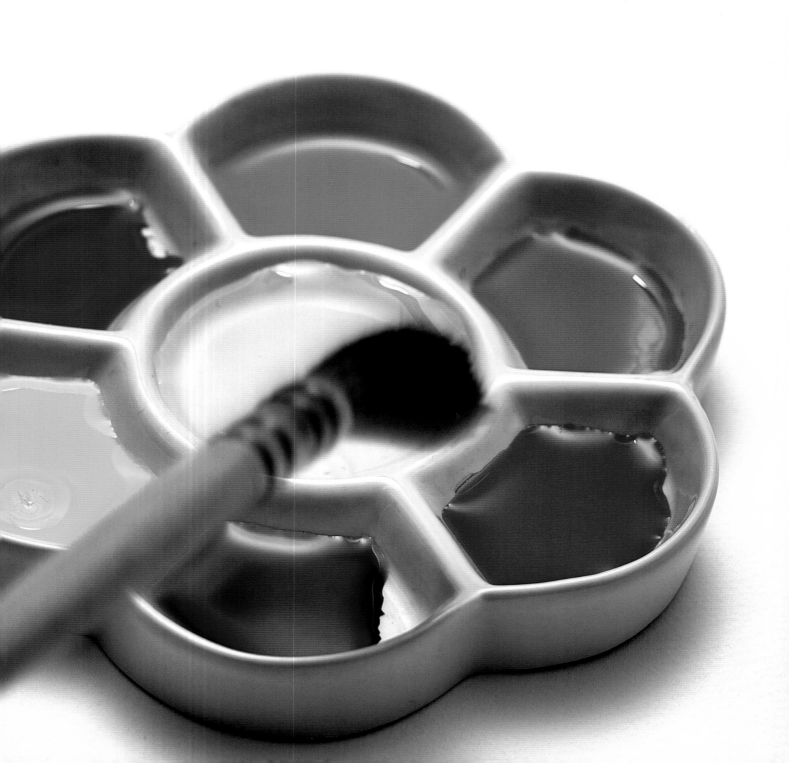

Chapter

4

Expressing Form
& Surface

INTRODUCING LANDSCAPES

Landscape has been one of the most popular and enduring painting subjects for centuries. In every part of the world people have been, and still are, describing their environment in paint. The term 'landscape' usually conjures up thoughts of natural vistas, but it can cover a broad range of topics from lonely, windswept marshes with huge skies to bustling cityscapes dominated by tall buildings, and may also include coastal scenes and seascapes.

The medium of watercolour, too, continues to be a favourite choice for painting landscapes. The transparency of the paint and the way the whiteness of the paper shines through enable you to create landscapes with a sense of luminosity that is unrivalled in any other medium, while the quick drying time allows you to work speedily to capture the often fast-changing light and weather conditions. Being so portable, it is also perfect for painting on location. A limited palette of eight to 12 colours is all you need to obtain a wide range of colour mixes, to cope with any painting possibilities.

Even if you choose to include very little sky in your painting, the effect of the light on the landscape below sets the whole mood. The colour of light is affected by the time of day. As

Golden Light ▶

CAROL EVANS

The warm, low, evening sun reflecting off the leaves is cleverly echoed in the gentle ripples of the water. The cool, bluish shadows of the rocks provide balance and contrast.

Cool Avenue

RICHARD THORN

The contre-jour view of this woodland path causes the leaves to become transparent and take on a green and yellow glow. The trunks and branches, though, are silhouetted against the light.

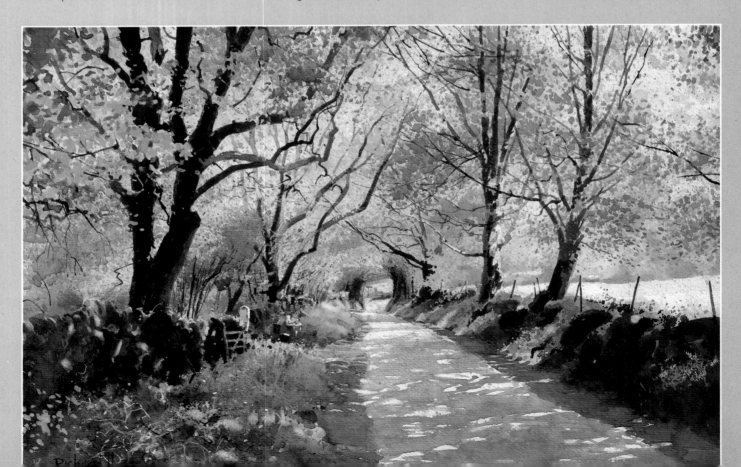

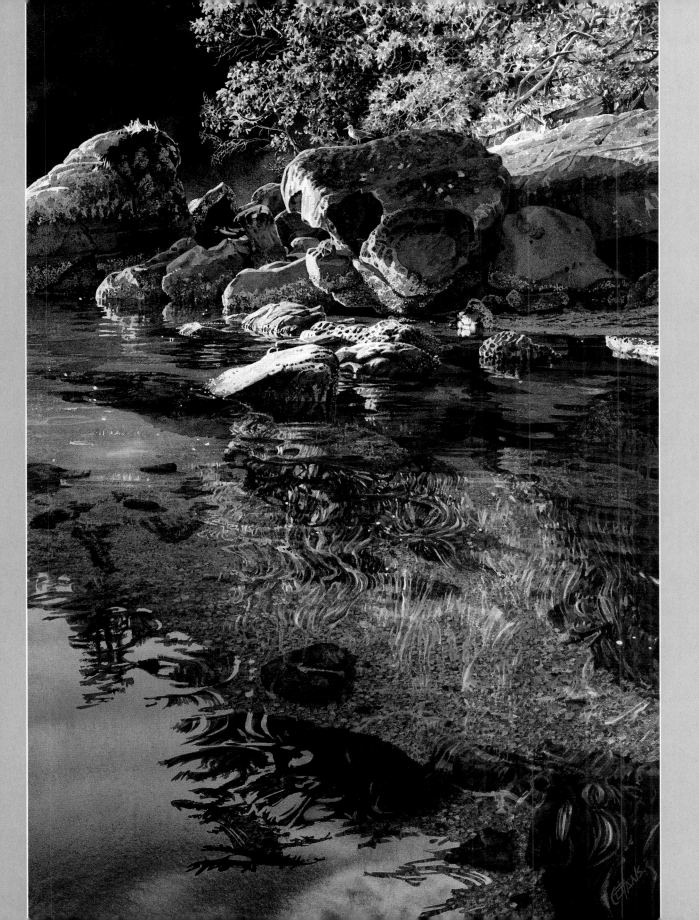

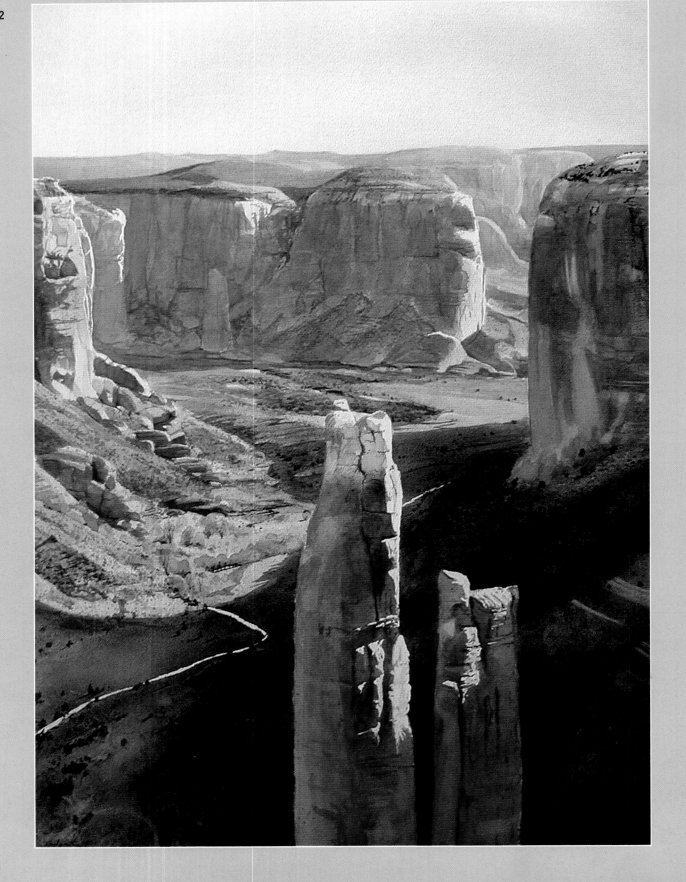

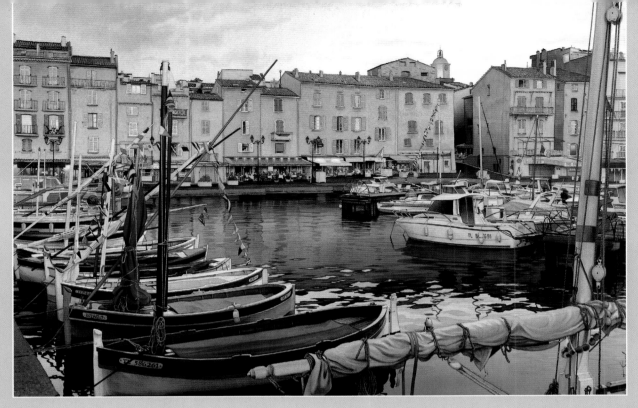

the sun sets it has to travel through a thicker layer of atmosphere to reach us, which contains dust particles that act like a filter, giving the light a reddish tinge. At midday, the sun is directly overhead and has only a narrow band of atmosphere to penetrate, making the light whiter and cooler. So a landscape dominated by trees and shrubs may appear quite cool around midday but, as the sun sets, the greens will become steadily more red and appear warmer in tone. Certain colour choices and combinations lend themselves to particular conditions. Cold, cloudy weather will be dominated by cool blues and greys, while warm, sunny weather may include reds and yellows. However, the light can change very quickly, so make a note of the angle of the light and the length of any shadows when you first start sketching or painting, so that you can maintain consistency over a long painting session.

Wherever you are on the planet, opportunities for painting the landscape in watercolour are never very far away. The land and sea provide a never-ending source of inspiration.

The Village of St Tropez

THIERRY DUVAL

The strong shapes of the boats in the foreground lead the eye towards the boats in the middle distance of the harbour. These, in turn, point us towards the buildings along the water's edge.

Morning, Bowron Lake

EVA BARTEL

The mountains reflected in the lake are almost mirror-like. A slight ripple, caused by a breeze, provides a little movement in the water, along with a thin line of reflected sky.

◀ Above Spider Rock

ROBERT HIGHSMITH

This painting conveys a great feeling of depth. The sun just catches the foreground rocks and streams through the canyon. The cool blue of the far wall completes the sense of distance.

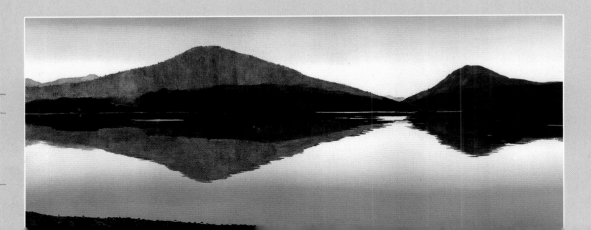

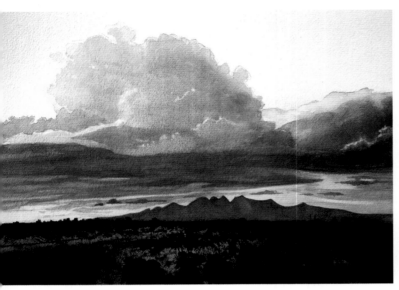

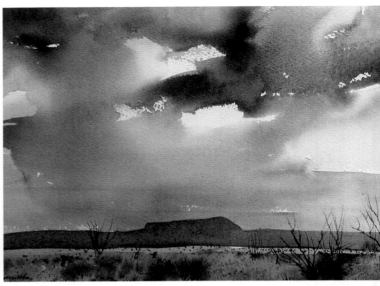

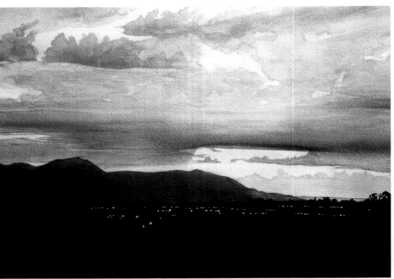

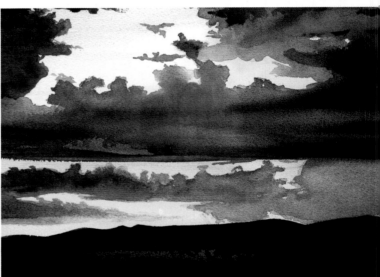

Skies & clouds

Skies are as many and varied as the landscapes below them, and watercolour is ideally suited to tackle the soft, airy nature of the subject. A few simple watercolour techniques are all you need: you can exploit the whiteness of the paper to create billowing cumulus clouds, use a wet-into-wet approach for grey, stormy skies, lift off paint with paper towel or a cotton bud to create thin streaks of cloud, and capture the glorious colours of a sunset with a simple variegated wash.

Sky Studies

ROBERT HIGHSMITH

These four sky images illustrate several features that are useful for painting skies. Linear perspective is evident in the way the larger clouds are foremost, with the smaller ones nearer the horizon. Wet into wet is also in play, and there are combinations of hard and soft edges.

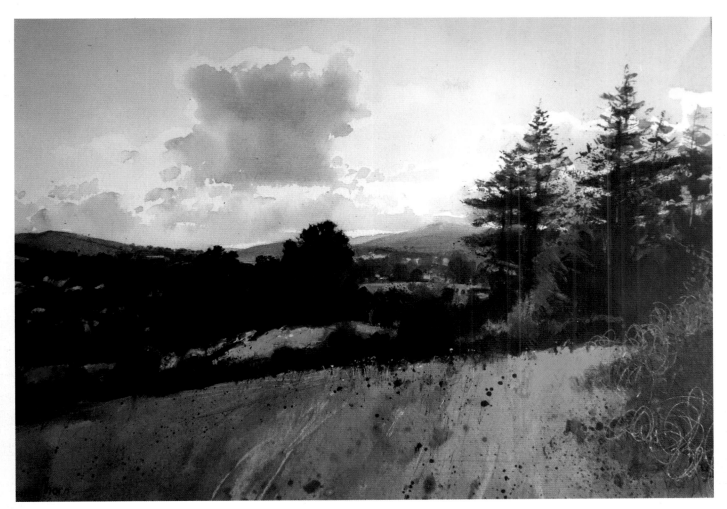

Chagford Sky

RICHARD THORN

The strong dark forms in the landscape contrast with the lightness of the sky. The artist has succeeded in portraying the 'silver lining' effect, caused by the position of the sun behind the clouds.

The English Convent

FERNAND THIENPONDT

The predominantly cool, dark blues and the silhouette of the buildings are offset by the small patch of warm, bright sun in the lower right corner.

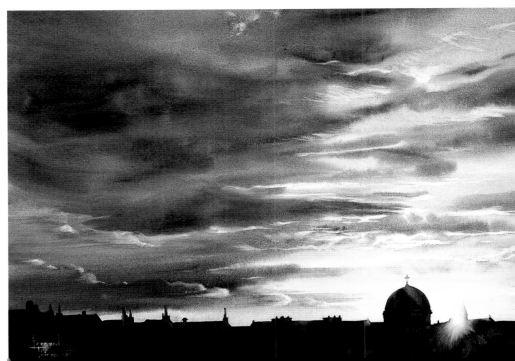

Moorland sky

In this exercise, a simple foreground with a low horizon allows a large area for the sky. The secret of painting a good sky with soft clouds is to use plenty of water, which allows the colour to flow freely on the paper without leaving streaks and unwanted hard edges. Whatever kind of sky you're painting, remember that skies vary enormously in colour and form. Several shades of blue may be present, and the intensity is usually at its strongest overhead, gradually lightening towards the horizon.

DAVID WEBB

MATERIALS

425 gsm (200 lb) watercolour paper

3B pencil

Mixing palette

Water

Mop brush

Watercolour paints: Cobalt Blue, Burnt Sienna, Alizarin Crimson, Raw Sienna

1 Tape your watercolour paper to a board with masking tape. Sketch the outline of the main features, including the rocks and footpath. Position the horizon quite low, so that most of the space is reserved for the sky. Make separate dilutions of each of the four colours.

2 Wet the entire surface of the paper. Working quickly, dip your brush into the Cobalt Blue and paint in the sky, leaving white areas for clouds. Brush Burnt Sienna into some blue areas to make grey. Add smaller amounts of Alizarin Crimson and Raw Sienna to the lower parts of sky. Wash Raw Sienna onto the land mass, adding Cobalt Blue in places to make a soft sage green. You should now have a soft, atmospheric foundation wash. Allow to dry completely.

3 Using Cobalt Blue on dry paper, create negative cloud shapes by painting the sky up to the cloud edges. Wet some edges of the clouds to allow paint to bleed in to create softer edges in places. Add more weight to the darker cloud on the left by re-wetting the area and mixing Cobalt Blue and Burnt Sienna on the paper to make a darker grey. Build form into the cloud areas by wetting some parts and adding more Burnt Sienna and Cobalt Blue. Keep your board at an angle to allow the washes to flow down smoothly.

Moorland Sky

DAVID WEBB

Mix a pale grey from Cobalt Blue and Burnt Sienna, and paint the rocks, using a stronger mix for the shaded sides. Paint the moors by mixing Raw Sienna and Cobalt Blue on the paper. The final result is a cloudscape that is full of light and movement, anchored by the thin strip of land at the base.

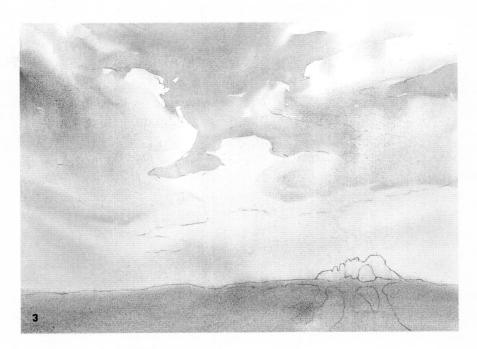

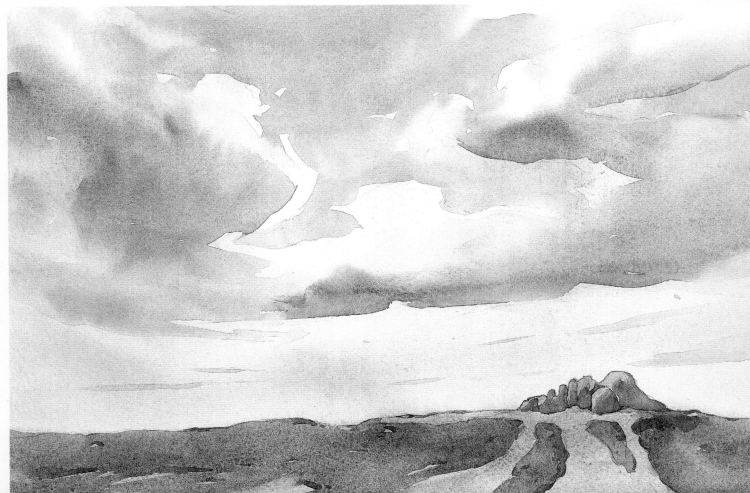

Trees & foliage

Whether they are a central theme of your painting or just a background element, trees and foliage are present in many landscape scenes. Within foliage masses, look for differences in tone to capture the effects of light and shade; wet-into-wet applications and even spattering are useful techniques here. When painting a woodland scene with many trees over a large distance, remember to use aerial perspective in your work: make the trees in the distance paler in tone and less detailed than those in the foreground.

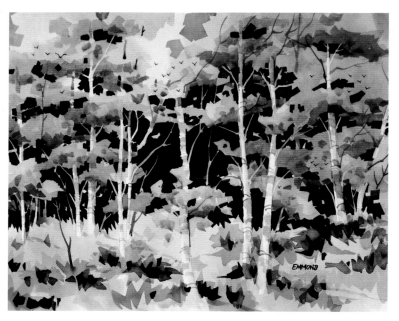

Aspen Grove

RANDY EMMONS

The artist has used contrasting tonal values to great effect here. The leafy areas and grass have been built up in transparent washes, from the lightest to the darkest tones.

Luce nel Verde

PASQUALINO FRACASSO

In this painting, comprising predominantly green shades, the white paper is used for the lightest areas and is balanced by the dark brown tree trunks.

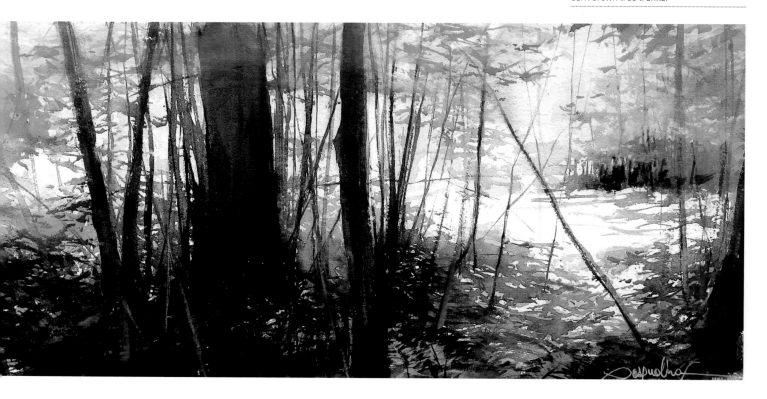

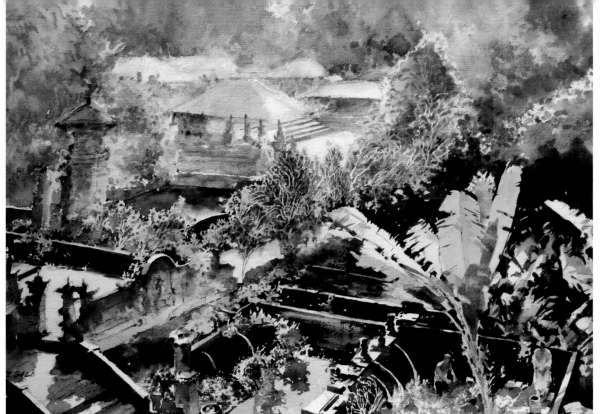

Holy Spring, Bali

ONG KIM SENG

Looking into the light, the artist has made clever use of negative painting techniques to create the light shapes, such as the palm fronds, by painting the sharp-edged, darker-toned areas that surround them.

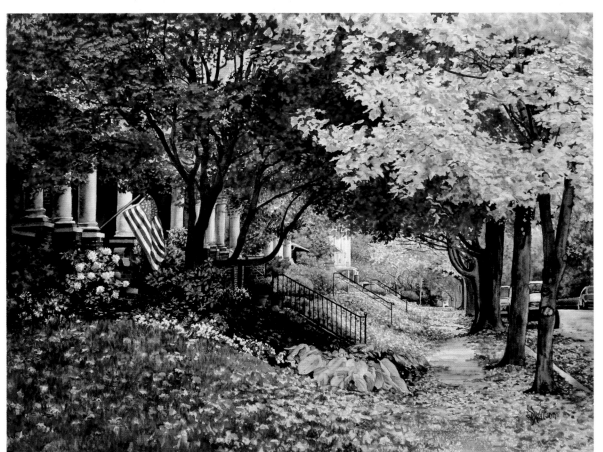

Buchanon Avenue

DEB WATSON

The one-point perspective view draws us into this colourful scene of an avenue in autumn colours. The yellows of the tree on the right contrast well with the deep. rich reds and purples of the left-hand tree.

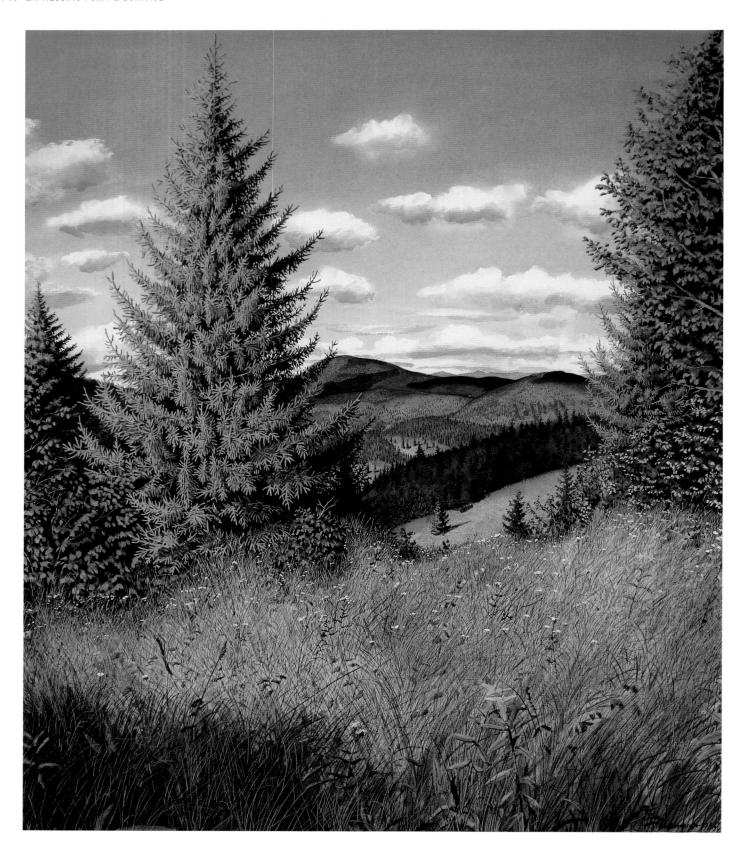

◄ Summer in the Mountains

STEFAN BLEEKRODE

A highly detailed technique describes this scene of a landscape dominated by fir trees. Detail is lessened as we are drawn further into the painting, which helps convey the feeling of great distance.

Rest

CARA BROWN

These vine leaves have been painted in greens, reds, oranges and yellows, with great attention to detail, creating a pleasing pattern in this square-format painting. You can almost feel the sunlight.

◄ Vernal Equinox Navels

CAROLYN LORD

The carefully drawn leaf shapes are filled with subtle warm and cool greens to portray a feeling of sunlight and shade. The white blossom makes good use of the natural white of the paper.

► Rhapsody in Nature — Acadia Ferns

DEB WATSON

In this unusual composition, an overall pattern effect of inter-locking fern fronds has been achieved by a precise, detailed drawing filled with autumn shades of greens, yellows and reds.

Autumn woodland

The key to painting foliage is not to get too caught up in the detail or to try to paint every individual leaf in exactly the right place. Loosely block in broad areas of colour, making the tones paler as you move towards the background, then use textural techniques to create a generalized impression of the leaves. Spattering (see page 80) is a great technique to use, as it enables you to keep the work loose and spontaneous.

NAOMI TYDEMAN

MATERIALS

Watercolour board, NOT surface

2B pencil

Old dip pen for applying masking fluid

Masking fluid

Mixing palette

Water

Salt

Brushes: No. 4 and no. 8 round

Watercolour paints: Winsor Blue, Venetian Red, Olive Green, Quinacridone Gold

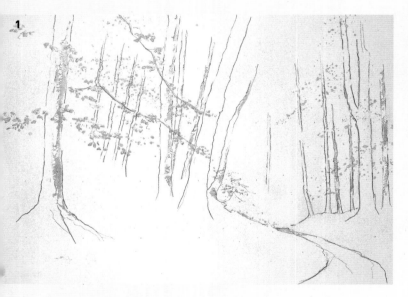

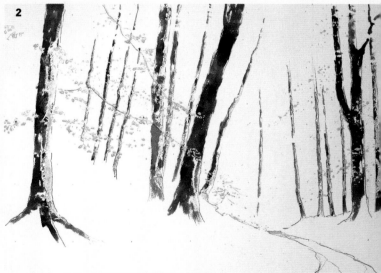

1 Sketch in the main elements of the picture — the tree trunks, the path and the angle of the foreground branches. Using a dip pen, mask out areas where the light hits the leaves and the bark of trees, carefully adding some detail in the nearer leaves. Allow the masking fluid to dry completely.

2 Using a no. 8 round brush, mark in the main tree trunks with a medium-toned grey mixed from Winsor Blue and Venetian Red, drybrushing it onto the paper to give a little texture and leaving some space for leaves to appear in front of the bark. This is to 'record' where they are before they are lost under the next layers. Leave some space for the leaves to appear in front of the bark.

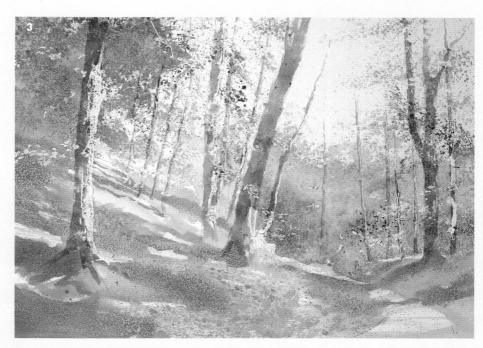

3 Spatter Olive Green and Quinacridone Gold randomly across the paper, increasing the density towards the ground and sprinkling salt as you go. The smaller brush (no. 4) will make smaller spatters than the no. 8, so vary their use according to the perspective. Reserve the brightest sunlit patches on the ground and an area of sky.

4 Build up the layers by spattering varying dilutions and mixes of Olive Green and Quinacridone Gold. Drop some warm greys (mixed from Winsor Blue and Venetian Red) into areas to create shadows and a sense of depth. Be careful to retain the light areas.
Inset: Use a dip pen to draw scratchy lines for the foreground grasses.

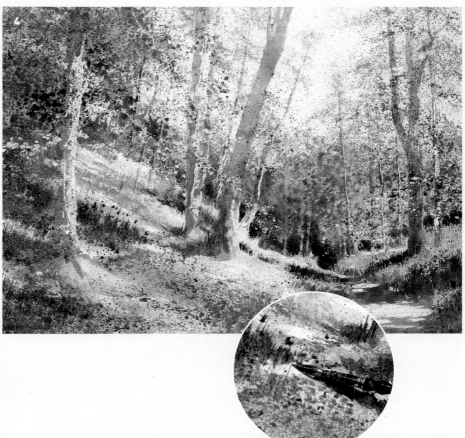

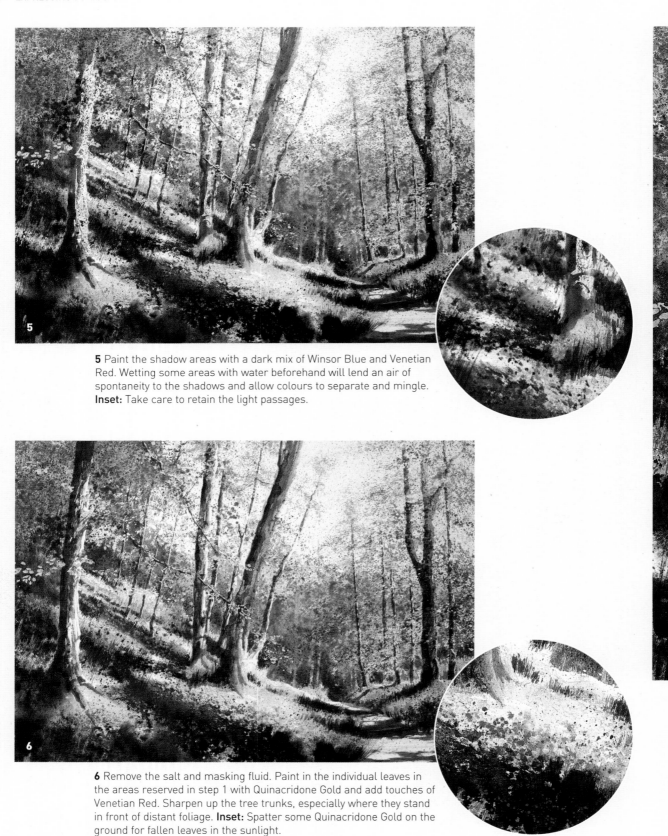

5 Paint the shadow areas with a dark mix of Winsor Blue and Venetian Red. Wetting some areas with water beforehand will lend an air of spontaneity to the shadows and allow colours to separate and mingle. **Inset:** Take care to retain the light passages.

6 Remove the salt and masking fluid. Paint in the individual leaves in the areas reserved in step 1 with Quinacridone Gold and add touches of Venetian Red. Sharpen up the tree trunks, especially where they stand in front of distant foliage. **Inset:** Spatter some Quinacridone Gold on the ground for fallen leaves in the sunlight.

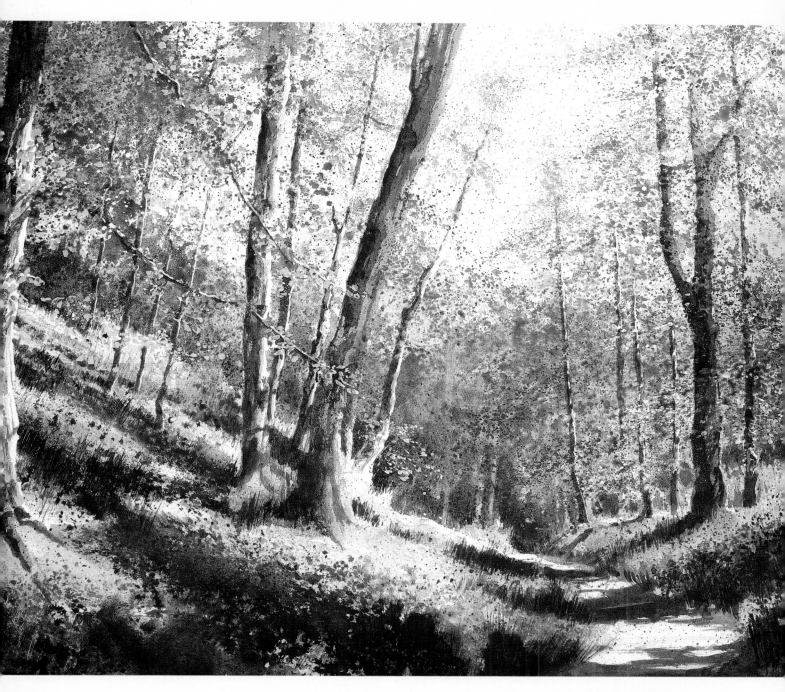

Autumn Woodland

NAOMI TYDEMAN

Autumn brings warm reds and
golds to this woodland scene,
where a path leads the viewer into
denser woods and lends an air of
mystery. A diagonal slope gives
strength to the design, which is
enhanced by the shadows created
by bright sunlight.

Study in green

In many landscapes, green is the predominant colour — and it's amazing just how many different greens there are! This project is an exercise in using a range of proprietary greens to create a unified scene that is full of light and shade. The key is to think about the temperature of the colours you use. Here, everything from the light, yellowy greens in the fresh, bright foliage to the blue-greens used in the shadow areas, is warm in tone, helping to create a scene that is suffused with summer sunshine.

RICHARD THORN

MATERIALS

640 gsm (300 lb) rough watercolour paper	Watercolour paints: Manganese Blue, Cobalt Violet Light, Cadmium Lemon, Ultramarine Blue, Permanent Mauve, Cadmium Orange, Cadmium Red, Yellow Ochre
2B pencil	
Masking fluid	
Old brush for applying masking fluid	
Mixing palette	Light greens: Brilliant Green, Phthalo Green Light
Water	Medium greens: Phthalo Green, Hooker's Green Light
Paper towel	
Brushes: No. 12, no. 1 and no. 3 round, stipple, rigger	Dark greens: Phthalo Green Dark
	Gouache: Permanent White, Cadmium Yellow, Cadmium Red, Brilliant Green

1 Using a 2B pencil, make a quick sketch, delineating the overall pattern and shapes — passages of light and shade, the beekeeper and hives (which are the main point of interest), the curve of the darker grasses in the foreground, the main foliage masses. Using an old brush, mask out the areas that you want to remain white. Note that the beekeeper wasn't there in the actual scene, but was added for a little human interest.

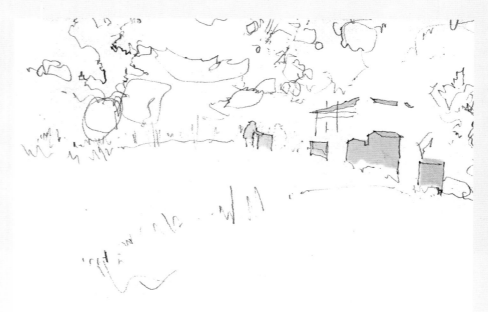

1

2 Paint the sky using Manganese Blue. Brush in the light greens. While this initial wash is still wet, drop in some medium and dark greens for variation of both colour and texture. There's a small patch of foliage with a slightly reddish tinge in the foliage on the right; paint this in a dilute mix of Cobalt Violet Light and Cadmium Lemon.

3 While the paint it still damp, use a small round brush dipped in clean water to lift off some of the blue from the sky. Stipple on dark greens to add more texture to the trees, being careful to leave some of the underlying colours showing. Add some painted marks, such as branches, in the trees with a no. 3 round brush. At this stage, try to keep the painting loose — but also be aware of holding the composition together. Leave to dry.

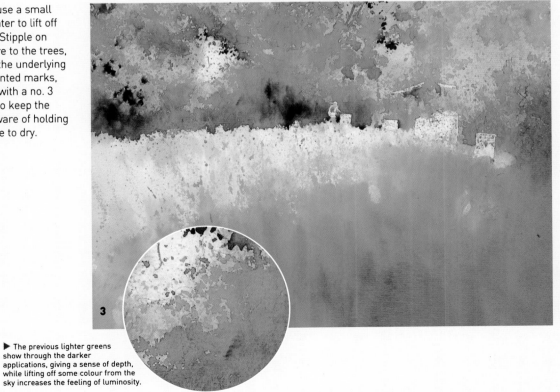

▶ The previous lighter greens show through the darker applications, giving a sense of depth, while lifting off some colour from the sky increases the feeling of luminosity.

4 When the paint is dry, stipple darker accents, such as blues and violets, onto the trees, taking care not to obliterate the underlying colours and textures. Wet the bottom half again and darken the foreground grasses, using upward strokes that follow the direction in which the grasses grow. Spatter some darker greens, blues and violet into this area to create more texture and liveliness and give an impression of the blue-green grasses/flowers in the foreground. Don't paint a hard edge for the shadow line, as it needs to blend into the lighter grasses.

5 Now work on the foreground, adding darker green and blue blobs and dots to the dry paper to delineate the depth and undulations of the grasses. When this is dry, drop some clean water randomly into the foreground, wait for it to lift the pigment, then dab it off with some absorbent paper towel. This brings back the underlying wash and creates the textures of the seed heads and flowers, which are more prominent in the bottom left of the painting. Add a few grass details using a rigger brush — but not too many, as they'll dominate the shadow line. You can put in more details in the final stages.

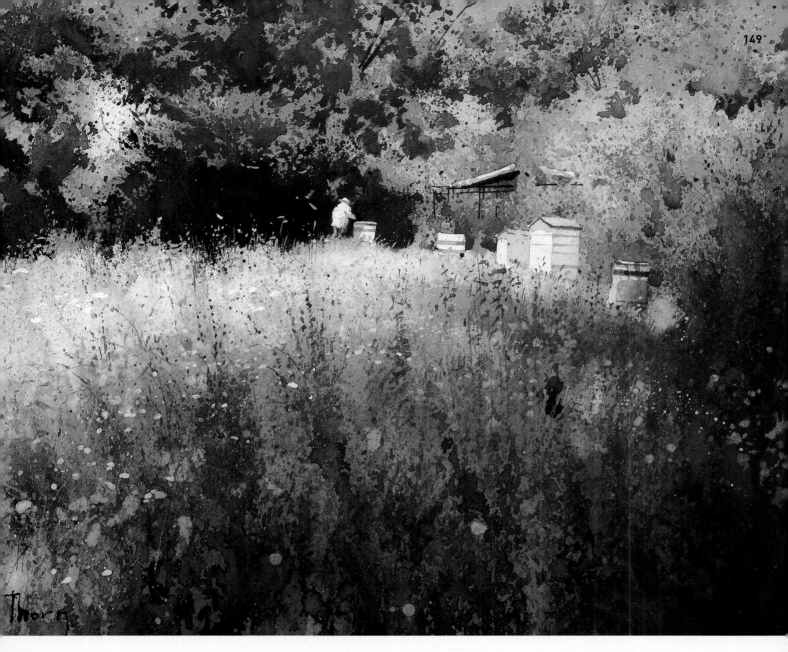

◄ The summer flowers add more colour to an otherwise green scene. Make the spatters and dots smaller as you move towards the background to give a sense of distance.

6 The depth and textures of the grasses are now developed enough to add body colour. Mix Permanent White gouache with Cadmium Lemon, Cadmium Orange, Cadmium Red and Brilliant Green gouache paints for the flower heads. Use both a stipple brush — spattering in here and there — along with small dots made with a no. 1 round brush and a rigger to give the impression of brightly coloured flower heads and create textural variation. Finally, rub off the masking fluid and work on the hives and the beekeeper. Use very dilute Manganese Blue for the shadows and details, dropping in a very small amount of Yellow Ochre to warm up the blue.

Study in Green

RICHARD THORN

The richness and variety of the greens describe a scene of abundance and plenty.

Sunlight & Shade

Bright sunlight is always attractive to portray, whether you're painting an urban landscape or a countryside setting. In watercolour, this is another situation where you can exploit the whiteness of the paper to create a sense of warmth and luminosity. The corollary of strong sunlight is rich shadows, which help to define solid objects and tend to be sharp-edged in bright, sunny situations. Even shaded areas that you might expect to be cooler in tone may have warm sunlight reflected into them, so choose your colours carefully.

◀ *Un Vélo à Copenhague*

THIERRY DUVAL

The effect of bright sunlight has been effectively conveyed in this painting, with dappled light creating shadowy shapes on the wall. The cast shadows of the bicycle also help to anchor it to the ground.

Bryce Arch

ROBERT HIGHSMITH

The canyon face on the left, although in shadow, retains a lot of light and colour, owing to the effect of reflected sunlight bouncing off the opposite side of the canyon.

Rhapsody in Green

HANNIE RIEUWERTS

There is a subtle blend of sunlight and shade in this painting. The brightness of the sunlit area is brought out by the cool shadows and the strong. graphic form of the bridge beyond.

◀ *Italian Fishing Village*

MOIRA CLINCH

The high key of this painting, along with the short shadows, help us determine that this subject depicts a time of around midday.

Waterscapes

Water can be calm and peaceful, fast flowing and raging, sparkling with bright highlights and broken up by myriad ripples, or completely still, displaying mirror-like reflections. All of this makes good painting material and watercolour seems tailor made for it: the translucency of the medium perfectly mirrors that of the subject.

Observe carefully how water behaves in its different moods. Sometimes it pays to just sit and watch how waves are formed and how they roll and crash onto rocks and beaches, or to study the flow of a stream and see how it it diverts when it encounters a rock.

When painting moving water, match the direction of your brushstrokes to the direction of the water flow. Look carefully at whether the water reflects its surroundings (reflections are generally softer and more muted in tone than the objects being reflected) or whether you can see the darker tones below the surface.

Fontaine Médicis

MICHAEL REARDON

Lovely, fluid wet-into-wet washes form the foundation of this painting, dominated by the water and reflection in the foreground. Wet-on-dry washes describe the more solid areas of the composition.

The Quiet Teign

RICHARD THORN

The wet-into-wet technique has been used to show the soft reflections of the trees, while skillful use of masking fluid creates the sparkle and highlights on the surface of the river, indicating the direction of flow.

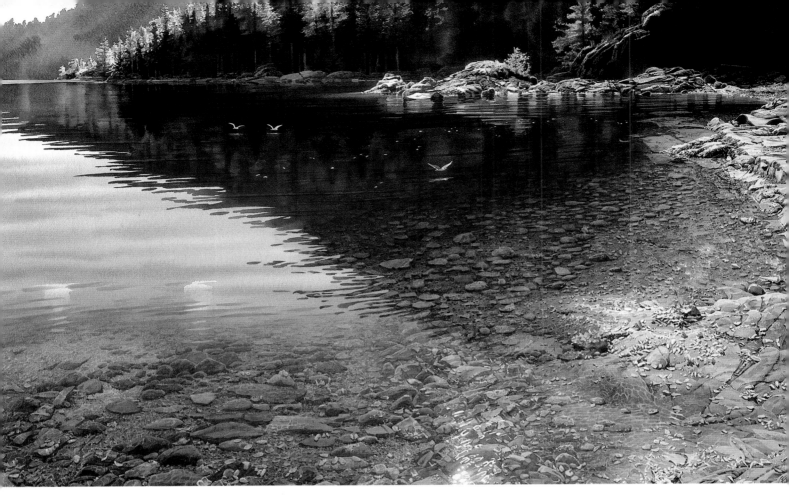

Pendrell Sound

CAROL EVANS

Wet-into-wet areas provide the gentle lapping surface of the water, reflecting the blue sky. In the foreground, clever use of transparent washes gives the impression of clear water in the shallows.

Brighton Pier

DAVID POXON

The impression of a mostly calm surface on the water under the pier has been achieved by several transparent washes, ranging from light to dark. Some areas have been reserved to represent foam.

Sparkling seascape

The sea is vast and majestic, changing colour and hue as it moves out towards the horizon — a painter's dream. The coastline in this scene is a wonderful mixture of colours and textures, contrasting beautifully with the transparent washes used for the water.

RICHARD THORN

MATERIALS

Khadi heavyweight paper (rough)	Brushes: No. 2 and no. 3 round, rigger, stiff oil brush
2B pencil	Watercolour paints: King's Blue Light, Cerulean Blue, Manganese Blue, Cobalt Turquoise Light, Hooker's Green Light, Cadmium Yellow Pale, Orange, Naples Yellow, Burnt Umber, Cobalt Violet Light, Permanent Mauve
Masking fluid	
Old toothbrush	
Paper stencils	
Mixing palette	
Water	
Ballpoint pens: red, blue	
Penknife	
Dip pen	
Paper towel	

1 Using a 2B pencil, make a simple thumbnail sketch showing the basic composition. Leave out the horizon line — you want the horizon to 'disappear' into the sky.

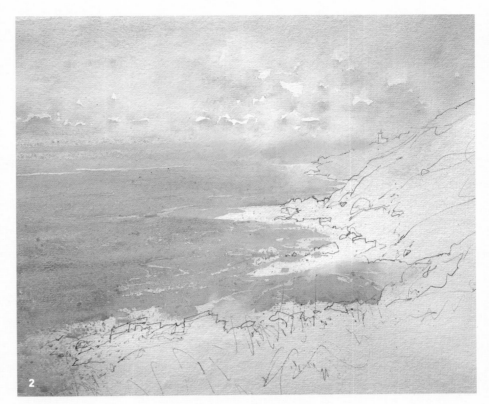

2 Using masking fluid, an old toothbrush and paper stencils to create sharp lines, mask out the areas where you want light passages, out towards the horizon. Draw in foamy lines nearer the shore with no. 2 and 3 round brushes. Leaving areas for white cloud shapes, wash in the sky colouur using a mixture of King's Blue Light, Cerulean Blue and Manganese Blue. Carry the wash down into the sea, adding Cobalt Turquoise Light and more Manganese. Gradually darken the wash as you come further down by adding more Cerulean Blue.

3 When the paint is dry, apply washes to the headland using equal amounts of Hooker's Green Light, Cadmium Yellow Pale, Orange and Naples Yellow. While this initial wash is still wet, drop in Burnt Umber mixed with Cobalt Violet Light.

Strengthen the sea with the same blues used previously, leaving white areas for the surf and allowing some underlying colour to show through. Add some cloud shadows using King's Blue Light with a little Cobalt Blue and a touch of Cobalt Violet Light.

In the foreground, scribble in lines of red and blue ballpoint pen; these will show through subsequent washes and add textural interest. Working wet into wet, apply washes using mixes of Burnt Umber, Cobalt Violet Light and Permanent Mauve over the pen work.

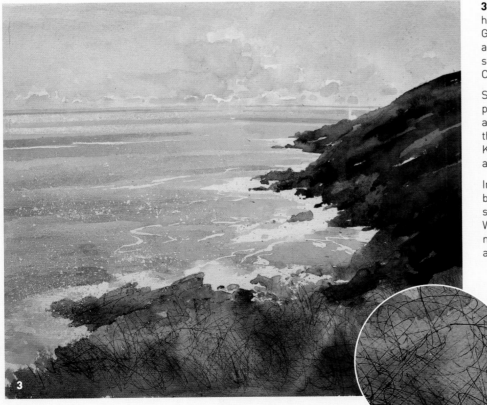

◀ Scribbled pen lines create the effect of rough foreground twigs and grasses.

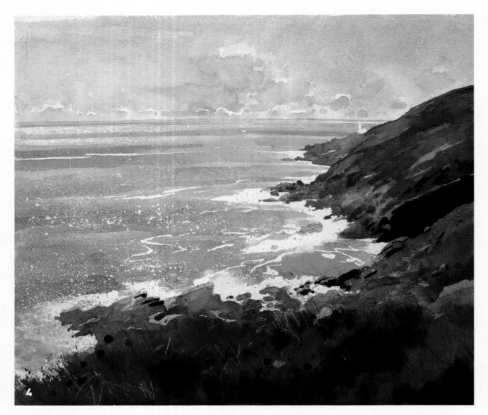

4 Strengthen the headland using the same colour mixes as before, again leaving some lines to add texture and direction. Now wash in more of the same colours for the foreground. While this is drying, carefully scratch out some lines using a penknife. Add more textural interest by dabbing with your finger here and there. Where the paint is dry, begin to add a few rock details using a no. 2 round and a rigger brush.

Using a mix of Cerulean Blue and Permanent Mauve, paint some darker lines out to sea. Finally, rub off all the masking fluid to reveal the white paper highlights.

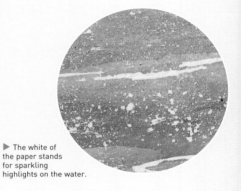

▶ The white of the paper stands for sparkling highlights on the water.

5 To finish the painting, darken all the elements using the same colours as in previous washes and spatter in some texture in the foreground. While this is drying, scratch out more lines for the gorse twigs.

When the washes are dry, 'draw' in the details with the small round brushes. Using your darker colours with the addition of Cobalt Blue, delineate the shadow side of the rocks.

Paint in the lighthouse and the boat, being careful to leave the lit side as white paper. Use clean water, a stiff oil brush and some paper towel to lift off some of the paint from the cloud edges and surf areas. Using a dip pen, draw in some of the twigs (seen more in the middle foreground).

Inset: Add some body colour to the foreground to add texture and bring this area forward in the scene.

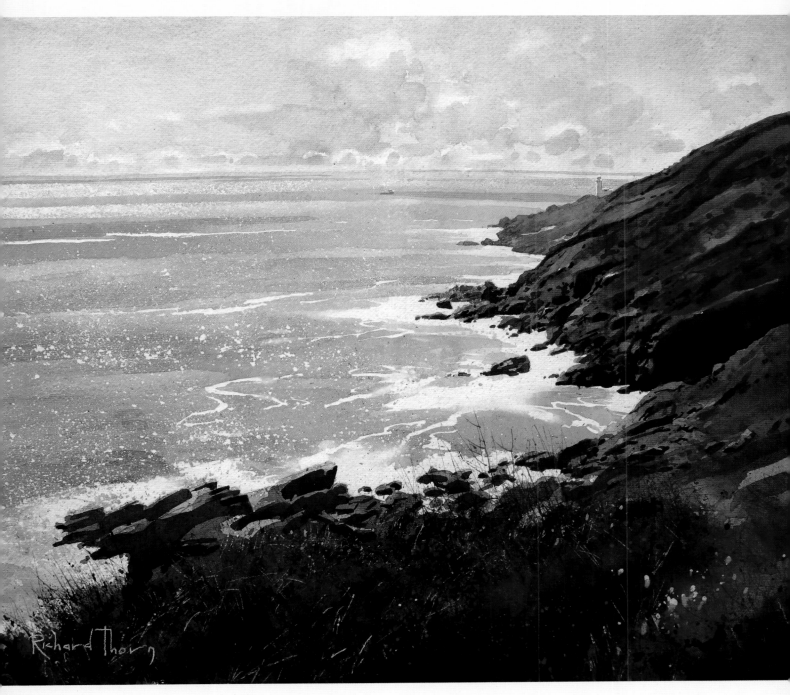

Out on the Lighthouse

RICHARD THORN

The transparent washes on the
sea and sky contrast beautifully
with the heavier applications of
paint on the rocky headland.
Scribbled, scratchy pen lines
and body colour add texture to
the foreground.

Rippling reflections

Rippling reflections indicate water that is moving due to the effects of wind and currents. The direction of that movement affects the way reflections occur. In still water, nearby objects are reflected directly beneath the object as mirror images. As water movement increases, the reflections bend and break consistent with the direction of water flow. As the water becomes choppy, the reflections will disintegrate; this can be shown with short, close, horizontal strokes. Lifting out a few random, horizontal marks will unify all shapes into one body of water.

NANCY MEADOWS TAYLOR

MATERIALS

Sketch pad

Tracing paper

4B pencil

640 gsm (300 lb) cold-pressed watercolour paper

HB pencil

Masking fluid

Old brush for applying masking fluid

Brushes: Large wash, selection of rounds, small filbert (for lifting out colour)

Watercolour paints: Antwerp Blue, Aureolin Yellow, Viridian, French Ultramarine Blue, Burnt Sienna, Cobalt Blue, Rose Madder Genuine, Indian Red, Lunar Violet, Raw Sienna, Cadmium Scarlet

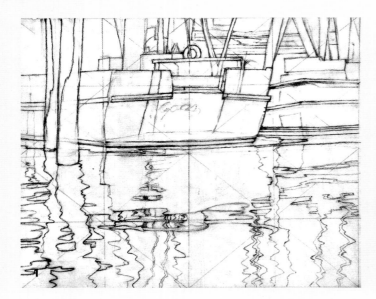

1 First, make rough sketches to work out the composition and tonal values. (Pilings were added to the left and water increased at the bottom to strengthen the design.) Referring to your drawings, make a detailed drawing on tracing paper. Using a 4B pencil, scribble over the lines on the reverse side, then attach it right side up to the watercolour paper. Trace over the lines of the drawing with an HB pencil to transfer them to the paper.

2 Using an old brush, apply masking fluid to any small shapes that you want to remain light. Wet the entire paper with clean water. Using a large wash brush, apply Antwerp Blue to darker areas and Aureolin Yellow to the light areas, leaving some of the white paper untouched.

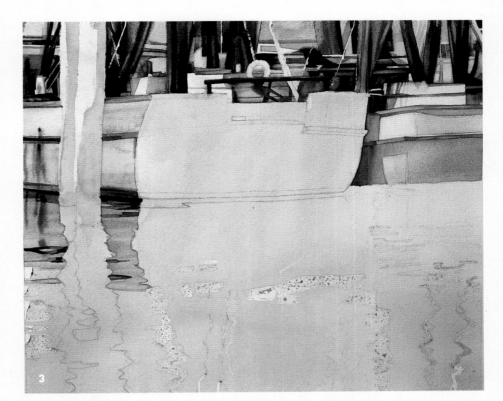

3 Start by painting the most distant area (the small shapes at the top of the boats), using round brushes of the appropriate size. Use mixtures of Viridian, French Ultramarine Blue, Burnt Sienna, Cobalt Blue, Rose Madder Genuine and Aureolin Yellow for the greens, browns and greys. Put the darks in early to establish these values for the remainder of the painting. Do not paint the life belt until the later stages.

4 Paint the left and right sides of the image, leaving the pilings until later. For the light grey of the shadow, use Cobalt Blue, Rose Madder Genuine and Aureolin Yellow; for the dark grey use French Ultramarine Blue and Indian Red. Use zigzagging, horizontal strokes in the reflections to read as water movement. For rust, dip a damp brush into undiluted Burnt Sienna and French Ultramarine and brush onto damp paper.

▼ Zigzagged brushstrokes read as water movement.

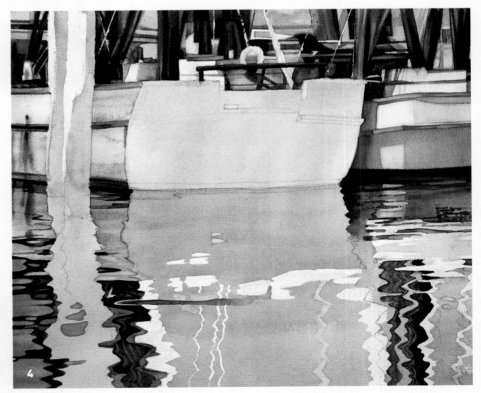

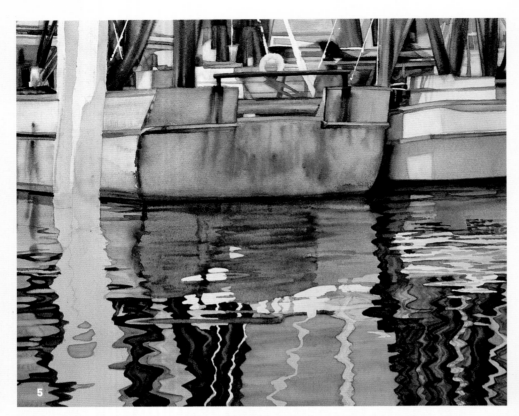

5 Develop the centre section. For the greys of the boat and their reflections, use deeper values of the same colours used previously. Note that the reflections of the boats are darker than the boats themselves, and make sure that the reflections align beneath the objects being reflected and that the direction of flow of the water and the reflections are consistent. Add Lunar Violet to the mixture for the boat to add a gritty look to the lower part.

▼ The rust colours granulate and spread randomly on the damp paper.

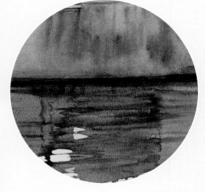

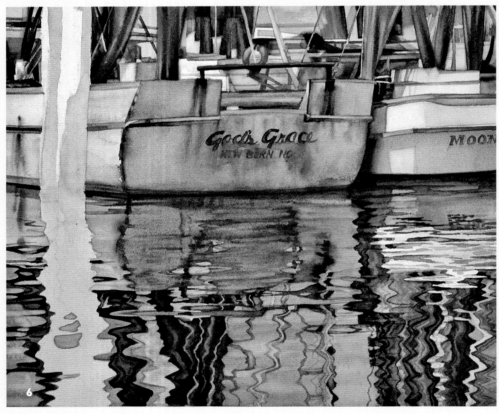

6 When the paint is dry, add the crisp, sharp details of the boats' names, using darker versions of the rust and violet colours. Paint the orange life belt and its reflection.

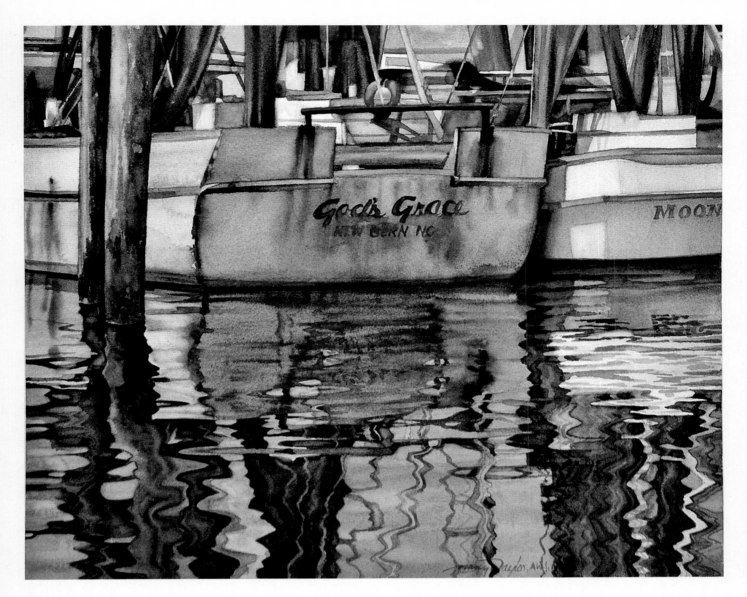

7 Paint the pilings last so that the edges overlap to support the illusion of perspective. Add visual texture by roughly brushing mixtures of Burnt Sienna and French Ultramarine Blue onto dry paper and dropping on water or pigment (Burnt Sienna). Add Raw Sienna to the light areas. Lift marks with a filbert brush and add drybrush for more texture. Paint the reflections darker than the pilings.

Safe Anchor

NANCY MEADOWS TAYLOR

Alone, water is an inert, colourless liquid that is very reflective. However, in the vicinity of boats and docks, water picks up surrounding colours and patterns which, when aided by wind and currents, are transformed into exciting and playful images. This painting shows that well, with zigzagging patterns reflecting the rusting boat and the green nettings in briskly moving water.

Snowscapes

A winter landscape, with a fresh fall of snow, makes a very appealing subject, especially if it is a rare occurrence. Once you are out there, though, it can be quite challenging. It's difficult to paint with icy fingers and a frozen water supply. Despite this, snowscapes make lovely subjects for watercolour, presenting opportunities to paint reflected light, bright skies and long shadows. Just make sure that you are well prepared and well wrapped up to get the most from the experience.

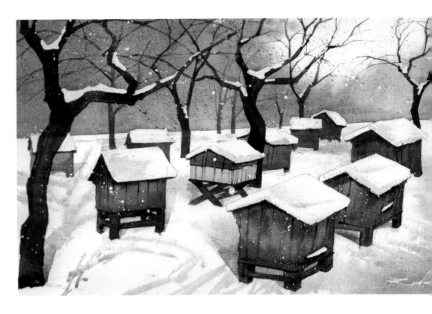

Beehives

RAFAL RUDKO

The elevated viewpoint chosen for this painting isolates the beehives from each other and makes an effective composition. The bright, snow-capped hives add a dash of colour to the otherwise monochrome scene.

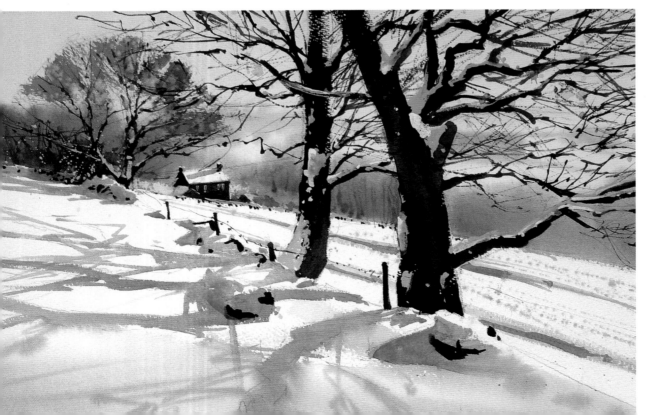

Two Trees

PAUL TALBOT-GREAVES

The weak sun, coming from the right of the scene, creates an interesting tracery of shadows on the tree trunks and branches, on the snow-covered foreground and in the middle ground of this winter landscape.

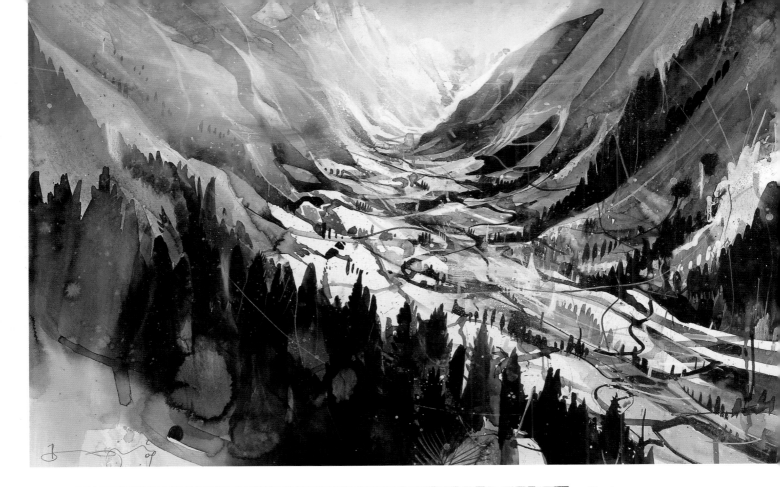

Piztal

BERNHARD VOGEL

The sunlit valley in this snowscape is bordered by the shady, tree-covered mountainsides, creating a natural path through the painting. We are led through the valley to the bright, sunny area in the background.

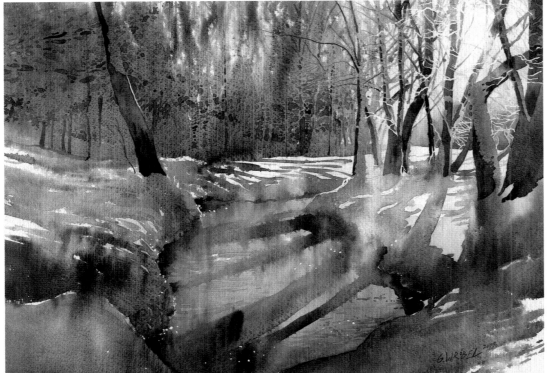

First of All, Passion

GRZEGORZ WROBEL

Despite the fact that this is a snow-filled landscape, most of the painting is dominated by shadow, owing to the backlit angle. It makes the bright areas all the more effective.

INTRODUCING TEXTURE

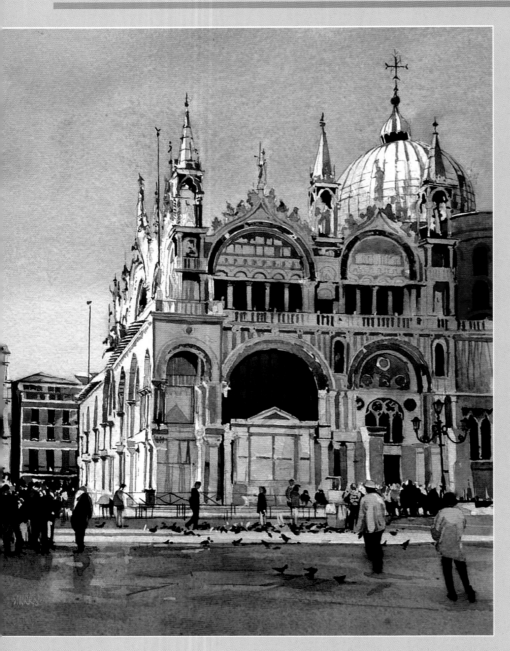

Every surface possesses a texture of some sort. Whether smooth or rough, texture can be described to great effect in watercolour using a variety of techniques, from glazes and wet-into-wet washes to drybrush.

There are innumerable possibilities for painting textures both in the natural world in man-made surroundings. Frequently, compositions can be created incorporating ideas and features from both. Use the many watercolour techniques at your disposal to describe them.

San Marco from the Piazzetta

DAVID MORRIS

Great care has been taken to describe, in some detail, the ornate stone façade of St Mark's Basilica in this painting. Careful observation and attention to shadows help to convey the structure of the building.

Feathers and Pebbles

NAOMI TYDEMAN

A detailed watercolour technique has been used here to show a combination of textures. The softness of the feathers has been well described, as has the shiny, surface of the wet pebbles.

Bubbles

DEB WATSON

Various textures are described in this colourful watercolour painting, ranging from the young girl's hair and the folds of her dress to the soft background blues and the spherical forms of the bubbles.

The Look of Love

LIZ CHADERTON

There are many ways to illustrate texture in watercolour, and this study of a cat's face shows that you don't necessarily have to paint every hair and whisker to give the impression of fur or hair.

Radiance

CARA BROWN

Not only is the velvety nature of the rose petals captured to perfection in this painting, but so too is the sunlight penetrating the flower heads, allowing us to almost feel their papery translucency.

Calm Within

ANGUS MCEWAN

This painting illustrates the power of nature and time, and shows every detail in this old wall and grille, revealing smooth and rough surfaces, cracks and fissures, wood grain, wire and decay.

Still life of shells

Still lifes do not have to be elaborate and packed full of lots of different objects — here, a collection of shells gathered from around the world provided the inspiration. As the shells themselves are relatively small, the key to depicting their form is to observe very carefully how the tones change as light falls away from the lit side to the shadowed side. The textures of the shells range from smooth and glossy to angular and ridged, so vary your brushstrokes from wet-into-wet applications to drybrush and pay particular attention to the highlights and cast shadows; all these things will help to make the shells look three-dimensional.

NAOMI TYDEMAN

MATERIALS

Watercolour board, NOT surface

2B pencil

Masking fluid

Old dip pen for applying masking fluid

Mixing palette

Water

Fine-nibbed dip pen

Brushes: No. 4 and no. 6 round, stiff bristle brush

Watercolour paints: Venetian Red, Burnt Umber, Yellow Ochre, Winsor Blue, Sap Green, Winsor Violet

1 Position the shells carefully, paying attention to patterns within the picture space. Here, there is a strong diagonal of larger shells, some columns of similar shapes and little groups of colours. When you are satisfied with the design, sketch them in using a 2B pencil and mask out any highlights on the shiny shells, using masking fluid applied with a dip pen.

2 Lay in the base colours of each shell, alternating between the no. 4 and no. 6 brushes depending on the size and complexity of the individual shells. Blends of the four main colours – the red, umber, ochre and blue – form the foundation of most of the shells and create a harmony within the painting.

▶ Small touches of Sap Green and Winsor Violet are used for local colour in the little green and pink shells.

3 Build up the patterns and basic characteristics of each shell, paying attention to the way the patterns curve around the body.

▼ Be aware of where the light hits the subject: subtle differences in tone as the light falls off slightly from one side to the other can reveal a lot about the shells' form.

4 Using the four main colours, mix enough of a soft purple-grey to paint all the shadows. (Use just a touch of the Yellow Ochre and Burnt Umber in the mixes to warm them up.) Note how the shadows cast by the shells anchor them on the paper and tell the viewer whether the tip of a shell is touching the surface or floating above it.

5 Develop the shadows on the curves of the shells themselves to increase the sense of light and form. Lift colour from the lit side of the shells using the stiff bristle brush, clean water and paper towel. **Inset:** Accentuate the details using a fine-nibbed pen dipped in watercolour.

6 Rub the masking fluid from the highlights. Some may need to be softened or sharpened, depending on the surface texture of the shell in question.

7 Lift curves of light in the deepest shadow areas, where light reflected from the surface of the paper creates more of a sense of form.

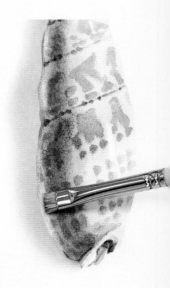

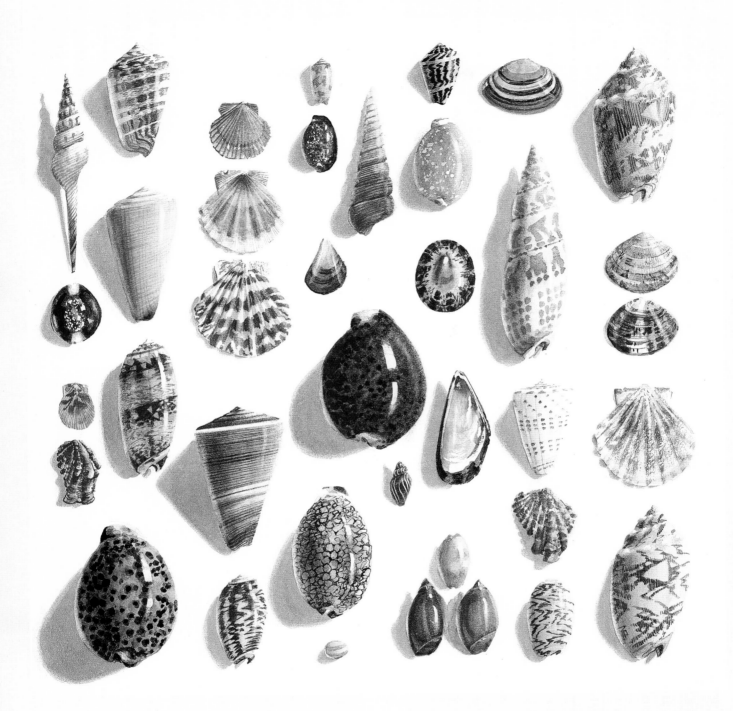

38 Shells

NAOMI TYDEMAN

A calm and considered representation of some of nature's overlooked life forms, this painting took quite a few days to complete. The result is a record of some of the beauty and complexity of life lived under water.

Decay & worn textures

The effects of time, weather and nature on both man-made and natural surfaces — the rusting metal of old chains, locks and hinges, flaking and cracking paint, pitted and cracked brickwork and stone or rotten or sun-baked wood — can make fascinating subjects.

Venetian Promise

DAVID POXON

The sunlight glowing from this painting picks out the rust and graffiti on the gates. It illustrates perfectly what a range of colours can be found in a subject, which, at first glance, may not initially seem obvious.

Ferguson System

RICHARD BELANGER

This is both a study of the smooth red-painted metal covering of the tractor and an exploration of the intricate, rusty textures of the machine's engine parts.

Key Moment

ANGUS MCEWAN

In this letterbox-format painting, the grain of the exposed wood is painstakingly rendered in a detailed watercolour technique. The cool grey-blue is balanced by the equally detailed ancient rusted lock.

Consecration Stone

JIM DUNBAR

The bright sunlight picks out every crack and crevice in this study of stone and lichen. The hard rock surfaces are complemented by the delicate, intricate, brightly coloured flowers.

Worn textures

Even the most apparently mundane things can form the subject for a painting. With its peeling paintwork, twisting iron bars and rusty old padlock, this old door, tucked away slightly off the tourist trail in Venice, provided an irresistible challenge. Build up the tones by glazing (see page 45) and use a variety of texturing techniques, including spattering (see page 80) and delicate blending.

DAVID POXON

MATERIALS

425 gsm (200 lb) cold-pressed watercolour paper	Water
2B pencil	Brushes: Large flat, large filbert, no. 1 rigger
Flexi-curve	Watercolour paints: Manganese Blue, Lemon Yellow, Phthalo Blue, Alizarin Crimson, Yellow Ochre, Burnt Sienna
Ruler	
Masking fluid	
Old dip pen for applying masking fluid	
Mixing palette	

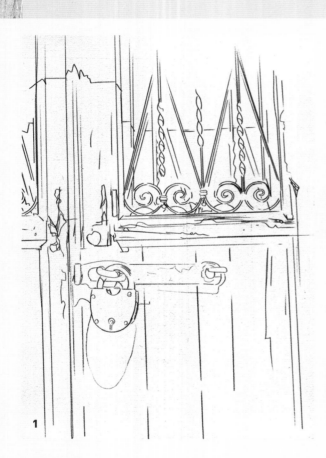

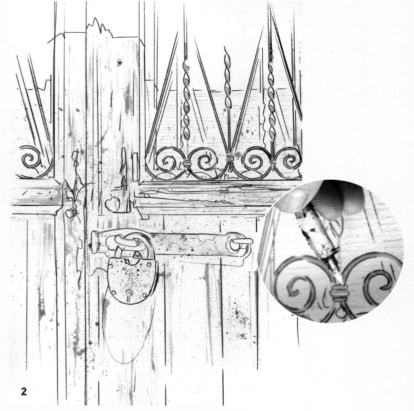

1 Using a 2B pencil, carefully draw the main outlines of the door. Use a flexi-curve or other curved object to accurately render the twisting ironwork of the metal bars. The padlock and door furniture is attached to the woodwork; later, you will use dark shadows to create a three-dimensional effect.

2 In pure watercolour no white paint is used, so use masking fluid to preserve areas of the paper that you want to remain white, such as the highlights on the twisted metal bars and the extreme lights in the wood-grain patterns. Spatter blue masking fluid over the padlock and peeling paint areas.
Inset: Apply the masking fluid with a fine, steel-nibbed pen or a sharpened stick and use a ruler to get straight edges. Wait for it to dry before you go on to the next stage.

Applying masking fluid

Applying the masking fluid with a sharpened stick or twig allows you to create lines of irregular width, unlike the very regular lines that you get using a pen. Using blue masking fluid rather than white makes it easier to see where it's been applied.

3 Mix a blue-green wash from Manganese Blue and Lemon Yellow and, using a large flat brush, apply it to the paper in vertical strokes. Mix a mauve/purple shade from Phthalo Blue and Alizarin Crimson and paint in the darkened window recess. Use a filbert brush to paint the padlock in Yellow Ochre, and then apply Burnt Sienna wet into wet. While this wash is drying, begin to introduce some of the wood grain lines with your rigger brush, alternating between Burnt Sienna and Yellow Ochre. Tilt the board slightly and let the colours merge and blend. Wait for the paint to dry, then repeat this stage two or three times until you have achieved sufficient tonal depth.

4 Mix a darkened lavender colour (the consistency of cream) from Manganese Blue and Alizarin Crimson and start to pick out the wood grain and edges of peeling paint. Spatter random mixes of Manganese and Yellow Ochre onto the door to suggest texture and weathering. Paint in the shadows around the padlock and door frame with the mauve/purple mix. When this is dry, carefully glaze another wash (the consistency of milk) over the blue-green over areas of the door. Wait for this to dry, then repeat this entire stage, including the padlock shadows, to further deepen and enrich the colours.

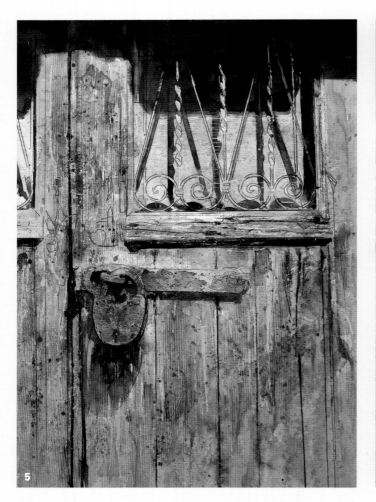

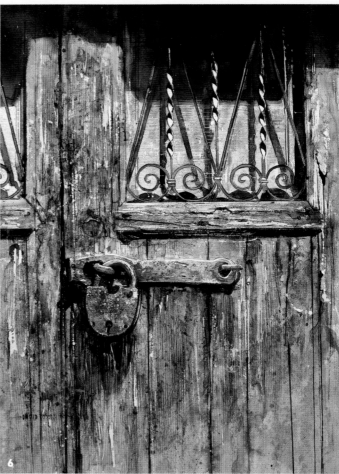

5 Remove all the masking fluid by rubbing it off with your finger.

6 Using Yellow Ochre and Burnt Sienna, mix a rust colour to the consistency of cream and carefully paint in the metal bars. Use the same colour to add details to the padlock. Check over the painting and tidy up areas of drafting that may have become obscured. Add more peeling paintwork shadows with the lavender colour and also darken the padlock's cast shadows. Use a darker mix of Manganese and Yellow Ochre to add any mid tones to the paintwork.

Hidden Lives

DAVID POXON

In this textural study (right), scratchy pen lines, spattering and glazing combine with wet-into-wet applications in which the paint is allowed to flow freely down the paper. This artist has achieved great tonal depth by multi-layering, and has created a realistic illusion by sandwiching finer painting and drawing in between each glaze. Note, too, the use of complementary colours (see page 32) — the rich blue of the window recess and the blue-greens of the wooden door against the rusty orange of the metalwork (left). Ancient doors and windows offer you the opportunity to really explore texturing and drawing techniques.

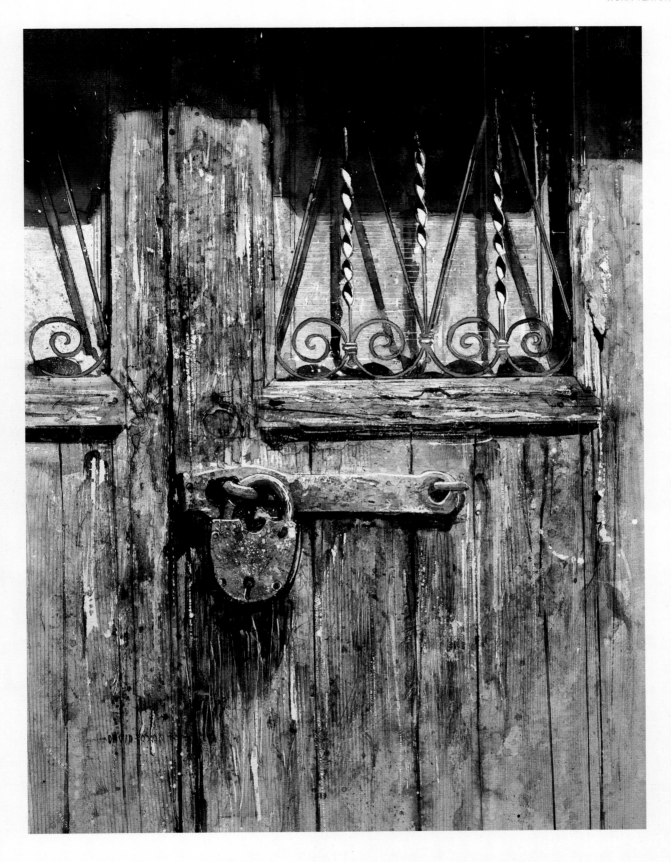

Fabrics

Fabrics come in many different textures, from diaphanous chiffons and smooth silks to soft-piled velvet and intricately patterned lace, and often feature both in still lifes and portraits. From a painter's point of view, they're much more interesting when draped to form interesting folds and creases: look for the changes in tone that convey such folds. With patterned or striped textiles, observe how changes in the direction of the pattern show how the fabric has been draped.

Chair

TONY BELOBRAJDIC

An area of the artist's studio is the focus for this still-life study. The chair is positioned so that it catches the sunlight, spotlighting the folds of the draped fabric.

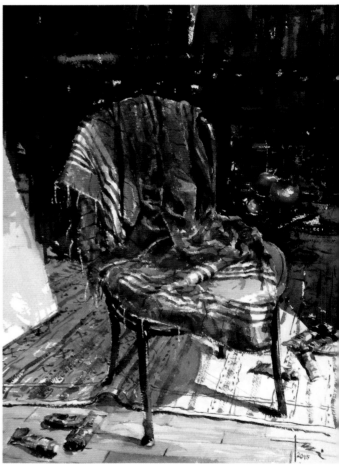

Monhegan Morning

DEB WATSON

A carefully observed study of fabrics and folds, with light from the open window casting shadows, creating interesting shapes and valleys. Attention has also been given to the tree canopy outside.

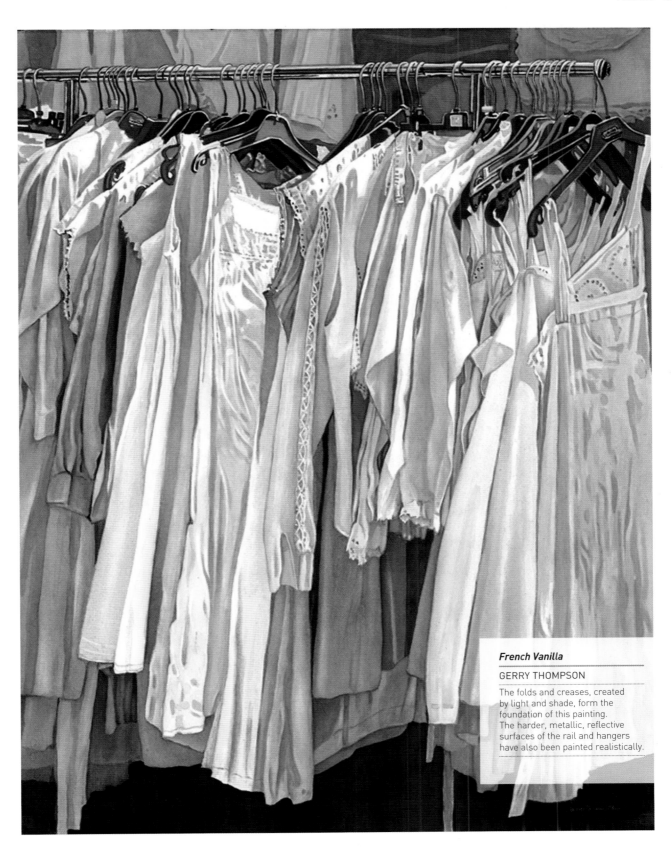

French Vanilla

GERRY THOMPSON

The folds and creases, created by light and shade, form the foundation of this painting. The harder, metallic, reflective surfaces of the rail and hangers have also been painted realistically.

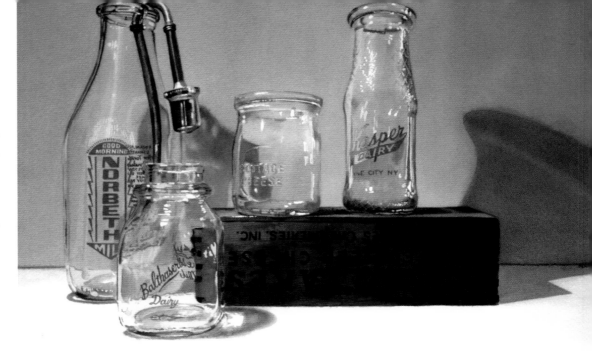

Pasteurised

DENNY BOND

An interesting variety of bottles and jars can make a good painting subject. The glossy surfaces, with their myriad highlights, combine well with the softer, non-reflective surface of the wooden box.

Glass & shiny objects

Still-life subjects provide a great opportunity for painting beautiful glass objects. Clear glass, coloured glass, cut crystal or even old bottles and jars can all be arranged in the optimum position for the light to show it off at its best. Quite elaborate arrangements can be assembled to paint, but even a single item placed on a sunlit window ledge can make a great painting.

The texture of metal can be both shiny and rough. Gleaming metal can possess similar qualities to glass when it comes to painting. Polished metal can make attractive subject matter: think of old cars with metal bumpers and hubcaps, or brass musical instruments like trumpets, French horns and trombones. All these surfaces reflect light and, in some cases, reflect distorted images of their surroundings too. The white of the paper can be used extensively for portraying bright highlights. Use masking fluid to reserve the many small, and sometimes intricate, shapes of catch lights.

Degrees of Illumination

BARBARA FOX

A low-angled light source, shining from behind these marbles, creates interesting long shadows coming towards the viewer. Both the shiny glass and the matte surface have been cleverly painted in watercolour.

Milestone

GERRY THOMPSON

The metallic, golden glazes of this commemorative cup and saucer have been portrayed with great accuracy using warm yellows and browns, and go well with the cooler blues and greys of the china and lace.

Dull Shine

DENNY BOND

None of the metallic objects in this still life are shiny or polished. Instead, the artist has perfectly described a range of items with a matte surface, with little or no bright highlights.

Architectural details

Buildings offer boundless opportunities for painting texture and detail in watercolour: new high-rise office blocks may have smooth, reflective walls and windows, while older buildings often feature more decorative windows, doorways and arches with fine details in stonework and metal.

Artists are often drawn to the decaying nature of neglected buildings like old factories and warehouses, in which broken windows and missing roof tiles allow shafts of sunlight to rake through the dust and dirt below. In such situations the textured nature of peeling paint, rotting timbers and cracked stonework can often be enhanced by the use of a rougher paper, which is more conducive to drybrush techniques.

Prague Towers

YURIY SHEVCHUK

The textures on the nearest towers and turrets in this aerial cityscape have been portrayed in great detail. However, the details are lessened as the buildings recede into the distance.

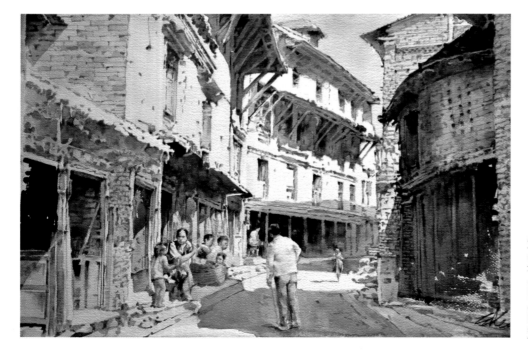

Entrance to Patan, Nepal

ONG KIM SENG

The detail in this street scene has been softly rendered in shades of brown. Great attention has been given to the textures of stone, brickwork and wood, even in the shadow areas.

Le Magasin Sennelier

THIERRY DUVAL

Stone, glass and wood have been accurately described here in a range of cool colours. The coolness is relieved by the slit of warm sunlight visible beyond the doorway.

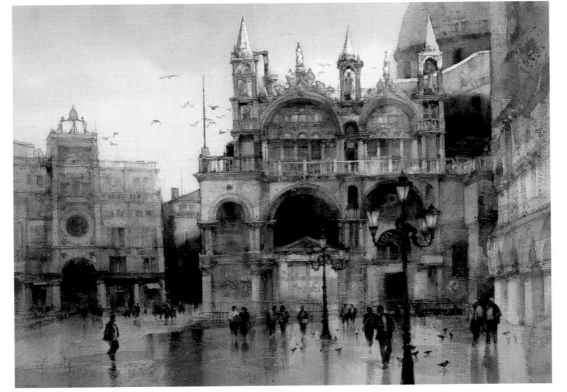

Twilight

CHIEN CHUNG WEI

The artist has managed to portray a highly detailed structure with a beautiful, soft technique. The essential information is all there, providing depth and form, yet the painting remains fresh and unfussy.

Architectural textures

This painting is an exercise in rendering some of the many textures found on old buildings — the brightly lit but smooth stonework of the statues and columns, the crumbling brickwork in the arches and the worn wooden pilings in the foreground. With so many different elements, a good underdrawing is essential, as is a careful assessment of the tonal values if the dazzling white statues are to look rounded and three-dimensional — but take care not to allow the drawing to dominate, otherwise the work may become laboured and lose some of its freshness.

DONNA WITTY

MATERIALS

Watercolour board

H pencil

Mixing palette

Water

Masking fluid

Drafting pen for applying masking fluid

Brushes: No. 4, no. 6, no. 8 and no. 10 round

Watercolour paints: Cobalt Blue, Permanent Rose, Quinacridone Sienna, Manganese Blue, Antique Pale Blue, Quinacridone Gold, Burnt Umber, Rich Green Gold, Prussian Blue, Cobalt Violet

1

2

1 Make a simplified but accurate line drawing directly onto the board with an H pencil. Don't put in too much detail at this point; leave yourself the opportunity to make changes as you go along.

2 Using a no. 4 or a no. 6 round brush and Cobalt Blue, Permanent Rose and Quinacridone Sienna, paint the shadows on and behind the statues, allowing the paint to mix and blend here and there; this will define the shapes. Lightly mix Manganese and Antique Pale Blue in the palette and paint the shadows on the balcony posts. Lastly, run a light wash of Quinacridone Gold along the stones above the water. Leave to dry.

3 With the drafting pen, mask the balcony railings and posts painted in the previous step, and the whites in the area below the balcony, on the statues and on the pilings in the water. Leave to dry.

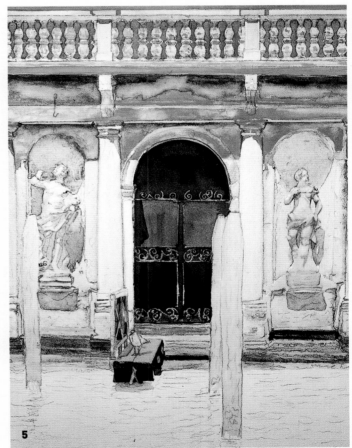

4 Mix Manganese Blue with Cobalt Blue and paint behind the balcony railings and posts. Continue this mixture down onto the façade of the building. Staying in the shadow area, use a light wash of Permanent Rose and Cobalt Blue for the 'white' areas. Use a mixture of Rich Green Gold and Cobalt Blue in the greenish-yellow areas under the second heavy beam below the balcony, and bounce some of this coloured light into the tops of the two arches. Deepen the base colour of the brickwork in the arches behind the statues and along the quay. Use Antique Pale Blue and Manganese together to create the blue of the remaining paint on the façade.

5 Mask the seagull, the light areas of the platform and the iron grillwork on the door. Let dry. Paint the platform using varied mixtures of Cobalt Blue, Permanent Rose and Manganese Blue, adding Burnt Umber to darken where necessary. Lightly mix Prussian Blue, Cobalt and Burnt Umber and paint the door; aim for some variation in tone here. When this has dried, go over the wash with the same mixes to darken areas and create the shadows behind the scrolls and the balcony railings. Add darks to the platform as well and also along the walkway stones.

6 Remove the masking fluid except for on the pilings and the seagull. Soften the edges of the iron scrollwork on the door and paint into them with Quinacridone Gold and Manganese Blue, allowing the colours to touch and blend in places (top left). Paint the broken brickwork in the arches using a mix of Quinacridone Sienna and Cobalt Blue, then apply this mix to all the brick shapes around and behind the statues, keeping the coverage uneven (bottom left).

7 Remove all the remaining masking fluid. Paint in the pilings using varied mixtures of Permanent Rose, Cobalt Blue and a little Quinacridone Gold, keeping the colour in tone with the rest of the painting. Paint the dark feathers on the seagull and its shadow with Burnt Umber and Cobalt Blue. Check for areas that may need to be adjusted by softening or by deepening shadows.

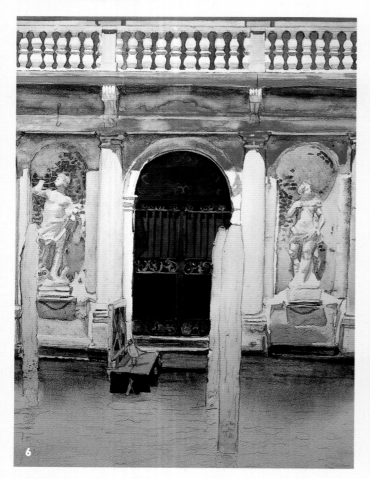

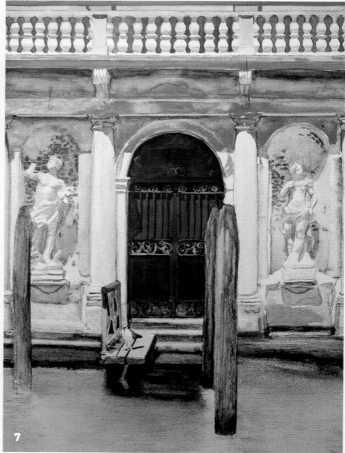

8 Wet the entire surface of the water, load a no. 4 or a no. 6 brush with the same Quinacridone Gold and Rich Green Gold as before, and run the brush along the edges of the stone. Tilt the painting and allow colour to run into the water. It will create its own reflection. Add more pigment and continue to tilt. Leave to dry.

9 Add reflections into the water. Begin slowly, adding colour and light and building up layers rather than punching in colour.

10 Loosely paint the exposed plaster behind the figures with a combination of Cobalt Blue and Quinacridone Sienna; this will push the figures forward visually. When dry, go over the red of the bricks in the shadow area with Quinacridone Sienna and Burnt Umber to deepen them and create a colour contrast with the bricks that are in the sunlight.

Create a deeper shadow area under the balcony with a mixture of Cobalt Violet and Rich Green Gold. When dry, use Cobalt Blue to lightly paint shadows around the peeling areas of paint and plaster within this area.

Using your smallest brush, create the texture of aging wood by adding cracks, wood grain and peeling paint to them as well. Paint the interesting little hook on the façade, just above the statue on the left.

The Guardians

DONNA WITTY

This painting captures the many different textures within the scene without ever losing freshness or spontaneity. The artist has utilised a whole raft of watercolour techniques, from reserving the white of the paper to creating soft but believable shadows and tilting the paper to allow the paint colours to flow together in an exciting but spontaneous way.

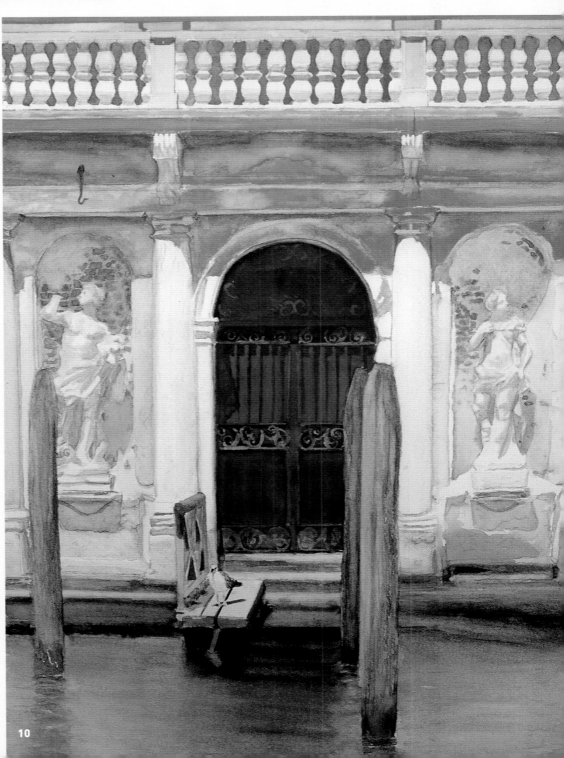

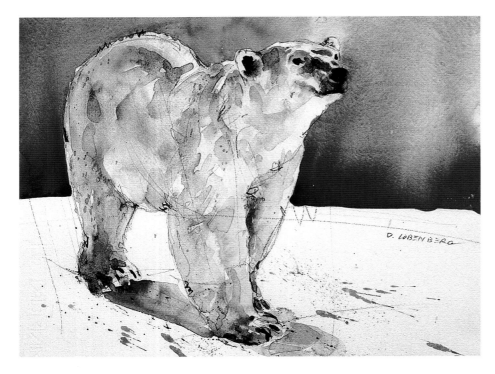

Bear on Ice

DAVID LOBENBERG

A loose watercolour style has been used for this study of a polar bear. A great variety of colours, applied wet into wet, has been used in the 'white' areas of the animal's fur.

Animals & birds

Animals are also good subjects for studying texture and a walk around your local zoo will provide opportunity to sketch fur, feathers and scales.

There are many techniques that can be applied to animal textures, including wet into wet, drybrush and the multi-layered approach. Fur can be painted in either a loose, impressionistic style to emphasise the character of the animal, or using a more detailed approach for a more illustrated look. Feathers, especially the downy variety present on chicks and ducklings, lend themselves to a soft, wet-into-wet treatment, although some areas of drybrush would indicate a little more form. Look for differences in tone within the fur and feather masses, as these will help you convey the skeletal structure and the main muscle groups of the animal or bird in question. Large scales, such as those seen on crocodiles, alligators and lizards, create interesting shadows, almost like the bark of trees. Some drybrush effect could also be employed here.

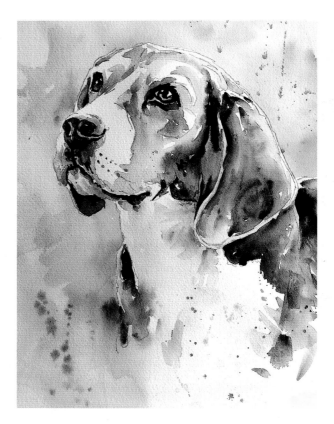

Dog is my Co-Pilot

DAVID LOBENBERG

The character of the dog has been captured in this loose, mostly wet-into-wet, painting. Areas of untouched paper have been left to represent the white parts of the animal's fur.

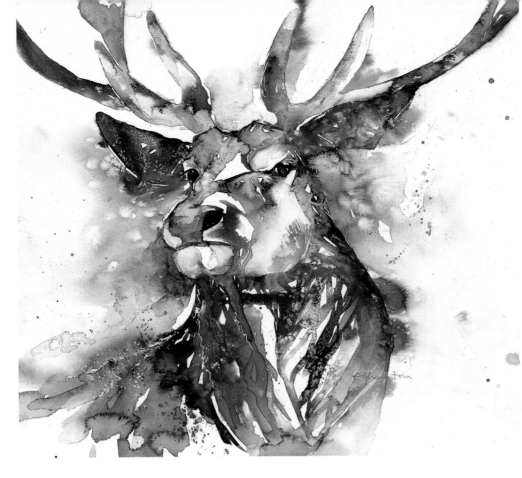

Stag

LIZ CHADERTON

Several textural techniques, including spatter and backruns, have been utilised in this loosely painted, mostly monotone, portrait of a stag. The background is minimal, to allow the viewer to focus on the animal.

Three's a Crowd

ANNELEIN BEUKENKAMP

The lively, alert nature of these hens and rooster has been captured in this closely cropped painting. A soft background of warm yellows and browns contrasts with the strong colours of the birds.

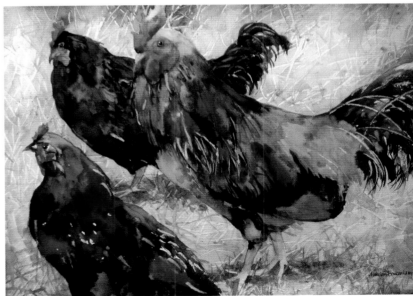

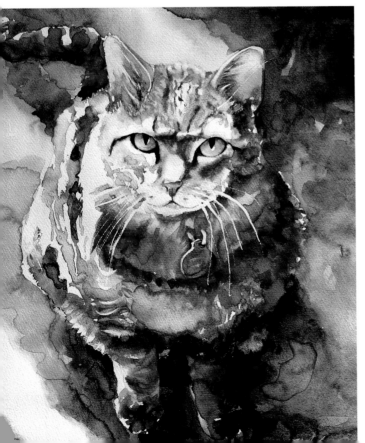

◀ Heads Up

VICKIE NELSON

The overhead angle chosen for this study works very well as the animal looks up at the viewer. The warm reds and oranges of the ginger cat contrast nicely with the cool blues and purples of the background.

Twin Dahlias

CARA BROWN

A lovely feeling of warm sunlight has been achieved in this study of two dahlia flower heads. Warm oranges and reds complement the cooler greens and blues of the background leaves.

Flowers

Watercolour is a wonderful medium for painting flowers. Because it is transparent, you can glaze one colour over another, capturing the subtle colour changes and value shifts as light shines through the translucent petals or the top layer of petals casts shadows on those below. You can also blend delicate shades wet into wet on the surface. Some plants, such as cacti, have more textured stems, and masking fluid may be useful here for reserving the fine needles, as well as for painting tiny, delicate stamens in the centre of a flower head or the fine veins in a leaf.

Spring Palette

ANNELEIN BEUKENKAMP

The various shapes of flowers and fruit have been carefully drawn in this still life. Good use has been made of 'light against dark' as the eye travels across the contrasting forms in the painting.

Catching the Last Light II

CAROLINE LINSCOTT

Great depth has been achieved here. By making the top flower cooler and shady it appears to recede, while the lower flower is brought forward by the sunlight playing on the petals.

Canna 2

NANCY MEADOWS TAYLOR

The delicate forms of the flower petals have been carefully painted in this study, as have the veined vertical structures of the background leaves. The warm oranges advance while the complementary greens recede.

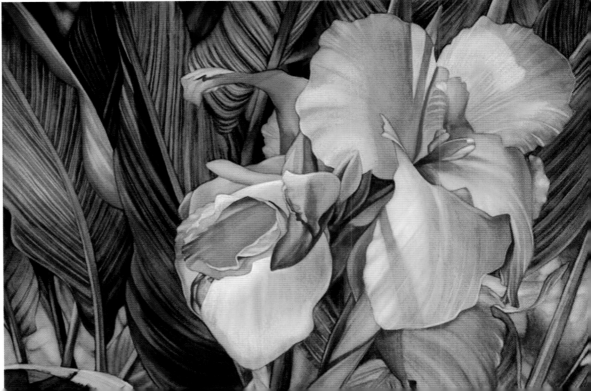

California poppy

Painting white flowers presents particular challenges. The illusion of white is created in two ways: by leaving the very lightest parts untouched by paint and through the use of colour combinations. Generally, as the light arcs and changes, you will see the colours move from blue and blue-violet (Verditer), to red-violet (Quinacridone Violet), to red (Scarlet Lake), to yellow (Permanent Yellow Light), to white. This project allows close analysis of the way light arcs and bends, as it changes character and hue.

KAREN VERNON

MATERIALS

Sketch and wash pencil

Drawing paper

3B pencil

Aquabord or 640 gsm (300 lb) cold-pressed watercolour paper

Mixing palette

Water

Brushes: No. 10 round, no. 12 shader

Watercolour paints: Verditer Blue, Manganese Blue Hue, Quinacridone Violet, Scarlet Lake, Permanent Yellow Light, Gamboge Nova, Sap Green, Phthalo Blue

Value sketch
Before starting a painting like this, it's a good idea to plan the composition in greyscale, as a small sketch, generally about 10 cm (4 in.), that focuses on the shapes of the values. Mark half and third points (see page 110) to assist in the design and loosely block in the values using a sketch and wash pencil.

1 Following your value sketch and using a 3B pencil, draw out your composition. Drawing directly onto the surface, rather than transferring the picture, allows you to create fluid, thick and thin lines that speak to you as you paint.

2 Dampen the surface with clean water, working at a mid-sheen level of wetness, and paint the shadows on the flower in light tones of Verditer Blue, allowing the paint to flow and create soft transitions. As the blues move towards the light (towards yellow), you can change to a light Manganese Blue Hue.

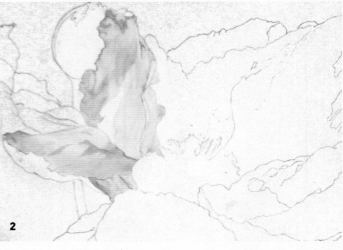

3 Now create more shadow values, keeping the colours pale while working on a damp surface. As the petals arc, ruffle and bend, the colours appear to change, going from violet-blue, a Verditer Blue and Quinacridone Violet combination, to light red, Scarlet Lake, to light yellow, Permanent Yellow Light, to white. Let dry.

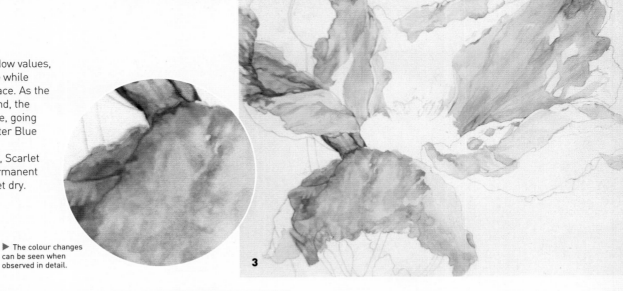

► The colour changes can be seen when observed in detail.

4 Dampen the bud with clean water, then paint the bud in Permanent Yellow Light, adding Manganese Blue Hue and allowing it to slowly crawl over the surface. Add Quinacridone Violet to the colour to dull it a bit when wet.

► The colours blend wet into wet on the paper.

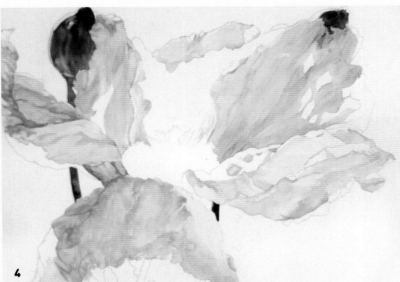

5 Wet the centre of the flower and wash in pale yellow. Mix Gamboge Nova and Scarlet Lake and add dots and strokes to create the illusion of the stamen and pistils. Drop Manganese Blue Hue into the background immediately behind the front petals, making the stamen recede. Allow this area to dry in order to have no bleeds from one colour to another.

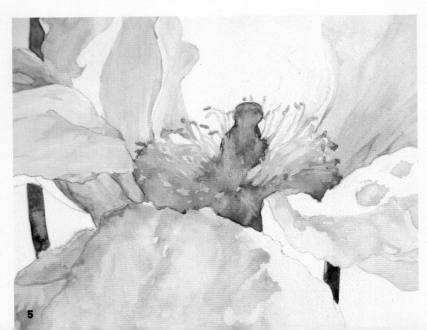

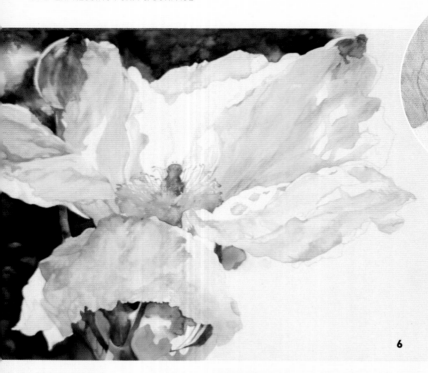

Yellow and green blend on the damp paper to create subtle gradations of colour.

6 Start painting the greens of the foliage by applying a wash of yellow wet on dry, pulling it out into the area you want to fill. Soften the edge with water where you stop. While the yellow is still damp, add Sap Green. Add Quinacridone Violet to dull where needed.

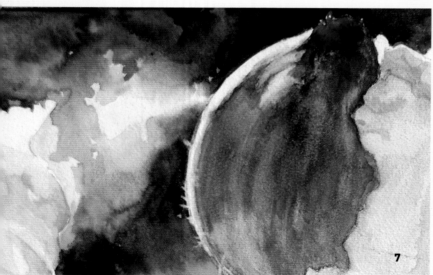

7 The flower now appears to be a pale blue — but when the darker-value background is added, the white is accentuated. Using fresh water, wet areas of the background and drop Sap Green, Quinacridone Violet and Phthalo Blue into it, allowing the colours to flow.

8 The colours blend wet into wet on the paper for soft, out-of-focus, background flowers. While damp, drop Permanent Yellow into areas to create a yellow bloom that results in soft, subtle lights.

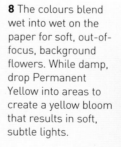

9 After glazing dark values wet on dry into the background, add details in the centre of the flower. Some of the details are put in by adding dark, wet-on-dry colour, while other details, such as the highlight along the stem, are created by removing paint with the shader brush. More tiny details, such as the fuzzy stems, can be lifted out before all is completed.

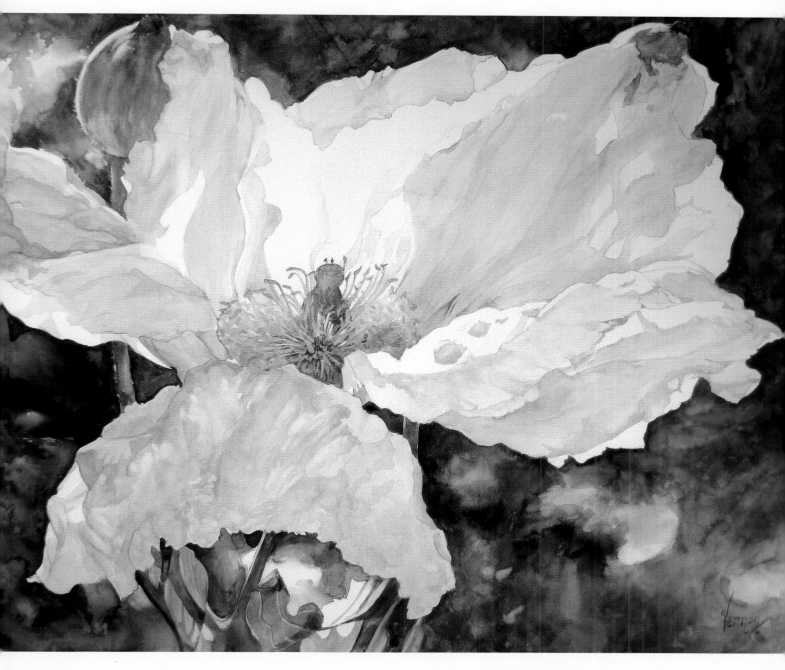

Light Dancer

KAREN VERNON

This painting is a wonderful adventure in painting light, texture and radiant colour. Soft colours are blended wet into wet on the surface, naturally creating the puckered effect of the petals in places. The soft, fuzzy buds and the spiny stems offer an interesting texture that subtly contrasts with the ruffled texture of the petals.

INTRODUCING FIGURES & PORTRAITS

Watercolour is a wonderfully fluid medium and these properties can be used to great effect in painting the human figure and portraits. Every face is different, and every face is capable of a plethora of expressions and nuances. Over the years these expressions become individual traits and form the character of an individual. It is these traits and nuances that you need to identify and translate onto paper in order to capture a likeness.

It is not easy to obtain a convincing resemblance: perhaps this subject, more than any other, requires accurate drawing and assessment of proportions. For example, the distance between the eyes, or between nose and mouth are critical details, which must be correct in order to create a portrait of someone we may recognise. Getting accurate proportions applies whether you work from life or use a photo as your reference source.

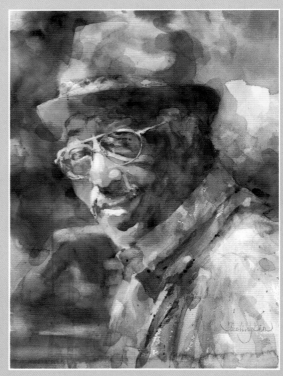

Hank

FEALING LIN

The lively character of the subject in this portrait has been captured in a wonderfully loose style. Detail has been restricted to the main features, which leads the viewer to the eyes of the sitter.

Uighur Woman

FEALING LIN

Careful drawing and attention to proportions of features are essential requirements for creating convincing portraits. Head-on poses are particularly challenging, but here the artist has used light and shade to successfully create a feeling of depth.

Ninety-two

DENNY BOND

The polka dots on the sitter's skirt are complemented by the similar backdrop pattern and also the string of pearls. The clock reminds us of the passing of time.

Painting of a Girl

LINDA KOOLURIS DOBBS

The dark hair, clothing and background help the viewer to focus on the young girl's face, which is sunlit and in stark contrast.

Lighting is also very important. Natural lighting, perhaps from a window, is very complementary. Direct sunlight is good but can be a little harsh, so use some sort of filter — such as a piece of translucent material — between the light source and the subject to take the level down slightly. If the lighting is too strong, the shadows it creates can also be harsh. They can be softened by placing a reflector — such as a large piece of white card — on the opposite side of the light source, which you can angle to bounce some light back into the shadows.

Artificial light is constant and unchanging, and you can move lights around until you get the desired results. A main light can be positioned at the front, quite close to the sitter and preferably from one side. This will illuminate the face but, on its own, may cause some harsh shadows. A second, weaker light, can be positioned on the other side of the sitter and from further away to provide some fill-in light for the shadows.

Posing for portraits

Posing a model is an important aspect of portrait painting. If the pose is to be for a head and shoulders study, or a seated position, it is important that your model can remain comfortable for a length of time, especially if they may be elderly. You then have to decide what viewpoint you want. Which angle works best? What is the sitter's best side?

There are several viewpoints to choose from. You may choose to have the sitter looking directly towards you, for an intense pose. A three-quarters view will still allow you to view both eyes of the sitter, but the model faces to your left or right. Or there is the profile view, looking completely side on. Also think about how much space to leave around your subject. The general convention is that it's best to leave space for the model to look into; however, a tight crop can sometimes create a more dynamic composition.

Steeped in Tradition II

BEV JOZWIAK

The brightly clad youngster in this portrait has been posed in profile, her eyes focused on something outside the picture area, unseen by the viewer.

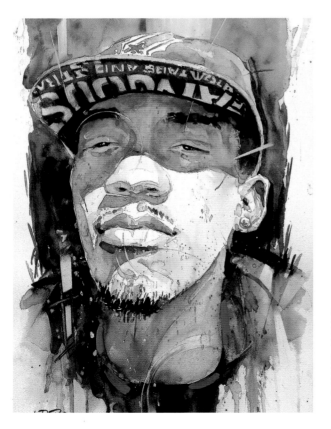

Deeper

DAVID LOBENBERG

The close-up approach adopted in this full-face portrait has allowed the artist to capture the character of this young man. His eyes, although in shadow, are a strong draw for the viewer.

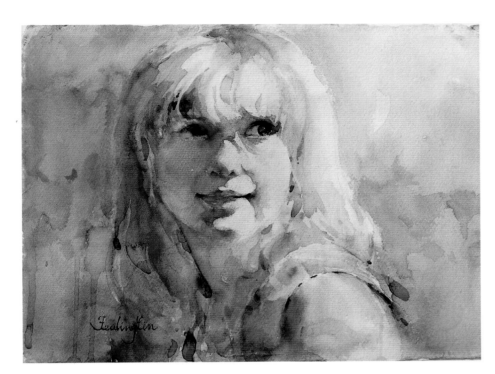

Her Smile

FEALING LIN

The subject's gaze has been attracted to something out of the picture, which creates a natural pose. The painting is beautifully lit, with light streaming in from the right, and warm reflected colours to the left.

Sketch Crawl in the Manchester Museum

LYNNE CHAPMAN

Watercolour is ideal for creating quick, lively portrait and figure studies such as this. A brush load of paint can quickly describe the shape of a figure before it moves. Here, the expressions and postures of both figures say much, without the need for detail.

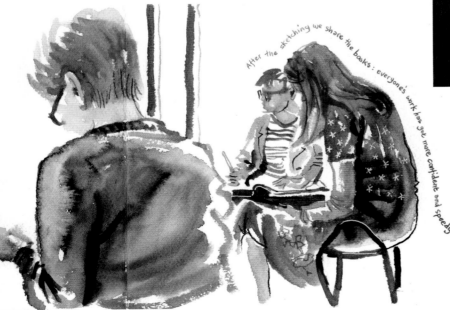

The Fisherman

DEB WATSON

By employing a landscape format for this profile-style portrait, the artist has allowed a good proportion of the picture area to be in front of the sitter, which gives him some space to look into.

Portrait

An older face is always interesting to paint as they're so full of character. Watercolour is a wonderful medium for painting portraits, as you can glaze colours to build up subtle transitions in skin tone. Here, drybrush, lifting out and negative painting have all been used to achieve a dramatic and lively portrait.

GLYNIS BARNES-MELLISH

MATERIALS

300 gsm (140 lb) cold-pressed watercolour paper

3B pencil

Mixing palette

Water

Brushes: No.12 and no. 6 round, no. 2 bright, 1 inch (2.5 cm) flat

Watercolour paints: Yellow Ochre, Alizarin Crimson, Cerulean Blue, Cadmium Red, Ultramarine Blue, Burnt Sienna, Burnt Umber, Cadmium Yellow

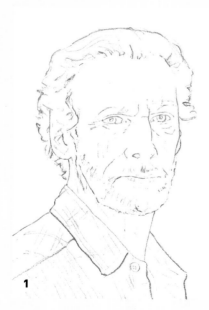

1

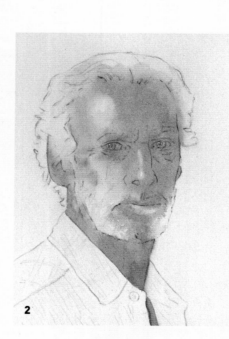

2

1 The classic composition for most portraits is a three-quarter profile. Having the face and body turned at an angle is more interesting, breaking up the symmetry and giving definition to the nose. In addition, the sitter should be slightly to one side of the composition, looking into the picture. Begin with a light 3B pencil drawing; don't press too hard — the lines will remain under the paint layers.

2 Mix Yellow Ochre and Alizarin Crimson for the base skin tone. Using a no. 12 round brush, paint this wash over the whole face and neck, including the whites of the eyes and the hair, leaving one or two white highlights on the forehead, nose and lips. Dilute the wash around the area of the beard to leave pale hairs.

3 Add a little Cerulean Blue to the first mix and, using the same brush, paint the darker skin tones to model the face, pushing back the eyes, the sides of the nose, the area under the lip and the chin. When this is dry, strengthen the shadows, particularly around the eyes.

4 Using a no. 6 round brush, add bright colours to the face: Cadmium Red at the inner eyes and the centre of the lips, Cerulean Blue in the hair and beard, Yellow Ochre on the sides of the face and Alizarin Crimson down the centre of the forehead and nose. Drybrush the colours on lightly, using the surface of the paper to break the marks up, allowing the previous washes and white paper to show through. Paint the check pattern of the shirt with Cerulean Blue and Yellow Ochre separately, and also mixed together to make a very soft green.

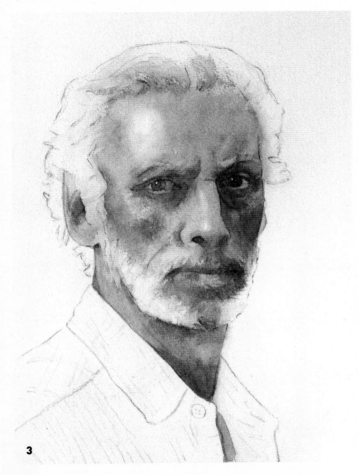

3

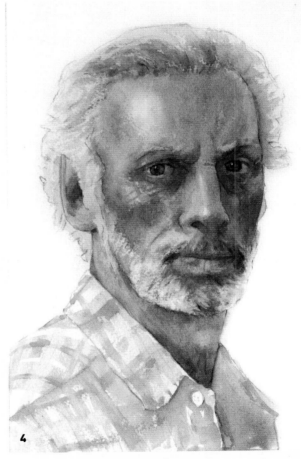

4

◀ Observe how the checks change direction as the fabric drapes over the man's body.

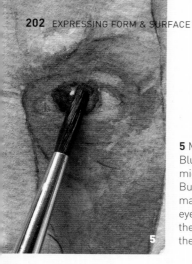

5 Mix together Ultramarine Blue and Burnt Sienna for a mid-to-dark shade. Use more Burnt Sienna in the mix to make a warm brown for the eyes and paint the whole of the iris and the shadows of the eye sockets.

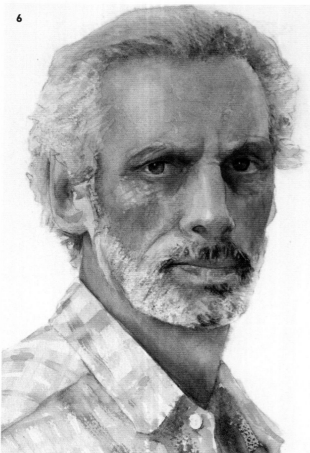

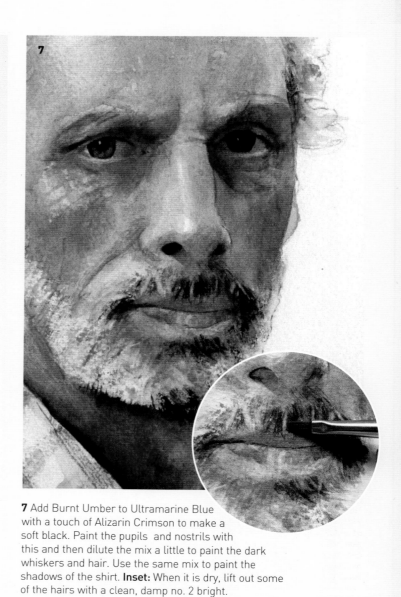

6 Add a little Ultramarine Blue to cool the mix and lightly paint the dark areas of the hair and beard, allowing the paint to break up on the surface of the paper. Use this cool brown to paint the shadows around the shirt collar and front opening.

7 Add Burnt Umber to Ultramarine Blue with a touch of Alizarin Crimson to make a soft black. Paint the pupils and nostrils with this and then dilute the mix a little to paint the dark whiskers and hair. Use the same mix to paint the shadows of the shirt. **Inset:** When it is dry, lift out some of the hairs with a clean, damp no. 2 bright.

8

8 Mix up a large amount of Cadmium Yellow and Ultramarine Blue. Use the 2.5-cm (1-in.) flat brush to paint in the background, taking care to retain all the little hairs around the face. Now add some more Ultramarine and Burnt Umber and apply this to the background while it is still damp, to create an impression of the foliage.

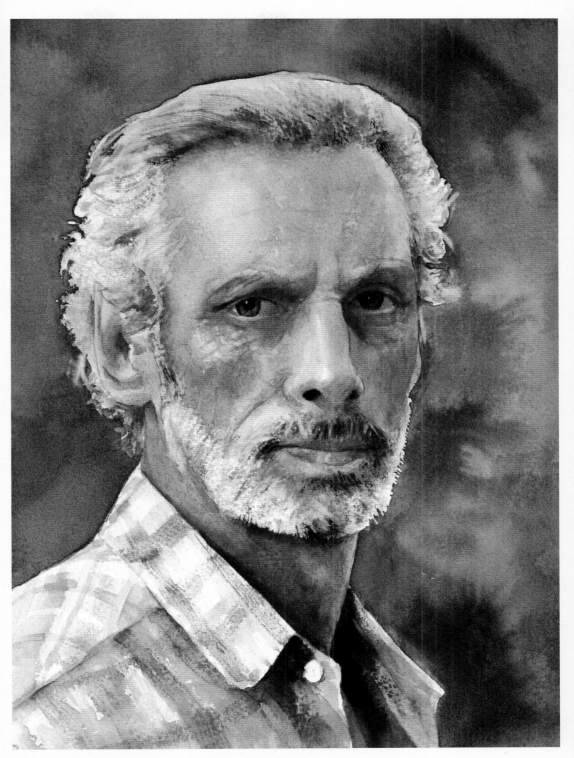

Portrait of a Man with a Beard

GLYNIS BARNES-MELLISH

This is a strong, dynamic portrait, with the model looking directly at us and holding our attention. The skin tones are built up in layers and carefully darkened to create modelling on the face. The close-cut beard and grey hair stand out against the dark background. In addition, the pattern on the shirt adds interest to the lower part of the painting.

Figures in locations

Putting figures into paintings helps to bring life to urban landscapes and city scenes. Without some indication of human life, such environments can appear deserted. Placing people in a scene also helps to give an indication of scale and perspective. They do not necessarily have to be rendered in great detail, especially if they are quite small in the painting. However, they should look as if they belong in the location, and you should take care to ensure they are lit in the same way as the rest of the painting.

View Through the Passage

DUSAN DJUKARIC

The picture is mainly dominated by dark tonal values, but the light from overhead helps pick out the strong positive and negative shapes of the figures.

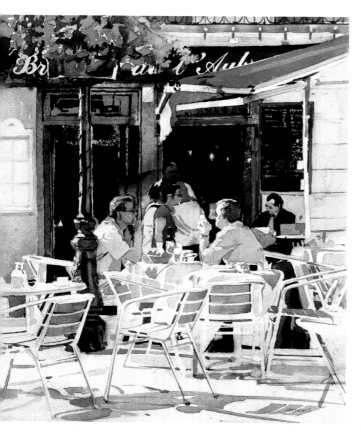

Tables in the Sun

DAVID MORRIS

Café scenes are popular subjects for the figure painter. Here, the large, dark area of thebackground window helps to pick out the group of seated figures in the sun.

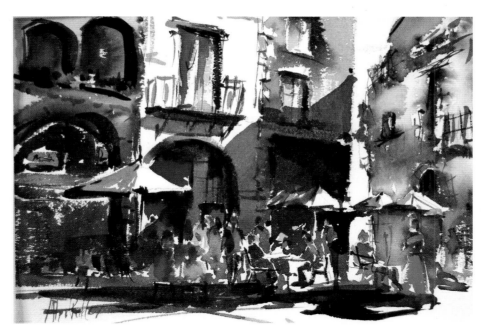

Figures

ALAN PEDDER

The figures in this street café scene are merely suggested. However, they are vital to the success of the painting as they add life and colour. Imagine how different the painting would be without them.

Midtown

DORRIE RIFKIN

The figures placed in this street-level cityscape help to populate the scene and put life into what might otherwise be a static subject.

On the Road to Mfuwe

JULIA CASSELS

Here, the figures are the main focus of the painting. They display a lot of character, and much thought has been given to the accuracy of the drawing. The painting positively glows with sunlight and colour.

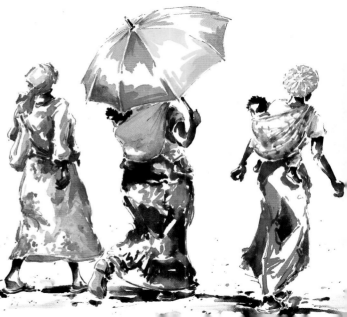

Street café scene

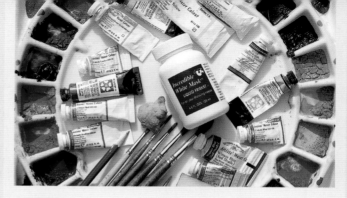

One of the most common mistakes made when painting people from a distance is to put in too much detail. Try to see them as abstract shapes and blocks of colour, rather than painting components such as the head, arms and hands, and legs individually. Different tonal values within these blocks will provide clues to the forms and make even simple, rather stylized figures look convincing. Look at angles, too — the tilt of the head in relation to the shoulders and the curve of the back.

DONNA WITTY

MATERIALS

Watercolour board	Watercolour paints: Winsor Yellow, Aureolin, New Gamboge, Quinacridone Burnt Orange, Winsor Red, Manganese Blue Hue, Phthalo Green, Cobalt Blue, Winsor Blue (red shade), French Ultramarine Blue, Brown Madder, Cobalt Violet, Quinacridone Gold
H pencil	
Masking fluid	
Drafting pen for applying masking fluid	
Mixing palette	
Water	
Brushes: No. 2, no. 4, no. 8 and no. 10 round, small stiff-bristle scrubber brush	

1 Using an H pencil, make a line drawing on the watercolour board.
Inset: Mask the whites and the lightest areas such as the parasol bases. Be sure to include the small areas such as between the chair rails and items on the tabletops. I use a drafting pen for this, as it enables me to create really fine lines and can be wiped clean with a paper tissue. White masking fluid is my personal choice.

2 With mixtures of Winsor Yellow, Aureolin Yellow and New Gamboge, paint the bright yellow parasols. Paint the yellow tablecloths and then the front of the first building. Add a touch of Quinacridone Burnt Orange to this mixture for the shadows on the first building and the base colour of building no. 4. Use this same mix for the underside of the parasols. When this is dry, paint the bright reds with Winsor Red (including building no. 5) and then add Quinacridone Burnt Orange to the red wash to paint the red-orange shadows. Paint the blue façade (building no. 3) in Manganese Blue Hue.

3 Mix Phthalo Green with Cobalt Blue for the façade of building no. 2. Using Winsor Blue and French Ultramarine Blue on the side of the blue building allows the green façade to be visually set back from the balcony along its front. Paint the blues between the balcony posts and the top of the lamp in a mixture of Cobalt and French Ultramarine, and the brown of the railing in Quinacridone Burnt Orange. For the darker shadows and the iron lamppost, mix Phthalo Green with Brown Madder, which creates a more interesting 'black'.

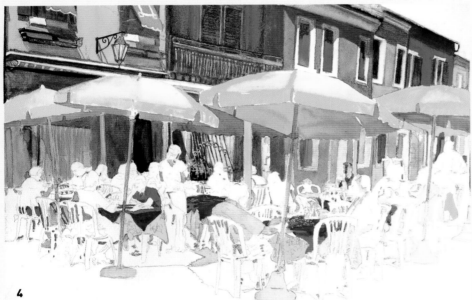

4 Enrich the background buildings with a second wash, using Winsor Red on building no. 5, New Gamboge and Quinacridone Burnt Orange on no. 4, Manganese and Cobalt Blue on no. 3 and Phthalo Green and Cobalt on no. 2, the shutters, the awnings and the chairs. When dry, paint the cast shadows on the buildings by darkening the previous mixtures with Brown Madder or French Ultramarine Blue as appropriate.

5 Using a larger brush, paint clean water across the foreground and between the shadows. While this is still wet, apply a very dilute mixture of Cobalt Violet and Quinacridone Gold into the area. When dry, mask the green chairs and any light shapes that you can find within the still unpainted shadow area, such as any white clothing, sunlight on the hair and arms of the waitress in the centre and the white tablecloths seen through the struts of the chairs. The mask will allow the colour of the chairs to show through.

▶ Note the granulating effect achieved with this paint mixture, which creates some texture on the ground.

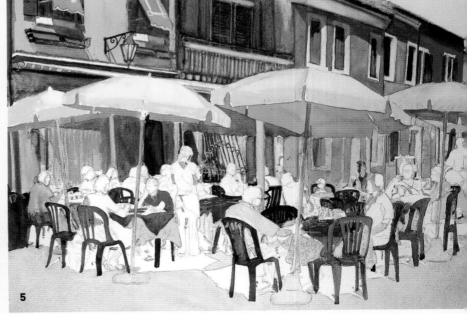

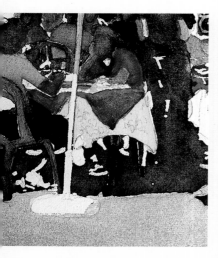

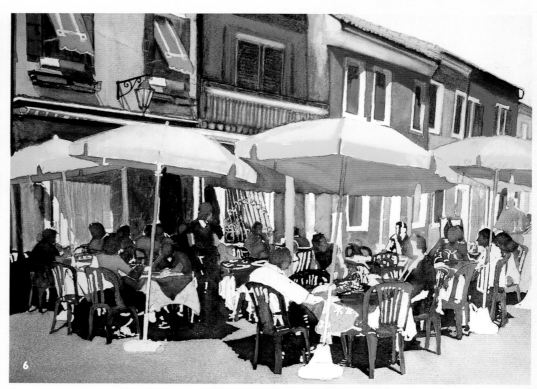

6 Mix up a large wash of French Ultramarine Blue and Brown Madder. Paint the dark shadow area under the parasols and include the adjacent darks of the figures on the left side of the painting. Drop in touches of Winsor Red to add some reflected light into the shadows on the ground. Begin to develop the figures. Keep them as abstract shapes, especially the ones in the background.

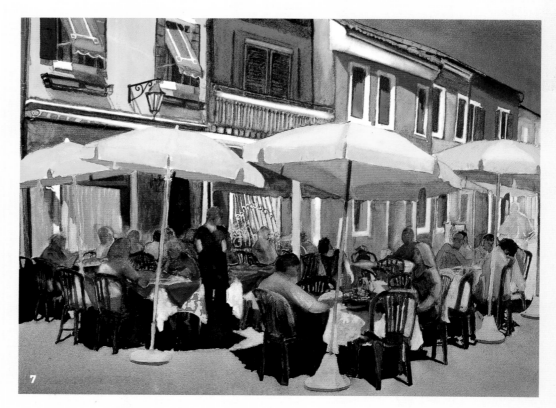

7 Remove the masking fluid and make final adjustments to shadows, values and details. With the tiny scrubber brush, soften and lighten the figures on the far right to add atmospheric perspective. To finish the painting, paint the roof tiles a reddish brown and (after it dries) add a wash of Winsor Blue (red shade) and French Ultramarine Blue to the sky.

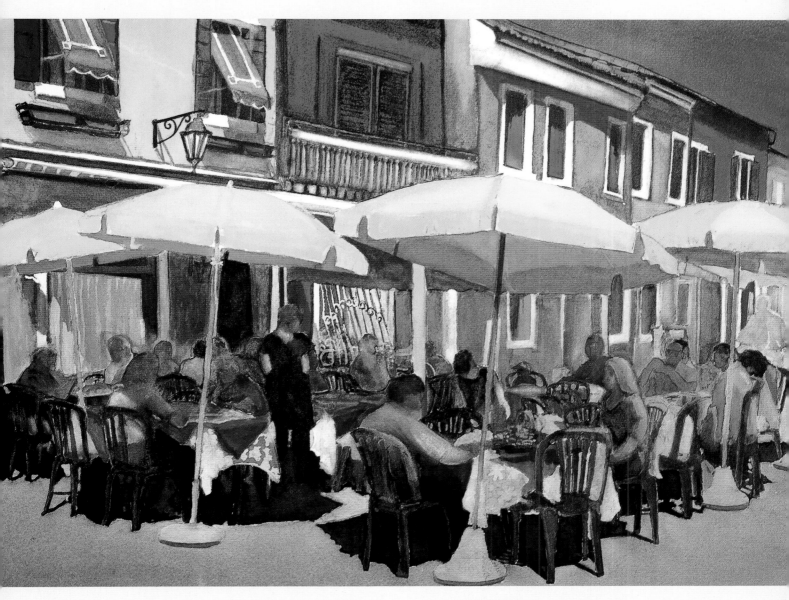

Limoncello

DONNA WITTY

When people are included in a painting, they usually command
centre stage. The focus here, however, is intended to be the
bright yellow parasols and wonderfully coloured buildings.
Because of all this colour, simplifying the figures as dark shapes
would only cause them to stand out more. Therefore, colour is
introduced into their abstracted and simplified forms to keep
them integrated within the surroundings. The group right in front
requires slightly more detail. To keep them integrated as well, the
artist changed the hair of the female to yellow/blonde to act as a
bridge of colour to direct the eye from table to parasols and keep
it moving around the finished painting.

5

Chapter

Approaches to Watercolour

Mike Barr
Keeping it simple

'Keep it simple and your paintings will impress.'

Biography
Mike Barr has been painting seriously for about 12 years. In that time he has gained over 50 awards in watercolour, acrylic and oils. He also writes for artist's magazines in Australia, the UK and the U.S.

Favourite colour Ultramarine Blue would have to be my favourite colour. It is a great all-round sky colour and mixed with Alizarin and other reds produces wonderful atmospheric purples.

Palette My palette has plenty of trays for colours and nice mixing areas.

Paints I confess to using any artist's quality paint! Ultramarine, Alizarin, Yellow Ochre, Burnt Sienna, Viridian, Black, neutral tint; then for highlights, Cadmium Red, Cadmium Yellow and White.

Papers I like medium to rough papers that grab the brush a little and produce nice effects with a dry brush. I mainly use 640 gsm(300 lb) Arches medium.

Workspace My workspace always disappoints the purists, but usually gives hope to those starting out. I mainly use the dining table and a sloped board — and, of course, a drop-sheet to protect the table and my life!

Watercolour painting is all about keeping things simple. Some of the most outstanding watercolours ever produced have been models of simplicity. It is worth taking the time to look at the watercolour work of the great English artist Edward Seago, and observe the simplicity he managed to achieve in most of his works.

Simplicity essentially means completing a painting in the least number of brushstrokes possible. It's the difference between a painting that looks laboured and one that looks like it just happened effortlessly — which is an illusion, of course, because it takes quite a bit of practice to make a painting look that way.

Plan for simplicity

The transparency of watercolour disallows constant fiddling, and in a way this is good because it forces us to keep things simple. It also makes planning essential — we need to know where we are going in any particular work before we start it. To this end, little thumbnail sketches in pencil, pen or paint are an enormous help. They take just a few minutes to put together, but they will provide us with a simplified blueprint of the finished work and a great deal of confidence when we start it. Completing a number of thumbnails will also help us to sort the composition out before we start on the bigger painting. Thumbnails are also confidence boosters. There is no pressure in doing a quick sketch that is not destined to be a finished work and we can do a number of them of the same subject. It's also a great way of loosening up and giving us a measure of confidence before the main performance.

Simplifying the scene

There are rarely any scenes in real life that are ready to go as paintings. One of the really fun things about being an artist is being in charge of the composition, and that means leaving out things that look awkward, or putting in things that balance it up. When looking at your photographic reference, ask yourself how you can simplify the scene. Give the scene a focus by simplifying the outer parts and adding a focal point. Having the same intensity of detail everywhere in a painting will kill it, which is why photographic reference should not be copied slavishly. The point of painting is to communicate feeling and atmosphere and not photographic reality.

Simplifying your palette

The range of colours available to artists seems to grow every year — the choice is astonishing and also confusing. One might easily think that artists should be armed with every colour available to them, when in fact the opposite is true. Having a simple and limited palette will help you in a number of ways.

Firstly, your paintings will look better. Too many colours may look striking at first, but they are almost impossible to live with. Having a simplified palette will harmonise your work. With colour, less is often more.

Secondly, by using a limited number of colours you will quickly learn about colour mixing and what each colour is capable of, and what other colours you can make by mixing them. Your colour mixing will become intuitive instead of relying on clunky colour charts — if we have one eye on colour charts we are not looking at our

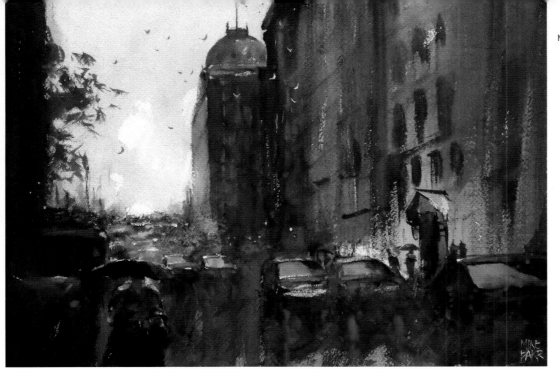

Bridge Street, Sydney

27 x 37 cm (10½ x 14½ in.)

This rainy-day scene may look complex, but it is all an illusion! The buildings are extremely simplified — see how many windows I have put in. The cars have hardly any detail, but they cannot be mistaken. A few lines are added to help with perspective and the figures are virtually silhouettes. It's all about mood, not detail.

painting! Have a core group of colours and a few for highlights. See my choice of paints, in the panel, opposite.

Simplifying the brush

By brush, I mean the stroke as well as the brush that delivers it. I don't think an artist can have too many brushes, but on any particular work, just use a few. Go for bigger brushes at first, then use the little ones for highlights and detail last. If possible, go for one stroke instead of several and see your work improve.

Simplifying the drawing

Watercolour depends on a good drawing, but be careful not to make it so you are painting by numbers and simply filling in between the lines. Too much attention to lines while you are painting will stunt the freshness you are looking for.

People Practice

10 x 30 cm (4 x 12 in.)

There's nothing like practice to get things right, and this is especially true of figures. These people-practice exercises will have you growing in brush confidence — but make sure you don't use a pencil.

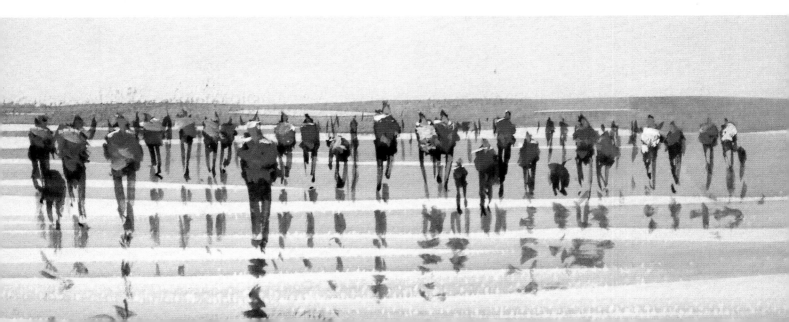

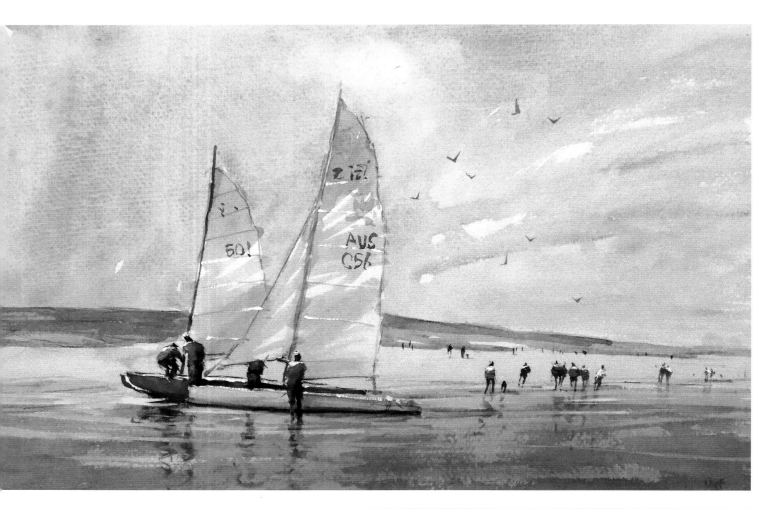

Beach Kats

23 35 cm (9 x 13¾ in.)

Walk-through

1 Sails are done in single, sweeping strokes. The sail shadows are a thin mix of Ultramarine Blue and Alizarin Crimson.

2 Lettering on the sails is not laboured. Precision here will require precision everywhere else — something we don't want.

3 I have loosely painted the sky in Ultramarine Blue and left white paper for the illusion of clouds. Just a bit of Alizarin Crimson is mixed near the bottom of the sky to give atmospheric perspective. I nearly always add the birds!

4 Figures painted with a few strokes. Spending too much time on them completely wrecks them. Keep the heads small. Distant figures are just single strokes, but the brain knows what they are.

5 The sea is a simple wash of Ultramarine Blue with a touch of Viridian.

6 Even though these hills may have been bright green in real life, I toned them down to set them back and focus attention on the foreground.

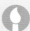 Techniques

Technique is a bit like style in that it will develop the more you paint. Here are some of mine:

> I try to work reasonably quickly — this tends to give things a fresh look. Getting bogged down in watercolour can look how it sounds.

> I like using the dry brush, which produces sparkles of white paper coming through.

> Where I can, I always have a splash of red!

> I don't worry too much about splashes, runs or other 'mistakes' — it all adds to the appeal of watercolour.

> I use big brushes until I absolutely have to use a small one.

Henley Yachts

27 x 19 cm (10½ x 7½ in.)

A very simple painting — and just look at all those lovely sparkles of white paper through the use of a dry brush.

Victor Harbour Yacht Club

13x 40 cm (5 x 15¾ in.)

It is always a delight to paint sails against the dark background of pine trees. There is nothing complex about this painting.

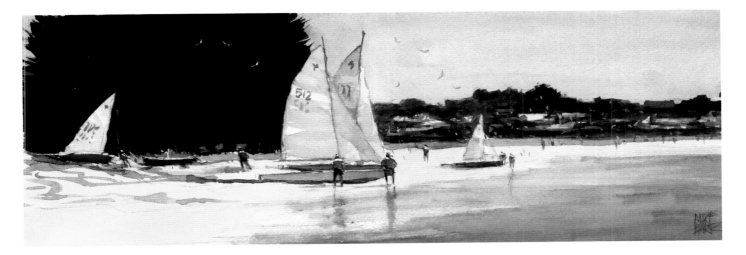

Jane Freeman

Beauty in the shadows

'A light area doesn't 'pop' unless it is near a dark.'

Biography

Jane has worked primarily in realistic watercolour since 1989, and has been juried into a number of national and international competitions. She has been featured in art magazines from Australia, France and the U.S., and authored a book on her painting techniques entitled *A Celebration of Light.*

Favourite colours Transparent Brown Oxide is one of my favourite colours. It is a non-staining colour, so I use it often in places where I want to do lifting. It makes a lovely transparent dark when mixed with Carbazole Violet, or a lovely warm shadow if mixed with Quinacridone Gold or Rose.

Paints I use Daniel Smith watercolours, but just make sure you are using artist-grade not student-grade paints. Find a group of colours and stick with them and learn their traits, then slowly add to your selection. It is better to work well with a few paints than to use many colours and not know what they will do for you.

Papers and brushes I have been using Arches 640 gsm (300 lb) rough lately, but I have used 640 gsm cold-pressed as well. For my brushes I use a lot of Daniel Smith and also Black Gold. The work-horse brush for me is the no. 8 round. I can paint an entire painting with it.

Workspace My space has a 2 metre (6 foot) long table that allows me to have everything I need within reach. Over it I have two long-armed Ott lights and above that I have five full spectrum lights. I try to keep the area neat and things stored, so that my environment does not distract me from my painting.

So often, artists talk about how to capture the light by saving those beautiful whites and light areas of the paper. However, a light area doesn't 'pop' unless it is near a dark — and darks can be dull and lifeless. Beautiful, dark shadows will make your painting more interesting and keep your viewers engaged as they see the hidden details you have created there. Keeping these hidden details near your centre of interest will help support that area and draw the viewer in. This technique is used by artists in realism and abstraction to keep a painting exciting and engaging.

If you are working from a photo, do not assume that a very dark area is as dark as it looks in the photo. It can appear as a dark, uninteresting hole in a painting. Enlarge that area on a computer or hold the photo up to a bright window, however, and you will see shapes hidden in the darks. Paint those shapes and then begin to darken the area with your local colour or shadow colour to make it appear to recede. Now you have a beautiful shadow that is interesting, too!

Closer examination of your darks and shadows gives you clues as to what is really there, so you can make artistic choices to make them beautiful rather than leaving them lifeless. For Monday's Wash (see page 218), for example, I could not see much of interest in the white spoon rest. I enlarged that area of my reference photo and discovered a rainbow reflection. I would never have imagined that to be in that shadowed area. I also found reflections of the bamboo, so I exaggerated these elements, which made the dish so much more exciting. I also exaggerated the bamboo by making light yellow transitions rather than the beige

colour I saw in my photo. It warms that area up and better describes the sunlight that was hitting the surface.

Shadows can be full of reflected colour or subtle local colour. I tend to paint my shadows in a more exaggerated manner, with detail to keep them interesting. By studying your photos, you can begin to understand what is actually there. You might even be surprised by the colours you find hidden in the darks or bounced onto the objects in the shadows. Capturing details in the shadows can turn a good painting into an amazing painting, so it is worth the effort to treat those areas with as much care as you have given the rest of your painting.

A Passion for Peonies

56 x 76 cm (22 x 30 in.)

Very often when painting shadows, I use the local colour and darken it so that all areas feel more unified. The pink peonies were darkened by adding Carbazole Violet and Indanthrone Blue to the pink I was using. This made areas recede but kept them in the same colour palette. For the white peonies, I again darkened the local colour — but I added a blue-grey to the top peony to make it more visually interesting than the lower one. The centre of that upper white peony is in the Golden Mean, and that little button in the centre of the flower is like a bull's-eye and draws you in.

Winter White Peonies

36 x 56 cm (14 x 22 in.)

These peonies were painted for an online auction to raise money for the 2011 tsunami disaster in Japan. The drama and beauty of the blooms are rendered by capturing the glow of light through the petals.

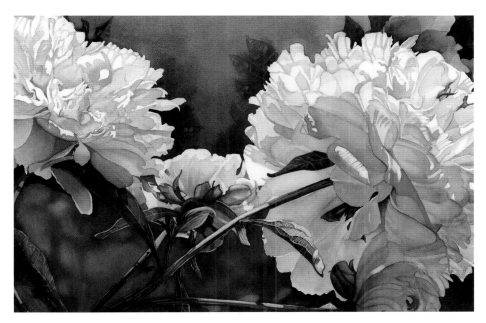

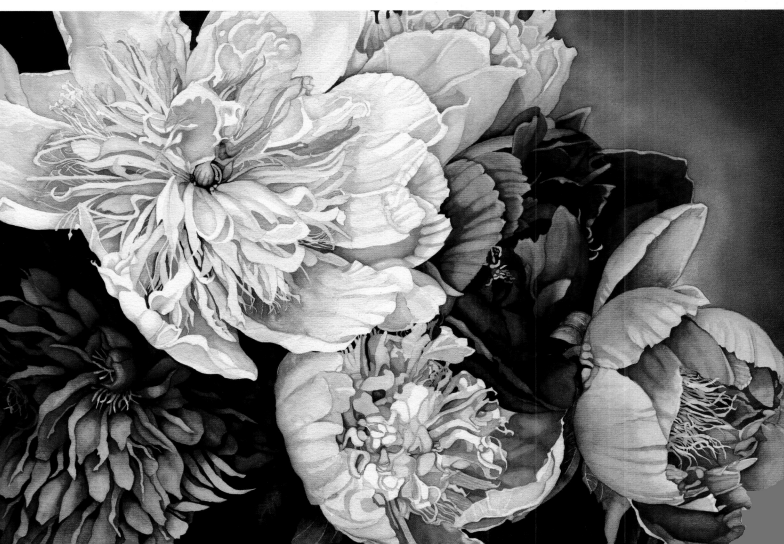

Monday's Wash

56 x 76 cm (22 x 30 in.)

Walk-through

1 The bamboo mat gave me lovely directional lines to lead in, and I painted them with Transparent Brown Oxide so it was easy to lift and give highlights. They create an interesting series of similar shapes, which makes for a strong composition.

2 Notice how, even though the front dish is white, it is all in shadow with no white paper showing — but it still reads as a white dish. I mixed Carbazole Violet with a little New Gamboge to grey it down for most of the dish shadows, but added reflected colours into it as well.

3 The fabric bow, clothes pegs and dish handle on the left lead the eye into the painting.

4 The group of clothes pegs tied with the ribbon is mostly in shadow, and I made that shadow warm by adding Quinacridone Rose to the Transparent Brown Oxide. That combination makes such a lovely shadow colour that almost seems to glow!

⬥ Techniques

My technique in watercolour has evolved over time, as all styles should if you are growing as an artist, but I still stay close to the realism I love.

> I plan for success by making a light drawing on my paper. With a good map to follow, I know I will have a successful painting.

> I wet individual shapes and paint that shape. Later I glaze over larger areas to unite them.

> I work with a limited palette of colours and mix them to create other colours, as I believe the painting is then more cohesive.

Sauced Grapes

56 x 76 cm (22 x 30 in.))

If I had chosen to follow my reference photo, the shadows would have been darker; I chose to go lighter, so that the pattern of the lace tablecloth became more obvious. As light passed through the holes, it cast patterns of subtle shadows that are more interesting and beautiful than a solid shadow would be. The dark shadows on the gravy boat give it weight, and the cloth then feels more delicate because it was left lighter in the shadows. Reflected colours in the silver give it interest and make those areas sparkle. Each grape was painted individually, allowing the grapes deep in the shadow to have interest even though they are tucked into the darks.

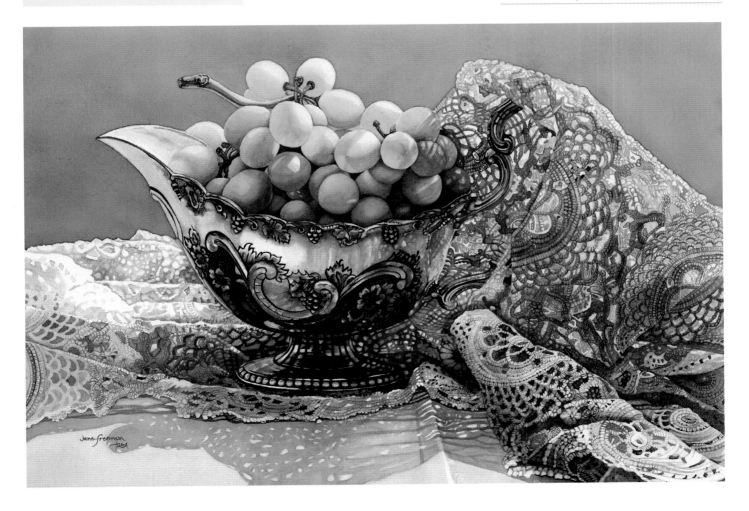

Laurie Goldstein-Warren
Creating watercolours that sparkle

'Creating watercolours that sparkle requires a strong knowledge and use of the value scale.'

Biography
Laurie has been painting watercolours for 16 years, and has won numerous awards in both national and international exhibitions. She is a signature member of many watercolour societies and she teaches popular workshops across the United States.

Favourite colour Since I only use four, they are all necessary to my paintings, but my favourite is Quinacridone Gold. This colour can give me everything from a pale yellow to deep golden brown without having to mix it with any other colour.

Paints I use two different brands of watercolour paint because of colour availability. My colours are Quinacridone Gold, Quinacridone Rose, Cobalt Blue and Antwerp Blue. I use Lamp Black to get small pieces of a true value 9 (see right).

Palette Because of the very large brushes and limited palette I use, a metal butcher's tray works for me. Each corner of the tray holds one of my four colours. Along the tray's edges the colours mix and I leave those mixtures in the edges to use.

Papers I use 300 gsm (140 lb) bright white paper in both cold and hot pressed, depending on the subject of the painting.

Workspace I have a small studio upstairs in our home. I also do my own framing, so I have a large wooden table with shelves for my framing materials in this small space. It's crowded, but it holds everything I need.

Creating watercolours that sparkle and shine requires a strong knowledge and use of the value scale (with 1 being the lightest and 9 being the darkest value in a painting). Colours used are secondary to the values chosen as you paint. My palette for all of my paintings consists of the same four colours and black. When I 'sacrificed' all those little compartments of beautiful colours, I gained so much more. I was forced to learn to paint with values, and soon it became second nature.

A good, detailed drawing
To create a great value-conscious painting that sparkles, you need to create a detailed 'map' of your subject. This step helps provide a path through your subject and removes any guesswork. When I draw, I join together like values that are adjacent to each other, making each value passage a larger and easier shape to paint. If the value of the street is a 7 and the value of an adjacent building is also a 7, I join these together into one value shape. Because of the detail in the drawing, I do not have to stop and consider the street and building separately — I just decide on the temperature (warm or cool) that I see for that value piece and paint a value 7.

Painting dark to light
Unlike most watercolourists, I prefer to paint from dark to light. After completing my detailed drawing, I search out and paint all of my value 9s and 8s. Now with the white of my paper and my darkest values

established, I can view more clearly how the painting is going to progress. I then just need to fill in the middle values of 7 through 2, leaving some white of the paper for my value 1.

Masking for sparkle
Making a painting sparkle requires the use of masking fluid. When painting traditionally with a brush, I search out any value 1 pieces in my composition and mask them off. If I am pouring a painting, such as in *NYC Reflections* (see page 222), I mask off any value shapes that are not a value 8 or 9. Then I pour my darkest darks. When this is dry, I remove the masking fluid and mask any value shapes that are lighter than a value 6 or 7 and pour my values 6 and 7. I do not mask the values 8 or 9 that I have already poured, as any subsequent pouring will only deepen those value shapes. At this point, a large portion of my painting is done. I remove the masking fluid and finish the piece, dark to light or from values 5 to 2, with a brush.

Still-life paintings that shine
When painting metallic objects, I use a lot of the same techniques I have already discussed. The one difference is that you do have to pay more attention to colour choices in your value shapes. Metallic objects reflect their surroundings, so if the colour is off, the painting can lose its reflective look.

Enlightenment

53 x 86 cm (21 x 34 in.)

This was painted from a photo I snapped at the front desk at a Chinese restaurant. I loved the rows of happy smiling faces and saw an opportunity to paint a metallic still life. The background with similar adjacent values in the figures was poured. I paid particular attention to the value shifts in the figures to give them their reflective look.

L'Arche de Nuit

76 x 56 cm (30 x 22 in.)

This painting was poured in two layers and finished with a brush. The challenge here was the lights of the cars coming at you, backlighting the figures and putting them in silhouette. Again, keeping similar values in one larger shape simplified this painting.

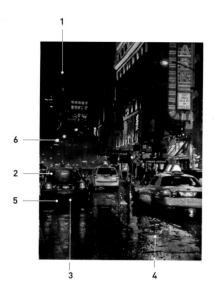

NYC Reflections

76 x 56 cm)30 x 22 in.)

Walk-through

1 After completing a detailed drawing, I masked off all the parts of the painting that were going to be lighter than a value level 8 or 9. I then poured a series of paints (Quinacridone Rose, Quinacridone Gold and Antwerp Blue) to achieve a dark value. I tilted the paper to let the colours mingle, giving me a rich dark.

2 After that layer dried, I removed the masking and masked off part of the cars and lights in the distant street to paint in the warm glow just above street level. I did not mask off the darks already poured and let the warm colour flow over those darks as well.

3 After I was satisfied with the darks and golden glow, I removed all masking fluid and completed the painting with my brushes. When painting the colours into the wet streets, the dark that was previously poured will bleed into the colours somewhat, which gives a nice transition between the colours and dark street.

4 Texture in the foreground was achieved with my mouth atomizer.

5 When painting cars, remember to paint the dark tyres, the dark shadows and the cars themselves as one value piece. It reads much more convincingly that the car is on the ground.

6 To finish, if I see any lights in the distance that are too bright or draw the eye too much, I use my mouth atomizer with a mixed grey from my palette to tone them down.

Techniques

What I tell students in my workshops is that all the tips and techniques I show them are similar to my being a store salesperson and giving them all kinds of shirts, trousers, shoes and so on to try on. Keep what works for you; leave what doesn't work at the store. You create your own style with this approach.

> Try limiting your palette. It is a good exercise for learning your values and also for learning what your colours are capable of.

> Make a value scale (see page 38) at least a couple of times a year. I usually end up giving mine away at workshops, so I make several a year and it keeps the knowledge of water-to-paint ratios fresh in your mind.

> Never try to paint like anyone else. Art is a personal statement and when you try to copy someone else's painting style, you are silencing your own voice.

> Do not wait for the perfect scene or photograph to do a painting. As artists, we can change any scene, make a cloudy day sunny or vice versa. My reference photos are far from good.

> If you use reference photos, take a chance and print off the photo in black and white. This will give you a freedom not to become a slave to the photo. You can make the choices.

Polished

56 x 76 cm (22 x 30 in.)

I set up this still life in my studio and painted it from life. This painting is a good example of how important the colour choices are when painting reflective surfaces. The sunflowers, tablecloth and even the background are reflected in the silver pieces. By carefully drawing the composition, the painting process was simplified and fun.

Heavy Metal

63.5 x 91.5 cm (25 x 36 in.)

These hubcaps were on a fence outside a blues club. I loved the almost liquid look of the chrome and all the reflections and value shifts. I used a mouth atomizer at a couple of the corners to subdue the hubcaps at the edge.

John Lovett

Transparency versus opacity

'The contrast between transparent and opaque of a similar tone and color produces a wonderful, shimmering effect.'

Biography
John Lovett has held over 50 solo exhibitions and is represented in collections all over the world. He is a regular contributor to *International Artist* magazine and is the author of a number of books and DVDs. John regularly conducts workshops in Europe, the U.S. and Asia, and from his studio in Australia.

Favourite colour I use a limited range of colours, my favourite being Indian Yellow or Quinacridone Gold. Both of these yellows produce strong, clean darks in mixes. The transparency of the pigments does not lift the tone or value of the mix, but influences the colour without creating a muddy sludge common with opaque yellows.

Paints Phthalo and French Ultramarine Blue, Permanent Alizarin Crimson and Indian Yellow (or Quinacridone Gold) are used for 95% of my work. They produce rich darks and a reasonably saturated colour wheel. I use Cobalt Blue, Permanent Rose and Aureolin for glazing. I also use Burnt Sienna ink, white gouache, charcoal and gesso in my work.

Palette For a studio palette I like one with a large mixing area and paint wells with a sloping side to drain the sludge away from the fresh paint.

Paper. My favourite paper is Arches 300 gsm (140 lb) medium. I buy it by the roll and I'm always amazed at the abuse it will tolerate.

Workspace There are a couple of important workspace requirements for me. The first is good light coming from my left, so that my right hand doesn't cast a shadow over my work. The second is for my palette and water to be on the right-hand side of my painting so that I'm not reaching across the work to mix colours or rinse brushes.

My approach to watercolour started in a fairly traditional manner, but I soon found the restrictions very frustrating. Gouache, gesso, ink, charcoal and pretty well anything that would not compromise the archival quality of the work gradually crept in to my paintings. I love the way the variations in surface texture, line quality and transparency provided by these other materials can be used to build up contrasting areas of mysterious, understated simplicity. These materials are also a little less predictable than pure watercolour, so the painting tends to develop a life of its own.

Gouache and gesso

Gouache and gesso are both water-based, opaque white paints. Gesso is traditionally used as a base coat or primer for canvas over which oil, acrylic or watercolour (in the case of watercolour gesso) is applied. Gouache is similar to watercolour in that it can be re-dissolved after it has dried, whereas gesso, being acrylic based, is permanent and insoluble once dry. The opacity of gouache comes from the addition of calcium carbonate and extra pigment. Gesso is opaque due to the addition of marble dust, pumice powder and extra pigment, which gives it a toothy texture receptive to paint and pastel.

In many of my paintings I lose areas of the work with translucent glazes of gesso. I apply it straight from the pot to the dry painting, and then spread it, diluted with water, and grade it over the area. It is important the gradation is even and there is no evidence of an edge to the area of gesso. A dry hake brush is ideal for feathering the gradation.

This milky translucency partially obscures the details underneath, but because of the toothy nature of gesso, the details can be subtly reinstated. Gesso can also be tinted with acrylic paint and applied in the same manner.

Gouache, being thinner and less viscous than gesso, can be used neat or tinted with watercolour to add fine details and highlights. Brick textures, for example, can be carefully painted onto a transparent wash of watercolour with gouache tinted to a similar tone and colour to the underlying wash. This contrast between transparent and opaque of a similar tone and colour produces a wonderful shimmering effect.

Gouache can also be used to flood big, soft areas of light into skies or water. Make sure the painting is thoroughly dry, wet the area to be treated, then pour or paint in an area of gouache mixed with water to a creamy consistency. Use a dry hake brush to feather and control the gouache. As the gouache dries it will lose intensity, so don't worry if it looks a little strong initially.

Other materials to create a contrast between opaque and transparent

I sometimes put a patch of acrylic paint into the focal point of a painting. The shiny, opaque finish contrasts well with white paper and transparent washes.

My favourite ink is Burnt Sienna pigment ink. Pigment ink is heavy bodied and opaque, whereas dye-based inks are transparent. I like the solid line of the pigment ink and often spray the marks with a light mist of water to make soft, spidery lines.

I also use black charcoal for initial sketching and to build up variety in the lines during the course of the painting, and white charcoal towards the end of a painting.

I sometimes fix patches of Japanese rice paper, which comes in all textures, colours and tones, to my watercolour

Summer Storms

28 x 36 cm (11 x 14 in.)

This painting shows how gesso glazes down either side and across the foreground make an understated, opaque contrast with the focal point of white paper, strong darks and clean, transparent washes. White gouache tinted with a mixture of Cobalt Blue and Permanent Rose watercolour was splashed loosely into the foreground to tie in with the purple-grey of the sky. The region of light in the sky is the result of opaque, white gouache feathered out over transparent underwashes of Cobalt Blue and Permanent Rose.

paper before I start to paint. I select a paper that suits the subject, then apply it in a balanced, interesting arrangement that doesn't exactly coincide with my subject. I like the change of texture the paper creates. Some papers are absorbent and will soak up paint, making dark perimeters around the shapes.

Summing up

I love the challenge of not knowing exactly what the outcome is going to be. I always start with a strong compositional plan, but allow the painting to meander around that plan. The ability to lose and obliterate parts of the painting, then bring them back to life again allows for a very flexible approach. I always keep a clean, high-contrast focal area with white paper and rich strong darks to hold attention. I like to contrast this focal area with simple understated areas of suggestion, often made opaque or translucent by the layering of gesso glazes. It's probably not the conventional way to do a watercolour painting, but for me it's addictive, a huge amount of fun and I am constantly amazed at what emerges when the painting is allowed to develop and evolve with little intrusion.

Tuscany

27 x 36 cm (10½ x 14 in.)

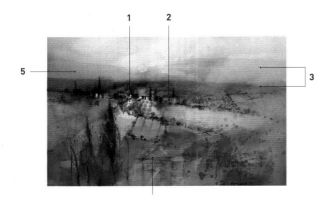

Walk-through

1 Areas of white paper were left around the focal point where detail was built up with a 6 mm (¼ in.) flat brush and a rigger brush. When the hills were dry, olive trees, cypresses and small details were added.

2 Pure Medium Magenta acrylic paint was applied to some of the roofs in the focal area.

3 A gesso glaze was graded over the hills, at the top right, and through the purple wash of the sky. Once dry, small details were reinstated with a rigger brush.

4 The loose suggestion of foreground buildings was washed over with more of the dirty yellow colour of the hills. A splash of diluted Medium Magenta acrylic was dropped into the foreground to help tie it to the sky and focal area.

5 A graded wash of purple-grey watercolour was brought in from either side to emphasise the light in the focal area and hold attention there.

 ## Techniques

Of all the techniques I use, these are the ones that best define my work.

> Loose calligraphic brush marks made with a 12 mm (½ in.) bristle brush contrasting with fine, focused detail.

> Areas of soft, translucent glazes made with layers of graded, dilute gesso.

> Spidery, feathered pen lines threaded through the painting to give unity.

> Strong tonal contrast at the centre of interest.

> Contrasting areas of flat, opaque gouache next to transparent washes of watercolour.

> Loosely scribbled charcoal and pastel pencil marks.

> Regions of tight control contrasting with areas of accidental chaos.

Bayside Reflections

55 x 75 cm (21½ x 29½ in.)

Gesso tinted with Phthalo Blue acrylic was glazed over the foreground and upper left of this painting. The subtle remnants of buildings and details were slightly reinstated with ink, charcoal, pastel pencil and watercolour. The impact of the focal point comes from strong tonal contrast, clean transparent washes of watercolour and contrasting warm colours.

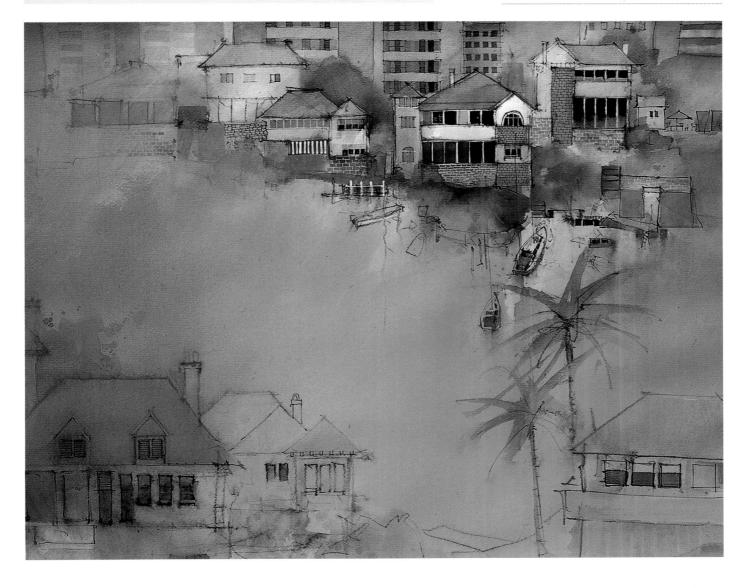

Leo Davey
Water ways

'Water ... can be as varied in shape, colour and complexity as a landscape.'

Biography
Leo has painted all of his life and has been a full-time artist since 2009. He comes from a family of artists all working in very different mediums and ways. He studied illustration at Falmouth College of Art in England, and has won a variety of awards including *The Sunday Times* Watercolour Competition's Smith & Williamson Cityscape Prize.

Favourite colours I'm a big fan of Turquoise, either straight from the tube or mixed with a little Viridian and white gouache (to make it less transparent) so that I can lay it on top of any colour.

Paints I use so much yellow. Looking around my gallery (as I write this) I wonder why, as yellow doesn't seem to feature all that much. I guess it's the bulk of a lot of mixes. I use tube watercolours — Winsor & Newton and Daler Rowney — I'm not too particular. These get mixed in with black Indian ink washes and various whites, including acrylic, gouache, inks and even stain block.

Palette I have five china palettes. They haven't been cleaned for five years. I must get on to that.

Papers I use a smooth medium-weight paper — Arches cold-pressed 300 gsm (140 lb). It ticks all the boxes for me. Unwanted pencil rubs off nicely and it accepts watercolour washes without leaving too many drying marks.

Workspace I work flat. My table is a glass-topped display table that I made at school. To my right is a wall of postcards/inspiration and I'm surrounded by materials. My studio is open to the public and doubles up as a gallery. Being 'off the beaten track' means that I'm not disturbed too many times a day.

Water features a lot in my paintings. It can be as varied in shape, colour and complexity as a landscape. Still reflective canal ways, translucent estuary streams and angry foamy tidal surges all have water in common — but little else.

Form in expanses of water is described mainly with the horizontal, and reflections are described mainly with the vertical. I say this quite broadly speaking, but it's good to have something that links the various expanses of water.

Water colours
Colour in water is dependent on its surroundings — what is under the water and what is above. More often than not, it is a combination of the two.

Apart from very still water with very strong reflections, colours in water tend to merge and blend into each other. I tend to work very wet when painting a large area of water. I lay, say, a wash of blue and refer to my reference (probably a photo), adding horizontal washes of exaggerated colour that appear in my reference. I dry this with a hair-dryer to speed up the process and repeat the process observing the reference again. Each time I do this, I see colours that I didn't see the previous time. I repeat this until I feel satisfied with the result.

Form in water
I think water is at its happiest when it's still — no waves, no ripples, not flowing, just flat. Still water is described with the horizontal — simple gradated colour, sometimes dark to light, sometimes vice versa. Moving water is more complex. There is the challenge of depicting the form and texture of the water.

Water's surface, even when quite still, is covered in horizontal teardrop and slug-like shapes. These shapes can be achieved with a pointed brush. Apply a little watered-down paint to your brush, start with the tip and drag, applying more pressure, then either remove the brush (for a teardrop) or apply less pressure and get back to the tip (for a slug). These marks should not be uniform and can have kinks in the middle and twists — vary your brushes from large ones in the foreground to smaller ones farther back. Larger versions of these marks and strokes can be used to describe waves. I often put washes of water or thin paint over these marks to soften the edges.

I paint foam and white water splashes with acrylic, gouache or even a white pen. To add white water to the top of a wave, I paint a broken line, varied in width. I often drag the end of a metal ruler along the top of the white, taking off some or all of the paint and leaving a clean edge. Sometimes I use a white pen for foam, but these pens seem only to have a single weight of line, so I limit this and vary it with other whites.

Reflections
It is important that the reflection comes directly below the object that is being reflected. The reflection's clarity is dependent on the stillness of the water. I think the reflection is mostly darker than the object being reflected, but I'm sure there are exceptions. Horizontal lines and horizontal breaks help to bring a reflection to life.

Regent's Canal – London

27 x 44 cm (10½ x 17 in.)

I like the way the vertical light is reflected in two separate puddles. The whites in this painting are really white, almost blinding against the contrasting dark, heavy cast iron. I have left a large area unpainted to give a sense of dazzling sunlight outside the shelter of the bridge.

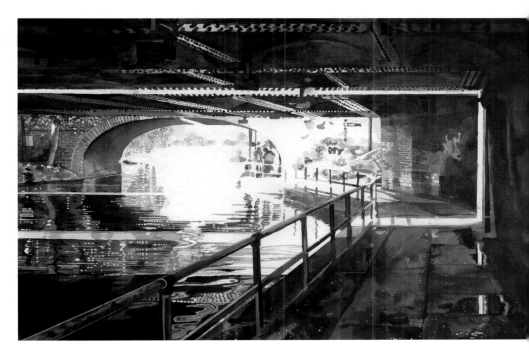

Light on water

Sunlight on water is most striking when contrasted with dark water. Where some artists might use masking fluid or leave paper peeping through, I put various whites on top towards the final stages of a painting. It's a great reward at the end that can really bring a painting together (or ruin it if you get it wrong!). The white 'highlights' (slugs, teardrops and dots) echo the shapes used to describe form and tend to be more in clusters. The key to getting a convincing look is to vary the mark making.

In most of my watercolours I map out in pencil where everything goes. I make an exception when I paint water (most of the time). Fluidity is essential and I don't want to be restricted by pencil lines.

Sun on the Sea

29 x 61 cm (11½ x 24 in.)

From a distance, this painting has an almost photographic feel to it. On closer inspection it is very stylized. The marks here are a combination of descriptive and decorative. Quite crudely applied white acrylic is softened and broken up with lines of white pen, watered-down Indian ink (and dip pen) and watercolour washes.

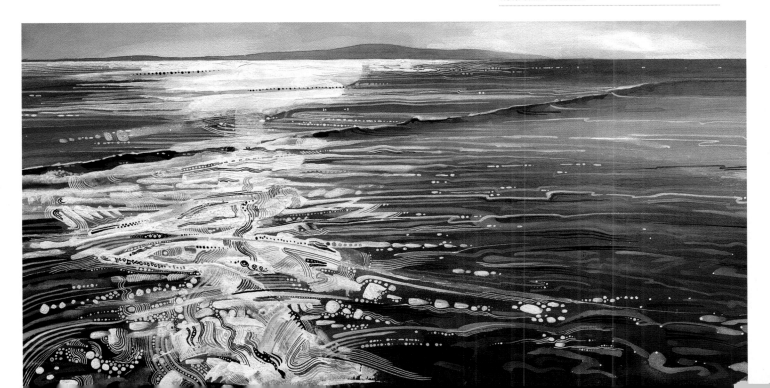

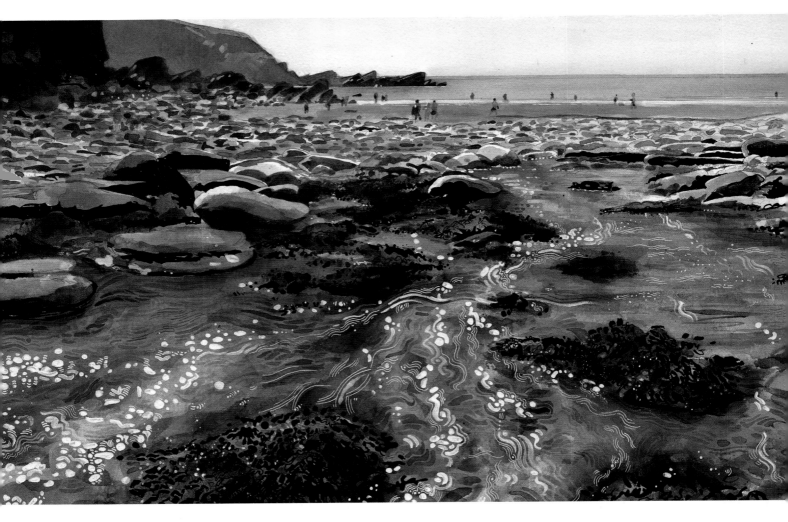

Tide Out, Lee Bay, North Devon

27 x 45 cm (10½ x 17½ in.)

Varyng and exaggerating the colours under or through the water gives a greater sense of transparency.

Walk-through

1 Darker colours in the foreground gradually change and lighten through the water flow; the sea is lighter still, giving the illusion of space.

2 'Slugs', 'teardrops' and 'dots' pepper the foreground, making their way around obstacles — all heading to the same place but taking different routes. Lots of varied mark making here.

3 Darker tones around rock edges give a sense of something under the water.

4 Single horizontal lines at the water's edge, some dark, some light and some broken, give the feel of waves.

Techniques

> As a painting develops I refer less to the reference and more to the painting itself. It's not about whether your painting looks like the photo; it's more about whether it works as a painting.

> I compose and rearrange reality if it makes for a better composition.

> My brushes have to be at death's door before I throw them away. You can get some great marks and strokes with tired, old brushes. Not so good for detailed work, though!

> I leave out anything that doesn't make sense in my reference.

Incoming Storm, East Quantoxhead, West Somerset

36.5 x 56 cm (14½ x 22 in.)

Wet rocks, breaking waves and sea foam were the challenges in this work. The distinctive silty colours of the Bristol Channel are a mixture of Yellow Ochre, Payne's Grey and Mauve — oh, and a bit of my favourite Turquoise. Slight changes in colour and tone and crisp white highlights give an impression of wetness on the rocks' surface.

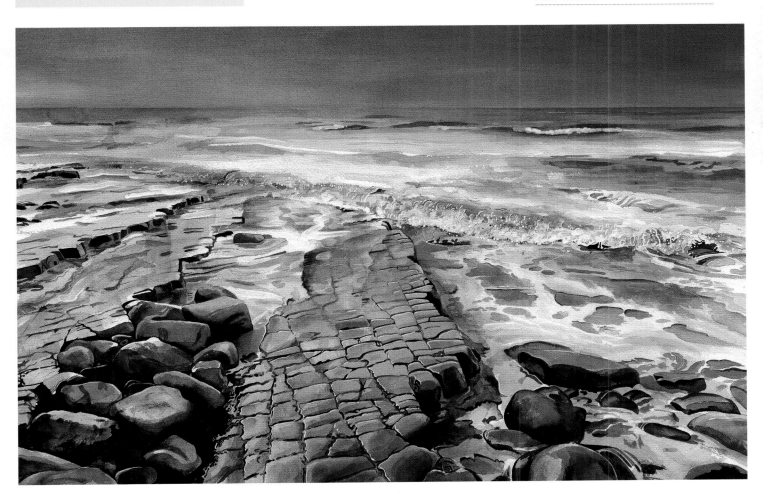

Painting fabric in watercolour

'Mastering how to portray fabric will also be an immense help with portraiture ...'

Biography
Graham is a Sydney-based artist who relocated from England in 1981. Trained in the UK, he gained his PhD in Australia. He has received a number of awards and has held 26 solo exhibitions. Besides painting in watercolour and oils, he makes prints and drawings, and conducts workshops.

Palette I favour china palettes and the mixing surfaces of the paint tins that hold my pigments. I mostly use pans rather than tubes, as the pigment is so much more intense and I get an immediate sense of the colour as I can see them in front of me. I use small china dishes bought cheaply to mix up washes of colours.

Paints I have several paint tins opened when I work, making available a whole host of colours. Far too many for the purist, but I enjoy surveying the watercolour pans when deciding which colour to choose and what to mix. I have favourite colours from a variety of brands — Winsor & Newton's Sap Green, Old Holland's Grey Violet, Schmincke's Translucent Yellow.

Papers I favour the heavier papers — usually 600 gsm (300 lb) and never below 300 gsm (140 lb) — so that I can avoid stretching the paper and can retain the beautiful deckle edge of the sheet. I prefer a hot-pressed surface or fine medium, as I can control the paint better and there is little textural interference.

Workspace I have a separate studio at the rear of the house, which means that there is no unnecessary travelling to and from the studio and I am able to grab slots of time between dealing with the stuff that often fills our lives.

I have collected fabric over many years, as I have always liked using it in the still-life and interior artworks that I enjoy painting so much. You need to develop a certain level of skill in order to achieve a plausible result when painting fabric — but while there is definitely a lot of detail involved, it is a far less tedious or neurotic exercise than most people think!

Mastering how to portray fabric will also be an immense help with portraiture, the success of which often hinges upon the 'chemistry' between the sitter and incidental details such as fabric, drapes and so on.

The drawing
Fastidious drawing at the outset is important, as achieving a convincing and deceptively 'artless' arrangement of patterns in fabric is, counter-intuitively, not something that you can just hope you get right as you go along. Take great care in drawing the patterns and blocking in the tones; there are no shortcuts, and getting the tones right is critical if the folds in the fabric are to appear credible. Look at how the pattern changes as the fabric drapes and folds. With a fabric such as gingham, for instance, a lot of those tiny, regular squares may appear as rectangles or triangles, depending on where the folds occur.

It is also very important to observe how light impacts upon the subject, as it is the interplay between the lighter and darker passages in the painting that creates the illusion of folds in the fabric and sets the mood of the painting as a whole.

Once the drawing is complete, I photocopy it to the required size, trace it and transfer it to the watercolour paper.

I never project images to increase the scale for a larger work, as I find too much detail and subtlety is lost in the process.

Painting the flat pattern — painting shapes
The first stage in actually painting fabric is to paint it as though it is flat, without worrying about folds or shading. The folds come later — preferably after several days, when the paint has hardened. If you attempt to see the fabric as folds from the outset, you will believe the whole exercise is too mentally challenging. Instead, see the fabric as shapes first, then see the effect of light on those shapes. Put in the base colour of the fabric, without trying to make some areas darker in tone.

Adding tone to create volume and a three-dimensional effect
The folds are where you gently introduce more pigment to darken the tones where necessary. Wait until the previous painted areas harden: when you paint the tone on the folds, you want to make sure that the pattern you previously painted does not lift. For the shadows I use a base of neutral tint with a warm or cool addition depending on the fabric colour. You must keep your shadow colours translucent. Don't worry too much about any bleeding — what you want is the illusion of the fabric pattern, not necessarily a photo-realistic rendition of it in every detail.

The 'fold' has to be on the fold, which is why clean edges are important. You will notice that, quite frequently, the bottom of the fabric needs to look heavier and the edge needs to be well defined; if you've applied too much pigment, you can lift it off using a cotton bud.

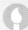 Techniques

> Gather random fabrics, some patterned, some
> striped and perhaps some that are just one
> colour, and then draw and paint sections of
> them. I then tie them all together into a painting.

> If you need to make a section darker, do it once
> the previous layer is really dry. Darken up
> gradually, keeping your pigment translucent.
> If you go too dark too soon, the pattern will
> disappear and the area will appear opaque.

**Still Life with William
Morris Wallpaper**

102 x 112 cm (40 x 44 in.)

I have always loved the work of
William Morris, the motivational
leader of the Arts and Crafts
Movement, and follow his premise
of bringing the essence of
the garden into my works
in the studio.

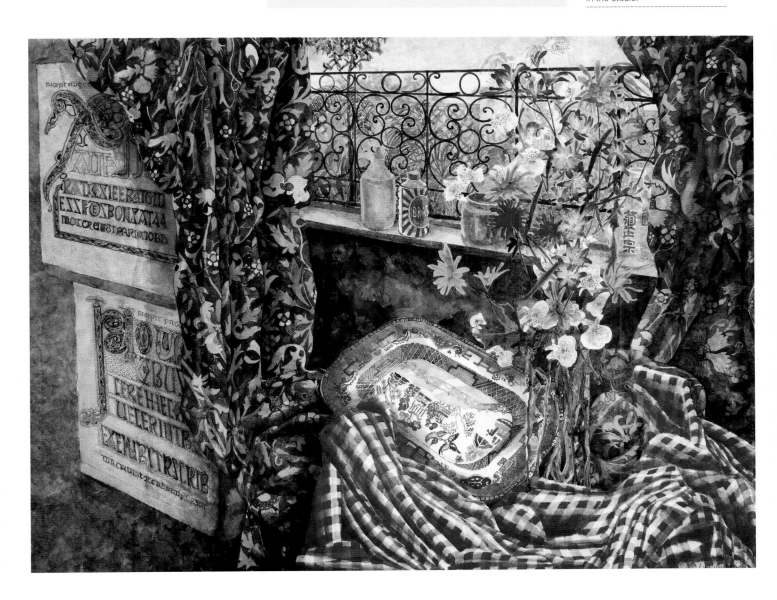

Outside Room, Inside Garden

102 x 112 cm (40 x 44 in.)

Walk-through

1 The oriental silks, gingham and striped materials are positioned to balance the composition.

2 I really enjoy combinations of patterns, fabrics and textures. They provide a challenging opportunity to explore different painting techniques.

3 The garden glimpsed through the window acts as a counterpoint to the swirling pattern of the foreground.

4 I am fascinated by illuminated manuscripts, which are the earliest form of watercolours as they date back to medieval times. I love the use of elaborate, stylised lettering inspired by natural forms and the coexistence of pattern and calligraphy.

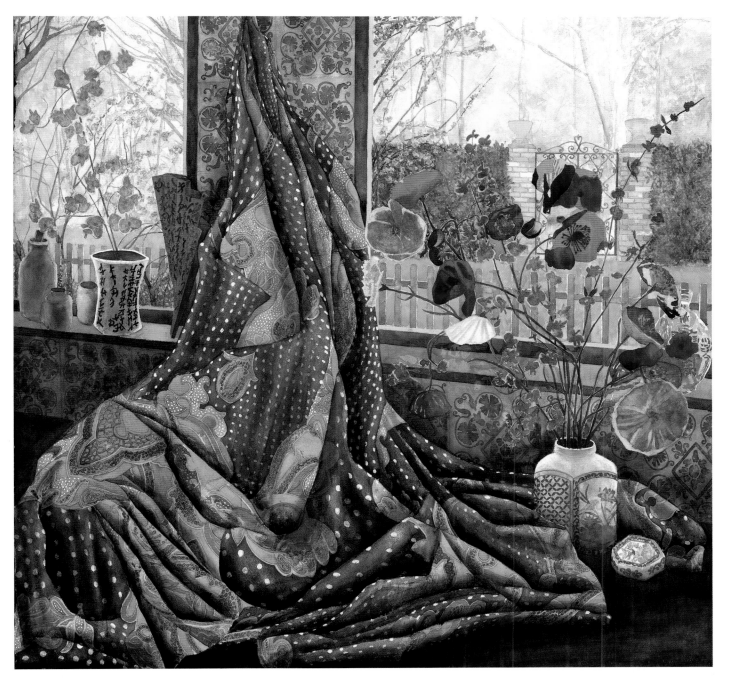

The Japanese Cloth

124 x 124 cm (49 x 49 in.)

This large watercolour was painted on a sheet of Arches 600 gsm (300 lb) paper, medium texture. The cloth was drawn first in pencil on a 56 x 76 cm (22 x 30 in.) sheet and then enlarged by photocopying it to the required size. The photocopy was then traced and transferred to the watercolour sheet.

Brenda Swenson
Stained paper collage

'Have a plan, know your plan and work your plan.'

Biography
Brenda Swenson is the artist and author of instructional books and DVDs on watercolour. Her artwork is frequently featured in books and magazines. She has served on the board of directors for the U.S. National Watercolor Society and Watercolor West. Brenda teaches workshops in the U.S. and abroad.

Favourite colour Quinacridone paints are amazing! The paint colours are unsurpassed for transparency, mixing, permanence and lightfastness.

Paints and adhesive My favourite brand of watercolours is Daniel Smith. I use a lot of paint when staining papers! To stick my collage papers to the watercolour paper, I use matte medium with medium transparency. Don't use gloss medium.

Palette I especially like the Pike's palette for its large mixing areas. The lid makes a wonderful working area for staining papers, too.

Watercolour papers I use 640 gsm (300 lb) rough watercolour paper; the surface needs to be strong enough not to warp with collage. For collage, I use Japanese paper (also called washi). Papers vary in thickness according to the fibres used (mulberry, wheat, hemp...). I like to use a variety of textures and thicknesses.

Workspace My studio is over 85 square metres (900 square feet); it has large windows that illuminate the space and ample storage.

I cherish the versatility of watercolour and the flexibility it allows in my artwork. Repetitiveness in anything, whether life, work or painting, creates boredom. Morning walks are an important part of my day. I'm always searching for something new. Quite often, I find inspiration in the world around me. It might come in the form of light, texture or a new subject. I frequently change the surface I paint on (papers). The challenge of not knowing how a paper will react requires me to respond to the moment and not fall into old habits. I need to keep boredom at bay for my creativity to flourish.

Staining and painting Japanese papers, blocking in shapes and moving them around the page is both visual and tactile. I like being able to see how things will look before I commit. This encourages me to interpret shapes and colours in a looser way. Japanese papers have amazing textures. The surface can look and feel so much like the real thing (stucco, wood, metal). Papers with writing also add a fun element to the artwork, though I am careful not to have the text in the paper dominate the art. It's purely for texture and visual excitement. People respond uniquely to my finished stained paper collages — they want to run their hand over the surface to experience the textures.

The process of stained paper collage is very different from traditional watercolour. It requires me to stop and think in a new and different way. I must toss aside all preconceived notions about watercolour— they don't apply.

Initial stages
I start by tearing an assortment of Japanese papers into workable sizes (roughly 10 x 23 cm/4 x 9 in. or smaller). A flat tray or large palette works best for staining papers. I lay individual pieces in the centre of my palette and use a flat 2.5 cm (1 in.) brush to paint or stain them. I paint the papers in colours relating to my subject.

One of my first instructors said, 'Have a plan, know your plan and work your plan'. These simple words have stuck with me. No matter what technique you use, have a vision. I begin with a small sketch in watercolour, pencil or pen. It is better to work things out on a small scale than waste time on a poorly conceived painting. What's determined in a sketch? Design, format and values.

Then I draw the image in waterproof ink on 640 gsm (300 lb) rough watercolour paper. I draw the major elements to establish placement. Most of the pen lines will disappear under the collage. If I need to establish the drawing, I can easily redraw on the surface later.

Collage
I begin the collage by blocking in the large shapes first and working towards smaller pieces. I prefer torn shapes to the hard edges of cut paper. To adhere stained papers I use a stiff brush with a small amount of matte medium. First I apply matte medium to a small section of the watercolour paper, then I place the stained paper on top and brush more medium on

Castle Green

76 x 56 cm (30 x 22 in.)

I have painted this historic building so many times that it feels like a familiar friend. The challenge in this piece was the size. It took a few days just to cover the entire watercolour paper with stained papers. I started with the largest shapes first — the sky and the building. The palm trees were done last, since it was easier to add them on top of the existing collage than to work around their many edges. The papers in the palm trees have more variety in texture. The final stage was to paint the intricate details of the architecture with watercolour. The white highlights were painted with Permanent White gouache.

CAL 41

38 x 28 cm (15 x 11 in.)

What originally attracted me to this old truck was the cast shadows and feeling of warm sunlight. Old trucks lend themselves to the technique of collage. The texture of Japanese papers enhances the textural feeling of old rusty metal.

top to secure it. I use enough matte medium to attach the paper to the surface, but no more. I cover the entire watercolour paper with collage. Any areas that need to be white are covered with unstained white Japanese papers (natural). I don't want any of the underlying paper left uncovered.

Painting

The technique of painting on a surface that is covered with acrylic matte medium is different from a traditional watercolour painting. The surface doesn't have the same absorbency as watercolour paper. The amount of water mixed with the paint and on the brush will need to be decreased.

The painting stage integrates areas of the collage, enhances values and creates details. The idea isn't to cover all the collage with paint, but to tie the image together and unify it.

Fresh Produce

28 x 38 cm (11 x 15 in.)

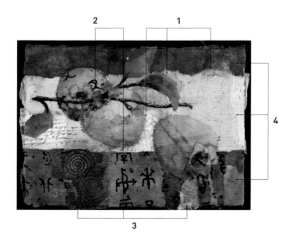

Walk-through

1 Torn edges create a softer transition between colours and subjects.

2 If a stained paper has a prominent pattern, texture or design, repeat its use more than once — otherwise it will become a focal area, whether you want it to or not.

3 An assortment of Japanese papers in the same hue (colour family), in a variety of patterns and textures. Colour harmony is pleasing to the eye. An assortment of textures can create interest to break up a large area of similar colours.

4 The challenge was to take a very simple subject and make it interesting by playing with the design. With the division of space each section needs to be a different width.

 ## Techniques

> I draw my design on 640 gsm (300 lb) watercolour paper with a waterproof pen or dark pencil. You'll be surprised how quickly the drawing will disappear once you start collaging.

> I use a flat, stiff 2.5 cm (1 in.) acrylic or oil painting brush to adhere collage papers with matte medium. The brush needs to be stiff enough to burnish down the papers, but not so stiff that it will tear the more delicate papers. Don't use good watercolour brushes with acrylic matte medium.

> Painting on a collaged surface is very different from traditional watercolour. The surface is not absorbent and the amount of water you use to paint will need to be decreased considerably.

Sun Over Pasadena

28 x 28 cm (11 x 11 in.)

This small collage was an exercise in colour. The colours are saturated but the values are what make it work. Colour can be arbitrary if the values are correct. A teacher once said, 'Colour gets all the glory, but values do all the work'.

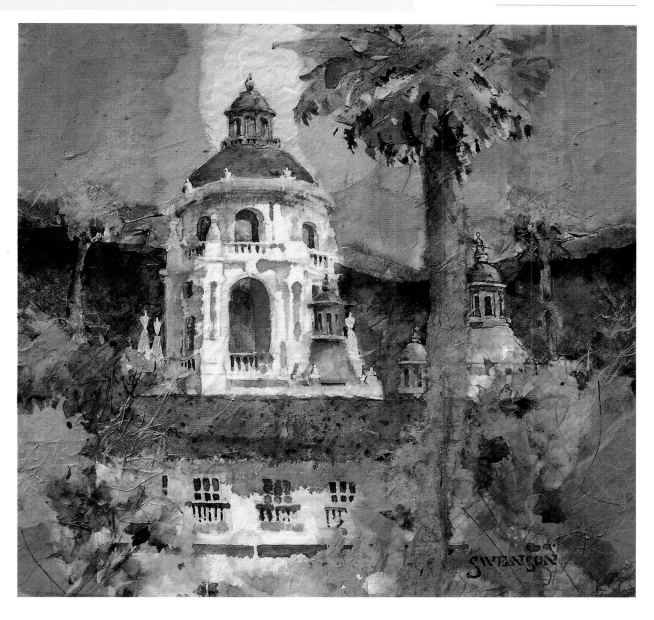

Thomas W. Schaller

Creating atmosphere in watercolour

'Watercolour is easy. Look! You're already half done!'

Biography
Thomas W. Schaller is a fine artist and author whose work is collected worldwide. From a background in architecture and architectural illustration, he is a signature member of the American Watercolor Society and a founding member of the North American Watercolor Artists. His work has featured in many prestigious international exhibitions.

Favourite colours The Daniel Smith Company has produced a set of pigments exclusively for me based on my preference for sediment-based colours that are also as lightfast as possible.

Brushes I use brushes produced by Escoda. The Aquario Series of mops of natural squirrel hair are fantastic for washes as they hold a large amount of water and pigment. These allow me to cover a great deal of space without having to reload the brush. This is especially helpful for larger works. I also love their Versatile Series of rounds. These are synthetic bristles, but approach the water-carrying capacity of natural hair brushes. I use their Perla Series of synthetics for more detailed areas.

Palette I use a folding brass travel palette by House of Hoffman. It has sufficient space for a fairly limited palette of pigments and enough mixing wells — one for yellow (light), red (warm), blue (cool) and violet (dark) and another well most often used for neutrals.

Workspace I enjoy plein-air painting and often work on smaller studies on location. I'm based in Los Angeles and produce larger works in my studio.

In my classes I will often hold up an unpainted sheet of watercolour paper and say: 'Watercolour is easy. Look! You're already half done!'

This is meant largely as a humorous comment, but in it is much truth. Unlike any other painting mediums, watercolour can be seen as 'subtractive'. What I mean by that is — unlike other mediums — white pigment typically is not added to suggest light. All the light is literally there already within the surface of the pure white paper itself. Every tone, value or colour we add during the painting process subtracts from the total amount of light available to the artist.

So, in a very real sense, what is not painted in a watercolour is just as important as what is. In fact this dialogue between the painted and the unpainted most clearly defines my own work. I tend to think of painting in watercolour as a natural extension of the act of drawing. The difference is that when drawing with a pencil or pen, the emphasis is upon line. But in watercolour, we paint more with shapes — shapes of tone, values, dark and light. And the magic of watercolour exists in the infinite variety of the sorts of light — warm, cool, bright or subdued — that shine through the luminous washes. Within this spectrum of light available to the watercolour artist exists the capacity of watercolour to tell a near infinite range of stories that carry a near endless range of emotional resonance.

An exercise in edges

It's often said that watercolour is an exercise in edges. And to a degree, I think that is true. But more broadly, edges — like values, colours, tones, etc. — are just other tools available to the watercolour artist in our quest to tell the stories we wish to tell. 'Found' edges are, of course, formed as a wet wash glides across dry paper forming a distinct shape. And 'lost' edges occur as one wet wash meets another, or is applied to wet paper. Here one colour or shape literally melts into another, thus forming an indistinct, mysterious transition.

A so-called 'found' edge — with a sharp definition between one shape and another — has a very different expression than a 'lost' edge — where one shape tends to gently morph into another. This distinction can most often be seen in watercolour depictions of skies, where one shape can blend with another or — by contrast — form a sharp edge. A variety of edges can express very different conditions of atmosphere and light, and carry very different emotional freight. At their best, these shifts in light within a painting elicit a range of emotional responses within the viewer.

Soft edges that do not clearly define one shape, one object or space, from another can convey a sense of mystery. In a successful work, this mysterious quality can cause the viewer to emotionally enter the work and become invested in an attempt to answer some of the questions — unravel some of the mystery — the work has posed. This silent communion between viewer and artist is the highest aim of my own work. It is in fact the very mission of my work.

For this reason, attempting to depict various types of atmosphere is a consistent goal in my work. Clouds, mist, rain, fog, and so on, are constant themes of inspiration for me.

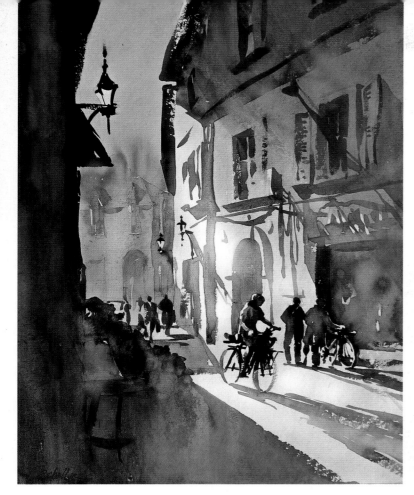

Cycling in Pisa

60 x 45 cm (24 x 18 in.)

How many words have been written about the unique qualities of light? I am always counselling my groups to not paint the things and spaces they wish to paint. Rather try to paint the light that informs and gives life to those things and those spaces. There is nowhere quite like Italy to study the myriad qualities of beautiful, atmospheric light.

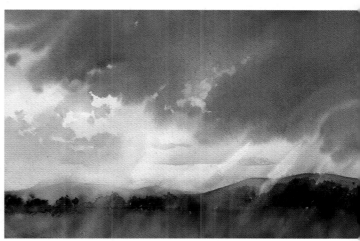

Turbulent Sky, Northern Ireland

45 x 60 cm (18 x 24 in.)

The very essence of Northern Ireland is atmosphere. The sky is constantly in motion. It morphs into the land. The land morphs into the sea. The landscape is literally a living thing. So the fluidity and expressiveness of wet-in-wet watercolour is perfect to celebrate the kinetic energy of this phenomenal place.

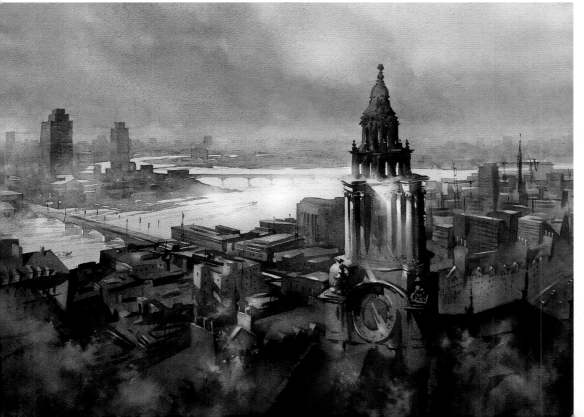

From St Paul's, London

56 x 76 cm (22 x 30 in.)

Anyone who knows this incredible city at all is no stranger to the powerful effect of its infamous fog. It is another character in the landscape — as valid as the glorious architecture and the majestic Thames itself. Painting fog in watercolour can be a tricky thing to do. But it is a real exercise in restraint and in remembering the power of that which is not painted being as powerful as that which is.

There are few better ways for an artist to reach a viewer than to pose a question to them in their work. And the attempt to answer those questions may encourage him or her to spend some time within the painting and begin to tell their own story. This is one sign of a successful work.

My painting *The Rail Walker* is a bit unusual for me. This is not a depiction of a real place. It is a painting drawn completely from imagination and memory. As a kid, I loved hiking along abandoned roads, trails and tracks, seeking out forgotten bridges and places. So for the painting, it was important to me that it looked as if it were emerging from the nostalgic fog and mist of time and memory. So many 'lost' edges were used — one shape merging gently with another. Shapes and objects become less and less distinct as they dissolve into the distance.

Initial sketch

Almost all my work is derived from my sketches — done either on site as I travel or from imagination. But these sketches are essential for me to work out options of formatting and the composition of shapes and values. It is crucial for me to have a basic value/composition plan before I begin the final painting. This plan may alter as I go along, of course, but it helps me to paint much more quickly and intuitively.

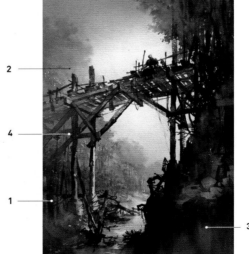

The Rail Walker

76 x 56 cm (30 x 22 in.)

I try to work all my paintings beginning to end in one sitting — never allowing it to dry completely along the way. This is especially helpful in the creation of atmospheric conditions such as mist, fog and rain. The wet-in-wet lost edges happen quickly. And as the painting begins to dry, the darker shapes and more clear edges can be laid in.

Techniques

> I paint on location about 40 to 50 per cent of the time.

> I try to 'draw' more and more with the brush and rely less and less on pencil-based drawings.

> I like to have examples of more controlled, even drybrush work, as well as much more loose, wet-in-wet techniques, and those much discussed 'lost and found' edges, appear together in a single work.

Walk-through

1 Adding greater detail and definition in the foreground creates a contrast with the hazy forms in the distance.

2 Colour also helps to establish perspective. Notice how the paler tones to the left make the midground and background recede in comparison to the darker colours in the right of the foreground.

3 The indistinct 'lost' edges also provide a sense of height as the sightline stretches from the bottom right to the top left corner of the painting.

4 The emphasis on vertical lines reinforces the sense of space and the desire to look up, into the painting.

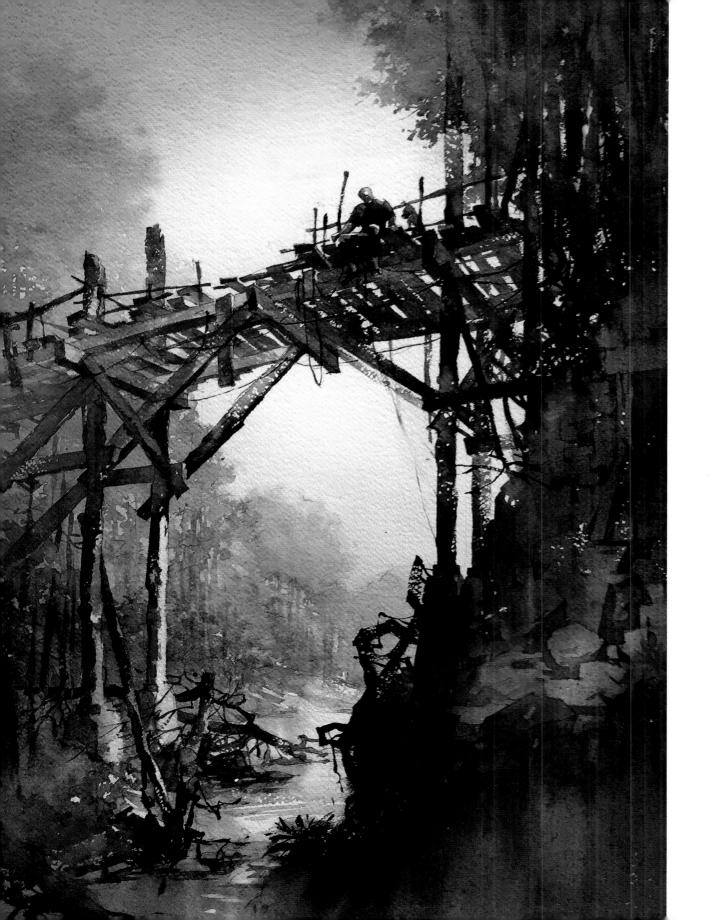

Théo Sauer Beauty in decay

'The alchemy between light and colours gives meaning to my work.'

Biography
Théo Sauer has been painting since childhood. After studying architecture, he obtained a diploma in decorative arts from Strasbourg's school of applied arts. His work has been shown in several international exhibitions.

Favourite colour It's obviously blue. Cobalt Blue, Ultramarine Blue, Turquoise, etc. I often make use of the association of complementary colours.

Paper For my work, I exclusively use Lana 640 gsm (300 lb) hot-pressed paper. For drafts and demonstrations, I use all kinds of papers.

Painting tools In addition to using brushes, I often paint with small pieces of wood, such as pieces of wooden crates or bamboo reeds, which I dip into my palette and press onto the paper to create fine lines. I also scrape them across the paper, using them in much the same way as a palette knife in oil painting, to create geometric shapes such as rectangles and lozenges.

Workspace I've set up my studio in a barn that has a large, south-facing glass door that lets in lots of natural light. I work on a drawing table, adjusting the angle of the table top as necessary.

Why industrial wastelands? They're perhaps not the most obvious subjects for watercolour paintings and people often ask me why I'm interested in this subject, yet I find beauty in the decay. When I visit abandoned places I always have a little rush of adrenalin; somewhat sinister, they seem haunted by their past. Later on, when I find myself in front of a blank sheet of paper, I feel that same sense of excitement but also new sensations. I imagine the human activity that went on there, the sounds and the smells. The alchemy between light and colours gives meaning to my work.

Above all, I like the space that you find in industrial buildings. Details such as a can, bits of old wood and metal, broken windows — all of this inspires me. I like to feel the beauty and the poetry of the place, alongside a sense of nature reclaiming its rights.

I often create series of works on the same subject, going back to the same place several times to see it in different lighting conditions at different times of day. Only rarely do I make sketches on the spot, for these places are quite unsettling and sometimes even dangerous; I'm often trespassing. When I feel I have exhausted all the possibilities of a particular subject, I look for new inspiration.

I often work from photos that I've taken myself, but I never copy them exactly. Sometimes I do a thumbnail sketch to change the framing or composition, but the colours and mood are always different to the photograph and a matter of my own personal choice.

Light and shade

I love the chiaroscuro effect of light coming in through openings (windows, holes, broken roofs) contrasting with dark interior shadows. For me, the best light is generally early in the morning or toward evening. In winter, autumn and spring, the light is low and razorlike. That's what I find most interesting. The most beautiful effect comes from backlighting.

I use the whole scale of values, from white (the white of the paper) to black, so there are strong contrasts between light and dark. The sense of light is reinforced when the lights border the darks.

It's traditional in watercolour painting to keep lots of light values, utilising the white of the paper. Personally, I am attracted to the opposite effect, which means lots of darks and few lights. This suits the mood of my subjects; abandoned buildings are often dimly or poorly lit.

To make this work, I divide my compositions into less than one-third light values and two-thirds dark values. A dark value that borders a light area will appear more luminous. In the same way, a transparent hue near an opaque, neutral hue will have more power and visual impact.

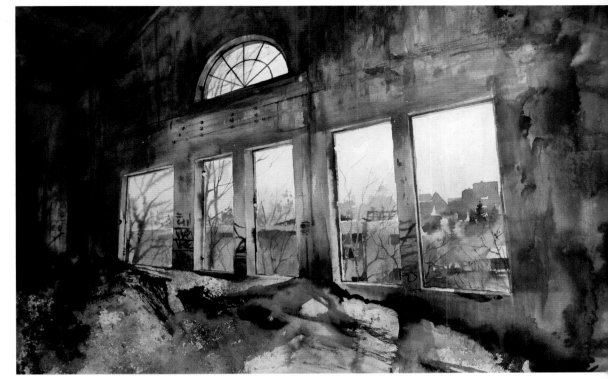

Pechelbronn

52 x 76 cm (20½ x 30 in.)

Here's a view with some lovely backlighting. The old wall was painted with several colour washes, which gives depth and patina. The foreground was rendered by spattering paint with an old toothbrush. There is always a sense of perspective in my work, and here I've tried to combine atmospheric perspective (the view through the broken windows) and linear perspective (the line of the windows themselves).

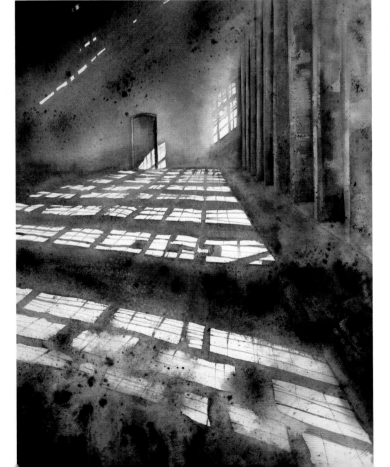

Colour choices

I find that using complementary colours is the key to a good colour harmony. Mixing two complementary colours enables me to obtain a neutral colour, and I find that the colours are magnified next to these coloured greys. I like light and shade, and I use a lot of blue for that because the sky is often reflected. For me, blue symbolizes calmness, serenity and infinity. It's the colour of dreams.

La Traversée (The Crossing)

76 x 52 cm (30 x 20½ in.)

This former industrial building looks like a cathedral. The way the light falls on the ground is complex, but I tried to simplify it in my painting. Generally, I like texture effects; here, my aim was to get to the essence of the scene.

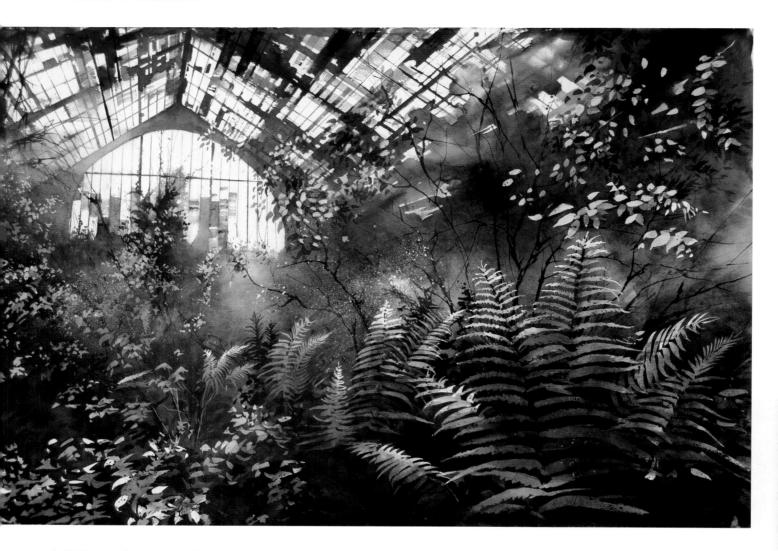

La Vieille Usine (The Old Factory)

52 x 76 cm (20½ x 30 in.)

Walk-through

1 The light areas of the ferns and other plants are reserved with masking fluid.

2 The lines and geometric forms are painted using a small piece of wood, either pressed onto or scraped over the paper.

3 Pale washes of colour are applied over the reserved areas, gradually building up the tones.

4 Applying several layers gives contrast and depth.

5 As I work from light to dark, I paint the dark areas such as this fern last of all.

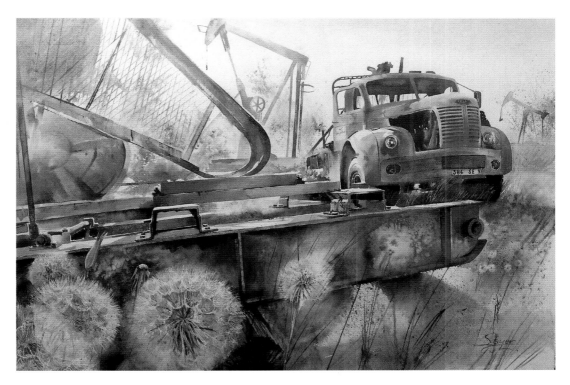

Le Berliet Bleu (The Blue Berliet)

52 x 76 cm (20½ x 30 in.)

Here, I kept a blue tone for the whole work. I especially love the contrast between the fragile plants and the rough, heavy, man-made machinery. The dandelion seed heads in the foreground were reserved with a thin feather and masking fluid, combined with water and salt effects. The straight lines were painted by dragging a small piece of wood over the paper.

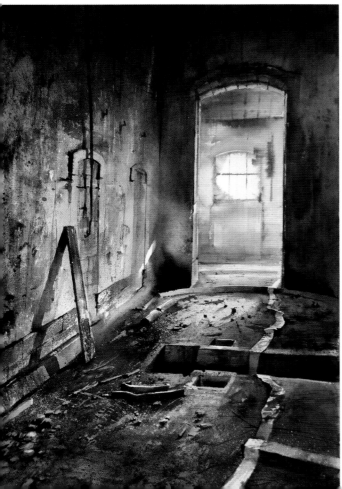

Le Fil d'Ariane (Ariadne's Thread)

76 x 52 cm (30 x 20½ in.)

The white plastic pipe on the ground leads the viewer's eye from foreground to background, while the bits of stone, wood and metal on the ground create shadows and interesting textures. I like to mix colours wet into wet on the damp paper, and apply several layers of coloured washes to the walls and ground, which gives a lovely patination.

Techniques

> First, I use masking fluid to preserve delicate and precise lights (leaves and lines, for example). I apply it with a synthetic rigger brush, which I moisten in water first so as not to damage the brush with the masking fluid.

> Once the masking fluid is dry, I wet all the paper and lay the first coloured washes. Then I start to build up contrast in some areas.

> After that, when the paper is dry, I moisten it again, if necessary, to apply wet-into-wet washes and darken the tones.

> The next stage is to remove the masking fluid. Gradually I build up darker tones and contrasts, applying colour washes over the white areas that I reserved at the beginning. The more layers there are, the more depth and space you obtain.

> I use lines and details, which gives texture to the foreground.

Frank Webb

A tale of two aesthetics: realism and the abstract

'It takes courage to paint what you think and feel.'

Biography
Frank Webb has been self-employed as an artist since 1947. He has earned 120 major awards and authored three books. He is a Dolphin Fellow and a vice president of the American Watercolor Society.

Favourite colour I am somewhat partial to Violet. When furiends ask why, I reply, 'Violet is the colour of royalty and of passion.' Although my tonal values are created in a preliminary sketch, I use colour intuitively.

Paints I prefer the large 37 ml tube. What a pity we no longer have the pleasure of squeezing the tin metal tubes of yesteryear.

Palette My palette has a flat floor that allows my brush to slide directly into the pile of paint.

Papers I try many brands and weights. Arches cold-pressed 300 gsm (140 lb) is my favourite. When I want a calligraphic dominance, I use hot pressed.

Workspace I believe that paint strokes should be made with the whole body, so I paint while standing at an adjustable table. From my hilltop studio, I can look out over a funicular that goes down to the city of Pittsburgh's Golden Triangle.

'Monet is only an eye', said Cézanne, 'but what an eye'. Most of us admire both of these painters. There certainly is room in this world for both Monet's impressionistic and Cézanne's semi-abstract approach, and most painters are in one or the other camp. It takes no courage to paint what you see. It does, however, take courage to paint what you think and feel.

I enjoy painting portraits in oil and pastel, but when it comes to landscape, I am partial to watercolour. Landscape appeals to me as an opportunity to orchestrate more complex and numerous parts into a unified whole, while adding insight to eyesight.

Abstract defined
Since the days of Monet and Cézanne, the subject of most contemporary art is not the narrative but the design of the painting. In this article, I'm using the word 'abstract' to mean semi-abstract—a complete abstract is best defined as non-objective. When we abstract, we emphasise certain qualities emerging from the subject while giving less importance to those parts that are less welcome. Thus, a painting is abstract to the degree that we depart from nature.

With this definition in mind, in my work I aim to fuse two opposing aesthetic ideas: realism and abstractionism. There are excellent works and poor works in each camp. To fuse the two, we need to focus less on the model and more intensely on the paper.

It is difficult or impossible to start with the academic drawing and then try to abstract it. Abstract first and then fit the realism into it.

Making the design
I start by making small, preliminary pencil drawings that include all the tonal values. The typical artist's sketch, done with line and only sparse bits of shade, will not do. I seldom find the lighting of the subject to be satisfactory, so I often change the light source. All my drawings are made on location, or by memory of location. I almost

Mini Patterns
These thumbnails are only 2 inches (5 cm) wide and are made with a ballpoint pen. Nothing is more important than the four to six shapes of the painting. The smallness of these sketches allows me to quickly make several and then to choose the best one. Once chosen, I follow with a larger 5 x 7 inch (12.5 x 18 cm) value drawing using an 8B graphite pencil.

never use photos. I say, 'Let photos be photography and let painting be painting'.

As I begin, I ask myself, 'What is my highest pleasure in this subject?' I walk around the subject to see all its character. During this process I often close my eyes. What I see with my eyes closed is what I need to paint. The subject then will be shorn of all inexpressive detail. Yes, detail is needed — but it must be significant and in selected areas.

Shape is the most important element of visual art. A good shape has some edges that slant in relation to the outer edges of the painting and it also interlocks with neighbouring shapes.

Continuing on the road to abstraction, I draw from nature before me, but in so doing I also make my own sizes and tonal values. I abstract pictorial space by making a flatter, more shallow space. (A picture is not a window.)

I make no colour notes. I want my colour to be abstract (away from nature).

Nostalgia Trip

41 x 76 cm (16 x 30 in.)

The format of the paper is going in the same horizontal direction as the subject. Consider the large white shape. It is what I call a linked shape. It is related to the subordinate white at the left.

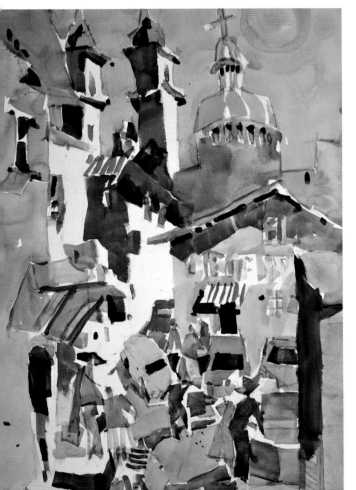

My drawings then follow me to the studio where, being less model bound, I am encouraged to make a more creative image. If I remain at the site, I turn my back on the subject and refer to the drawing.

Finishing the painting

The drawing now before me has solved most of the design problems, so I am free to give most of my attention to colour and running of washes. I have made my own shapes, lines, tonal values, textures, sizes, colour and directions. If the painting fails, I have the information needed to repaint. I have sought to give it the vital import and delight of one person's imagination. When I look at your painting, all this is what I want to see. I want to see a subject that has been imbued with your heart and mind.

Taxco, Mexico

76 x 56 cm (30 x 22 in.)

Colour in this painting expresses my enchantment with the subject. I believe the shapes also express delight. Note the piece of white: my rule for locating the important white is that it should not be centred and it should not be too close to a border.

Basking Floral

41 x 76 cm (16 x 30 in.)

This is a layered painting. Each application is put on a dry surface, one after another.

Walk-through

1 Flatness abstracts this decorative concept. All hard-edged shapes demand they be entertaining. I painted the background colour first, covering everything except the whites. This mother colour lends harmony to the whole scheme.

2 Overlapping pulls shapes together and flaunts the transparency of watercolour. You can see overlapping of two colours and in some places more than two overlap. Transparency is one of watercolour's greatest characteristics.

3 Note the variety of sizes of the all-important whites. Whites make a painting sparkle. Note that the most commanding shapes here are where the darkest darks come near the whites.

4 Larger areas here are a nice foil against selected areas of greater eventfulness.

5 Interlocking helps to hold the parts together as in a jigsaw puzzle. If possible, each shape should have a bite or two taken out of it and then other parts sticking out.

6 Every long line or edge should be interrupted by an incident.

7 At each of the four corners is a different size and shape.

Techniques

> I use mostly flat brushes, up to 7,5 cm (3 in.) wide. Often I use the corner of the brush. I seldom use a pointed brush.

> My early career included some lettering, so I have an intimate acquaintance with the flat brush, which I can twist, turn and use to caress the paper, making shapes from the inside out rather than from the outside in. Since letterforms are abstracts, I have gained expertise in making shapes with a minimum of strokes.

Maple Sugar House

56 x 48 cm (22 x 19 in.)

I call this kind of colour 'patchilism'. Colour variations are introduced with each brushstroke. While the paint is still wet, the edges fuse. The trick is to maintain the tonal value of an area while changing colour.

Funchal Beach

56 x 76 cm (22 x 30 in.)

I was intrigued by the possibility of linking several houses into one white shape. My shape dominance here is the triangular. The dominant cool colour surrounds and intensifies the subordinate warm colour.

Index

A

abstraction 248–51
acrylic paint 224, 226, 229
aerial (atmospheric) perspective 32, 33, 37, 116, 118–19
 trees and foliage 138
Alizarin Crimson 14, 15, 20, 32, 34, 35, 36, 124
analogous colours 32, 74, 120–1, 122
animals 112, 188–9
Antens, Jos 86, 113
architectural textures 182–7
artists' quality paint 12, 14
ASTM system 14
asymmetrical balance 110–11
atmosphere, creating 124–7, 240–3
Aureolin Yellow 14, 32, 34, 35, 36

B

backgrounds
 mood and atmosphere 124
 negative painting 64, 72–3, 139
 tinted washes 54, 56–9, 64, 124
backruns 8, 51, 55, 63, 84–5, 86
Bapat, Dhanashri 93
Barnes-Mellish, Glynis 200–3
Barr, Mike 212–15
Bartel, Eva 133
Bedard, Liane 65, 121
Belanger, Richard 172
Belobrajdic, Tony 92, 116, 178
Beukenkamp, Annelein 189, 190
birds 188–9
Bleekrode, Stefan 140
blooms see backruns
board
 angle 50, 52, 60
 attaching paper to 25
 stretching paper on 24–5
body colour see gouache
Bond, Denny 106, 180, 181, 197
Brown, Cara 47, 111, 121, 141, 167, 190
brush case 16, 18
brushes 16–19
 cleaning 18
 fan 17
 filbert 17
 flat 16, 17, 65, 77, 251
 goat hair 18
 holding 19
 mop 16, 19, 50–5
 rigger 16, 17, 19
 round 16, 19
 sable 18
 size 16, 17, 213, 221
 squirrel hair 17, 18, 19
 storing 16, 18
 synthetic fiber 18
 toothbrush 27
 travel kit 29
 for washes 16, 50–3
brush pens 17
Burnt Sienna 14, 15, 34, 35, 36
Burnt Umber 14

C

Cadmium Red 14
Cadmium Yellow 14
calligraphic marks 62
Cassels, Julia 92, 205
cauliflowers see backruns
Cerulean Blue 15, 35, 36, 124
Chaderton, Liz 86, 189
Chamberlain, Trevor 8
Chapman, Lynne 17, 199
charcoal 224–5, 227
chiaroscuro 244
cityscapes 182–7
Clinch, Moira 74, 125, 150
clouds 60–1, 64, 82, 134–7
 wet on wet 136–7
Cobalt Blue 12, 14, 15, 32, 34, 35, 36, 124
Cobalt Green 37
Cobalt Violet 15, 35, 36
cold-pressed paper 22–3
collage
 Japanese rice paper 225
 stained paper 236–9
collapsible water pots 29
colour 46–7, 220–3
 aerial (atmospheric) perspective 118–19, 138
 analogous (harmonious) colours 32, 74, 120–1, 122
 background washes 56–9
 balance 120, 123, 124, 127, 131
 colour wheel 32–3, 120
 complementary colours 32–3, 120–1, 122, 124, 244–5

as compositional device 120–3, 249
dominant 121
gouache 94
limited palette 34–5, 93, 212–13, 220–3
line and wash 26, 88–93
mixing *see* colour mixing
and mood 124, 245
neutral colours 32, 245
opaque colours 14, 94–9
pigments *see* pigments
primary colours 32–3
ratio of pigment to water 40
reflected 219
secondary colours 32–3
staining colours 15, 76
strength 40–1
synthetic 76
temperature *see* cool colours; warm colours
tertiary colours 32–3
tonal value 38–9, 48–9, 220, 223, 239
transparency 14, 34, 224–7
washes *see* washes
Colour Index (CI) name 15
colour mixing 32, 35, 36–7
glazing 42, 45
greys 35
greens 32, 35, 37, 43, 44
in the palette 42–3
on paper 42, 44
complementary colours 32–3, 120–1, 122, 244–5
balance 124
composition 110–11, 242, 248–9
asymmetrical balance 110–11
colour 120–3
dynamic 111
focal point 110–13, 114
framing devices 113
horizon line 110, 116
landscape format 105
lead-in 114–15
letterbox format 105, 116, 173
linked shapes 249
picture format 105, 249
portrait format 105
portraits 111
rule of thirds 110–11, 112

S-path 114
tone 120–3, 192
U-path 114
value sketches 39, 192, 242
viewpoint 104–5
visual path 114–15, 120
contre-jour 48, 126, 127, 130, 132
cool colours 32–3, 34, 124
background washes 56–9
balance 123, 127, 131
mood and atmosphere 124
shadows 46, 47
sunlight and shade 150
variegated washes 54
cotton buds 27
Covington-Vogl, Laurel 82

D
dampening paper 96
dark to light, painting 220–3
Davey, Leo 228–31
Da Vinci, Leonardo 105
deckle edge 22
definition 60, 62
Dentinger, Ric 78
direct method 100–1
distance, suggesting 116–19, 125, 132, 140
Djukaric, Dusan 108, 125, 204
Dobbs, Linda Kooluris 49, 123, 197
drybrush technique 23, 66–7, 164, 168, 182, 188, 200, 215
Dunbar, Jim 173
Duval, Thierry 119, 133, 150, 183
dynamic compositions 111

E
easel 28
Emmons, Randy 64, 138
enlargement, photocopied 235
Evans, Carol 131, 153
Evansen, Andy 122
eye level 116–17

F
fabrics 178–9, 201, 232–5
fan brushes 17
figures in location 196, 204–9, 213
filbert brushes 17
Fletcher-Watson, James 8
flowers 190–5, 217

focal point 110–13
hard edges 124
landscapes 112
rule of thirds 112
still-life paintings 113
visual path 114–15
foliage 138–49
foreground areas 66, 155, 156–7, 222
format, picture 104, 105
found edges 240, 242
Fox, Barbara 54, 180
Fracasso, Pasqualino 126, 138
Freeman, Jane 217–19
fugitive colours 14
fur 188–9

G
gesso 224–7
glass 180–1
glazing 34, 46, 164, 174–7, 194, 226, 227
colour mixing by 42, 45
gold 181
Goldstein-Warren, Laurie 220–3
gouache 13, 94–9, 224
coloured 94
opacity 13, 94, 96
pigment content 94
spattering 94–5
texture effects 94
thinned 96–9
granulation
pigments causing 15, 207
salt effects 80–1, 86
greys 35
textured 15
greens 32, 35, 37, 43, 44
aerial perspective 37, 138
proprietary 37, 146–9
trees and foliage 138–49, 151
gummed paper tape 17, 24–5
Gurney, James 99

H
hair-dryer 27, 51, 229
hard and soft edges 60, 62–3, 72, 240, 242
focal points 124
giving prominence 97
mood and atmosphere 124
negative painting 72

resist technique 68
skies 134, 136
softening hard edges 70, 72, 95
stencils 155
high key 47, 126
highlights
gouache 94
masking fluid 168–71
see also white areas
Highsmith, Robert 48, 132, 134, 151
horizon line 110, 116
seascapes 154
hot-pressed (HP) paper 22–3
"hues", paint quality 12
Hunt, Douglas 79, 115

I
Indian Yellow 35, 36
inks
line and wash 26, 88–93
non-waterproof 91
pigment inks 224–5
watercolour 13
waterproof 88

J
Jaramillo, Omar 117
Jozwiak, Bev 111, 198

K
Kolinsky sable brushes 18
Kurbatov, Sergey 124, 127

L
landscape format 105
landscapes 130–5
aerial perspective 32, 33, 138
colour balance 120
focal point 112–13
graduated washes 52
light 130, 133
mood and atmosphere 124, 244
panoramic 105
skies and clouds 44, 46, 52, 54, 60–1, 64, 82, 134–7
snow 162–3
sunlight and shade 150–1
trees and foliage 138–49
variegated washes 54, 134
weather conditions 133

wet on wet 44, 46, 60–1, 125, 127, 136–7
working on location 130
see also seascapes; water
Lapin 93
layer masking 74–5
layered painting 250
Lee, Roland 110
letterbox format 105, 116, 173
lifting out 27, 76–7, 78, 158–61, 170, 200
 staining colours 15, 76
light 240–1, 244
 backlighting 126, 221
 landscapes 130, 133
 mood and atmosphere 124–7, 244–5
 portraiture 207
 reflected 151, 180–1
 and shade 38–9
 on water 2290
light colours over dark 94–5, 149, 229
lightfastness 14
 watercolour inks 13
Light Red 14, 35, 36
Lin, Fealing 115, 199, 206
linear perspective 116
line and wash 26, 88–93
Linscott, Caroline 123, 191
Lobenberg, David 105, 188, 198
Lord, Carolyn 46, 107, 141
lost edges 240, 242
Lovett, John 224–7

M
McEwan, Angus 123, 167, 173
mahl hand 72
Marchant, Graham 232–5
masking, generally 80, 86, 155
masking fluid 26, 68–71, 72, 78, 152–3, 155, 158, 184–7, 220–3, 246–7
 applying with pen 174, 206
 highlights 168–71
 layer masking 74–5
 spattering 80, 174–7
masking tape 25, 26
measuring angles and proportions 117
metal 180–1, 219, 220–3
mixing paint

palettes 20–1
see also colour mixing
mood, creating 124–7, 213, 244–5
mop brushes 16, 19, 50–5
Morris, David 104, 117, 164, 204
mouth atomizer 222
multiple-wash method 100–1

N
Naik, Sachin 93
Nash, Keith 46, 109
negative painting 64, 72–3, 139, 200
Nelson, Vickie 189
NOT paper 22–3

O
Ong King Seng 139, 182
opacity 224–7, 233
 gouache 13, 94–9, 224
 pigment 14
outdoors, working 12–13, 130

P
pads, watercolour 22, 29
paintboxes 12–13
palettes 13, 20–1
panoramic scenes 105
pans, paint in 12–13, 29
paper 22–3
 cockling 24
 cold-pressed 22–3
 damp 44, 50, 60–1, 94, 160
 dampening 96
 deckle edges 22
 handmade 22
 hot-pressed (HP) 22–3
 Japanese 225, 236–9
 line and wash 88
 mold-made 22
 NOT 22–3
 rough 22–3, 66
 stained paper collage 236–9
 storing 22
 stretching 24–5
 textured surface 66
 watercolour pads 22
 watermarks 22
 weight 22–3
 wood free 22
pastels 227
pattern 141, 248

Pedder, Alan 205
pencils
 graphite 26, 62
 watercolour 13
pens 88, 228, 229
 adding texture with 155–7
 drawing with watercolour 170
 line and wash 88–93
 masking fluid application 174, 206
 waterproof 26, 88
permanence 14
perspective 116–19, 213
 aerial (atmospheric) 32, 33, 37, 116, 118–19, 138
 linear 116
 measuring angles and proportions 117
 one-point 116–18, 139
 two-point 116–18
 vanishing points 116–19
Phthalo Blue 14, 15
pigments 12, 14–15
 Colour Index (CI) 15
 gouache 94
 granulation 15, 207
 mixed-pigment colours 15
 opaque 14, 87
 ratio of water to 40
 staining colours 15, 76
 transparent 14, 34
 undissolved 41
 see also colour
portrait format 105
portraits 111, 196–203
Poxon, David 153, 172, 174–7
primary colours 32–3
Purcell, Carl 72, 79

R
rain 65, 213
Raw Sienna 14, 34, 35, 36
Raw Umber 14, 15, 35, 36
realism 248–51
Reardon, Michael 64, 118, 152
reflected light 151, 180–1
reflections 64, 65, 99, 108, 131, 133, 151, 152–3, 158–61, 186–7, 219, 228
 glass and shiny objects 180–1
 resist technique 68–71, 72
 see also masking fluid

Rieuwerts, Hannie 48, 105, 116, 151
Rifkin, Dorrie 122, 205
rigger brushes 16, 17, 19
Rogers, Betty 108
rough paper 22–3
Rudko, Rafal 162
rule of thirds 110–11, 112
Ryan, Denis 52, 120

S
sable brushes 18
salt, effects created with 82–3, 86, 143
Sap Green 37
Sauer, Théo 244–7
Schaller, Thomas W. 240–3
scratching out 156
seascapes 109, 124, 154–7
 graduated washes 52
 horizon 154
 wet on wet 60–1
 secondary colours 32–3
selective seeing 106–9
shadows 35, 38–9, 48, 105, 217–19, 244
 cool 46, 47
 sunlight and shade 150–1
Shevchuk, Yuriy 182
shiny objects 180–1, 219, 220–3
simplicity 212–15
sketches 22, 88–9, 242
 thumbnail 109, 212, 244, 248
 tonal values 39, 192, 242, 249
 written notes 109
skies 44, 46, 82, 134–7, 240
 graduated washes 52
 variegated washes 54, 134
 wet on wet 44, 46, 60–1, 64, 136–7
Smith, Ann 64, 106, 113
smudges, lifting off 71
snow 162–3
S-path 114
spattering 27, 80–1, 86–7, 148–9
 gouache/opaque paints 87, 94–5, 149, 157
 masking fluid 174–7
 seascapes 157
 trees and foliage 142–5, 148–9
 water 95
sponges 27

square format 105
squirrel hair brushes 17, 18, 19
staining colours 14, 15, 20
steelyard balance 110
stencils 155
still-life paintings 106, 180–1
 focal point 113
 texture 168–71
 viewpoint 104–5
stippler brushes 17
stippling 146–9
students' quality paint 12
studio space 28
subject matter 106–9
 light and dark shapes 108
 selective seeing 106–9
 viewpoint 104–5
sunlight 49, 150–1, 204
Swenson, Brenda 236–9

T

Talbot-Greaves, Paul 87, 98, 112,
 114, 162
Taylor, Nancy Meadows 158–61,
 191
tertiary colours 32–3
texture 86–7, 164–71, 224, 245
 animals and birds 188–9
 architectural 182–7
 backruns 84–5
 drybrush technique 66–7
 fabrics 178–9, 232–5
 flowers 190–5
 foreground 155–7, 222
 gouache 94
 granulation 15, 207
 mouth atomizer 222
 pen lines 155–7
 salt crystals 82–3, 86
 shiny objects 180–1
 spattering 80–1, 86–7, 94–5
 wax resist 71
 wet on dry 62
 worn 172–7, 182, 244–7
Thienpondt, Fernand 65, 135
Thompson, Gerry 179, 181
Thorn, Richard 107, 130, 135,
 146–9, 152, 154–7
three-dimensionality 39, 116,
 168–9, 232
tonal values 38–9, 48–9, 138, 220,
 223, 239, 244

aerial (atmospheric)
 perspective 118–19, 138
balance 131
chiaroscuro 244
 as compositional device
 120–3, 192
contre-jour 48, 126, 127, 130,
 132
dominant 122
graduated washes 52–3
high key 47, 126
light and dark shapes 108
mood and atmosphere 126
painting dark to light 220–3
sketches 39, 192, 242, 249
tinted background washes
 56–9
white areas 79
see also shadows
transparency 14, 34, 224–7, 233,
 250
travel kit 13, 29
trees 138–49
tubes, paint in 12–13, 29
Tydeman, Naomi 126, 142–5, 165,
 168–71

U

Ultramarine Blue 15, 35, 36, 124
U-path 114

V

vanishing points 116–19
variegated washes 54–5, 56, 134
Vermilion 14, 32, 35, 36, 124
Vernon, Karen 192–5
viewpoint 104–5
 eye level (horizon line) 116–17
visual path 114–15
Vogel, Bernhard 80, 87, 163

W

warm colours 32–3, 34, 35, 46
 background washes 56–9
 balance 123, 127, 131
 mood and atmosphere 124
 sunlight and shade 150
 variegated washes 54, 134
washes
 backruns 51, 63, 84–5
 board angle 50, 52, 60
 brushes for 16

flat 50–1, 65
graduated 52–3, 64, 226
landscapes 136–7
layering 250
line and wash 26, 88–93
masking 74–5
mood and atmosphere 124
multiple-wash method 100–1
negative painting 64, 72–3
ratio of pigment to water 40
resist technique 68–71
rundown 55
salt effects 82–3, 86
stripy and uneven 51, 53, 55
tinted background 56–9, 124
variegated 54–5, 56, 134
wetting paper for 41
wet on wet 60–1, 64, 65, 86, 90,
 125, 127
white areas 56, 64
water 152–61, 228–31
 direction of flow 152
 foam 153, 228
 reflections 64, 65, 131, 133,
 151, 152–3, 158–61, 186–7,
 228
 rippling 158–61
 sparkling 66, 67, 68, 80, 87,
 152, 154–7
 transparent 153
 wet on wet 152–3
water, mixing paint with 40
watermarked paper 22
Watson, Deb 78, 139, 141, 166,
 178, 199
wax resist 68, 71
Webb, David 37, 68, 76, 136–7
Webb, Frank 248–51
Wei, Chien Chung 47, 112, 127,
 183
Wesson, Edward 8
wet on dry 62–3, 152, 194
wet on wet 60–1, 65, 86, 90, 127,
 164, 168, 188, 192–5
 colour mixing by 44
 edges 242
 landscapes 44, 46, 125, 127,
 136–7
 skies 44, 46, 60–1, 64, 134,
 136–7
 water 152–3
white areas 38, 78–9, 229

background washes 56
bright sunshine 125, 138,
 150–1
drybrush technique 66, 67
gouache 94
lifting out 76–7, 78, 170
masking fluid 68–71, 78, 80,
 152–3, 158, 168–71, 174–7
negative painting 72–3
scratching out 156
spattered highlights 87
wax resist 68, 71
white flowers 192–5
white paint 14, 87, 149, 229
Wilmot, Tim 109, 115
Winsor Green 37
Witty, Donna 184–7, 206–9
wood free paper 22
worn textures 172–7, 182, 244–7
Wrobel, Grzegorz 163

Y

Yellow Ocher 14, 35
Yule, Liz 125

Credits

Quarto would like to thank the following artists, photographers and agencies for supplying images for inclusion in this book:

Antens, Jos www.josantens.nl pp.86br, 113bc
Barnes-Mellish, Gynis p.203
Barr, Michael pp.213, 214, 215
Bartel, Eva www.evabarte.com p.133br
Bedard CSPWK, Liane www.lianebdeard.com pp.65bl, 121tr
Belanger, Richard www.richardbelanger.ca p.172cr
Belobrajdic, Tony pp.116tr, 178cr
Beukenkamp, Annelein www.abwatercolors.com pp.189cr, 190br
Bleekrode, Stefan www.stefanbleekrode.com p.140
Bond, Denny www.dennybond.com pp.106tr, 180tr, 181bl, 197tl
Brown, Cara www.lifeinfullcolor.com pp.47tl, 111bl, 121bl, 141tr, 167tr, 190tr
Cassels, Julia p.205br
Chaderton, Liz www.lizcaderton.co.uk pp.86tr, 166bl, 189tl
Chapman, Lynne p.17
Clinch, Moira pp.74–75, 125tl, 150br
Covington-Vogl, Laurel p.82
Davey, Leo pp.229, 230, 231
Dentinger, Ric www.ricdentinger.com/art p.78
Djukaric, Dusan www.dusandjukaric.com pp.108bl, 125tr, 205tr
Dunbar, Jim www.jimdunbar.co.uk p.173br
Duvall, Thierry www.aquarl.free.fr pp.119, 133tl, 150t, 183t
Emmons, Randy www.randyemmons.com pp.64cl, 138tr
Evans, Carol www.carolevans.com pp.131, 153t
Evansen AWS, PAPA, NWWS, Andy www.evansenartstudio.com p.122tr
Fox, Barbara www.BFoxFineArt.com pp.54, 180br
Fracasso, Pasqualino www.pasqualinowatercolour.com pp.126tl, 138b
Freeman, Jane pp.217, 218, 219
Goldstein-Warren, Laurie pp.221, 222, 223
Highsmith AWS, NMWS, Robert www.rhighsmith.com pp.48bl, 132, 134, 151tc
Hunt, Douglas www.douglashunt.ca pp.79tr, 115tr
Jarmaillo, Omar omar-paint.blogspot.com p.117tr
Jozwiak Bev pp.111tr, 198tr
Kooluris Dobbs, Linda www.koolurisdobbs.com pp.49, 123tr, 197br
Kurbatov, Sergey www.skurbatov.com pp.124, 127tl
Lee, Roland www.rolandlee.com p.110tr
Lin, Fealing www.fealingwatercolor.com pp.115tl, 196
Linscott, Caroline wwwwatercolorsbycarolinelinscott.com pp.123tl, 191tl
Lobenberg, David www.lobenbergart.com pp.105tl, 188, 198bl
Lord, Carolyn www.carolynlord.com pp.46tr, 107tl, 141bl
Lovett, John www.johnlovett.com p.225, 226,227
Marchant, Graham pp.233, 234, 235
McEwan RSW, RWS, Angus www.angusmcewan.com pp.123bl, 167, 173
Meadows Taylor, Nancy www.nancymeadowtaylor.com pp.161, 191
Morris, David pp.104br, 105bl, 164, 204bl

Nash, Keith pp.46bl, 109tr
Nelson, Vickie p.189bl
Pedder, Alan www.alanswatercolours.co.uk p.205tc
Poxon, David www.davidpoxon.co.uk pp.153bl, 172cl, 177
Purcell, Carl www.thewatercolorteacher.com pp.72, 79
Reardon, Michael pp.64tr, 118, 152tr
Rieuwerts, Hannie www.aquarieuwerts.nl pp.48tr, 105bl, 116bl, 151bc
Rifkin, Dorrie www.dorrierifkin.com pp.122br, 205cl
Rogers, Betty www.BettyRogersArt.com p.108tr
Rudko, Rafal p.162tr
Ryan, Denis pp.52, 120
Sauer, Théo pp.245, 246, 247
Schaller, Thomas W pp.241, 242
Seng, Ong King www.ongkimseng.com pp.139tl, 182bl
Shevchuk, Yuriy www.shevchukart.com/www.yuriy-shevchuk.pixels.com p.182tr
Smith, Ann www.annsmithwatercolors.com pp.64bl, 106br, 113tr
Swenson, Brenda pp.237, 238, 239
Talbot-Greaves, Paul www.talbot-greaves.co.uk pp.87br, 94–95, 112br, 114, 162bl
Thienpondt, Fernand www.vlaamseaquarel-tekenschool.be pp.65tr, 66, 135br
Thompson, Gerry www.gerrythompson.ca pp.179, 181tr
Thorn, Richard www.richardthornart.co.uk pp.107br, 130, 135t, 149, 152, 157
Tydeman, Naomi pp.126br, 145, 165, 171
Vernon, Karen p.195
Vogel, Bernhard www.bernhard-vogel.at pp.80, 87t, 110bl, 163t
Watson, Deb pp.78tr, 139bl, 141br, 166tr, 178bl, 199
Webb, David pp.37, 68, 76, 137
Webb, Frank pp.249, 250, 251
Wei, Chien Chung pp.47br, 112tr, 127bl, 183bl
Wilmot, Tim wwwtimwilmot.com pp.109bl, 115bl
Witty, Donna p.209
Wrobel, Grzegorz grzegorz-wrobel.com p.163bl
Yule, Liz pp.104tl, 125br

L. CORNELISSEN & SON

With special thanks to L. Cornelissen & Son who supplied the featured tools and materials used in this book. Contact them at L. Cornelissen & Son, 105 Great Russell Street, London WC1B 3RY. For online enquiries, go to www.cornelissen.com.